RoseLee Goldberg

performance

LIVE ART SINCE THE 60s

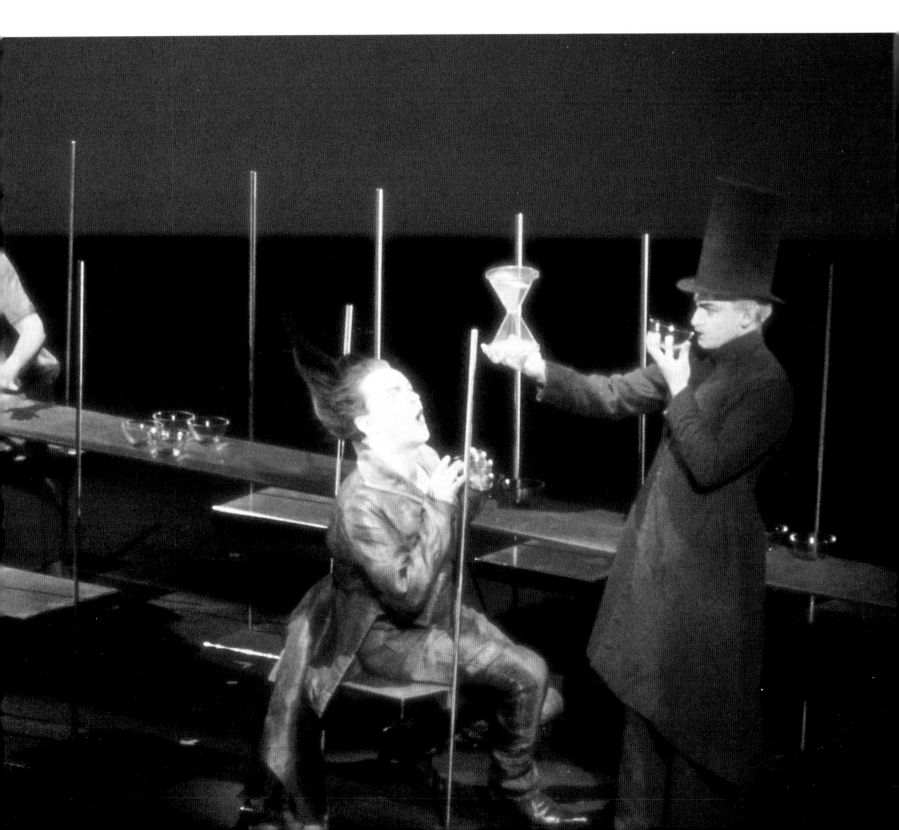

for my family, Dakota, Zoë, Pierce

acknowledgments

My dear friend and editor extraordinaire Nikos
Stangos (1936–2004) commissioned my first book,
Performance: Live Art 1909 to the Present in 1979,
and brought into existence, with perfect timing, my
subsequent books, right up to the time he departed
Thames & Hudson to concentrate on his own
writing and poetry. Nikos lives on in every line
I write, with love, admiration and gratitude.

A heartfelt thank you to the artists and
photographers whose remarkable work is
presented in this book. A very special thanks to
Jens Hoffman for his invaluable assistance, to
Maggi Smith for her design, and to the whole
team at Thames & Hudson: Clarissa Cairns (editor),
Margaret Hickson (production), Joanna Marsh
for help with picture research. Thanks also to Jon
Hendricks, Chrissie Iles, Lois Keidan, Harvey
Lichtenstein, Joseph V. Melillo, Jill Poller, Donna
Brodie and the Writers Room, Gwendolyn Wright,
Mark Russell, Bettina Funcke, Simon Herbert,
Virginia Baxter, Keith Gallasch, Martha Wilson,
Kathy O'Dell, Nancy Spector, Tom Stromberg.
To Pierce, Zoë, and Dakota Jackson, to whom
this book is dedicated.

P. 1: ANTHONY HOWELL, *Life into Art*, 1984
P. 2: ROBERT WILSON, TOM WAITS, and
　　　PETER SCHMIDT, *Alice*, 1995
P. 4: FORCED ENTERTAINMENT, *Marina and Lee*, 1991
　　　JOAN JONAS, *Funnel*, 1974
P. 5: YAYOI KUSAMA, *Infinity Mirror Room*, 1965
　　　AN HONG, *Fortune Cookies*, 1997
　　　PIERO MANZONI, *Living Sculpture*, 1961
　　　POPPO AND THE GO-GO BOYS,
　　　A New Model of the Universe, 1989

First published in the United Kingdom in 1998 by
Thames & Hudson Ltd, 181A High Holborn, London WC1V 7QX
www.thamesandhudson.com

British Library Cataloguing-in-Publication Data
A catalogue record for this book is available from the British Library

ISBN 0-500-28219-6

Designed by Maggi Smith

Printed and bound in Singapore by C. S. Graphics

performance

E ART SINCE THE 60s

Thames & Hudson

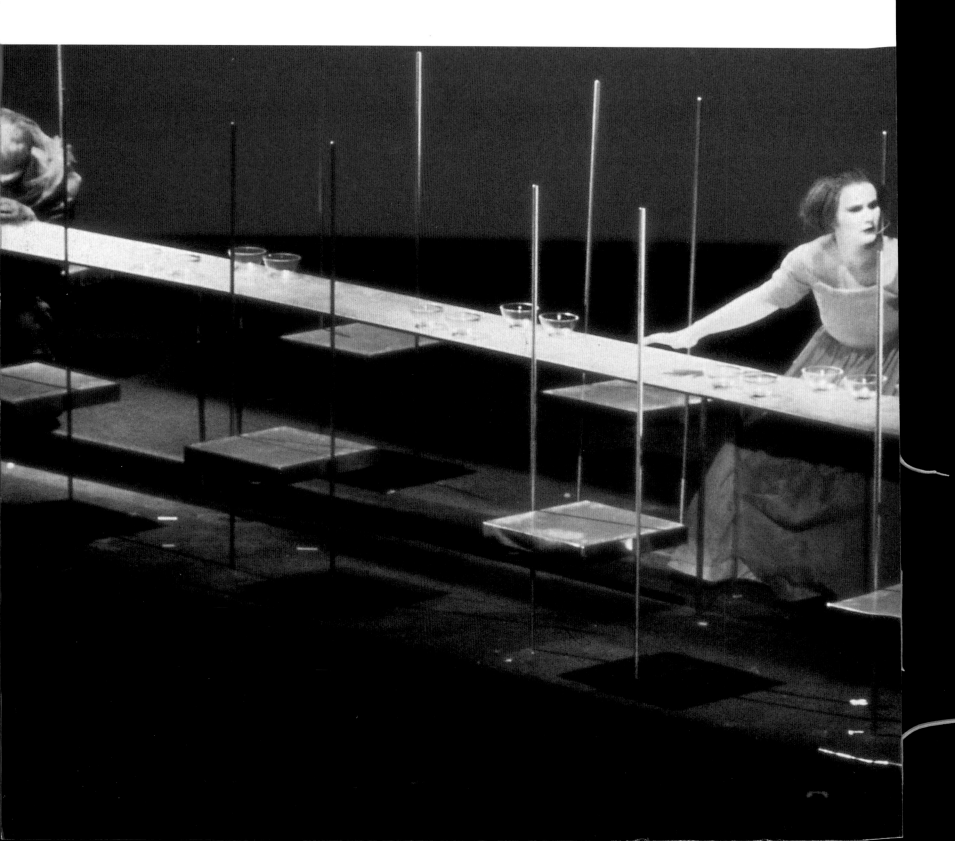

contents

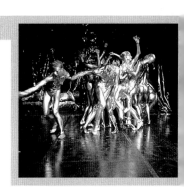

foreword *by Laurie Anderson*

this is the time and this is the record of the time

As a young artist on the '70s New York downtown scene, I was pretty sure that we were doing everything for the very first time, that we were inventing a new art form. It even had a clumsy new-sounding name "Performance Art," and critics and audiences struggled to define this "new" hybrid that combined so many media and broke so many rules about what art was supposed to be. So when RoseLee Goldberg's book *Performance: Live Art 1909 to the Present* was first published in 1979, I was completely amazed to find that what we were doing had a rich and complex history. Marinetti, Tzara, Ball, and Schlemmer sprang from the pages. Dada and Futurist manifestos, diagrams, posters, sets, events, happenings, and concerts came alive in all their chaotic and fertile inventiveness. I especially appreciated details like an account of an event by "The Incomparables Club" in 1911 which featured The Earthworm Zither Player—a trained earthworm who slid along the strings exuding drops of "mercury-like sweat" that made the instrument resonate. In her new book, Goldberg continues the story, following the thematic threads and presenting, along with the photographic artifacts, a cogent analysis of styles, ideas, and socio-political background.

Live art is especially ephemeral. Once performed, it tends to become myth and a few photos and tapes. Many of the artists in this book only occasionally reconstruct their performances, mainly because much of the work—performed by the artists themselves—was designed on the most basic levels for that particular artist's voice or body. Also, there are no performance companies to re-present the work. So representing this work as text and images becomes an act of imagination.

Because I've seen much of the work illustrated in this book, the images are especially rich. I can hear the voices of Vito Acconci, Christopher Knowles, picture the breakneck speed of Molissa Fenley, re-experience the grinding gears, sparks, and shopping carts careening around in the dark of a La Fura dels Baus event. But even if you've never seen any of this work, the images speak. The sets, stills and performance shots are vivid snapshots of an art form that resists documentation.

I myself used to be very proud that I didn't document my work. I felt that, since much of it was about time and memory, that was the way it should be recorded—in the memories of the viewers—with all the inevitable distortions, associations and elaborations. Gradually

I changed my mind about making records of events because people would say things like, "I really loved that orange dog you had in that show!" And I've never had an orange dog ever. I started to keep track of things after that. I just didn't want it to disappear.

When live art is documented through film or audio recordings it immediately becomes another art form—a film or a record—another rectangle or disk. It's in the can. But live art is continually elusive. This book covers an immense amount of work in many media and extremely diverse styles. Tracing the trends and links, RoseLee Goldberg has let the work resonate through its images.

Many of the artists in this book are friends—some have been collaborators—some acquaintances. Most of them are still making art and reinventing their vocabularies and styles. Some of them are just beginning. This is literally living art that continues to evolve and expand. As it continues to change, I've come to feel that it's crucial to preserve this work. It is the anarchic and experimental arm of our culture. It isn't supported by the mass media and is not recorded by it. We live in a time in which everything gets captured and processed and made to fit into boxes and categories. This is a difficult task with live art. In this book, the images and text are presented in the spirit of the work itself: ever evolving and reinventing.

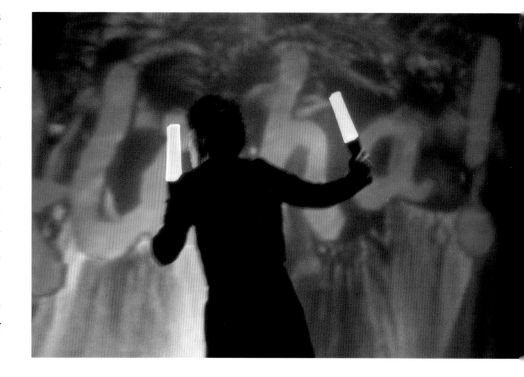

LAURIE ANDERSON
Stories from the Nerve Bible, 1992

First performed at Expo '92 in Seville, *Stories from the Nerve Bible* used computerized imagery and holograms to create a spectacular setting for Anderson's apocalyptic songs.

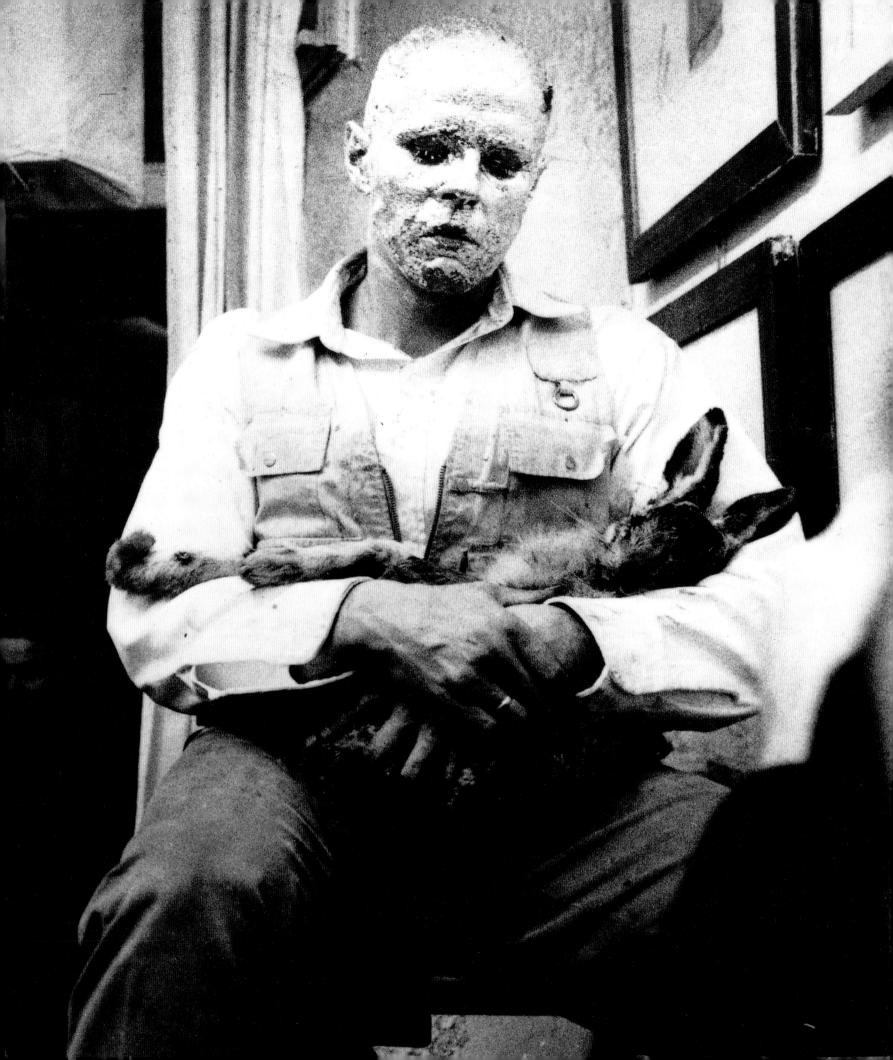

introduction

Performance art was the one place where there were so few definitions

Laurie Carlos

When I was writing my first book on performance art in the late 1970s, there were very few publications on the subject.[1] Those that were available covered specialized areas, such as Futurist performance or Happenings, and were dealt with as separate episodes unrelated to one another. My task in constructing the first history of a medium with no real name involved searching through old journals, ephemera, and photo archives, looking for material that had been all but forgotten. It was overlooked because it often fit no category, and unexamined because this material could no longer be seen, only described. I nevertheless ended up with an unexpected conclusion to my book. Not only did live art by artists represent the very spirit of its own times and reveal the ways in which artists from different disciplines interconnected, it also showed me how certain ideas in a painting or a sculpture, which as a traditional art historian I might have looked for in other paintings or sculptures, often originated in some sort of performed action. Indeed, the history of performance throughout the twentieth century showed performance to be an experimental laboratory for some of the most original and radical art forms; it was a freewheeling, permissive activity for intellectual and formalist excursions of all kinds that could, if studied carefully, reveal layers of meaning about art and artmaking that simply were not clear before. As such, it was a missing piece in the big picture of art history studies.

In the 1990s, performance is an important reference, not only in art history but also in the very latest courses on contemporary culture, whether in philosophy, photography, architecture, anthropology, or media studies. Performance—whether autobiographical monologue or personal ritual, dance theater or artists' cabaret—provides incomparable material for examining contemporary viewpoints on such issues as the body, gender or multiculturalism This is because live work by artists unites the psychological with the perceptual, the conceptual with the practical, thought with action. According to the current tenets of critical theory, the viewer of art, the reader of a text, the audience of a film or a theater production are all performers, since our *live*, immediate responses to an art work are essential to the completion of the work. Even the lecturer or the critic "performs" a text, as I do too in these pages, allowing each

JOSEPH BEUYS
How to Explain Pictures to a Dead Hare, 1965

For three hours in a gallery in Düsseldorf, Beuys silently mouthed an explanation of his art to a dead hare, an ironic comment on the difficulties of communicating through art.

reader to insert her or his own social, economic, psychological, and educational experience between the lines. In this way, we are all activists, never more passive recipients of the material of culture; we are kinetic collaborators in the construction of ideas.

The term "performative" has come to describe this state of perpetual animation. It appears regularly in academic texts to underline the significance of engagement by artist and viewer. It is used retroactively to examine the profound role of performance in the heroic paintings of Jackson Pollock, or in the calmer paintings of Jasper Johns, particularly those incorporating cast body parts. The 1967 essay "Art and Objecthood" by the American art historian Michael Fried is now seen as pivotal because it blamed the demise of purely abstract painting and sculpture on Minimalist art that with its stage presence *"approaches the condition of theater,"* and demands that the "work of art *confront* the beholder." In present-day criticism, the term is used to describe the work of many, very different contemporary artists, from Cindy Sherman to Eric Fischl or Matthew Barney, whose art is considered "performative" for its unusually charged content. According to photographer Richard Avedon who insists that "all portraiture is performance," even Rembrandt, "must have been acting when he made his own self-portraits.....Not just making faces, but always, throughout his life, working in the full tradition of performance." [2]

As a result of this intense focus on performance and the performative quality of a work, new publications abound on a broad spectrum of topics connecting performance art to psychology, pedagogy, gender, masculinity, ethnicity, anthropology, or politics. A vast bank of frequently repeated images emerges—Yves Klein's *Leap into the Void*, Carolee Schneemann's *Interior Scroll*—which may become as iconic to the history of performance as are Marcel Duchamp's *Fountain* or Andy Warhol's *Campbell's Soup Cans* to the study of modern art. In addition, performance studies departments in universities in the United States, England and Germany have expanded their faculties, increased their research archives, and devised innovative curricula to incorporate the intricate web that connects performance art to dance, theater, music, literature, and media studies. At the same time, museums are commissioning specialist curators to mount major exhibitions on performance art, while small performance spaces for live art are included in the building plans for new museums.

Several factors explain this surge of interest. One is the interactivity of modern life in the last years of the twentieth century, which provides endless opportunities for participation—in games of virtual reality, in Karaoke sing-along-singing, or in movie theaters where, at the touch of a button, the audience can change the narrative direction of a film. Cyberspace offers users the illusion of constant movement, while even the new graphics, with directional lines, wavy texts, and words that slip around pages, seem to be in motion. Many artists operate

in a similar state of flux, mining the media and the iconography of art history for visual references which they remake into bold spectacles—in painting, photography, or performance art. Even the most favored terms of current critical theory journals—the "gaze" and the "Other"—imply action. Distance must be traversed between the gazer and the object, and between the "Other" and the "same." This restless motion, back and forth, between variously depicted realities and across a thin divide between high culture and popular entertainment, is best captured in performance art, which retains a tentativeness that allows the obsessions of our cultural moment to seep from its edges.

Another reason for the ever-widening interest in performance art is the fact that the decade of the '70s, the nascent years of performance, is now history.[3] Scholars and curators are directing their scrutiny on this period, only to discover overwhelming quantities of performance material from the years when conceptual artists with their elegant intellectual propositions all but obliterated the urge to make objects of any kind. At this time performance art was flourishing in the form of actions, body art, and large, opera-scale events. The only tangible substitute for an art of ideas, it provided a direct line to artists for small groups of avant-garde followers, in artist-run alternative spaces that were then in their heyday. Examining this material, contemporary historians are finding sources for the many strands of formal and aesthetic sensibilities of the '80s and '90s. The '80s fascination with the tools and meanings of media, for example, emerged directly from the teaching studios of some of the most intellectual conceptualists of the '70s, while their early use of photography as a medium of straightforward record, blossomed over a twenty-year period into the high-gloss finish and art-directed naturalism of the late '90s. Historians are also discovering that the body—as a measure of space, of identity and of narrative—so central to the art of the '70s, now pervades the art and scholarship of the late '90s.

Indeed, the latest generation of art historians—themselves products of an overwhelmingly media-directed culture—is at last re-evaluating the history of performance in this century. Moving along the same trail described in my earlier book, and taking off on hundreds of tangential routes, these researchers are systematically connecting the dots of performance art to the fine arts of painting and sculpture, broadening as they go the intensely complicated and varied picture of the art of the past.

From the vantage point of the present, the past is always in the process of being redrawn, and radical inquiries into gender, sexuality, and "other" cultures, have, over the last two decades, uncovered work that might well have remained invisible without them. Supported by extensive and rich theoretical writing (also initiated in the '70s by conceptual artists who harnessed art and philosophy to the same yoke, using the language of French Structuralism

and Deconstructivism to explain the connections) the new material opened the window for the first time on to many cultural and aesthetic histories that would not otherwise have been viewed so closely. The kaleidoscope of current criticism is therefore constantly being reshaped. The multiculturalism of the late '80s, for example, has encouraged a far livelier scholarship that includes cultures well beyond the usual North American and western European boundaries. African-American, Latino, Afro-Caribbean diasporal cultures, and the art and culture of Japan, Korea, and South America are all subjects of study. No longer a distant reference for a few specialists, this material is being folded into even the most traditional histories of art and performance itself. Because of this multicultural awareness, we now realize that Marinetti's *Futurist Manifesto* was published in 1909 in Japan only three months after it appeared in *Le Figaro* in Paris, and that it was the Japanese Gutai movement in the '50s and early '60s that provided the initial connections between Japanese, European, and American Happening and Fluxus activities.

Then as now, the definition of performance art is open-ended. In my earlier book, I wrote that performance art actually defies precise or easy definition beyond the simple declaration that it is live art by artists, and this still holds, although each emerging performance artist, and each new writer on performance, inevitably expands the scope of that definition.[4] To some the term may still feel both uncomfortable and vague for the very reason that it encompasses such a broad range of artistic endeavor and such a number of diverse disciplines and media—literature, poetry, theater, music, dance, architecture, and painting, as well as video, film, photography, slides, and text, and any combination of these. In Britain there is a preference for the term "live art" because it is more directly descriptive and this is used as frequently as "time-based art"; in Australia, "performance" quite specifically refers to work that has originated in the traditions of theater, while "performance art" refers to performance artists with bona fide art-school diplomas.

Yet the earlier definition remains valid because it refers to work that throughout the twentieth century has taken place within the context of the art world. It has been in art spaces—at first in small galleries or so-called alternative spaces, later in museums—where the most experimental new work in music, dance, or live events found its audiences, before it was eventually understood and embraced by the establishment of a particular discipline. Such was the case, for instance, with performer-composers Steve Reich and Philip Glass, choreographers Trisha Brown and Lucinda Childs, or theater and opera director Robert Wilson, whose early work was, in each instance, supported almost exclusively by art audiences and the independent art-spaces of the early '70s. It was only later that, like prodigals, these

American artists were welcomed back into the fold of official music, dance, and theater respectively. Similarly, the American actors Eric Bogosian and Spalding Gray invented their own monologue forms and gained their reputations in downtown art-world venues, before moving over much later into mainstream theater. The art world has thus provided the licence for artists to think about a particular discipline in ways that have nothing to do with traditional training in that field, resulting in a John Cage concert where no musical instrument is played, an Yvonne Rainer dance piece consisting of walking and talking. It is only in what we call the art world that it is possible to invent a new genre from scratch, as each of these artists have done. The reason is that the art world remains the most permissive of cultural and social sub-sets, whose core of followers are as eager as the artists themselves to be overwhelmed and provoked, and to have the framework around "art" periodically challenged, expanded, and redefined.

Provocation is a constant characteristic of performance art, a volatile form that artists use to respond to change—whether political in the broadest sense, or cultural, or dealing with issues of current concern—and to bring about change, in relation to the more traditional disciplines of painting and sculpture, photography, theater, and dance, or even literature. Performance art never settles exclusively on any one theme, issue, or mode of expression; rather, it defines itself in each case by responding provocatively. It rarely aims to seduce its audience and is more likely to unravel and examine critically the techniques of seduction, unnerving viewers in the process, rather than providing them with an ambiguous setting for desire. It can sometimes be ridiculous, sometimes grotesque, and now and then frightening. Some performers aim to expose the roots of taboos and of fears through their work. "I only learn from what I fear most," Marina Abramović, the Belgrade-born artist, has said of her performances which often play with danger—in one, pythons were wrapped around her head like a turban. Others have induced fear—in an early work, New York-based Vito Acconci blindfolded, swung out at the audience with a crowbar. Others have caused horror in those watching, such as Viennese artist Hermann Nitsch with his ritualistic orgies involving animal carcasses and blood-covered performers, or the Australian artist known as Stelarc, whose body was held two stories above a busy street by sharp hooks threaded through his skin.

STEVE REICH AND MUSICIANS
Drumming, 1971

Reich's landmark work was a ninety-minute composition in four sections for tuned drums, marimbas, glockenspiels, and voices. First performed at the Museum of Modern Art in New York, it established Reich's signature style: a phase-shifting technique, using repeating musical patterns, as well as non-Western orchestration.

HERMANN NITSCH
2 Aktion, 1974

From his earliest performances in the late 1950s to his '90s four-day-long "mystery theater" festivals held at Prinzendorf, his castle in Austria, Nitsch created rituals that mingled quasi-Catholic ceremony and imagined primitive rites.

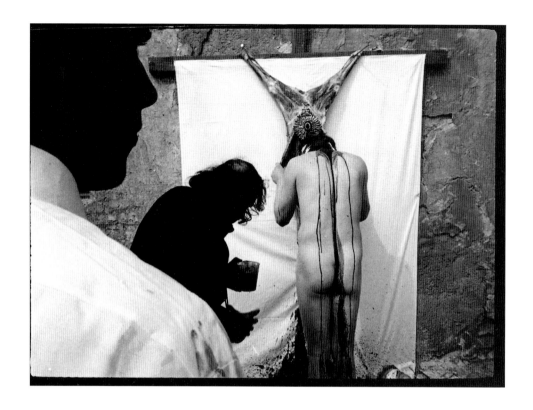

Pushing beyond the decent and the acceptable, pouncing on a particular concern, like AIDS, censorship, or child abuse, performance artists have thrown their outrage in the audience's face, sometimes metaphorically, sometimes literally. American Karen Finley, trance-like, with a voice that mounts the scale like a wailing siren, alerts audiences to the appalling things people do to each other in the name of intimacy. The Kipper Kids—originally from Britain and Germany, now based in the USA—are possibly the funniest duo to play the art scene: for visual effect, they toss bags of flour, brightly colored paints, and cans of soup over one another, and sometimes on watchers. Their live "collages" of drip-paintings, teapots and tiny umbrellas, are punctuated by grunts and roars which they intersperse with songs and mime that recall vaudeville artists, like Flanagan and Allen, or Abbot and Costello.

Performance artists have shown us things that we won't see twice, and sometimes things we wish that we had never seen at all. Above all, we know to expect the unexpected, and to hope for even a single image that will imprint itself on the mind's eye.

Live performance, in the closing years of the twentieth century, continues to be an important form of expression in the world of art, and in ever-new ways. In Japan, in Europe, in North America, in an increasing number of venues in almost every continent, performance artists are engaged in works that can be contemplative and critical, or fast-paced and provocative,

and usually highly conscious of the political, artistic, and social issues of our times. The amount of performance work being produced in the '90s, with its impact on the aesthetics and content of film, theater, opera, dance-theater, multi-media art, environmental art, video, photography, the Internet, advertising, and youth culture, calls for an attempt to survey its development since the 1960s—a period of four decades during which there has been not only an explosive growth in the number of artists who make performance, but which has also witnessed its impact on cultural discourse in the work of critics and historians who have followed its unusual trajectory.

It was in the 1960s that an increasing number of artists turned to live performance as the most radical form of art-making, irrevocably disrupting the course of traditional art history and challenging the double-headed canon of the established art media—painting and sculpture. Performance has attracted very different practitioners: Yves Klein, Piero Manzoni, Joseph Beuys, and Hermann Nitsch in Europe; Yoshihara Jiro, Yoko Ono, Atsuko Tanaka, Shigeko Kubota, and Yayoi Kusama in Japan; Carolee Schneemann, Robert Whitman, Claes Oldenburg, Robert Morris, Yvonne Rainer, and Allan Kaprow in the United States. But they all believed in an art of action—in creating works in which the audience was confronted by the physical presence of the artist in real time—and in an art form which ceased to exist the moment the performance was over. Their actions, more often than not, were provocative and ironic, and they were frequently responsive to the political and socially transforming developments that raged around them. The events that they directed sparked with the creative energy of explorers in new realms—of sensory perception, behavioral psychology, emancipated sexuality, metaphor, and theatricalization. The ramifications of their deliberately anti-formalist methods of art-making became as widespread, and as radical in the world of art as the social revolution that we call "The Sixties" proved to be for the world at large.

Emerging from the angst of post-war Existentialism in the 1950s, artists of the '60s created public gestures that were poetic and harsh at the same time. The spirit of the work often contained traces of Sartrian Existentialism. A sense of "nothingness," or absence, pervaded Yves Klein's famous exhibition in 1958 in Paris entitled "The Void." It consisted of nothing but the whitewashed rooms of an empty gallery to which a select audience was invited. Those who entered had nothing to confront but themselves, making self-definition the metaphor embedded in the

YVONNE RAINER
This is the story of a woman who...., 1973

The ways in which Rainer approached dance and film as storytelling was a revelation for her audience. This innovative dance work using film and slides, performed in New York, was made into a feature-length film the following year. This was to be Rainer's penultimate live performance before she gave up dance for film making.

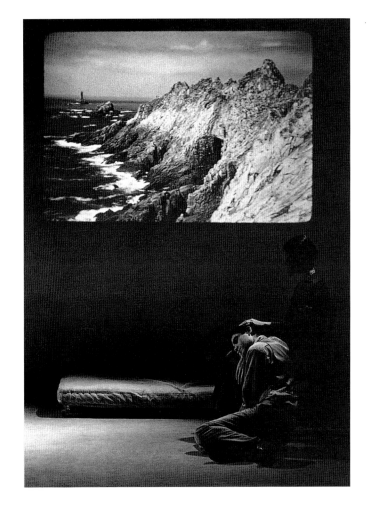

experience of being in a setting marked by the very absence of anything at all. Simply "being," or presence, was the essence of Kazakura Sho's exhibition in a Tokyo gallery in 1962. A protest against police threats to close his outdoor exhibition, Sho's work *The Real Thing* consisted only of the artist himself standing still and naked in the gallery space, devoid of accouterments or references of any kind. Simply being there, in real time, Sho presented himself as the art object, in contrast to the traditional art product with its commodity value. In this sense, viewers were reminded that creativity resides first in the mind and body of the artist. A year earlier, in 1961, Piero Manzoni had signed his name on the arms and backs of selected visitors to a Milan gallery, declaring each to be a "living sculpture" and awarding each a "certificate of authenticity" as confirmation of his gesture. Executed in the spirit of Marcel Duchamp's "found objects," Manzoni's sculptures asserted an artist's prerogative to label an object or a person as a work of art, and to transform for a moment a person's own sense of self into a purely physical status, object-like, of aesthetic interest and contemplation.

A sense of great irony was implied in these gestures, which were profound and ridiculous at the same time. To these artists, it was important to relinquish the heavy mantle of high art, to declare that everyday life was not only material for art, but was itself art.

From the very beginning of the twentieth century, the narratives of classical academic art were beginning to be rejected in favor of the intellectual and emotional vibrancy of real experience, as expressed in live performances by the Futurists and Dadaists, or in collages and environments that incorporated fragments of everyday objects. There was an increasing desire to question and challenge the commodity value of art objects in the hands of art patrons, collectors and museums. Manzoni infamously produced and sold cans of his own faeces at the current price of gold as condemnation of an art market

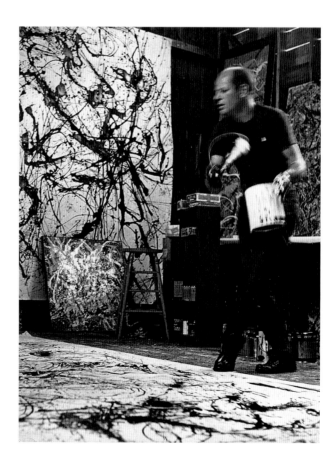

JACKSON POLLOCK
The artist in action in his studio, photographed by Hans Namuth, 1949

Namuth's photographs and films of Pollock at work were widely published in 1951. They would have a strong impact on artists in the '50s and '60s, many of whom turned to making performance and installations.

which reduced artists' passions to an exchange of cash for goods. The question implied by such gestures was, how does an artist function in the art world and in the world at large, or, as the Futurists and later Robert Rauschenberg expressed it, in the gap between art and life? The desire to bring the two closer together, to obliterate differences, continued in the 1980s obsession with bridging "high art" and "popular culture," a relentlessly pursued goal of many who choose to work in the medium of live performance.

In more formal, painterly terms, the meshing of live action with fine art became a category all its own, from Pollock's revolutionary athleticism in the late '40s in his Long Island studio—stepping back and forth over canvases laid on the floor, dripping paint with a brush directly from can to canvas—to Georges Mathieu's famed performance-paintings in Paris in 1954, which were executed with theatrical sweeps and slashes, and with the artist often wearing specially made costumes. The sheer physicality of painting, and the connection of the artist's body to canvas, led to numerous performances in which the body was viewed as an integral material of painting and vice versa. In Japan in 1955, at the first Gutai exhibition, Kazuo Shiraga created "mud paintings" by rolling in piles of wet muck. The following year he painted large abstract works with his feet, while fellow Gutai artist, Shozo Shamomoto, broke

bottles of paint over a canvas in a public performance. In the United States in the late '50s Allan Kaprow's first Happenings were, he said, an expression of his relief at participating directly in the world around him: "I simply gave up the whole idea of making pictures as figurative metaphors for extensions in time and space," he said of his shift from being an "action painter" to an "action artist." Painter Carolee Schneemann was to take the bold step, in 1963, of placing herself, naked, at the center of a huge three-dimensional painting-construction in her loft. Of this private performance captured in photography, *Eye Body*, Schneemann said that she wanted her body to be

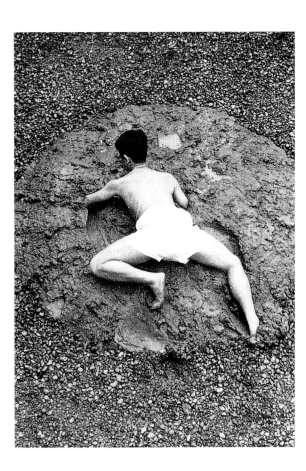

KAZUO SHIRAGA
Challenging Mud, 1955

Shiraga was a member of Gutai, the Japanese action art group. He made energetic foot and body paintings in public performances, with movie and still cameras trained on him.

CAROLEE SCHNEEMANN
Up to and Including her Limits, 1973

Starting as a solitary performance, this work developed into an installation incorporating film, video, and live action.

combined with the work, "an integral material...a further dimension of the construction."

In the 1960s, very different concepts of the body were introduced into the artworld by a group of New York choreographers, including Yvonne Rainer, Trisha Brown, Lucinda Childs, Steve Paxton, Simone Forti, and Judith Dunn. Some had met each other in California at Ann Halprin's dance workshops, others in the composition classes of Robert Dunn at the Merce Cunningham studios. Accomplished dancers, they formed the Judson Dance Theater in 1962 and organized workshops in which they methodically replaced traditional ballet steps with ordinary movements, such as walking, running, and jumping, and everyday tasks, such as lifting a box, or peeling an onion. They showed how the body itself could be picked up, lifted, moved around like an object in a space, and was capable of carrying multiple meanings. Their first "concerts" at the Judson Memorial Church on Washington Square in New York City were startling events which knitted together Dada and John Cage's notions of chance, Merce Cunningham's propositions about natural movement, Zen tenets on "presence," and a general '60s belief in functioning as a non-hierarchical, non-exclusionary community. Anyone could dance, and anything—a film, a poem, an action—could be a dance. Their heady inventiveness attracted artists such as Carolee Schneemann, Robert Morris, Jim Dine, Robert Rauschenberg, among others, fascinated by the dancers' very different understanding of bodies in time and space, and by the movement vocabulary that emerged from close contact with other bodies. The collaborative "concerts," which explored the physical intelligence of each participant, provided a shift in focus from Happenings (also presented at Judson Memorial Church) with their more painterly and plastic effects. While elements of both performance styles could be traced to John Cage's unusual composition classes, it was the choreographers who broke conceptual ground in addressing issues of identity, politics, and the unconscious, and whose explorations into the connections between movement and the spoken word would have a far-reaching effect on artists of many other disciplines throughout the 1960s.

In Europe, with its long performance history from early in the century, live actions carried the weight of far more political rhetoric than in America. Particularly in France—during the pre-eminence of Nouvelle Vague, of Simone de Beauvoir, Jean Genet, and

Jean-Paul Sartre—performance was regarded as a "combative art," part of a "political *and* artistic revolution." For French artist Jean-Jacques Lebel, who had participated in Happenings in New York and who organized a series of "Festivals of Free Expression" beginning in 1964, these events had intellectual affinities to texts such as Sigmund Freud's *Totem and Taboo*, or Herbert Marcuse's *Eros and Civilization*. "The breaking of taboos in a Happening," he wrote, "prepares the participant's disposition for abolishing all forms of despotism; political, social, economic, artistic, and sexual." [5] In the early '60s, the Situationists, the Paris-based group of writers, philosophers, poets, and artists," tied their philosophy of civil unrest to the "poetics of action"—"the revolution will be a festival, or it will be nothing." They viewed the cultural and social explosion in the streets of Paris in 1968, often in the form of performance events, as the spontaneous clash of everyday life and political engagement.

Performances by Wolf Vostell and Joseph Beuys in Germany, Robert Filliou and Ben Vautier in France, Hermann Nitsch and Günter Brus in Austria, Milan Knížák in Czechoslovakia, Yoko Ono and Shigeko Kubota in Japan, Gustav Metzger and John Latham in England, as well as the actions of the Situationists in France, represented a broad range of contemporary political and artistic ideologies. Frequently violent and destructive—Nam June Paik famously destroyed a piano in one performance—and violently moved by the regular flare-ups of social rebellion against repressive government actions across Europe and the United States, artists' actions appealed to "an international class of disaffiliated young people," as Jeff Nuttall described it in *Bomb Culture* (1968): "Young people are not correcting society, they are regurgitating it." Referred to interchangeably as Happenings, Aktionen, Art Aktuel, Art Total, or Fluxus, performance throughout the '60s and across the world, attracted more and more artists, not because they wished to join the bandwagon, but precisely because its open-ended manifesto in the context of rapid social flux provoked them into producing new ideas and exhibiting them regularly in a public setting. [6] Performances were closely related to the political activism of the period, in which large groups of people took to the streets in actions that were often part theater, part grassroots demonstration. Ways of constructing such events—group participation, improvisation and the collaboration of individuals from an array of disciplines—affected the visual arts, theater, film, as well as the style of some political protests. John Lennon and Yoko Ono's "Bed Peace" of 1971, for example, when the couple remained in bed in an Amsterdam hotel room for several days, holding a press conference there to explain their views, was both a peace protest and a work conducted in the manner of one of Ono's many Fluxus artworks.

YOKO ONO
A Grapefruit in the world of Park..., 1961

Composer and Fluxus artist Yoko Ono performed a work for "strawberries and violin"—text and sound—for David Tudor at Carnegie Hall in New York. Ono is pictured behind the poster.

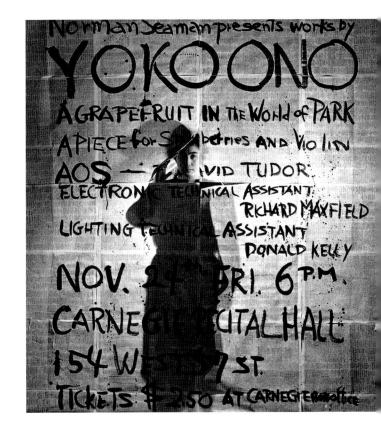

Both political event and art happening gained momentum through the strong sense of identification that this post-war generation exhibited toward one another, and through the spirit of participation generated by such feelings. In the United States, and in England, France and Germany, organized student protest on the one hand and events organized by artists on the other would reach a crescendo in 1968 and 1969. The confrontations at Kent State University, Chicago's Democratic Convention, Berkeley's People's Park in San Francisco, Woodstock, the University of Paris at Nanterre, the London School of Economics—all marked crises in the storm of political and social unrest that had begun in the early '60s in response to the explosive issues of Vietnam, Algeria, Civil Rights, the Cold War, the atom bomb, feminism, sexual emancipation. "By the early seventies," wrote activist Todd Gitlin, "the upheaval was over." [7]

But the seeds for artists' performance had been deeply sown. Despite lowering the sights for political engagement, artists in the early '70s retained the residual effects of direct experience in live work and of the analytical practice that came from attempting to force art so deeply into the public domain. A new generation stepped back from the barricades of collaborative, public events to create far more discursive material in settings made by artists for artists. So-called alternative spaces—in downtown New York in the early '70s, and in London, Amsterdam and Australia by the mid '70s—were venues for nightly events (and daytime installations) attended mostly by other artists and small audiences on the look-out for unusual performance fare. Intensely anti-institutional, these artist-run programs showed supreme indifference to the selective mechanisms of the gallery and museum world, and to the critics and curators who provided the conduit to them. Instead, they provided the setting for the wave of performance artists who seized on the previous decade's maxim to make work in many media—music, dance, poetry, film, video. At the same time they often added an intellectual layer to their actions, such as the importance of time and space, or the relationship between performer and viewer, although

ROBERT WILSON AND PHILIP GLASS
Einstein On The Beach, Act III: Spaceship, 1976

After five hours of slow-moving pictures, slow-motion dance, and serial music, the final scene of this remarkable collaboration between Wilson and Glass was a dazzling crescendo of sound and light.

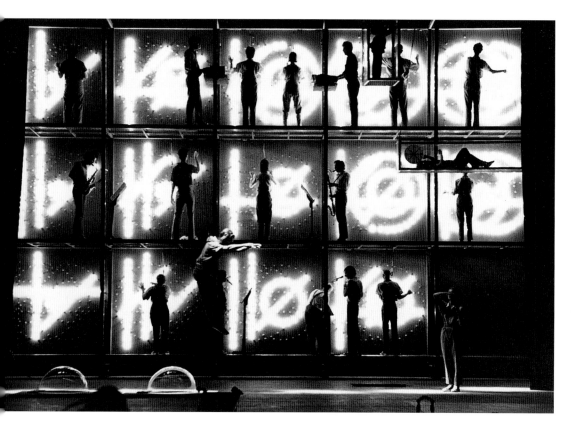

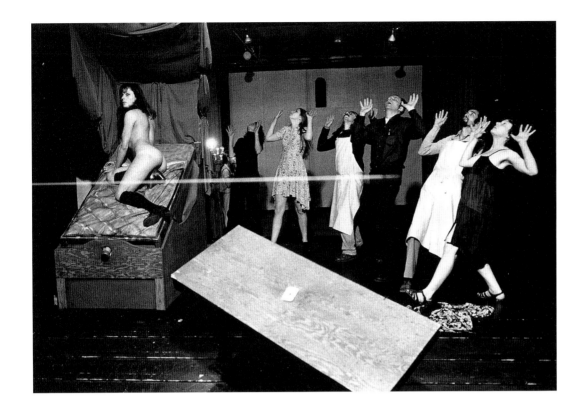

they did very little to communicate their paradoxical findings to audiences beyond the self-contained art world.

During the 1970s, when conceptual art made it difficult for viewers to respond to its somewhat didactic content and its anti-consumerist ideology, performance art became *the* predominant art form of the period. The range of material grew enormously, to include Body Art, Living Sculpture, Autobiography, Feminism, Ritual, Costume Art, and more, and the scale of productions expanded with it. In the mid '70s the American artist Robert Wilson, with a background in architecture, constructed vast theaterworks and created twenty-four-hour spectacles with music, dance, and scenery, setting new sights for artists' performance. Following his collaboration with composer Philip Glass on *Einstein on the Beach* (1976), a five-hour visual and aural spectacle, he and Glass also set the stage for new avant-garde opera.

Wilson's "theater of images" was matched in kind by the American Richard Foreman's theater for the intellect, a complicated construction of words, actors, and objects piled high on a small stage. At the side or in front of the stage, the director usually sat with a micro-phone, intermittently coaxing further meaning out of an already polemical text from actors who performed as though they were conductors for the intricate wiring of his brain. The American performers Meredith Monk, the Wooster Group, Mabou Mines, Squat Theater, and others, created a rich genre of performance theater that took its cue from the extraordinary

mix of inventions discovered in collaborative exercises with other artists at the turn of the decade. Space was investigated as motion and visual plane; the spoken word as sound rather than narrative; music as notation and architectural environment rather than rhythm, melody, or harmony; and the body as the linchpin connecting all these elements. None of this had anything at all to do with the traditions of theater, even of avant-garde theater. Nor were these artists interested in the plight of the actor and the psychological coaching that brought character to the surface of written scripts, nor in destroying the fourth wall of the stage to agitate the audience into participation through empathy. These artists were performer, director, scriptwriter, scenic designer and choreographer rolled into one, and for them the stage was a laboratory for visual and perceptual experiments. The performer was a physical vehicle for mapping a space, and the text, like the music, was a means to punctuate visual images (but might just as easily have no connection with either), while both might dissolve slowly and imperceptibly into yet another unrelated three-dimensional picture. The audience response was usually of a purely visceral nature. Only later might viewers find the words to describe the associations of feelings and ideas they had experienced visually, although the

LA MONTE YOUNG
The Tortoise, His Dreams and Journeys, 1964

La Monte Young developed a sustained micro-tonal scale that involved improvisation around a preselected harmony. Played here by (from left) Tony Conrad, Marian Zazeela, La Monte Young, and John Cale at the Pocket Theatre, New York, this work could last from 4–5 hours.

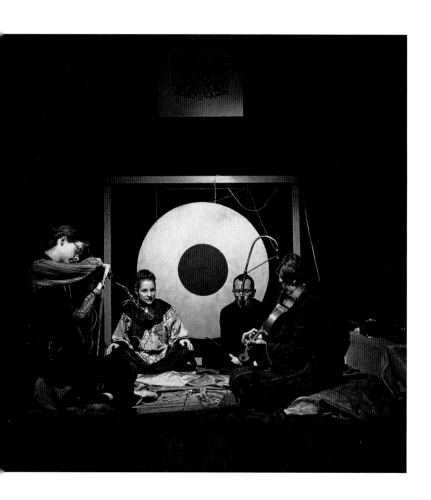

actual meaning of a performance might remain forever suspended in a non-verbal realm of sensations. For these theatrically inclined performance artists, continued inspiration came from the explosion of aesthetic and perceptual investigations taking place in the art world around them, and from the enthusiasm with which their material was greeted by their peers in the art community. For the same reasons, avant-garde composers gravitated towards alternative spaces, eager to present their work in a context in which the basic tenets of their experimental language would be understood. They wanted to unravel the sound of music and to hear its separate and distinct parts, to incorporate chance and everyday "found sounds" into that material, and to forge new shapes for music's traditional forms, beginning with repetition as a way of making the listener really listen. In the United States, Steve Reich, La Monte Young, Robert Ashley, Philip Glass, Pauline Oliveros, Alvin Lucier, Terry Riley, Joan La Barbara, and others provided a broad base for experimental music that would, by the end of the '70s, produce an inventive generation of sophisticated "New Music" performers.

Even as the medium was transformed by visionary performers into multi-layered works involving several performers, making performance venues into large sensory fields of sounds and images, others made

works which were the polar opposite of such expansive ambition. Artists all over the world, such as Marina Abramović, Ulay, Vito Acconci, Ana Mendieta, Hermann Nitsch, Valie Export, Mike Parr, Linda Montano, Stelarc, and Gina Pane, retreated into the human psyche, tending to perform solo, concentrating on singular gestures that were often painful to endure, and unnerving to watch. Invoking shamanism, cathartic therapy, ritual, and behavioral analysis, this kind of performance, practiced throughout the '70s, provided artists with access to their own emotional histories, and a tool for attacking taboos, whether sexual or social. Antonin Artaud's manifesto "Theater of Cruelty," Wilhelm Reich's *The Sexual Revolution*, or R.D Laing's *The Divided Self* were frequently referred to by artists as inspirational texts through which their public actions could be measured against substantial research demonstrating the cathartic value—in performance or in mental health—of working with the raw nerves of sensation buried deep beneath socially acceptable norms. Not surprisingly, a powerful masochistic streak, threaded through with varying degrees of narcissism, was attached to this material.

In England, the swing between the droll and the dire could be found in work such as Gilbert & George's Living Sculpture performance, *The Singing Sculpture* (1969), in which they appeared neatly dressed in tweed suits carrying one walking stick and one glove and moving like marionettes to Flanagan and Allen's song "Underneath the Arches," played on tape over and over again. There was also Stuart Brisley's unforgettably shocking appearance in a London gallery in 1972 in a work entitled *And for today…nothing* : he lay partially submerged for two hours every day for two weeks in a bath of cold black liquid in which floated rotting meat. Brisley and artists such as John Latham, Alastair MacLennan, Brian Catling, and Nigel Rolfe, were sympathetic to the cathartic and aggressively interactive performances being produced in Poland, Austria, and Germany They presented actions that were shrouded in metaphorical darkness as a necessary means of identifying personal disturbances and of illuminating larger social and political crises. Performances in this context were often viewed as modern rituals with curative potential for both performer and viewer.

In an entirely different vein, women artists such as Rose Garrard, Annabel Nicolson, Sally Potter, Rose English, Sylvia Ziranek, Bobby Baker, and Roberta Graham created performances that were as psychoanalytically searing as those of their male counterparts, but far less expressionistic in form and less threatening. Video tapes, photographs, film, installation and performance, often in combination, provided the matrix for an emphatically feminist iconography. Specific references to mother and child—not the virginal mother and child of the Western art tradition,

GILBERT & GEORGE
The Singing Sculpture, 1969

Gilbert & George declared themselves Living Sculpture even before they graduated from art school. With their signature suits and formal demeanor, they have remained rigorously in character in public and in private ever since.

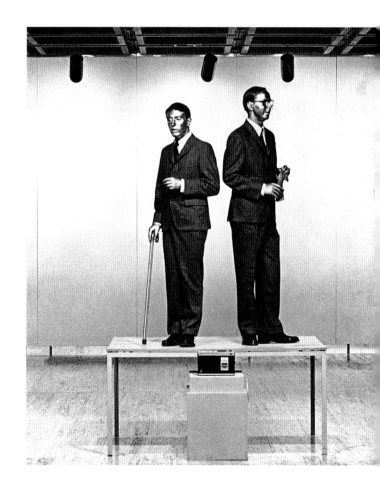

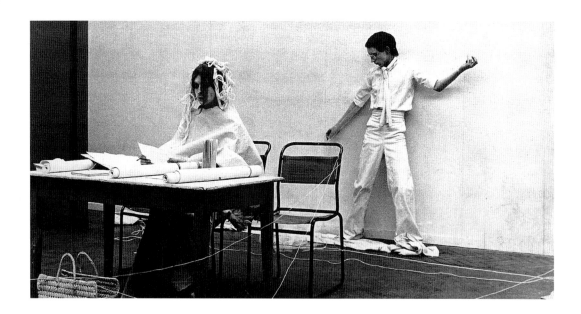

CARLYLE REEDY
Tang Dynasty Poetry Reading, 1973

Reedy (pictured here with Keith James at the Whitechapel Art Gallery) was among a small group of women artists who were active in performance in Britain in the late '60s and early '70s. Her events were "participatory rites" which included the sharing of food and art materials, and involved "meditation, poetry, music, silence, narrative, incantation, and slides."

but rather an intensely female rendering of the emotional, sexual, and intellectual realms that are involved in a woman's relationship to her child—were incorporated into ground-breaking projects by the British-based American Susan Hiller, by Tina Keane, Catherine Elwes, and Mary Kelly. Although packaged in highly theoretical and neo-psychoanalytical debate, Kelly's *Post Partum Document* (1973–79)—a six-year photo-and-text diary of her son's early development—was a deeply provocative and radical work because of the way it situated the relationship between mother and child at its very heart. Aesthetically close to performances by Vito Acconci or Ana Mendieta, for example, in which privately performed events were later exhibited as documentation, Kelly's decision to force the mother-child issue into the avant-garde domain was highly challenging in the context of feminist theory, so often the discourse of single white women, and it remains rare more than two decades later. Indeed feminist art was little known in the somewhat subdued art world of 1970s Britain. It would

THE GUERRILLA GIRLS
Do Women have to be naked to get into the Met. Museum? **Poster mid-1980s**

Guerrilla Girls posters were plastered around New York City on billboards and building sites. Anonymous and in disguise, members of the group also presented lectures and held protests at art institutions, critiquing the continuing inequalities of art-world power and politics.

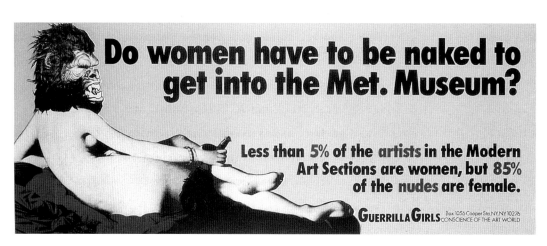

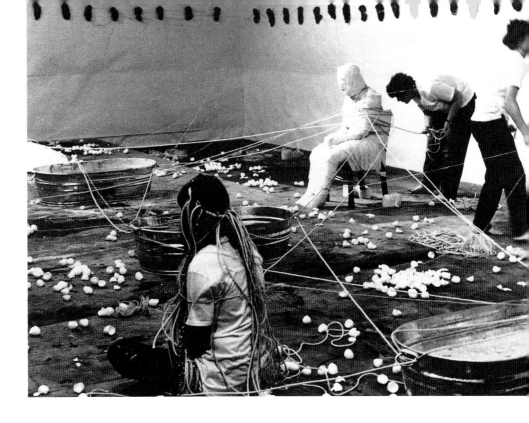

take several years, and a feminism more on the scale of that in the USA, before the significance of these women artists would be fully acknowledged. Their work only became influential in the UK in the '80s and '90s.

Feminism in the art world of 1970s America began with a rallying cry that was very different from developments in Britain. It had followed a decade of Civil Rights activism—mass marches on Washington led by the Rev. Martin Luther King and others, bus boycotts and freedom rides in the South, Black Panther militarism with its separatist black identity salute of clenched fist held high and the slogan Black Is Beautiful. Increasingly sophisticated tactics were developed by underground leaders to move grassroots protest to the front pages of the American press and to create powerful political lobbies for change. Similar tactics were adopted by caucuses of women's groups around the USA. Judy Chicago set up the first feminist art workshop at Fresno State College, California, in 1970 (it re-located a year later to the highly visible California Institute of the Arts) and with Miriam Schapiro inspired the collaborative student exhibition *Womanhouse* (1972). Numerous exhibitions and conferences followed, and the art world was confronted with the first battles of an entirely new internal war. A new vocabulary—craft, pattern, decoration, gender, identity, collaboration—and new imagery and subject matter were introduced. Performance became the most effective means for conveying ideas that emerged during consciousness-raising sessions—group discussions in which highly personal material was presented and discussed, and which became a continuing source for feminist debate. Suzanne Lacy, Faith Wilding, Cheri Gaulke, among others, built a repertoire of collaborative actions based on highly charged emotional subjects that emerged from these discussions—rape, homosexuality, domestic abuse. These works were evaluated, above all, for their ability to communicate directly to audiences serious socio-political sexual issues.

On the East Coast of the United States, the collaborative era of Judson in the '60s and the Grand Union in the early '70s gave way to solo performances by Adrian Piper, Hannah Wilke, and Julia Heyward, whose work was less literal and considerably less didactic in terms of feminist critique than the California artists—although consciousness-raising, the prevalence of autobiographical material, was common to both. Women's willingness to incorporate self-scrutiny in their work influenced male artists during the '70s. The manner in which these American women artists isolated and framed particular sensibilities defining a "female

JUDY CHICAGO, SUZANNE LACY, SANDRA ORGEL, AVIVA RAHMANI
Ablutions, 1972

Judy Chicago's performance workshops used material from consciousness-raising sessions to create collaborative works, such as *Ablutions*. Performed at Womanhouse in Los Angeles, it dealt with the trauma of rape, and its soundtrack was a tape-recording of women describing their ordeals.

identity" was to become a model for minority groups in the mid 1980s when they made their presence felt in multicultural politics.

By the late '70s it was clear that, of the many artists working exclusively in the medium of performance art, most would continue to do so into maturity. This was in contrast to earlier practice in the history of performance art when the Dadaists or the Surrealists in the '20s, and Oldenberg and Rauschenberg in the '60s resorted to performance for brief periods only to return to painting, collage, construction, or sculpture. In the late '70s museums in Europe and the United States began to include performance in survey exhibitions or as separate festivals. Specialized performance art departments opened in selected schools, several magazines devoted exclusively to the genre were founded. The widening appeal of the medium drew a more extensive press coverage and gradually a larger audience. The management of performance venues changed as a result. Now artists were invited to present work on consecutive nights and were given rehearsal time as well. Even so, performance art remained an unpredictable "discipline," and would assume entirely different forms in the hands of the next generation, the first fully fledged media generation which came of age in the late '70s.

Brought up on rock 'n' roll and B-movies, twenty-four-hour television and fast food, as well as the impact of the '60s, artists in the United States, such as Robert Longo, Eric Bogosian, Ann Magnuson, John Jesurun, and Michael Smith used performance to shuttle between alternative art space and late-night music clubs, where Punk ruled. The works they created for both had the hard drive and edgy sexuality of the times. Men often dressed in standard-issue black jeans and white shirts, sometimes with skinny black ties, and women in gender-neutral pants, boots, and sweaters. They had no trouble in meshing the highly conceptual and intellectual framework of the art in which they had been immersed as students with the cacophony of rock's revival and the dark glamor of sparsely inhabited and rundown urban downtown areas. If anything, they looked to Andy Warhol's famous blend of high art, commercialism, and his own version of an art-rock underworld as the model for their own ambitions. In the mid '70s, androgyny, as explored by David Bowie, Lou Reed and the members of Roxy Music, had added a highly seductive twist to performance and to the work of many artists working in a whole range of media. It now held sway once more in club performances. The high style of camp had been splendidly portrayed by Jack Smith

ERIC BOGOSIAN
As Ricky Paul, 1979

Bogosian's earliest performance was a "portrait" of a belligerent night-club entertainer, loosely based on Lenny Bruce, which he used to provoke audiences in the late-night music clubs of downtown New York.

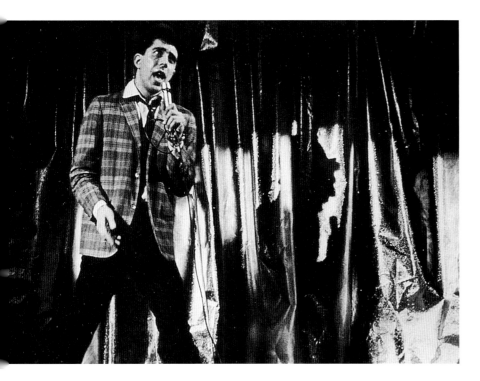

of *Flaming Creatures* fame, John Vaccaro, and Charles Ludlam, all of whom had been working actively since the '60s. Their influence only became evident much later as the energy and sensibilities of their spectacular and intense pieces resurfaced in the work of much younger artists. In the 1990s, a new generation of artists, among them Catherine Opie, Yasumasa Morimura, and Lyle Ashton Harris, explored this

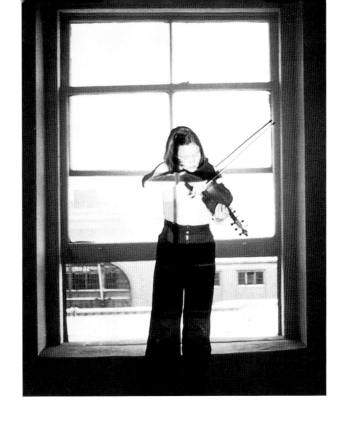

LAURIE ANDERSON
For Instants—Part 3:
Song writing for 3 light sources, 1976

Light has always been a key material in Anderson's work. In this early performance she moved back and forth in the corridor of light between projector and projected image.

fascination with disguise in a range of costumes and personae. Their selfconscious and art-directed performances in front of camera resulted in life-size, glossy photographs whose super-realism emulated the thrill of live performance.

In 1981, Laurie Anderson led the way across the invisible divide between high art and popular culture with a contract for six records with industry superpower Warner Brothers. After this, many other artists began to appraise the mass media as a desirable and feasible vehicle for their work. Anderson introduced a refinement of style and execution into a medium which until that time had exhibited the rough and often tentative sensibilities of work that was rarely rehearsed or repeated. Of a performance that ran for several days (*United States Part 2* at the Orpheum Theater in New York, 1980), Anderson felt "guilty that it was more or less the same every night because I was so used to changing things around for every performance." Her highly produced concerts of the '80s radically changed expectations about the quality of performance for audiences and artists alike, yet her awareness of straddling the no man's land between the worlds of popular music and art gave the work an unnerving vulnerability and tentativeness. "I still think like an artist," she once replied to a question on how the music business had affected her work.

Performance art in the media-driven 1980s took on the professional gloss of mainstream theater and television, with stand-up comics, talk shows, and cabaret as models for work that closely examined the impact of popular culture on high art. Michele Luke and the group Tsch Tsch Tsch in Australia both ricocheted off the popular mass idioms of television and pop entertainment in that country, while in Britain Stephen Taylor Woodrow and Miranda Payne protested the general tendency towards commercial entertainment, turning

themselves into Living Paintings that expressed their commitment to the lineage established by Gilbert & George's Living Sculpture.

In the United States, the monologue had been at first a vehicle for creating live portraits of male archetypes in the style of Lenny Bruce, but was also reminiscent of contemporary and earlier soloists, Lily Tomlin, Ruth Draper, and Brother Theodore. This form was developed by Eric Bogosian in the late '70s in response to the ways in which his peers—young media-generation artists like Longo, Cindy Sherman, and Richard Prince—selected images from the popular media, and framed and rearranged them for display in an art context. At the same time, Spalding Gray used his confessional monologues that had served as the throughline for a trilogy of collaborative projects with Elizabeth LeCompte and the Wooster Group in 1975, to present as his first evening-length solo performance in 1979, *Sex and Death to the Age 14*. With Anderson, whose work, despite its scale, centered on intimate storytelling, these artists inspired many young performers to turn to the monologue form. Twenty years later it continues to attract emerging artists, and is possibly the longest-running and, at this point, the most predictable genre in the history of performance art in the United States. The form is irresistible to young artists, because its elements are so very basic—a single performer, with hardly any sets, written material based on personal experience, and inexpensive to produce. It is also accessible to audiences because its premises are understood from the start. The monologue has since emerged elsewhere: in Australia with William Yang and Kooemba Jdarra, in Britain with Sarbjit Samra and Maya Chowdhry, for example, the best of them providing a vivid verbal landscape of continents and the people and times that shape them.

In contrast to the seemingly innocuous, even entertaining performances during this decade, and perhaps because the mainstream media concentrated on lighthearted material, performance was used by many artists to publicize political and social issues from AIDS to homelessness, to racial and gender prejudice. At a time when the mechanisms for grassroots politics had almost disappeared, performance in the hands of David Wojnarowicz, Karen Finley, Tim Miller, Holly Hughes, the members of ACT-UP or Gran fury—was both sophisticated and relentless. The 1969 Stonewall riot in New York, one of the first public demonstrations by homosexuals against prejudice, was an early model for ACT-UP (Aids Coalition to Unleash Power, founded in 1987), which has been essential for raising public awareness of AIDS. Allen Ginsberg's "Howl" (1956) had caused public indignation for its openly homosexual references, and nearly thirty years later Holly Hughes's "World Without End" (1989) with its threat to "family values," triggered a similar censorship battle in Washington, resulting in a radical downsizing of the only federal arts funding body, the National Endowment for the Arts. Many artists, including Anderson, Bogosian, Finley, and

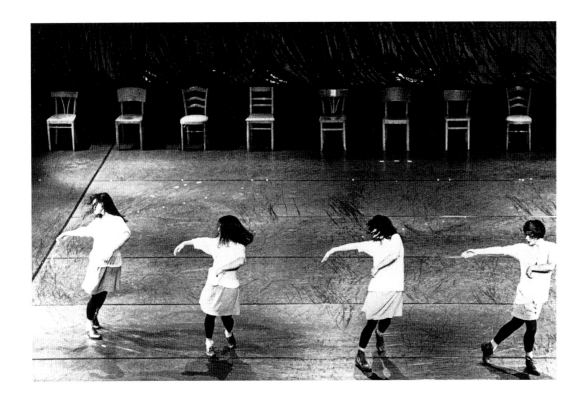

ANNE TERESA DE KEERSMAEKER
Rosas danst Rosas, 1983

This was the first work of the new Belgian company Rosas, with choreography by the 23-year-old De Keersmaeker. Music was by Thierry de Mey and Peter Veermeersch.

Magnuson, used the conservative backlash as raw material in the early '90s, and the lyrics of Lou Reed's song "Sex With Your Parents," was a no-holds-barred retort to prejudice in high places.

Political shifts in Europe, particularly the fall of the Berlin Wall in 1989 and the collapse of totalitarian communism, revealed two decades of virtually unknown performance material as the first wave of eastern European artists, including Valery Gerlovin, Rimma Gerlovina, Ilya Kabakov, and Kolmar and Melamud traveled abroad in the early '80s. Black Market, established in 1985 as a loose network of performers in eastern and western Europe, showed that the material was in the direct line of Fluxus-like actions, with an extra layering of metaphorical references to politics, to western European performance artists, such as Rebecca Horn, and to literary texts, such as those of Georges Bataille.

At the same time, excitement was generated in the dance world by several extraordinarily inventive choreographers who were deeply influenced by performance art—among them, Pina Bausch in Germany, Anne Teresa De Keersmaeker and Wim Vandekeybus in Belgium, Lloyd Newson in Britain. "Dance theater" became one of the most visually interesting developments on the stage, based as it was on the notion of the body as a superbly trained object that could, in the most daringly physical ways, depict the very heart of contemporary conflicts and sensibilities. Funded by ambitious federal programs, especially in France under

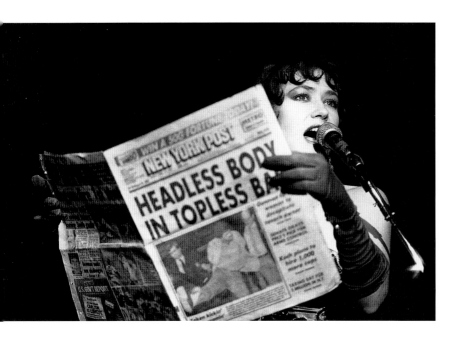

ANN MAGNUSON
NY Talks, 1986

A late-night performance at a downtown
New York disco, which featured artists'
cabaret as regular fare.

President Mitterand and in Britain by organizations such as the BBC and the Arts Council with the "Dance for the Camera" series, dance-performance thrived throughout the 1980s and early '90s.

The British art "renaissance"of the '90s—that began in 1988 with a wave of young artists emerging from Goldsmiths' College in London—also produced a vibrant group of artists working in performance. Sophisticated, literate, and weaving the fine threads of British performance in all its forms from the '60s onwards— "fringe" theater, street theater, agit-prop, live art, time-based media, media theater, dance theater—with an informed awareness of the work of their peers, these artists have contributed to some of the liveliest and most thought-provoking performance festivals and symposia at venues across the country. Britain has been transformed into a clearing-house for performance art from around the world by the National Review of Live Art, held every other year in a different venue; the annual NOW festival in Nottingham; the year-round ICA Live Arts program of exhibitions, performance, and lectures at the Institute of Contemporary Arts in London; and by organizations such as Locus Plus in Newcastle and the Laboratory in Oxford. *Hybrid, Live Art,* and *Performance Research,* magazines which cover performance in all its guises, as well as performance-related departments at many universities, including Dartington, Cardiff, and De Montfort in Leicester, provide a forum for academic discussion of the material in both its historical and contemporary context. Furthermore, the remarkably large interest in live art in '90s Britain spans the academic and the popular, with a lively performance scene in the late-night clubs of London's East End, Glasgow's Garnett Hill, and Nottingham, reminiscent of earlier associations between the music and art worlds of the '60s and early '70s.

Despite broad acceptance of performance art in the '90s, it is still untameable and unmarketable. Those few who have made it into the mainstream—Laurie Anderson, Spalding Gray, Eric Bogosian, Ann Magnuson—whether in film, music, or television, face the contradictions of maintaining a large following while retaining the innovative and radical thrust expected of artists. The medium demands a "presentness"—the audience's presence in real time, and content that sharply reflects the present. Its ability to respond to the political, artistic and social changes of the times, remains one of its most valuable characteristics.

Historically, performance art has been a medium that challenges and violates borders between disciplines and genders, between private and public, and between everyday life and art, and that follows no rules. In the process, it has energized and affected other disciplines—

architecture as event, theater as images, photography as performance. Indeed, its anarchic ways have always kept it at the forefront of the avant-garde. But new technologies have created an avant-garde for the masses, a popular world of computers, web sites, zines and virtual realities, subscribed to by global youth who navigate its brilliant pathways with the exhilaration and energy of first-time explorers. For a while, artists were overwhelmed by the challenges it presented. But there are now many—Gary Hill, Bill Viola, Laurie Anderson, Douglas Gordon, Matthew Barney among them—who have harnessed the capabilities of advanced technology to their own, while aiming to inject a new humanism and new cultural values into the hardware that seems always in danger of subsuming both. By its very nature the medium of performance is in constant evolution, and so it is inevitable that performance artists should now appear to straddle new technologies and their avant-garde inclinations. It is equally inevitable, indeed certain, that new performance that makes use of new technologies will resist the obvious and make use of and interpret its potentials in unexpected ways.

Artists, as well as computer-users in all disciplines, hover on the edge of a fast-paced new culture, just as the Futurists did at the beginning of the century, when they tried to incorporate the machine aesthetic in their work. Futurism celebrated a love of speed—"the dynamic sensation made eternal"—and its adherents would most likely have been ecstatic to experience the accelerating speed of our current communications networks, whose high-tech users are eager to catapult themselves into the future through words and images without actually going anywhere. Interestingly, both artist and computer-user are entirely comfortable with a highly conceptual approach to their material, similarly dispensing with the need to create objects, delighting instead in the elegance and exhilaration of ideas.

As yet unnamed and lacking the bombastic and all-embracing insights into the modern world expressed in the Futurist manifestos, the art of the late '90s is nevertheless replete with sensibilities which come from the pacing, redefined aesthetics, and content of a pervasive, international media culture, a culture that looks to the future each day as the very latest technologies are projected directly from the computer screen to the production line. High-density digital imagery—collaged, layered and re-imaged—has created a level of sophisticated picture-making that has never been seen before, spliced through with techno music and its vast bank of collected sounds, CDs of artists' installations and multi-media concerts. The availability and use of new media give a thoroughly modern definition to the word *Gesamtkunstwerk*. Douglas Gordon, Gillian Wearing, Inez Van Lamsweerde, Christian Marclay, and Mariko Mori construct worlds from archives of images and sound, resulting in spectacular two or three-dimensional works in film installations, photographs, music and performance, that are as subtle as they are mesmerizing. Bristling with current obsessions of

CHRISTIAN MARCLAY
David Bowie, from the *Body Mix* series, 1991

Marclay remixed music and images from rock 'n' roll, in photography, installations, and performances.

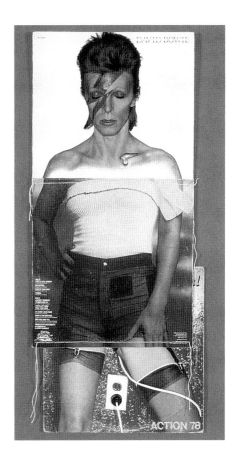

sexuality, violence, bodily functions, fashion, film, music and media, the work of artists like Gordon and Van Lamsweerde is akin to performance in the way in which it virtually envelops and touches the viewer. Furthermore, there is a fluidity, defying traditional categorization, between the work of these artists and performers such as Claude Wampler, Patty Chang or Vanessa Beecroft. Their live material is as vivid in color and as deliberate in art direction as that of their peers working two-dimensionally, and is just as obsessive. Brash and lyrical, like the streetwise music of Jean Wyclef, exploring identities and social mores, like the naked revelations of a Mike Leigh film, and sometimes permeated with an unbridled sexuality reminiscent of a Pasolini or a Fassbinder movie, performance in the late '90s has become one of the few live art forms available to audiences in which they can actively confront artists and their ideas. In the swiftly moving world of new media, performance art is as unpredictable and deeply provocative as it ever was.

This book is a visual story of a hybrid medium which contains and expresses the raw material of the late twentieth-century artists' passions and preoccupations. At the outset, such a book would seem to resist, to contradict even, the very nature of a medium that insists on actual presence, on the experience of "being there"—being affected, effected, bored, enthralled, irritated, inspired. In the past, artists used "documentation" merely as evidence that an action occurred. A more considered look at the texts, photographs, film stills, and all the other leftovers of a performance, seems to contradict the very reasons for making live art in the first place—which was, in part, to protest traditional art's focus on object-making and marketing. So how can an often poorly lit photograph possibly convey the thrill of a one-time live experience? Isn't such a record a contradiction in terms?

Selecting photographs for this book confronts and, I hope, answers this question in profound ways. Not only do these printed residues of past live events recall the aesthetic sensibilities of an era—the plain black-and-white photographs of '70s conceptualism, the more carefully staged color slides of the media-conscious '80s. As each double-page spread aims to show, they also encompass concerns of a period that reach way beyond the actual photograph, such as the place of nudity, ritual, cultural identity, or gender in our late twentieth-century world. Loaded with as much information about psychological intent or social context as the iconography of a classical painting, or as its visual and spatial composition, each photograph reveals the capacity of the artist to create series of indelible images. Indeed, it became obvious to me while researching this material that many artists intended it that way from the start. Joseph Beuys recognized the iconic worth of still photographs of his events, and no doubt was satisfied that the single image of himself,

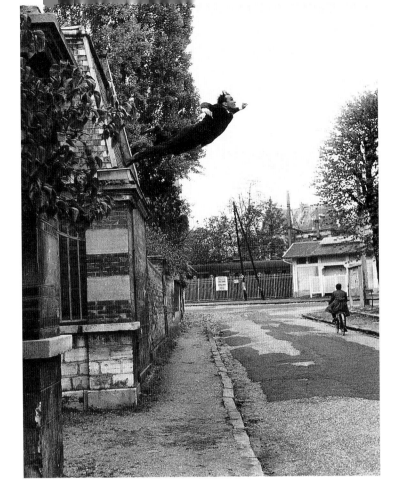

YVES KLEIN
Leap Into The Void, 1960

Yves Klein's leap from the second story of a building was restaged for photographer Harry Shunk ten months after the first undocumented leap. Klein usually had a photographer on hand to freeze the action into an iconic image.

wrapped in a felt blanket in a small room with a coyote, reverberated around the world through publications, conveying his pointed message about man and animal long after the actual event had taken place. The photograph of Yves Klein leaping into the void from the second story of a building was restaged for photographer Harry Shunk in two parts, ten months after Klein's first undocumented leap. The first photograph taken was of a group of friends catching him in a tarpaulin, and the second was of the empty street a few moments later; these were collaged together in the darkroom. The final photograph of Klein's self-endangering and bold feat would profoundly influence generations of artists, yet the fact that he went to such great lengths to create a very particular image of this action (and all the others that were photographed or filmed), makes clear Klein's canny understanding of the photograph as an essential element of his performances. It was his way of making concrete the "immateriality" that was a key tenet of his work. It also emblematically illustrates an important point in Mikhail Bakhtin's philosophy, the difference between what is *now* and what is *after-now*.

Indeed, more people "see" performances through reproduction than can ever actually attend them. Inevitably, the experience of reading and looking on a printed page is different from looking at something that unfolds live. Readers may view the image of a one-time only performance as frequently as they like, resuscitating the live performance repeatedly in their imagination, while quotations from the artist and descriptions of the event, indicating

sequences and duration, may provide a fuller explanation of a performance than was evident during the actual presentation. It is the element of duration, of time, that is at the heart of a performance. But there is a time of experiencing and a time of memory, of reviving in the imagination, and there is no essential contradiction between the two.

Choosing ways to assemble the rich visual information into coherent chapters has been crucial in constructing this book. A chronological and geographical survey would have been impossibly cumbersome, leading to several parallel histories that would have been tiresome to follow. Rather, the decision was made to connect the work thematically—to collate related sensibilities, motives and tendencies—not because these categories are in any way absolute, but because holding one artist's work up to the other, as a variation on a theme, serves to illuminate the diversity and originality of approach in each of them. Needless to say, the work of any number of these artists straddles several themes—feminism, ritual, and cultural identity, for example, in the work of Marina Abramović, or politics, dance, and media in the case of Bill T. Jones. For the sake of structure and comprehension, these artists are discussed in the chapter in which their contribution to the history of the form and their influence on other artists can best be understood.

The process of shaping this art-historical storyboard came closer to planning a documentary film than to constructing a conventional book. In the hands (and eyes) of the book's designer, juxtapositions of images reinforce the concentration of ongoing movement that is unavoidably reproduced frozen in each photograph. The camerawork is usually by a devoted coterie of photographers from around the world who have followed individual artists, often over several decades, in response to their own motives and desires. Rarely commissioned, and as infrequently compensated (artists themselves receive little income from their performances), these photographers are historians of performance. Each has a special point of view of an artist's work and of the intimate milieu in which they both move, often in tandem. For Babette Mangolte, a filmmaker and photographer whose memorable photographs are crucial to our understanding of what it felt like to be at a '70s performance, her goal was to take photographs that showed not only the time sequences of a work, but also frequently gave a glimpse of the space and the audience. "I wanted the photograph to describe, very precisely, the sequence of events," she said. "But when artists began to use video for documentation…and they wanted studio-quality photographs for publicity purposes," Mangolte added wistfully, "my work came to an end." Paula Court began taking photographs of her friends in the late '70s performing at The Kitchen in New York, where she worked in its heyday, and continues to photograph artists whom she knows well. "You're more generous on all levels, intellectually, emotionally, when you're close to the artist," Court

explains. "It goes beyond just taking pictures. You put yourself in the realm of the work. You try to think about *their* work as well as what a photograph can bring to the work." It takes great concentration and it is a continuous learning process which, for her, she says, has no end. "In some respects these artists are my teachers," Court adds. "I gain a huge amount of knowledge from the people with whom I work." Dona Ann McAdams, Harry Shunk, Robert McElroy, or Hugo Glendenning each take photographs which focus our attention in different ways on the unique aspects of artists they have chosen to photograph. They provide us with keys to understanding what it is that makes an artist's material important.

As in a photo album, the pictures in this book are, for some, triggers of memories: for those who were present when Laurie Anderson performed *United States* in its entirety for the first time in 1983, they unleash dream-like sequences, not only of the performance itself, with its dissolving opera-size projections behind a diminutive Anderson and the silent replay of her plaintive song "O Superman," but also the New York skyline at night, glittering against a navy-blue winter sky, seen from the Brooklyn Bridge as we returned from the Brooklyn Academy of Music. And for those who were not there, the photographs vigorously stir the imagination. To enter the deathly silence of an Ana Mendieta photograph, to "smell" the earth with which she covered herself, to identify deeply and personally with her "thoughts" behind closed eyes we, the viewers, participate in a "performance." Each picture carries the residue of time, and each has a way of making the past present and fleetingly real. Like performances themselves, these photographs allow us to feel our experiences more deeply.

New York, February 1998

Notes

1 *Performance: Live Art 1909 to the Present*, London and New York, 1979. Revised editions published as
 Performance Art: From Futurism to the Present, London and New York, 1988; 2001

2 Avedon, Richard, "Borrowed Dogs," in *Performance and Reality: Essays from Grand Street*, ed. Ben
 Sonnenberg, London and New Brunswick, 1989. Quoted in Peggy Phelan, "Developing the negative:
 Mapplethorpe, Schor and Sherman," in Phelan's collection of essays, *Unmarked*, New York, 1993

3 See my essay "Performance: The Golden Years" in *The Art of Performance: A Critical Anthology*,
 ed. Gregory Battcock and Robert Nickas, New York, 1984

4 See my foreword in *Performance*, 1979, rev. edns 1988; 1995

5 Günter Berghaus, "Happenings in Europe," in *Happenings and Other Acts*, ed. M.R. Sandford, London
 and New York, 1995

6 Distinctions can be made, however, as to when certain terms were introduced—Happenings in 1959,
 Fluxus in 1961—and affiliations of artists with different groupings

7 Todd Gitlin: *The Sixties: Years of Hope, Days of Rage*, New York, 1987

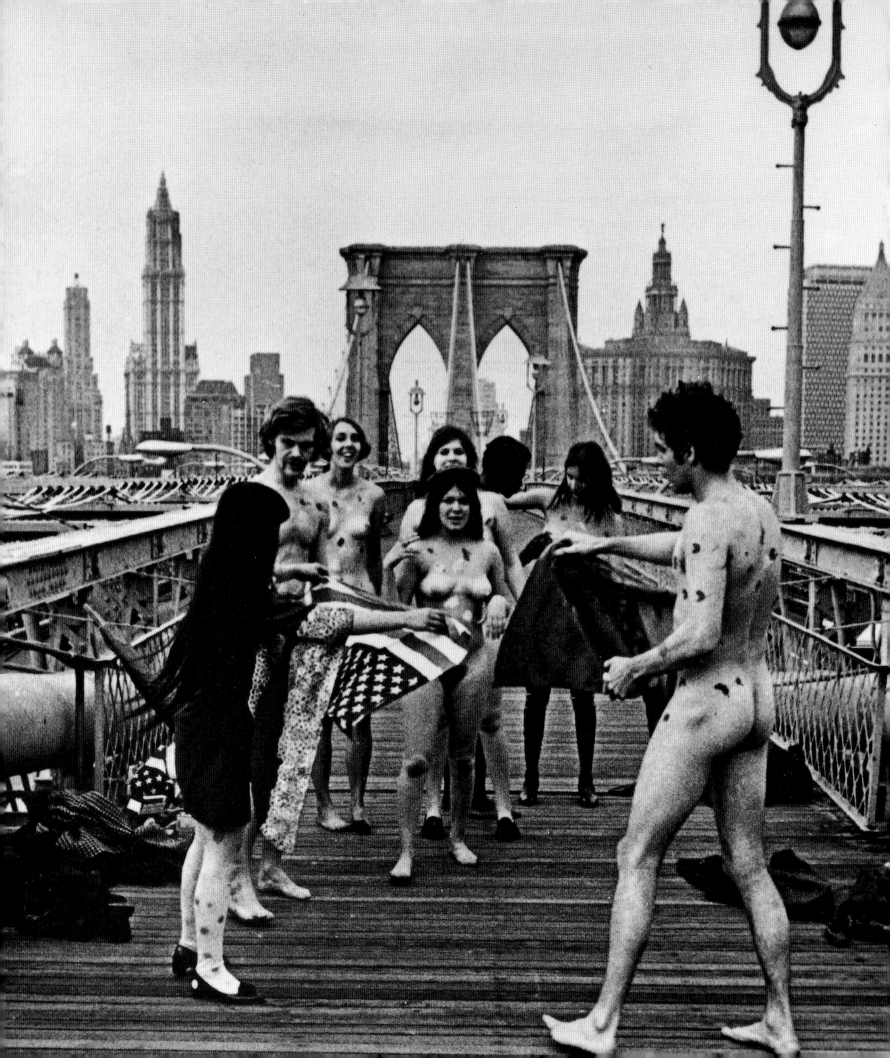

CHAPTER 1 *performance politics real life*

It is against a background of a political and intellectual battle for cultural change in major cities across Europe, Japan, and the United States that performance must be viewed. Rich in metaphor and symbolism, these early performances were a reaction to a decade in which the traces of post-war trauma were slowly erased by expanding consumerism on both sides of the Atlantic. They were also an extension of Dada and Futurist gestures, which deliberately blasted traditional art academies and forced art into the domain of public confrontation. "We must become preoccupied with and even dazzled by the space and objects of our everyday life," American artist Allan Kaprow wrote in his homage to Jackson Pollock in 1958. "It is important to declare as art the *total* event, comprising noise/object/movement/color, and psychology," proclaimed German-born Wolf Vostell in 1968, describing '60s art events as continuing in the spirit of Marcel Duchamp's ready-mades. His own work, he said, was "a merging of elements so that life can be art." Indeed, for those artists wishing to be directly engaged in the seismic social shifts of the times, and to interact with the public, live art also offered a particularly seductive role for the artist—as activist, shaman and provocateur.

Since the mid-'50s, artists' actions had taken place sporadically in cultural centers around the globe, but by the end of the decade, the sheer number of such events was evidence of an important and growing tendency. In May 1957, the Gutai group in Japan had organized a "Stage Art Exhibition" in Tokyo and Osaka, with huge inflated balloons filling the stage, and a performer wearing a dress made of lights. In spring 1958 Yves Klein invited guests to witness his *Anthropometries of the Blue Period* at Robert Godet's Paris apartment. In Cologne the following summer Wolf Vostell's *Fernseh-dé-coll-age für millionen*, initially planned as a TV program during which viewers would be instructed to carry out certain actions, was in fact presented live. A month later, in Provincetown, Rhode Island, Red Grooms in *The Walking Man* made a painting in front of an audience in the manner of French painter Georges Mathieu. In October, Allan Kaprow's *18 Happenings in 6 Parts* at the Reuben Gallery in New York included several artist friends who were all active event-makers themselves—Red Grooms, Dick Higgins and Robert Rauschenberg among them. From that evening, and for several years to come, the media would use the term "Happening" to describe a broad range of artists' events and gatherings.

YAYOI KUSAMA
"Anti War" Naked Happening and Flag Burning at Brooklyn Bridge, 1968

Kusama targeted key New York City locations—Brooklyn Bridge, Central Park, Wall Street—for her events. She said they were "anti-war, anti-establishment...about economics, politics, Japan, and scandal." The performers wore little but Kusama's signature polka dots.

Kaprow's events were emphatically participatory, while Claes Oldenburg's were more concerned with engaging the viewer visually—his *Ray Gun Spex* events were, he said, "paintings in the shape of theater," fragments of which the viewer could purchase from his Storefront studio. Robert Rauschenberg, whose performance collaborations began in 1952 with Merce Cunningham and John Cage at Black Mountain College, maintained a clear separation between performer and viewer in all but the intensity of the perception-altering surprises that he created. "I don't call my theater pieces Happenings," he said in a 1965 interview, "because of my involvement with theater through dance." The collaboration between artists—especially dancers—and the way they altered each other's notions of the body in space, was the key component that kept him absorbed by performance throughout his prolific career.

By 1960 there were regular festivals of performance in most European cities. Usually collections of independent actions, they displayed little of the collaborative exchange between artists of different disciplines that was so inspirational for many American artists. In Nice in 1961, for example, Arman destroyed a chair and table in *Anger*, and Niki de Saint Phalle in *Surprise Shoots* used a rifle to shoot at a panel containing glass objects and plastic bags filled with paint and smoke bombs. But 1961 saw the introduction of Fluxus, named by George Maciunas, an artist and poet born in Lithuania and working in New York. Fluxus was a loosely constituted group, more concerned with music and language than with painting and environments; it attracted artists from a broader spectrum, and had a more intellectual and socio-political edge. There was a direct link to John Cage through George Brecht, who had studied with him, and many of the group were classically trained composers—Nam June Paik, Yoko Ono, David Tudor, Charlotte Moorman. Fluxus concerts were often presented in traditional concert halls, like Carnegie Hall in New York, and stages were frequently littered with musical instruments which were "prepared," mistreated, or destroyed in the process of creating "noise music," and challenging, symbolically at least, the rigidity of the music academy and the barriers between "high art" and the music of everyday life. In Paik's second concert, *The Exposition of Music Electronic Television* in a Wuppertal gallery, 1963, he assaulted three prepared pianos (one covered with a brassière, padlock, barbed wire, and other objects), and thirteen television sets. He was joined at one point by Joseph Beuys, a visitor to the exhibition, who helped hack apart one of the pianos with an ax.

For Paik, Fluxus was an "international passport," much like Dada had been some fifty years earlier. As its name made clear, it had no fixed center, ideologically or geographically. From Prague to Amsterdam, Cologne, Tokyo, Stockholm, or Sydney, it gave rise to the spontaneous art event. Everyone could do it, artist and non-artist alike. Its fluid agenda attracted many women—Yayoi Kusama, Yoko Ono, Shigeko Kubota, Ay-O, Alison Knowles. At the same

time its vaguely anarchic ways suited the various political tenets behind the protests of the '60s. Its very failure to become an "ism" was its success, according to Beuys, and he responded to its inclusionary spirit by joining Fluxus concerts, and creating highly ritualized events of his own. Beuys, who saw art as a tool for awakening both spiritual and political awareness, put a strong emphasis on music: "The acoustic element and the sculptural quality of sounds have always been essential to me in art," he explained in a 1979 interview. His first Fluxus concert, after a meeting with Maciunas at a neo-Dada concert in Düsseldorf in 1962, took place at the Galerie Parnass in Wuppertal: Beuys played a piano with pairs of old shoes until it fell apart. The following year he and others organized the Festum Fluxorum Fluxus Festival in Düsseldorf; twenty artists participated in an evening of *Music and Anti-music: Instrumental Theater*. By 1965, however, Beuys's passion for dramatic ritual and its ability to touch the audience led him to separate from Fluxus. At the Düsseldorf Galerie Schmela that year, Beuys's *How To Explain Pictures to a Dead Hare* was a startling three-hour event which he described as "a complex tableau about the problem of language, and about the problems of thought, of human consciousness, and of the consciousness of animals."

Through the '70s, the work of radical artists of the '60s—Hermann Nitsch, Günter Brus, and Arnulf Rainer in Vienna, Gustav Metzger, John Latham, and Stuart Brisley in London—continued to exert great influence on the next generation of performers, who were just as intent on the connections between art and everyday life, between art and psychology, and between politics and the aesthetics of action. The range of work produced at this time was enormous—from the elegant and eloquent work of Arte Povera in Italy, to the unyielding political symbolism of British and Irish artists in the '80s. Performance as metaphor—a means of articulating broader cultural spasms from shifts in political or economic strata rather than focusing on personal concerns—was a particularly male preference, and the artists who emerged from eastern Europe at the end of the '80s added many examples. Disturbing and curiously suspended in time, like visitors from another place, their performances alerted viewers to the continuing fragility of human life in the frame of world politics, all but forgotten by those who lived through the affluent '80s when performance, as monologue and media parody, came as close as it ever has to standard entertainment.

Artists of the '90s use performance as a critical evocation of everyday life, now an extraordinary mix of visual languages and value systems. Threaded through with technology as much as with the traces of spirituality of their own invention, contemporary performance artists force us to confront our own particular moment in time, and to attempt to name it.

ALLAN KAPROW
Household, 1964

Every artist's approach to live actions was quite different, depending as much on background as on temperament. The ebullient Kaprow designed his events for maximum audience participation, as in this Happening at Cornell University, Ithaca, New York.

JOHN CAGE
John Cage preparing a piano, before 1950
Reunion, 1968

Cage's "prepared pianos" were evidence of his iconoclastic approach to the traditions of classical music and of his interest in making performances from found materials. For *Reunion* he invited composers (and friends) David Tudor, Gordon Mumma, David Behrman, and Lowell Cross to perform their live electronic music simultaneously, while Cage, Marcel Duchamp, and Teeny Duchamp played a game of chess on a wired board.

◄ **ROBERT WHITMAN**
American Moon, 1960, 1976

➤ **JIM DINE AND JUDY TERSCH**
Car Crash, 1960

American Moon was first performed in 1960, and was reconstructed in 1976. Whitman, originally a sculptor, created highly effective spatial illusions with paper, cloth, and lighting. His Happenings were known for their careful preparation and visual lushness. Jim Dine's brief events, on the other hand, were far more sketchy; he considered them to be an acting-out of his personal obsessions.

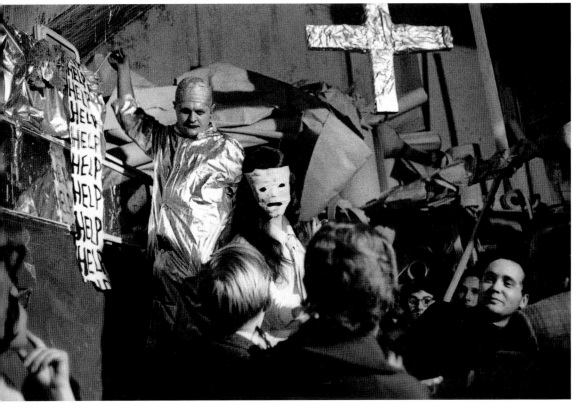

ROBERT RAUSCHENBERG
Elgin Tie, 1964

Painter and assemblage-maker Robert Rauschenberg, who came to Happenings via dance, maintained a clear separation between performer and viewer. *Elgin Tie* (right) was part of *Five New York Evenings* at Stockholm's Moderna Museet.

NIKI DE SAINT PHALLE
Shooting Painting, 1962

For her violent action paintings, De Saint Phalle shot at large assemblages covered in balloons filled with paint (opposite, top). Each bullet splashed a different color across the canvas.

NAM JUNE PAIK
Simple, 1962

Paik's performances were witty and clever, often verging on intellectual slapstick, and erotically charged. An energetic participant at Fluxus festivals, he ridiculed the pretensions of the art world with deliberately absurd actions. Wearing a business suit, he poured a bucket of water over his head, as part of the Fluxus International Festival of New Music in Wiesbaden (opposite, below left).

CHARLOTTE MOORMAN/NAM JUNE PAIK
TV Bra for Living Sculpture, 1970

Moorman, a cellist, and Paik first performed this work in 1969 as part of an historical exhibition "TV as a Creative Medium" in New York. The next year they were "exhibited" in "Happenings and Fluxus" in Cologne (opposite, below right).

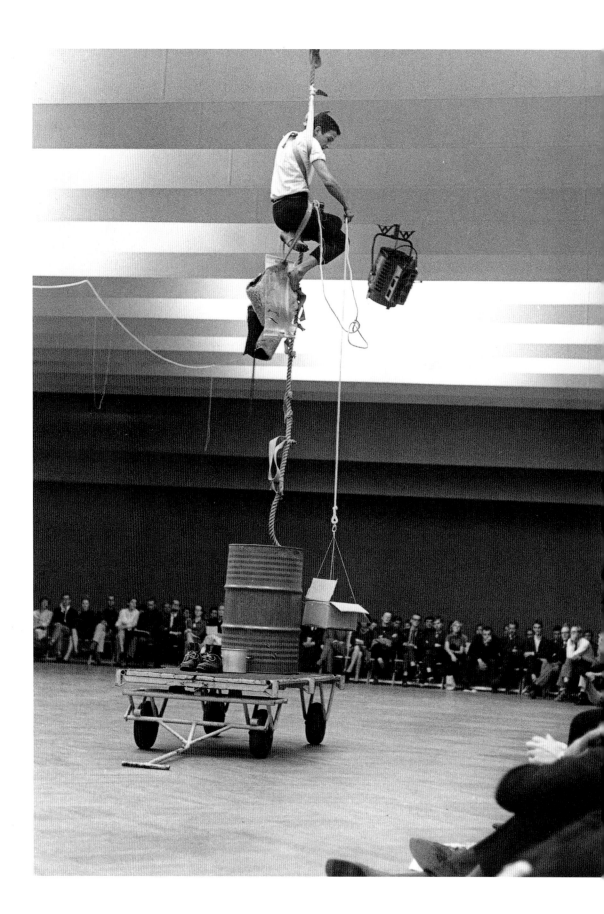

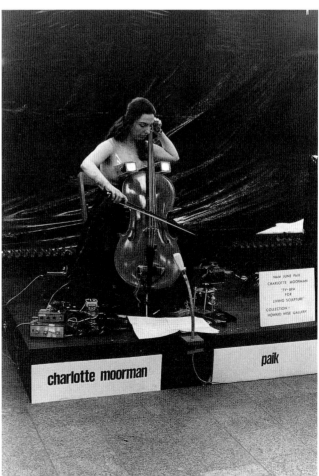

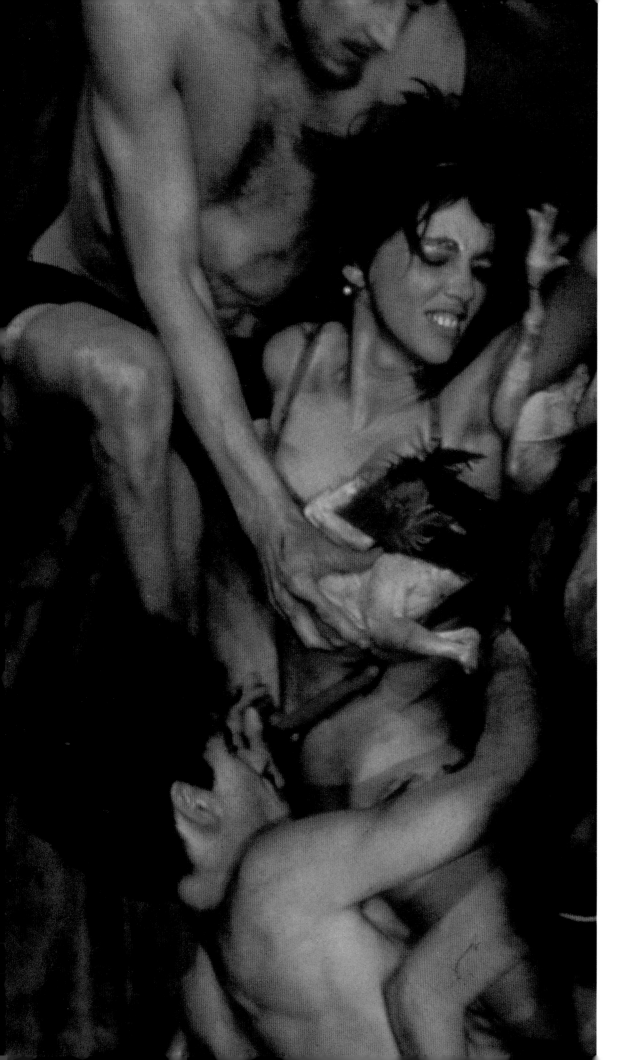

CAROLEE SCHNEEMANN
Meat Joy, 1964

Schneemann's major opus was a seventy-minute Dionysian spree in which male and female performers painted each other's semi-naked bodies (they wore fur-enhanced bikini underwear), rolled in tight embraces along the floor, crawled through mountains of paper, and threw red meat, fish, and dead chickens into the mix of hair, paint, bodies, and mattresses. A backing soundtrack included "My Guy," "Baby Love," "Noh Ho L'Eta," as well as taped Parisian street sounds. Seen at Jean-Jacques Lebel's First Festival of Free Expression at the American Center in Paris, 25–30 May 1964, it was performed again at the Judson Church in New York in November of that year.

▲ **KAZUO SHIRAGA**
Sambaso Ultra-Modern, 1957

◄ **THE NEO-DADA ORGANIZERS**
Untitled, 1960

Formed in December 1954 by Jiro Yoshihara, in Osaka, the Gutai Group's manifesto called on its members to "create what has never existed before." Art for them was both a theatrical event and a gesture of individual freedom, as well as a political response to a post-Hiroshima mood of desolation. Kazuo Shiraga, dressed in red, appeared in the 1957 exhibition "Gutai Art on the Stage" in a two-part program of twelve Actions, including sound and media projections, reviewed in the New York *Times* of 8 September that year. The Neo-Dada Organizers, formed in 1960, was a short-lived group which operated out of Masunobu Yoshimura's studio, and which took a far more aggressive approach. In fact, several of their street actions ended in skirmishes with the police, and their first exhibition was cancelled even before it opened. There were three Neo-Dada exhibitions in Tokyo in 1960, and Masunobu (right) and Kinpei Masuzawa (left) are pictured parading through the streets during the third.

GUSTAV METZGER
Destruction in Art Symposium, London, 1966

HI RED CENTER
Be Clean!, New York, 1966

JEAN-JACQUES LEBEL
Pour Conjurer L'Esprit de Catastrophe, Boulogne, 1962

The political atmosphere of the 1960s infused art actions with political rhetoric and an anarchic energy that was intensely anti-establishment. Art institutions were considered irrelevant, together with critics, curators, and collectors. Instead, artists performed in the streets, and confronted authority and public with their ideas for a radical new culture. Metzger and others organized the two-day Destruction in Art Symposium (above), which included Wolf Vostell, John Latham, Hermann Nitsch, and Yoko Ono. Extreme left-wing critics of the inequities of Japanese postwar culture, Hi Red Center (above right) performed their street-washing piece in New York (assisted by Fluxus artist Maciunas) and Tokyo. In Boulogne, Paris, and Milan, Lebel's Festivals of Free Expression (right) were major events; to his delight, their anarchistic slogans and the nudity scandalized the international press.

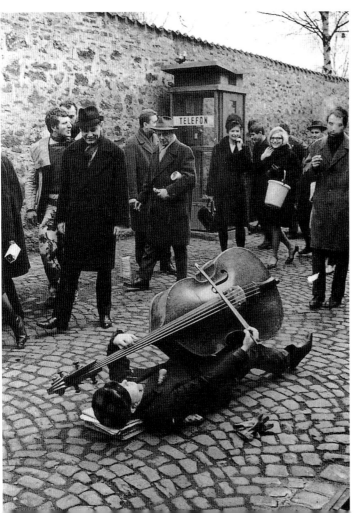

JOHN LATHAM
Skoob with Powder, Destruction in Art Symposium, London, 1966

GUERRILLA ART ACTION GROUP
Blood Bath, New York, 1969

WOLF VOSTELL
Happening: Erdbeeren, Berlin, 1974

MILAN KNIZAK
Street performance, Prague, 1964

Latham's book-burnings (top left) suggested that "the cultural base had been burnt out." GAAG's art strikes and street protests included *Blood Bath* (top), a call for the resignation of the Rockefellers as Museum of Modern Art Trustees. From the late '50s to the late '70s, Vostell (above) was an incessant action-maker, telling spectators, for instance, to "go into a laundry and ask in which year we are living." Knížák (left), co-founder of AKTUAL whose actions were often stopped by the police, "wanted to make revolution in everyday life."

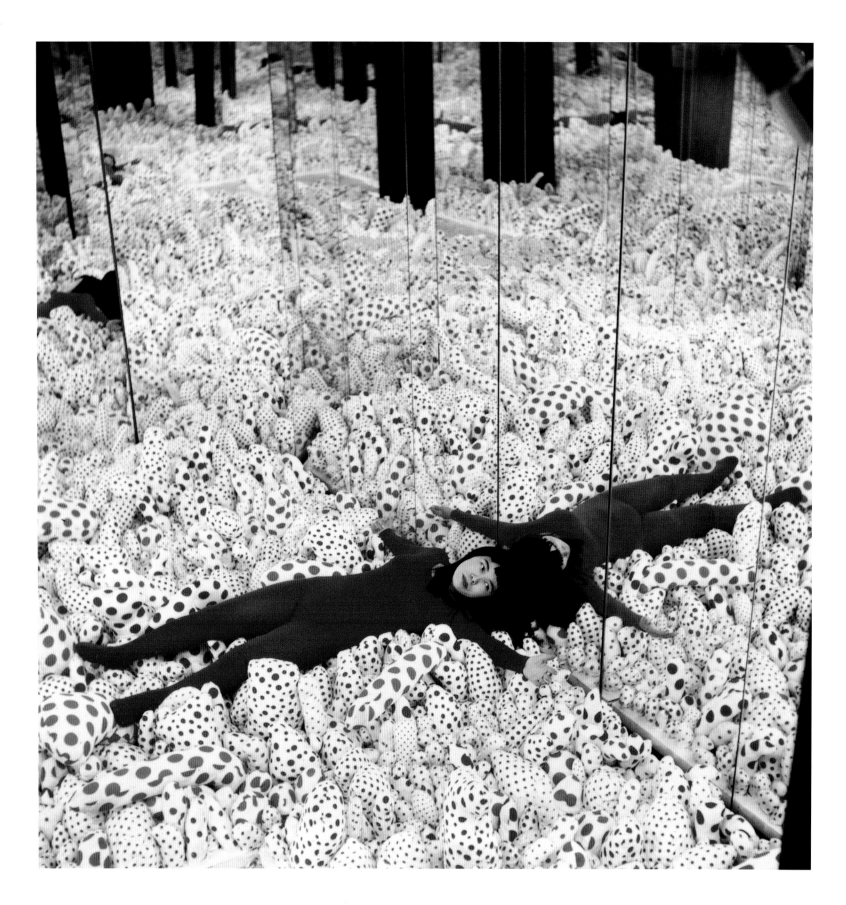

◄ **YAYOI KUSAMA**
Infinity Mirror Room, 1965

Kusama used the term Obsessional Art to describe paintings and environments that emerged as much from her own episodes of acute depression as from observations of the repetitiveness of daily life—what she called "the consciousness of living in continuation." "Think of breathing," she said. "You have to breathe so many times." Her mirrored rooms gave architectural form to her intense sensations. This piece was part of her solo exhibition "Floor Show" at the Castellnar Gallery, New York.

► **FLUXUS**
Graffiti announcing street events, New York, 1964
Fluxus Festival of Total Art and Comportment, Nice, 1963

Fluxus was a term introduced in 1961 by George Maciunas, to connect a broad collection of artists, musicians, writers, and poets, who were already hugely active in creating events in cities around the world. His intention was to open Fluxus activities to non-artists as well; "the goal was social (not aesthetic)," he said. Maciunas wrote manifestos, organized festivals, and tirelessly documented these activities. Fluxus members felt compelled to state their distinct approaches. "Each of us had his own ideas about what Fluxus was," wrote George Brecht, "and so much the better." Dick Higgins, Lette Eisenhauer, Daniel Spoerri, Alison Knowles, and Ay-O are pictured above, and Ben Vautier (signing certificates in Nice) below.

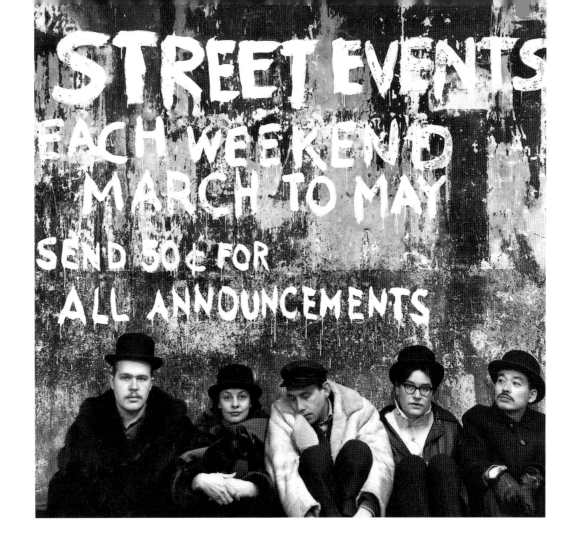

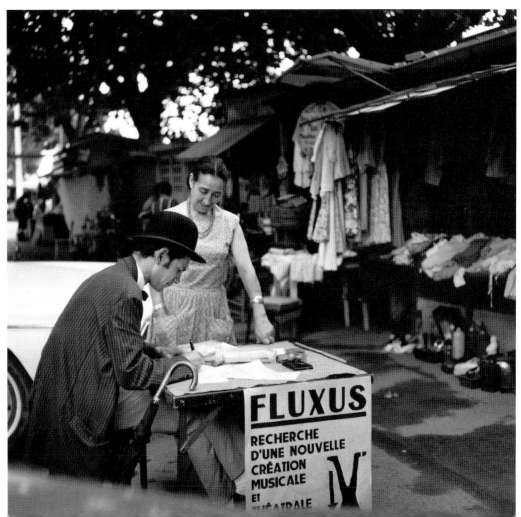

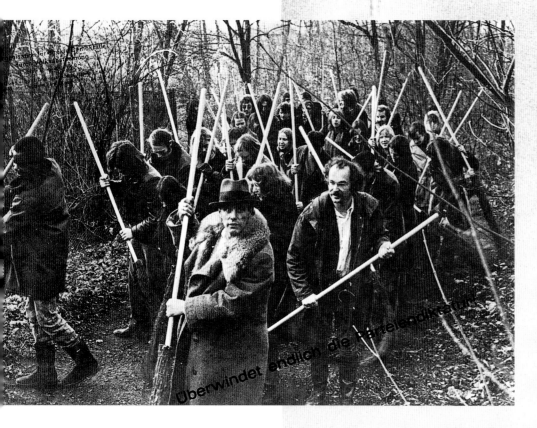

JOSEPH BEUYS
Save the Woods, 1973
Coyote: I like America and America likes me, 1974

Committed to the idea that art has a capacity to transform people—socially, spiritually, and intellectually— Beuys created what he called "social sculptures." These might include lectures, collaborative protest activities (such as *Save the Woods*), or symposia on art and politics. For Beuys *Coyote* was a metaphor for the tragic decimation of the Native American peoples (who respected the coyote) by the early European settlers (who despised and shot it). Beuys spent a week "in captivity" with the wild animal in a New York Gallery.

JANNIS KOUNELLIS
Untitled (with Horse), 1972

Born in Greece and educated in Rome, Kounellis was steeped in classical philosophy and imagery, which he used freely in a series of eloquent performances. For him everyday life in Italy *was* "high art," and the mix of the two was less of a contradiction than an acknowledgment of fact. Like his peers—Michelangelo Pistoletto, Luciano Fabro, Mario Merz, Marisa Merz, Giulio Paolini, or Giuseppe Penone—he was equally comfortable with history and contemporary life, and shared the Italian love of metaphors to link them. Kounellis described this performance in the Sonnabend Gallery in New York as a painting.

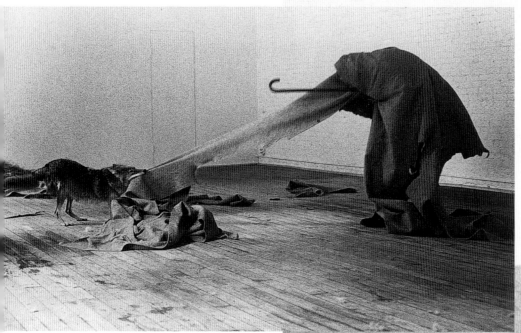

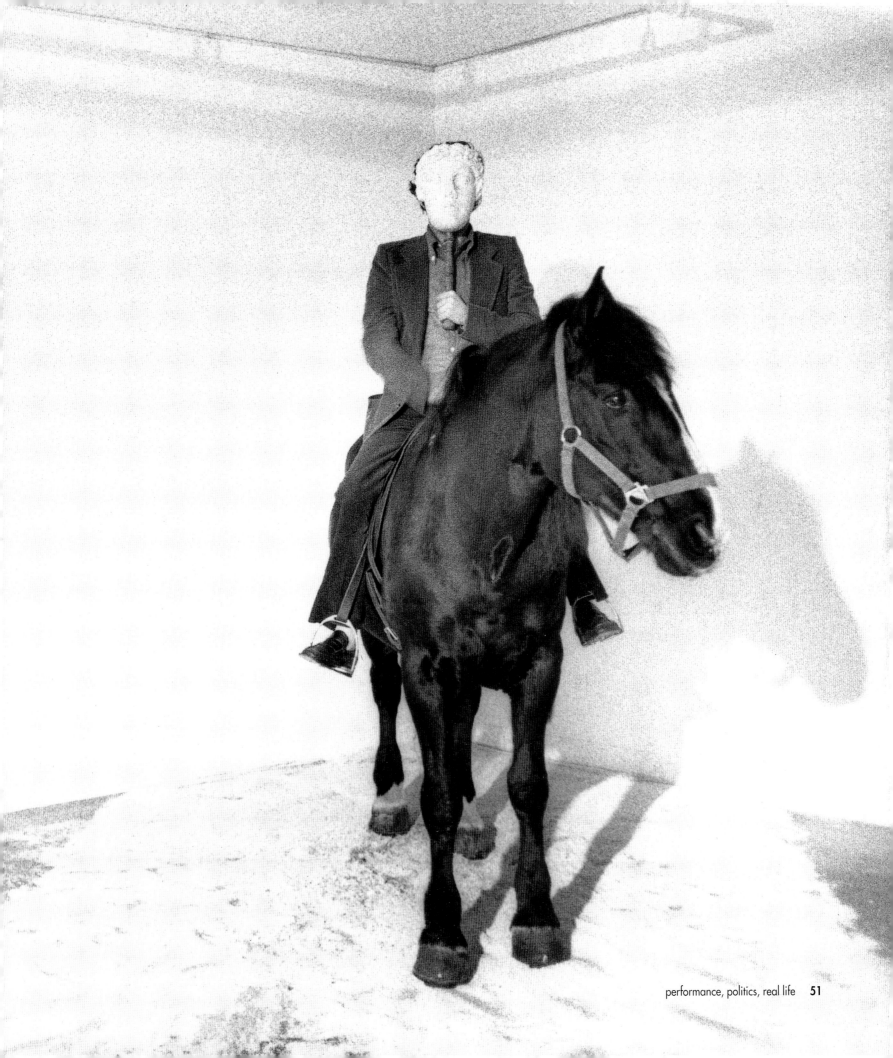

▲ ALASTAIR MACLENNAN
Lie to Lay, 1986

Influenced by Zen Buddhism and a belief in "everyday experience as a key to enlightenment," MacLennan's harsh, sometimes sado-masochistic tableaux are for him cathartic events that heal "spiritual, psychological, political, social, and cultural wounds." *Lie to Lay* took place in an abandoned warehouse in Newcastle upon Tyne. He transformed it with rows of hospital beds, bales of hay, and stacks of old clothes into a dramatic backdrop for his 120-hour endurance work about healthcare in Britain.

▶ ANNE BEAN and PAUL BURWELL
At The Kitchen, New York, 1978

A key figure in British performance art from the early '70s, Anne Bean, musician and artist, formed the art-parody band The Moodies, and later joined with Paul Burwell and Richard Wilson, to form the Bow Gamelan Ensemble, active in the '80s and early '90s. During their ritualistic events, Bean's powerful figure held central stage while Burwell's drumming, on home-made percussive instruments, including electric motors and fans, metal pipes, old washing machines, and sheets of glass, created an atmosphere of frantic and explosive drama. Their events often also included fireworks.

STUART BRISLEY
Moments of Decision/Indecision, 1975

In Britain, Germany, and Austria in particular, an aspect of '60s performance was its penchant for violence—both as a tool for individual catharsis, and as a form of aggressive public protest against Cold War politics and the war in Vietnam. British artist Stuart Brisley drew together influences from the Viennese Actionists and the political events of the early '60s in the USA, as well as his reading of R.D. Laing's radical psychoanalytical texts, to create powerfully original performances of his own. *Moments of Decision/Indecision* took place in one large room, lasted six days, and dealt with sensory deprivation that increased throughout the day, as Brisley drenched himself in white and black paint to the point that he could barely move or see. It was unusual at that time for being performed behind the so-called Iron Curtain (it was presented at Galeria Teatra Studio in Warsaw), and Brisley's futile attempts to climb the walls of the room built up increasing feelings of frustration and helplessness in the watchers.

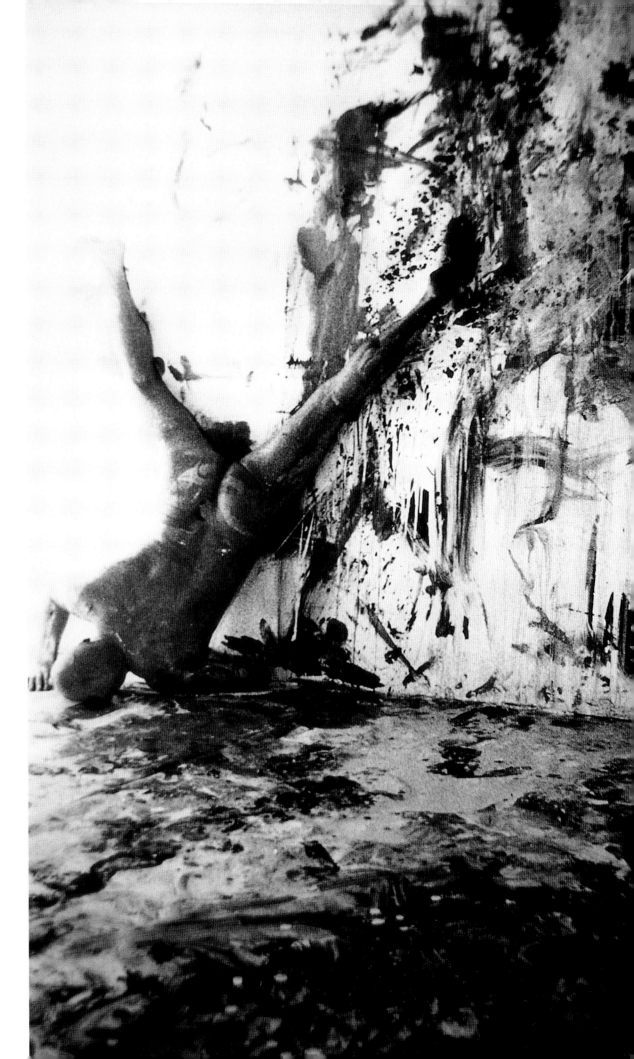

▲ BRIAN CATLING
Luna Prayer, 1989

Catling's performances, poetry, and written vignettes are intensely sculpted works made of words and actions. His writing precisely navigates a space—"in a square room with no windows a glass tube runs along the walls"—while his performances fill the spaces in between with his large body, silent gestures, and vivid poses. *Luna Prayer* was performed at the Museum of Modern Art, Oxford.

◄ ANDRE STITT
Second Skin, 1996

Stitt's pieces reek of the agony of growing up beside the Belfast barricades. His manic, funny, and frightening street appearances, covered in ketchup and mayonnaise, contrast with his somber indoor performances. *Second Skin,* part of Brighton's Violence of the Imagination Festival, was a four-hour work in which he hammered and cleansed an old enamel bathtub.

▼ NIGEL ROLFE
Rope Piece: The rope that binds us makes us free, 1985

For this enigmatic work "made for Ireland,"at New York's Franklin Furnace, Rolfe, like Catling, used language to give resonance to his performance. "From one of the cottages [in Leitrim]… I took a ball of twine…. To bind my head…. To capture, to contain, to smother—perhaps a symbol of Ireland."

MONA HATOUM
Variations on Discord and Divisions, 1984

"My work often refers to hostile realities, war, destruction, but it is not localized, it refers to conflicts all over the world," says Hatoum of her unstructured performances that are usually a response to a specific site and a particular moment in time. "I want to remind the audience that there are different realities that people have to live through." *Variations,* about forty to fifty minutes long, was performed in Vancouver. The entire space was lined in newspapers; dressed in black with her face covered in an opaque stocking mask, Hatoum tried to scrub the floor, but smeared it instead with red-stained water.

TOMAS RULLER
8.8.88, 1988

Pursued by the state police for his radical activities and his connections to artists abroad, Czech artist Ruller was forced to perform in secret, often documenting his events on video. A show of his drawings in a Prague gallery in the summer of 1988 was cancelled just before the opening; instead, Ruller invited visitors to join him in a two-hour walk around the neighborhood. "It was a day close to the anniversary of the Russian invasion of 1968," Ruller recalled. "I used fire, which was related to Jan Palach who burned himself in protest..."

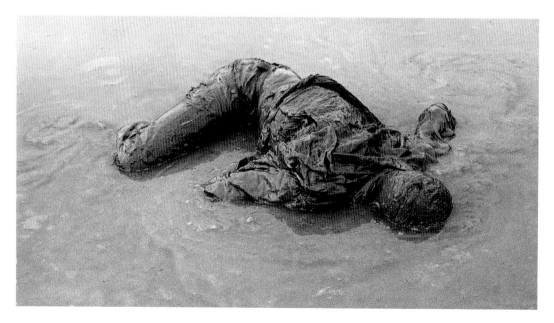

BLACK MARKET INTERNATIONAL
Basle, 1995; St. Gallen, 1992; Berne, 1997; Helsinki, 1991
(clockwise from below left)

Established in 1985 as a "a meeting of at least two or more people," this group of all-male European artists perform as a loose collective, sometimes solo, sometimes collaboratively, at festivals throughout Europe. Often silent, their emblematic, improvised sequences, lasting anything from a few hours to twenty-

four, and usually presented in large, non-theater spaces, frequently refer to recent east-west political conflicts, which is to be expected given the combination of Finns, Russians, Poles, Germans, Swiss, Czechs, and Irish. Guest artists are sometimes invited to participate in the performances, which are never repeated.

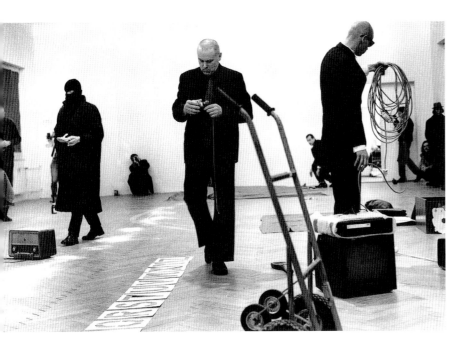

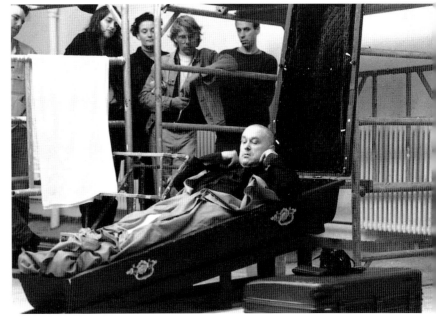

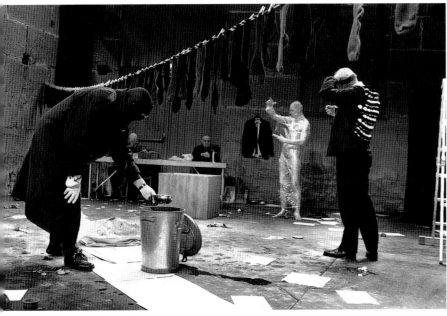

▲ PEDRO GARHEL AND ROSA GALINDO
Vertigo Virtual, 1989

Garhel and Galindo's exaggerated costumes
are full of references to the past, such as Martha
Graham's body-tubes of the 1930s, and Oskar
Schlemmer's padded Bauhaus dancers of the
1920s. They select unusual architectural spaces,
like the cloisters of León Cathedral, for quasi-
ritualistic performances that often incorporate
images of pain, ecstasy, and death.

► LUCY ORTA
Refuge Wear: Collective Survival Sac, 1997

Orta's Body Architecture provides an ironic twist
to clothing. Refuge Wear can be transformed
from suit to temporary shelter. Each design is
related to a collaborative social project, such as
a Salvation Army center for homeless families
(Paris, 1995) or a "communication workshop"
with groups of prisoners (Metz, 1996).

TAMAR RABAN
Dinner Dress, Tales about Dora, 1997

First performed in an apartment in Vienna, Raban's festive five-course dinner for twenty, accompanied by sound and slides, took place around a large table in an arts center in a disused Tel Aviv bomb shelter. A tablecloth—the skirt of the artist's dress—reached the floor, and transparent plates placed over cut-outs in the cloth, provided peep-holes to video monitors installed below. A culinary tableau, *Dinner Dress* was a play on private and public ritual, and ways of connecting the two in the most intimate and visceral ways. "The dress as the extension of my body, they are eating my body, they are consuming me," Raban wrote.

RIRKRIT TIRAVINIJA
Untitled, 1994

Tiravinija is always concerned with directly engaging his audience, and has involved spectators in activities such as the installation of an actual rehearsal studio in a gallery or the consumption of a Thai meal cooked and served by him. His interest lies in the process around art—the backroom of a gallery in Lucerne as in this work, or a theater—and he usually lists "lots of people" as an ingredient in his work.

CAI GUO-QIANG

The Century with Mushroom Clouds: Project for 20th Century. Event at Nevada Nuclear Test Site, 1996
The Century with Mushroom Clouds: Project for 20th Century. Event at Manhattan, 1996
Cultural Melting Bath, 1997

Born in Fujian Province China, Cai Guo-Qiang brings to the West a deeply spiritual sensibility that is as mysterious as it is curiously recognizable. Explosions of gunpowder in landscapes are reminders of cinematic techniques in faking battles and also of the more sinister atomic experiments of the 1950s. Yet they are intended as ceremonies wherein "the moment of explosion creates chaos in time and space," conveying a "Chinese view of human beings as a microcosm of the universe." *Cultural Melting Bath,* made of thirty tons of *Taihusu,* a limestone from the bottom of Lake Tai near Cai's native city of Suzhou, incorporated *feng-shui* (ancient Chinese geomancy) and herbal medicine. Cai invited various individuals to bathe together in the healing waters.

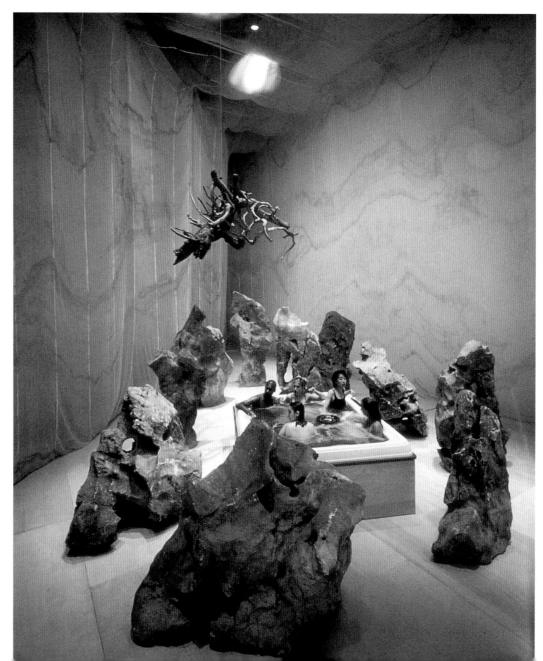

ROMAN SIGNER

Aktion, 1987
Kleine Ereignise (Small Event), 1996

Transformation of ordinary objects like kitchen tables, bicycles, or balloons into "action sculpture" is at the heart of Signer's work. Using pyrotechnics, water pressure, or the wind, his events and installations continue the line of exploration begun in the early '70s by artists more concerned with underlying perceptual processes than with making objects. Blasting gunpowder adds both subversiveness and the humor of surprise to his work. Whether working in the Alpine landscape or in his Lucerne studio, before an audience or a video camera, Signer prepares each project with the care of an architectural draftsman (for which he trained) and the concentration of an acrobat.

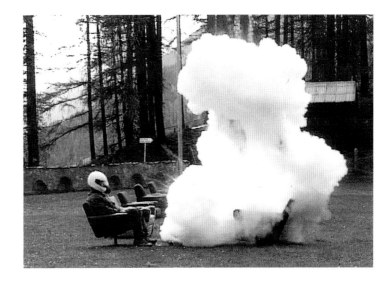

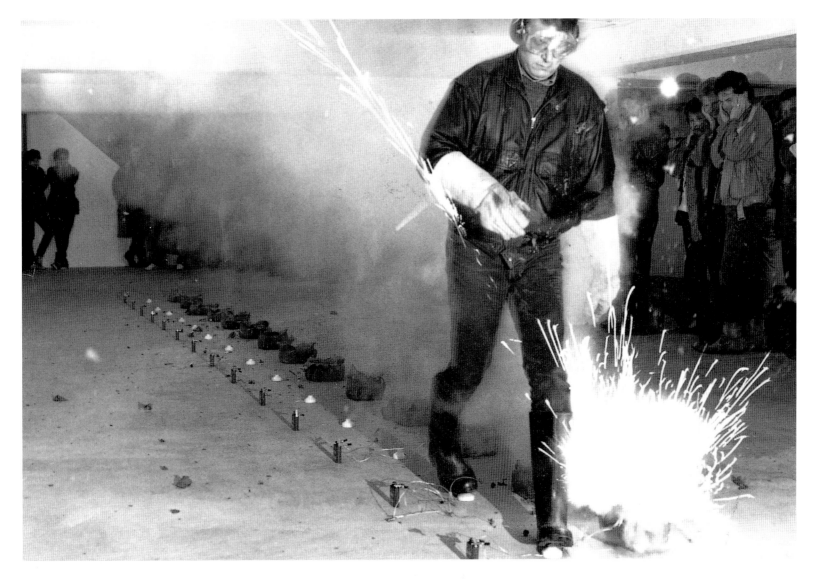

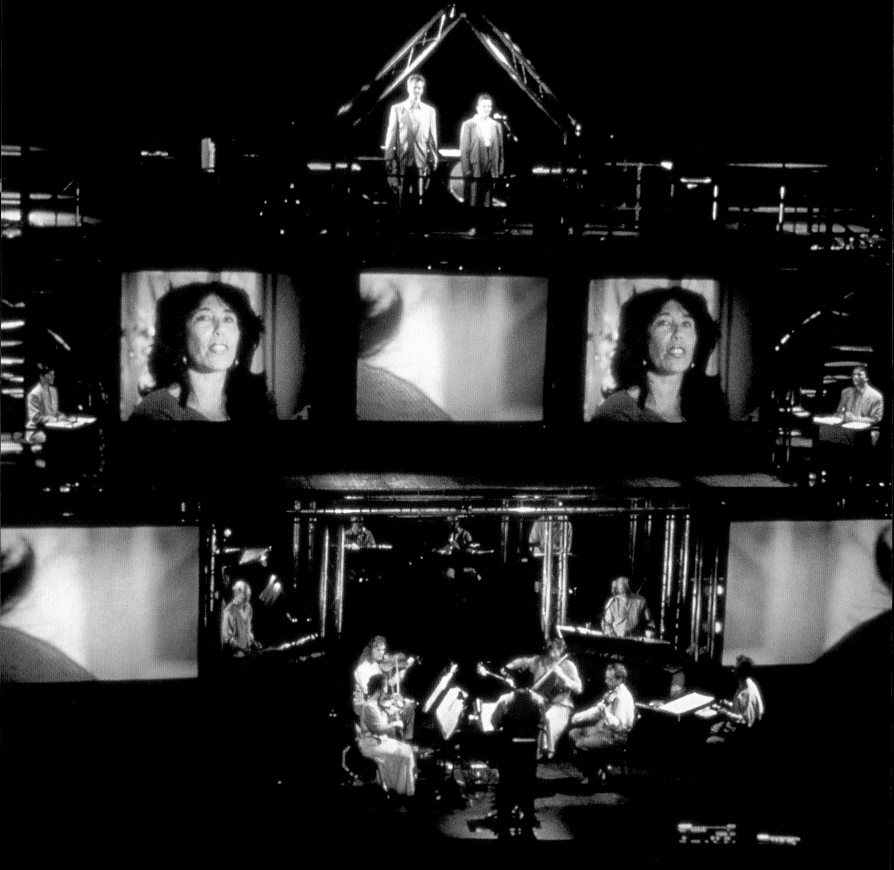

theater, music, opera

Radical American and European theater of the 1950s and 1960s was deeply influenced by the innovative theater directors from earlier in the century—Vsevolod Meyerhold, Konstantin Stanislavsky and Jerzy Grotowski. But it would be avant-garde artists and musicians, not theater directors, who would trigger a rethinking of the very nature of performance. The work of idiosyncratic American composer John Cage, especially his writings on silence and chance, was as radically important as the ideas that came from Futurism, Dada, Surrealism, from Marcel Duchamp and Antonin Artaud. Cage's now famous "untitled event" was presented at Black Mountain College in North Carolina in the summer of 1952. There was improvised dancing by Merce Cunningham in the aisles surrounding the audience, poetry readings by several performers perched on ladders, film projections on the walls, white paintings by Robert Rauschenberg hanging from the ceilings, and music on a "prepared" piano by David Tudor. This watershed event, coupled with Cage's composition classes at New York's New School for Social Research, was to exercise a profound influence on the development of art, dance, and music over the next forty years, particularly in the United States. Cage's contention that theater was in the mind of the beholder was a revelation to those who worked with him; "I try to get it so that people realize that they themselves are doing their experience and that it's not being *done* to them," Cage said.

Allan Kaprow attended Cage's composition class, and absorbed his teachings on chance as a motif and "found sound" as music. But he emphasized that the prime sources for Happenings were visual. "The direct line of historical stimulation (usually conscious)," Kaprow wrote, "seems to have been the Futurist manifestos and noise concerts, Dada's chance experiments and occasional cabaret performances, Surrealism's interest in automatic drawing and poetry, and the extension of these into action painting." American theater director Richard Schechner was, in turn, deeply affected by Cage and Kaprow; their influence, and that of the art world, he wrote, "cannot be overestimated." "It was from the direction of

BERYL KOROT and STEVE REICH
The Cave, Act 1: "Who is Sarah?", 1993

A three-hour visual and sound spectacle combining art and politics, video and music, on-stage singers and musicians, *The Cave* with its operatic scale, pushed the idea of the "total art-work" into the realm of high-tech.

music and painting that theater was revolutionized," he said of developments in the United States. So too, Julian Beck of the Living Theater, expressed his desire for "a revolution in the theater similar to those which had already taken place in painting and sculpture."

The avant-garde art world of the 1960s was a strong magnet for those in theater seeking a break from the psychological approach both to the audience and to acting that had been prevalent in the '50s. New York City in the late '60s—an *event* in itself, according to Spalding Gray who arrived in 1967—was a boom town of alternative theater groups which took their lead from the latest experiments in the art and dance worlds. Performance could be sampled nightly at the Judson Church, the Merce Cunningham studios, Richard Foreman's *Ontological Hysteric Theater*, the Living Cinema, the Film-maker's Cinemathèque or La Mama Experimental Theater. During the day, performers could attend workshops run by fellow artists, where collaborative work was encouraged. Wilson's Byrd Hoffman School for Birds offered classes in movement and body awareness and attracted highly original dancers and performers, among them Meredith Monk, Cindy Lubar, Andrew de Groat, Stephan Brecht, and Spalding Gray.

It was clear that this new performance-art theater had nothing whatsoever to do with even the most basic of theatrical concerns: no script, no text, no narrative, no director, and especially no actors. "No Previous Theater Experience Necessary" read an advertisement for Robert Wilson's *The Life and Times of Sigmund Freud* (1969). Instead, focus was on movement, "more like dance" Wilson said; on images, which washed the stage like hundreds of blown-up movie stills; and on time, which might be stretched as long as twenty-four hours to allow the eye to absorb the richness of the visual details distributed across the stage. This resulted in a wealth of unforgettable productions; Mabou Mines's *The Red Horse* (1971), Meredith Monk's *The Education of a Girl Child* (1972), Richard Foreman's *Pandering to the Masses: A Misrepresentation* (1975), The Wooster Group's *Three Places in Rhode Island* (1974–78), Robert Wilson's *A Letter for Queen Victoria* (1974).

It was Wilson's collaboration with composer Philip Glass, however, on the opera *Einstein on the Beach* (1976) that would have a pan-European influence. It premiered in July 1976 at the Festival d'Avignon, and was afterwards performed at the Venice Biennale. Both the action, which was slowed down in parts as to be almost imperceptible—"it gave you time to think"—and the imagery, which was on the scale of city buildings—"a theater for the eyes"— were indelible visual and visceral sensations for all who experienced it. Even for those who did not, Wilson's reputation throughout Europe, where he worked almost exclusively during the 1980s, had an enormous impact on young performers, such as the groups La Fura dels Baus in Spain and Falso Movimento in Italy, or Jan Fabre in Belgium. They used Wilson's

daring as a springboard for their own work. This new generation of European performance artists had been formed by the traditions of European theater, with its grand Wagnerian-scale productions in state-subsidized opera houses, and such brilliant directors as Peter Brook, Ariane Minouchkin, Giorgio Strehler, and Peter Stein. Yet their bold and complex works remained rigorously text-based and actor-centered, which explains the enthusiasm that greeted the Americans' work from both the theater and the art worlds of Europe. Above all, it was the overwhelmingly cinematic visual effects (particularly in the work of Wilson and Laurie Anderson) that appealed. The Americans' commitment to creating material from scratch, using autobiographical references, everyday life, and media culture as content (Monk, Anderson, the Wooster Group) had a liberating effect, and so did their indifference, for the most part, to narrative and to the actor as a "character." Furthermore, Wilson and Anderson actively sought broader audiences, establishing the contradictory notion of a popular avant-garde as a force for the '80s. These were some of the factors that would radically transform European performance in the mid-'80s, and that would also have a great impact on the evolution of dance-theater.

Much of this new work was introduced into Europe through the gateway of Amsterdam: there at the Mickery Theater from 1975 onward, director Ritsaert ten Cate presented the Wooster Group, Robert Wilson, Meredith Monk, John Jesurun, and many more. By the mid '80s, visual theater groups were flourishing in nearby Antwerp, led by the wildly imaginative Jan Fabre, who also took his inspiration from the complex and cathartic endurance pieces of Marina Abramović and Hermann Nitsch. The more cerebral Jan Lauwers and the pop-oriented Michel Laub, choreographers Anne Teresa De Keersmaeker and Wim Vandekeybus, and musicians Thierry de Mey and Peter Vermeersch, made up the Belgian "New Wave," whose innovative productions could be seen in a closely linked network of theaters—the Kaaitheater in Brussels, the Theater am Turm (TAT) in Frankfurt, and the Hebbel Theater in Berlin. It was as though, by the end of the '90s, the seeds planted some twenty years earlier by performance artists in Europe and the USA, concerning time, motion, space, imagery, the body, and sound, had at last come to marvelous fruition.

Einstein on the Beach became the model of a new *Gesamtkunstwerk* with its storyboard of non-sequitur scenes, a libretto made up of numbers and solfage symbols and sung by singers untrained in opera and performing mostly from the orchestra pit, with Glass's signature electronic music rendered in cycles of repetitive phrases. It not only left a school of visual theater in its wake, but also inspired many contemporary composers, who, in the next fifteen years, took *Einstein on the Beach* as an inspiration for their own inventions. An explosion of new opera followed, Glass's own *Satyagraha* (1980), *Akhnaten* (1984), and

Voyage (1992); John Adams and Peter Sellars' *Nixon in China* (1987), Peter Greenaway and Louis Andriessen's *Rosa, A Horse Drama* (1994), among others. Composer Steve Reich and video artist Beryl Korot introduced yet another dimension for visual opera with *The Cave* (1993), a majestic music-theater piece which meshed the latest in visual and sound technologies; videotaped documentary material projected on to five large screens gave the lead to music that mimicked the speech melodies of the taped performers. The result was a high-tech musical discourse on race, ethics, gender, cultural history, the Torah, the Koran, and contemporary politics.

It needed the confidence of the revitalized art world of late '80s Britain for a visual theater, influenced by live art, to emerge in full force. Works by groups such as Station House Opera and Forced Entertainment, Desperate Optimists, Gob Squad, and Blast Theory produced energetic theatrical performance in the '90s. Performance-theater in Britain in the '60s and the pre-Thatcher '70s, with its labor strikes and marches, was a mix of street-performance styles incorporating mime, vaudeville, poetry, and public confrontation. Troupes such as Welfare State, the People Show, or John Bull's Puncture Repair Kit, toured provincial cities, intentionally avoiding fashionable London, and could be seen mostly up north performing in places where workers gathered—forecourts of steel mills, the docks, the local pub—or performing at rock and arts festivals. At the same time the rock 'n' roll theater of *Hair* or *The Rocky Horror Show* that came on the tail end of London's "Swinging Sixties" and the mood of a highly creative youth culture at its center, kept the gates open between the worlds of art and pop music as it did between the different strata of Britain's social classes. Musicians who emerged from art schools in the north, like David Bowie or Brian Eno had no reverence for the "high-versus-low" debate; Eno's interests lay in working precisely in the spaces in between—art and music, classical and modern, and even performance and recording. For Eno the recording studio itself was a compositional tool, and his "ambient music," "Music for Airports," for instance, a sophisticated avant-garde riff on stale, canned "muzak," provided a means for his invasion of architectural spaces as well. On the other hand, musicians like Bow Gamelan and Stephen Cripps used Cornelius Cardew's eccentric ideas about Scratch Music as the model for their own highly eclectic concert performances. "A Scratch Orchestra is a large number of enthusiasts pooling their resources (not primarily material resources) and assembling for action (music making, performance, edification)," wrote Cardew.

In New York in the '70s, musical innovation continued along the lines introduced by John Cage. *4'33"* (1952) was among his works that opened composition completely to chance; his book *Silence* (1959) inspired a number of American composers to break with the

Europeans Stockhausen, Messiaen, Boulez, and Berlanger. La Monte Young, Terry Riley, Philip Glass, Steve Reich, Robert Ashley, Alvin Lucier, John Cale, and Pauline Oliveros, and many others, produced work from the mid-'60s that established a place for electronic music and minimalism built on repetitive structures "with reduced pitch relationships." This served as a framework for material that eventually incorporated research into the rhythms of African, Indian, and Asian music, as well as the inclusion of spoken language. The New York clubs of the late '70s such as CBGB's, the Mudd Club, and TR3 were, according to Glass, part of "the most important and vital new music scene today, more challenging and innovative than what I was hearing coming out of the schools or from people imitating me," and they provided a showcase for Peter Gordon's *Love of Life Orchestra*, Patti Smith, Alan Suicide, Glenn Branca, and new jazz by art-world musician John Lurie's *Lounge Lizards*. In the '90s, the Knitting Factory continues to sponsor the most interesting developments in new music from John Zorn to Christian Marclay and DJ Spooky.

Laurie Anderson's early performances in the mid-'70s were a sophisticated mix of her conceptual art background and her training as an accomplished violinist (an ability which she initially disguised in the creative climate of that time in which virtuosity was anathema to conceptually oriented artists, dancers, and performers). Autobiographical, intimate, and punctuated with visual notation, custom-made violins, and fragments of home-made movies or doctored slides, she captured audience attention with a "stage presence" that had previously been absent from artists' performance. This was very evident in her opus of 1983, *United States*, in which she was the single performer at the center of a huge stage for most of the eight-hour production. The kick-off for an '80s fascination with art that moved beyond the container of the art world to the limitless possibilities of the popular media, *United States* with its signature song "O Superman" also led Anderson more deeply into the music world; collaborations with Peter Gabriel and Brian Eno, and recordings such as "Strange Angels" gave her a unique passage through several highly sophisticated industries at once, qualifying her by the late '90s to break new ground in the very latest high-tech territories. *Life* (1998), a "live" installation involving an incarcerated prisoner, whose image is projected via cable into a museum gallery, and *Moby Dick*, an electronic opera that will have its premiere in 1999, show Anderson on the edge of the twenty-first century with the tools to provide us with telling portraits of our society.

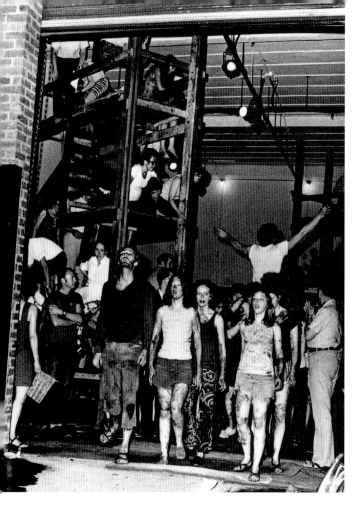

◄ RICHARD SCHECHNER and THE PERFORMANCE GROUP
Dionysus 1969, 1969

Schechner was fascinated by Cage's notions of chance and "life as theater," and by the radical approaches to performance of painters like Allan Kaprow. Kaprow's rules of thumb for Happenings, such as "the line between art and life should be kept as fluid, and perhaps as indistinct as possible," were the model for his own manifesto on theater, *Six Axioms for Environmental Theater* (1967). *Dionysus 1969* illustrated several of these axioms, such as "all the space is used for performance," and it was a powerful example of his belief in involving the audience (here shown being led into the street).

▼ MABOU MINES
The Red Horse Animation, 1971

Artists' performance, new dance, and the new music of downtown New York freed approaches to theatrical material, but for director and playwright Lee Breuer, acting skills and storytelling were still an important part of the theatrical process. He and the Mabou Mines group collaborated on a series of so-called "animations"—non-sequential stage pictures with a strong comic-book flavor. "Dramatic movements," says Breuer, "have 'POW,' 'KRACK,' and 'AARGHH' written all over them." For this show at La Mama Theater, the slatted wooden wall was "live" with microphones, and functioned as a percussive instrument.

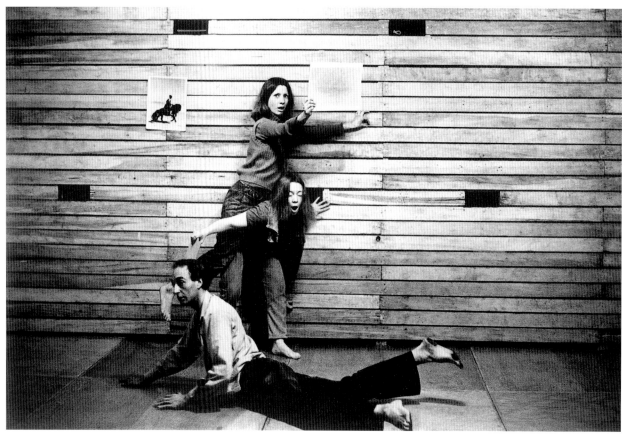

THE WOOSTER GROUP
BRACE UP! 1991
The Hairy Ape, 1997, first performed in 1995

Spalding Gray and Elizabeth LeCompte, both
members of Schechner's Performance Group,
were drawn to the non-narrative, movement-
focused work of Meredith Monk and Robert
Wilson. In the spring of 1974, LeCompte,
a painter, and Gray, an actor, began
experimenting with material from Gray's early
childhood; LeCompte created a collage of
memories—records, slides, interviews, texts,
and actions. From these beginnings came the
Wooster Group ensemble which, with LeCompte
as director, developed a highly sophisticated
and complex collaborative medium for their
ideas, made up of film, video, text, and
energetically choreographed performances.
BRACE UP!, an epilogue to the trilogy *The Road
to Immortality,* continued their practice of using
biographical material as a starting point, while
The Hairy Ape, based on Eugene O'Neill's
1920s text, is an example of their approach
to classic texts, which they cut, splice, and
reconfigure to give an entirely modern and
radical meaning to contemporary drama.

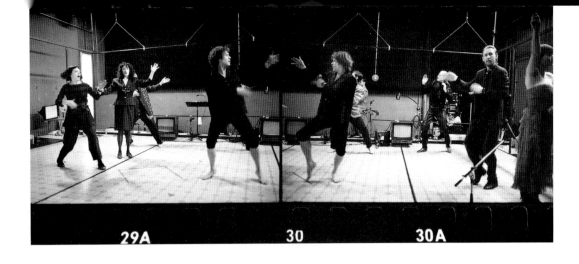

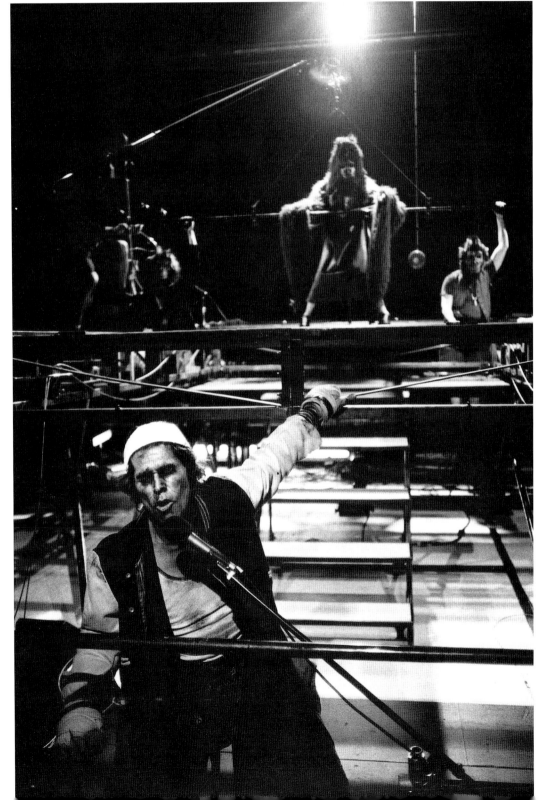

◄ **RICHARD FOREMAN**
I've got the shakes, 1995

Foreman's theater is currently as layered, fragmented, and obsessive as it was thirty years ago, with its recurring themes of intellectual doubt and a search for life's meaning. While the earlier material was spiked with a ribald sexuality and driven by the need to find a language to contain it, the more recent work, no less argumentative, confronts unnerving themes of mortality, death, and decay.

MEREDITH MONK
Quarry, 1975

Quarry retells World War II as seen by an American child. It is one of Monk's seminal works for the ways that it threads together her talents as choreographer, filmmaker, composer, singer, and visionary. It is scored for forty voices, two pump organs, one electric organ, magnetic tape, and performers who engage in actions, such as sweeping and cycling, that are part of the precisely orchestrated sound.

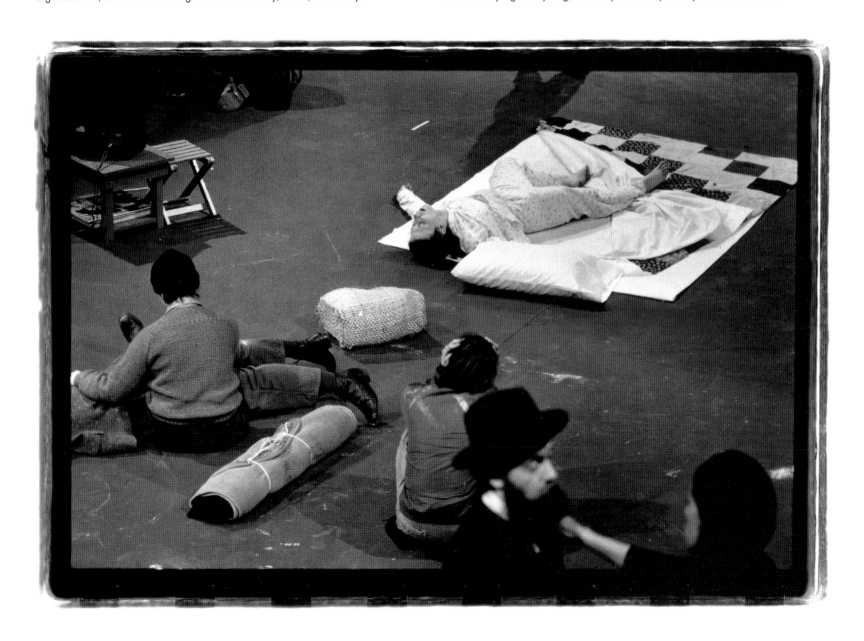

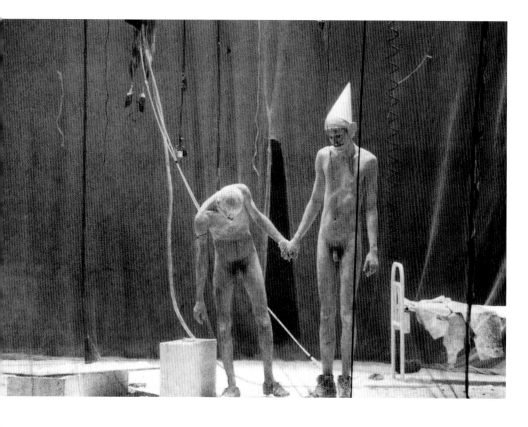

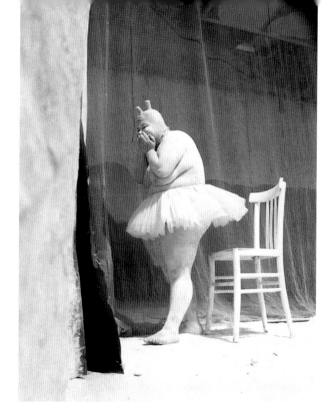

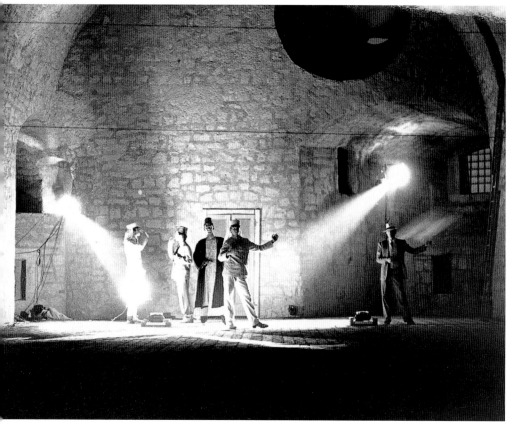

▼ **ROMEO CASTELLUCCI/SOCIETAS RAFFAELLO SANZIO**
Oresteia, 1995

Horses, a donkey, the corpse of a goat, and unforgettably shaped humans made up Castelluci's nightmarish rendering of this classic tragedy. Slow-moving and three hours long, the visually amazing installation included contraptions circulating blood-red liquid through overhead pipes and ominous-sounding wind machines.

◄ **FALSO MOVIMENTO**
Otello, 1983

Verdi's melodramatic opera, reinterpreted by New York musician Peter Gordon, was presented with cinematic bravura in the deepest cellar of a medieval castle in Naples. "Turning the stage itself into a screen," this 60-minute work was structured in the manner of a series of fast-paced film sequences.

► **LA FURA DELS BAUS**
Suz/O/Suz, 1991

Oil drums, gas cylinders, supermarket carts, TV sets, unmuffled motors, and a washing-machine are used as noise-makers for this explosive work in which performers hang from suspended racks in tall towers, plunge into tanks filled with water, and toss raw meat in chaotic mock battles.

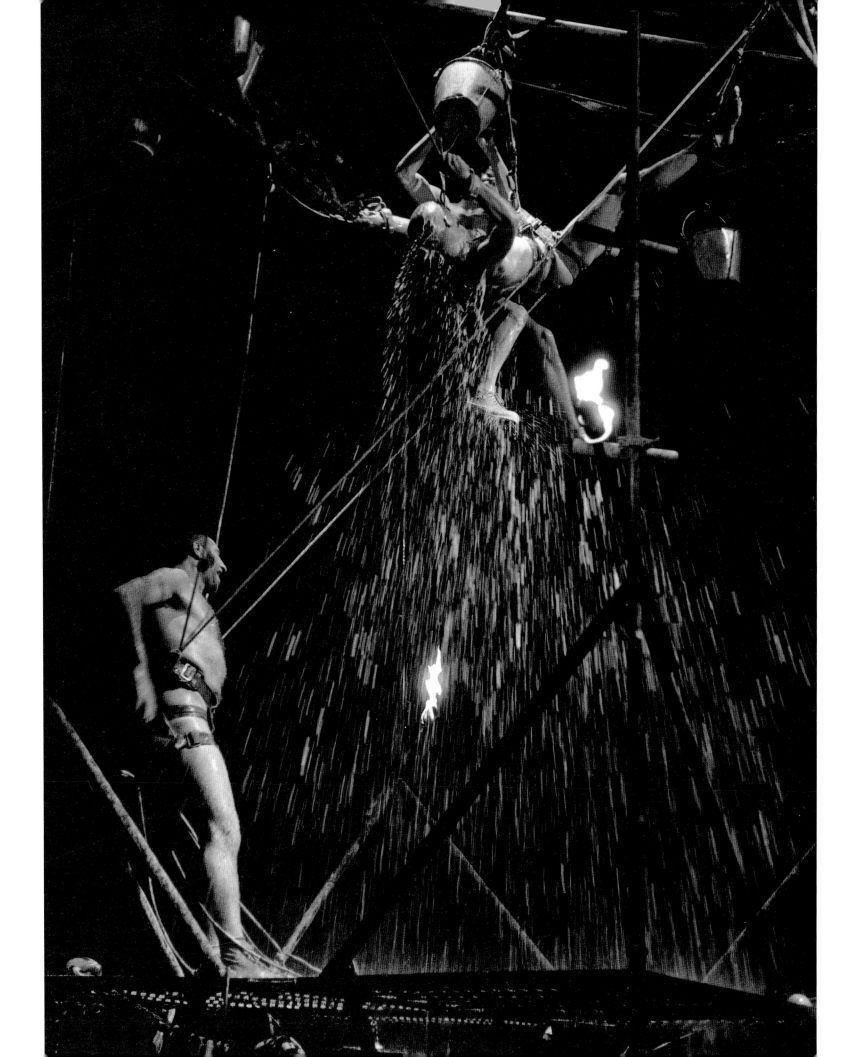

▼ **JAN FABRE**
Silent Screams, Difficult Dreams, 1992

Fabre's fantastic imagination and ferocious energy combine to take the form of large-scale operas, dance, installations, solo performances, video, and sculpture, all made with an obsessive attention to visual detail, seductive surfaces and an excellence of execution. For *Silent Screams* (performed at documenta 9 in Kassel), the second in his opera trilogy *The Minds of Helena Troubleyn,* the stage was dark, strung with black beads at the perimeter, the performers dressed in brilliant blue. White china plates were used as shoes, as furniture, as pedestals, and for the dramatic finale as "white rain" when hundreds came crashing down from the ceiling.

► **HEINER GOEBBELS**
Ou bien le débarquement désastreux... Or the disastrous landing, 1993

Passionate about radio, and the seamless transitions from sound to text and back again that make the *Hörstücke,* or sound play, of German radio so appealing, Goebbels developed a large-scale and influential music theater in which words and music were absolutely connected. *The Disastrous Landing* (which premiered in Paris) took texts by Joseph Conrad, Francis Ponge, and Heiner Müller and collaged them with music that crossed the boundaries between jazz, rock, art music, and classical compositions. "When I'm directing it's more like composing and when I'm composing its more like directing," he says.

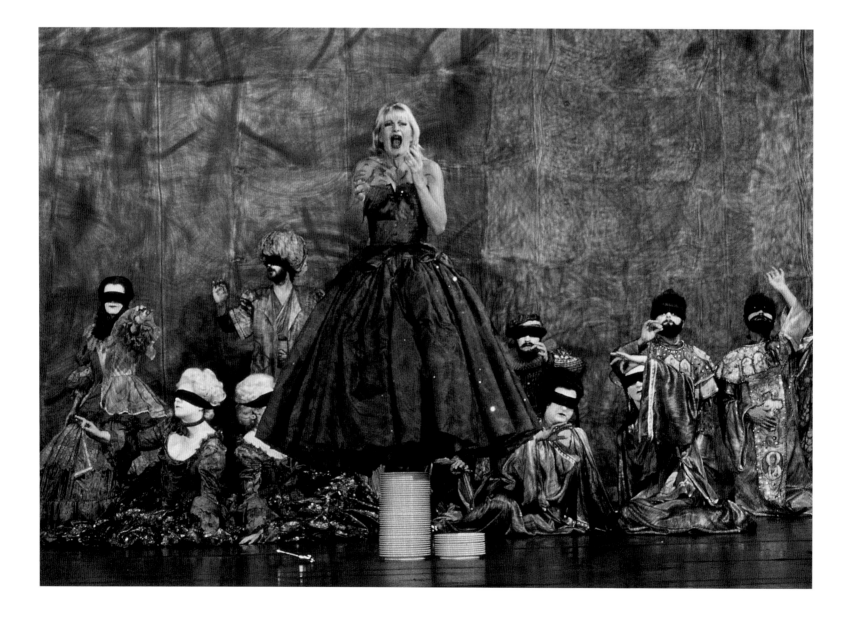

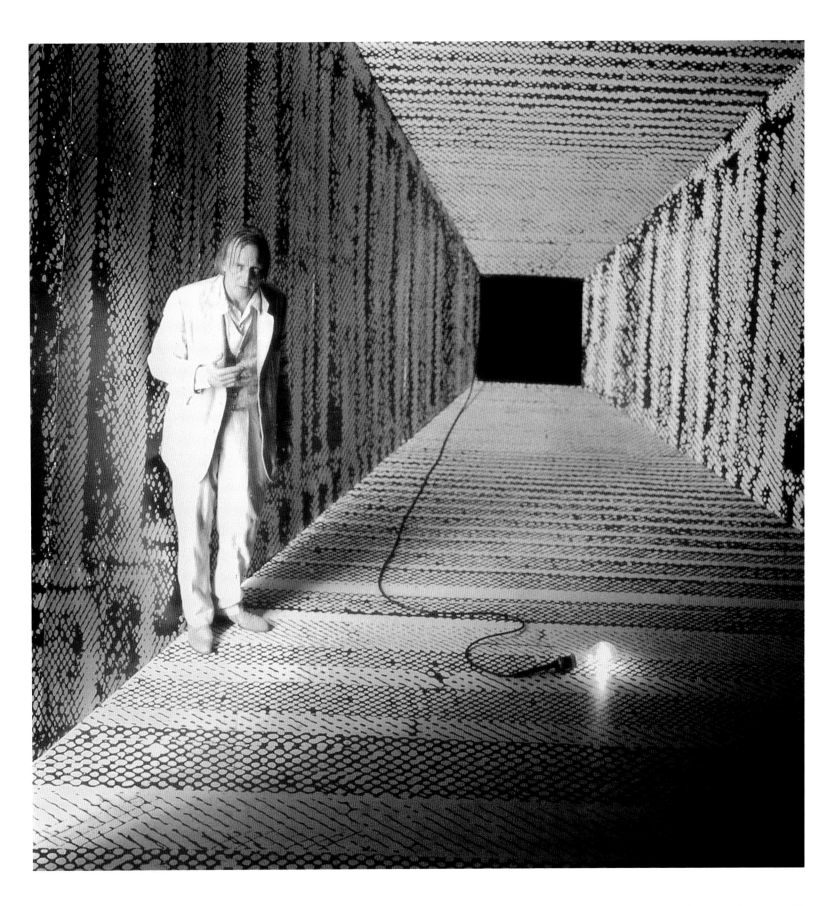

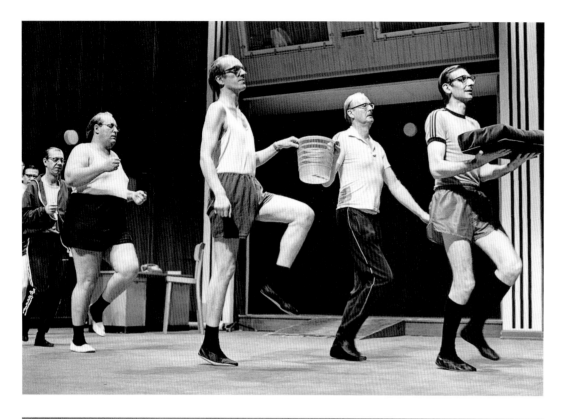

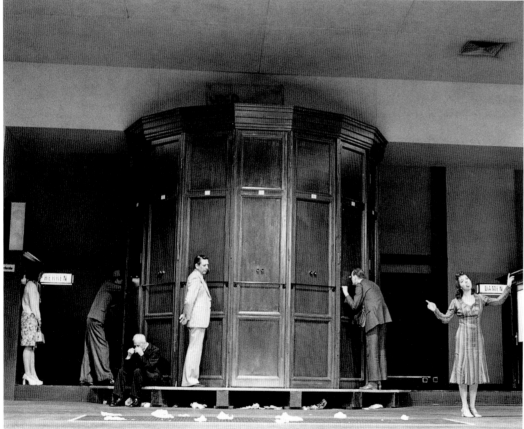

CHRISTOPH MARTHALER
Stunde Null, oder die Kunst des Servierens
(*Zero Hour: The Art of Waiting Tables*), 1995

A former musician and practicing clown, Marthaler is fascinated by the banality of the everyday; observing people on tramways or in railway stations, he reconstructs their body language for the stage, extracting the inherent slapstick of their ordinary exchanges. In *Stunde Null* the performers have very little to say, yet their bodies speak constantly. Moving awkwardly but rhythmically, they give form to Marthaler's research into training courses for top management in Germany; he urges them, bureaucrats in body and dress, to find individual personalities in improvisation behind the public operators they portray. Set on a stage designed by collaborator Anna Viebrock, with exacting rooms and "public" spaces built of wood, Marthaler's work is a subtle critique of contemporary northern European culture.

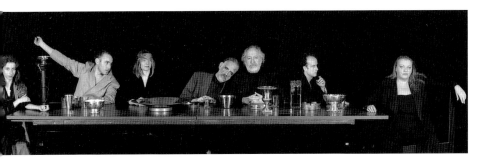

◄ **JAN LAUWERS**
Needcompany's Macbeth, 1996
The Snakesong Trilogy/Part One/Le Voyeur, 1994

Lauwer's signature conference table provides both a format and a framework for his highly aesthetic and rhetorical rendering of Shakespeare's plays. Art, he says, must make room for reflection. Hence, when Duncan lays his head on Banquo's shoulder in *Macbeth* (first performed in Brussels), "you see a picture, and get time to think." *Snakesong* (which opened in Frankfurt) illustrated another of Lauwer's obsessions, that of putting powerful women center stage in his eloquent visual and linguistic dramas.

▼ **MICHEL LAUB/REMOTE CONTROL**
Planet LULU, 1997

Sexy, trashy, and supremely elegant at the same time, Laub's *LULU* (Arhus Danstheater, Denmark) was an anarchic mixture of media—"I think of it as a radio piece with images and choreography... as a musical rather than an opera," Laub said. It was also a compilation of Lulus, five to be exact, based on Wedekind's erotic original and Louise Brooks's portrayal in Pabst's 1929 film *Pandora's Box.* The mint-green chaise-longues were designed by Marina Abramović.

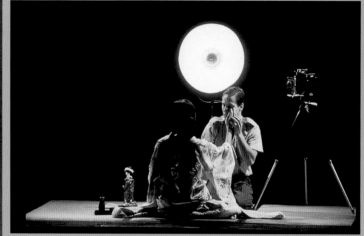

ROBERT LEPAGE
7 Streams of the River Ota, 1994–96

Lepage's eight-hour epic of life at the end of the twentieth-century was a collage of tableaux vivants, film, slides, operatic singing, kabuki, banraku puppetry, and traditional acting so true-to-life that certain scenes achieved a level of excruciating hyper-realism. Canadian-born, raised bilingually, and trained in drama, Lepage glided his elliptical narrative between East and West, past and present. The low horizontal platform with washes of brilliantly textured cloth and celluloid color gave his stage the quality of Cinemascope. Variously timed—from the recitative pace of storytelling to the urgency of fast forward—and with a cast of nine performers, *7 Streams* was Lepage's third major epic, following *The Dragon's Trilogy* (1985–86) and *Tectonic Plate* (1988).

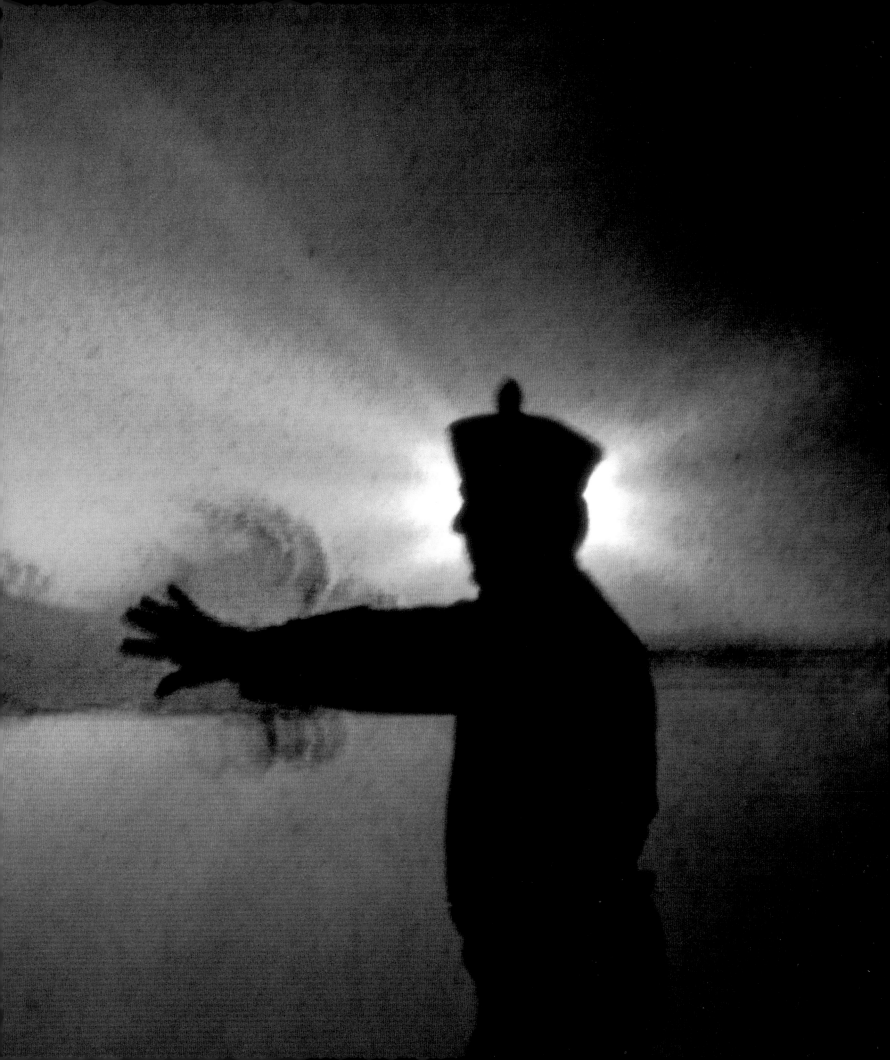

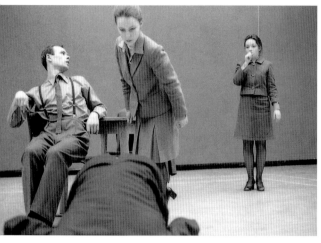

▲ **TING THEATER OF MISTAKES**
Going, from *Scenes at a Table,* 1977

When first performed as *Homage to Pietro Longhi (Scenes at a Table)* at the Serpentine Gallery in London in 1976, each performer imitated the improvised actions of the previous actor. The following year, for the Paris Biennale, all the actions were meticulously rehearsed.

▶ **GARY STEVENS**
If the Cap Fits, 1985

Inspired by double comedy acts, such as Laurel and Hardy with their bungled speech, mimed action, and games of "tit for tat," Stevens and Caroline Wilkinson continued to put on more clothes all through the performance, blurring the edge between garments, bodies, and objects.

STATION HOUSE OPERA
Limelight, 1995

The ruins of the Frauenkirche in Dresden were the backdrop for this work (music by Agnes Ponizil), which included cabaret acts and a long wall-building sequence (opposite). In a powerful finale, the breeze blocks fell like dominos.

ROBERT WILSON, LOU REED, AND DARRYL PINCKNEY
Time Rocker, 1997

ROBERT WILSON, TOM WAITS, AND WILLIAM BURROUGHS
Black Rider, 1990

Time Rocker was the third in a triptych of spectacular pop operas loosely based on nineteenth-century texts, and created for the intensely physical actors of Hamburg's Thalia Theater. In this theatrical extravaganza, Wilson used H.G. Wells's *The Time Machine* as a launch pad for his startling visual imagination, inspiring rock pioneer Lou Reed to create sixteen songs that are both memorable theater-music and charged rock and roll. Like *The Black Rider,* based on Carl Maria von Weber's folk opera *Der Freischütz,* and *Alice,* a reworking of the Lewis Carroll story, *Time Rocker* is a theatrical work "made for the eyes."

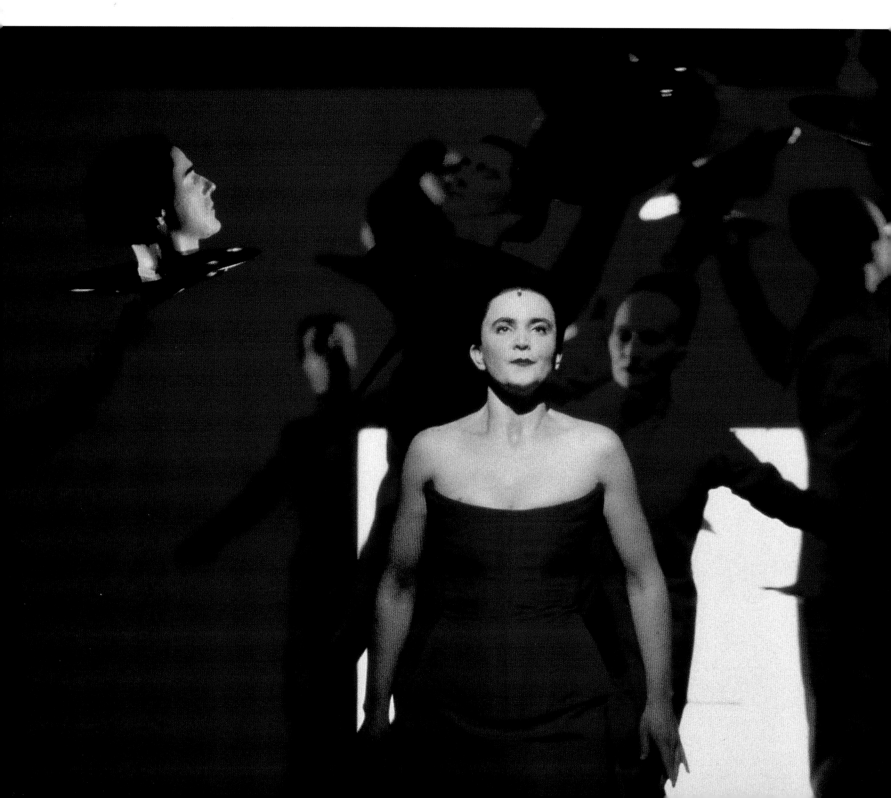

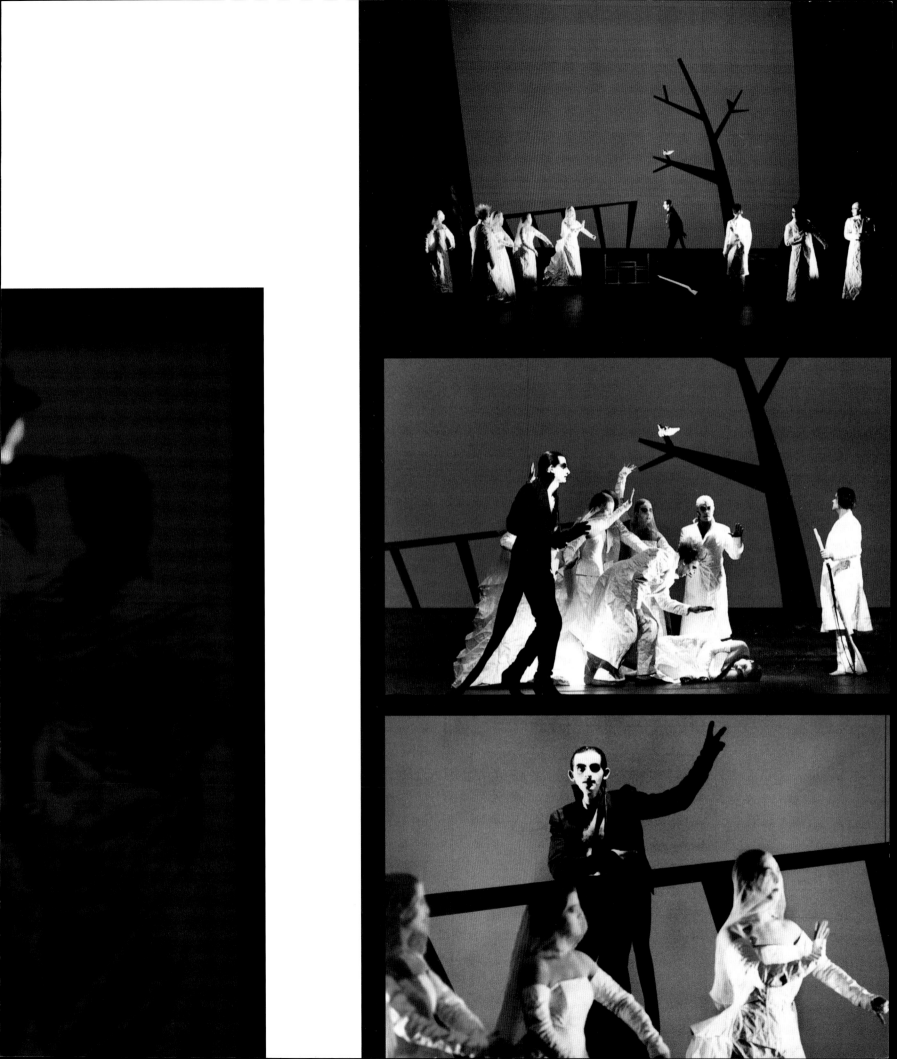

ALAIN PLATEL AND ARNE SIERENS
Bernadetje, 1996

Choreographer Platel and writer/director Sierens wove a modern tale of street life, sexual awakening, and saints into a breathtaking work of hyper-real dance and music theater. The piece (first performed in Ghent) was 75 minutes long, with eleven performers, mostly teenagers who had never acted before, in five bumper cars on a dodgem track. The soundtrack (Bach, House, and disco music) was mixed live on stage. "The cars perform a modern mating dance," wrote one reviewer. "The audience gets not one moment of peace during the performance," wrote another.

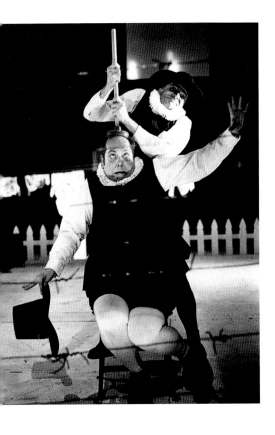

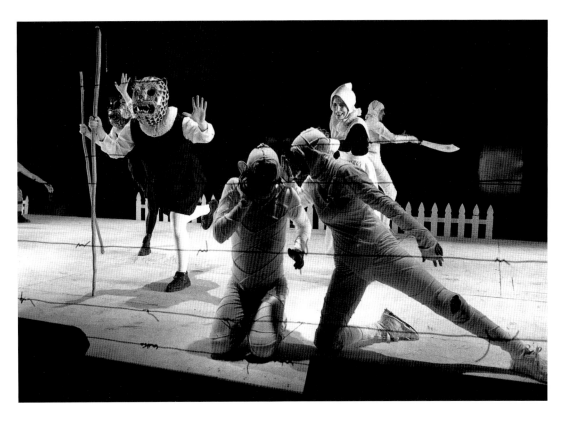

REZA ABDOH
Quotations from a Ruined City, 1994

A white picket fence, barbed wire, metal cubicles, ramps, two separate performance platforms, formed the architecture of this elaborate urban staging in an old warehouse in New York. Abdoh's frenetic actors spewed text, drummers beat snares, and singers performed spirituals—live, on tape, on back-projected film, and on video. All this provided Abdoh with a sufficiently complex and chaotic vehicle for his passionate critique of American culture and his own place in it—"as an outsider; a queer, HIV+, emigre artist of color, born in Iran, and educated in London and Los Angeles."

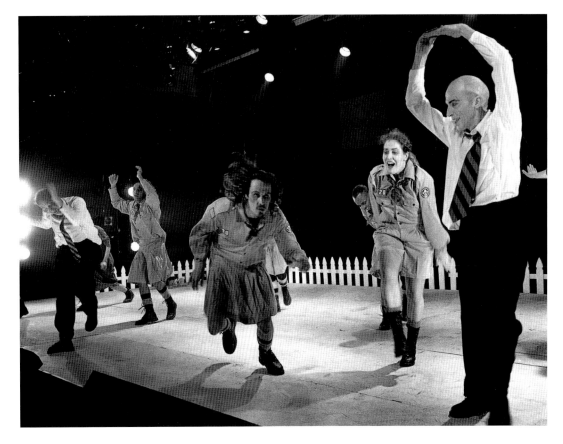

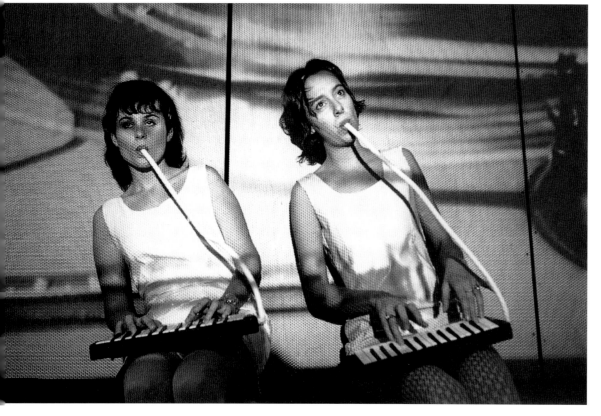

◄ **GOB SQUAD**
Show and Tell, 1997

Living and working in Nottingham, this
British-German group juggle with city life,
consumerism, and a passion for the banal in
ordinary settings—private houses, offices,
shopping centers, railway stations, parks,
as well as theaters and galleries.

▶ **STEFAN PUCHER**
Ganz Nah Dran, (Almost there), 1996

In this fractured, disturbing portrait of '90s
youth culture, a baroque frame surrounded
a huge screen on which live video images of
the audience were projected, DJs scratched
techno-music, and an eighty-year-old radio
personality read Bret Easton Ellis-like tales of
over-indulged party-goers. This was performed
with members of Gob Squad.

▶ **FORCED ENTERTAINMENT**
200% and Bloody Thirsty, 1987

Three drunks in bad wigs caroused in a sea
of secondhand clothes, repeatedly re-enacting
the events surrounding the death of one of their
friends. The piece, which opened at the ICA in
London, combined a brash physicality with
high-speed gibberish, broken slang, and the
melancholy musings of angels on video
monitors who looked down on the protagonists.

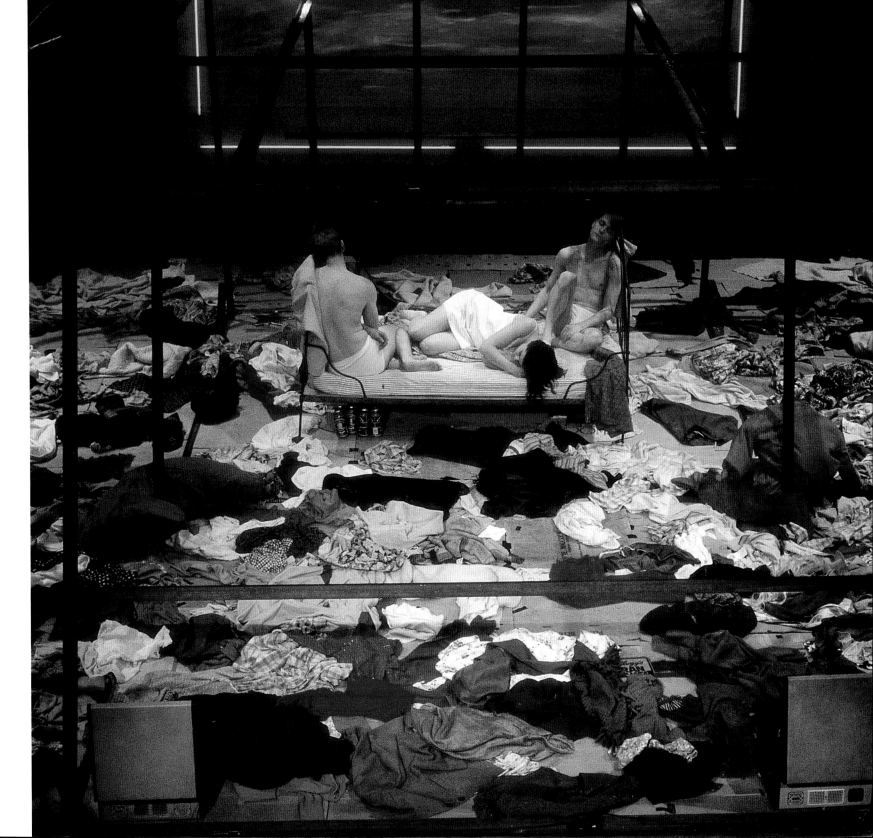

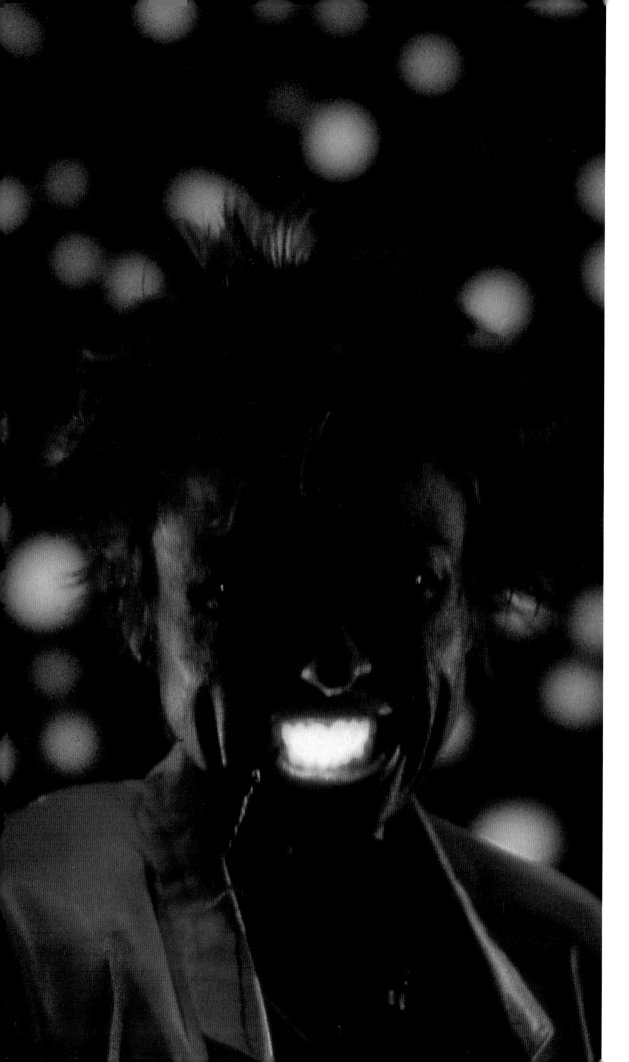

LAURIE ANDERSON
Wired for Light and Sound, 1986
Stories from the Nerve Bible, 1992–93

From her earliest performances, Anderson used custom-built instruments. One was a "tape-bow" violin with a tape-recorder head in place of strings and a bow containing pre-recorded tape. Another was a wiring system that turned her into a human drum, producing a threatening "boom!" when she tapped any part of her body. The special microphone and light bulb in her mouth (left) allowed her to sing "like a violin" and gave her cheeks a blood-red glow. Anderson used her home-made instruments in highly inventive ways in her 1979–83 eight-hour opus *United States,* first performed at the Brooklyn Academy of Music. Against backdrops of low-tech slide projections and Super-8 film, often of rough stick-figure animations, Anderson told stories about the ironies of living in, and possibly being consumed by a high-tech world. A decade later, in her full-scale musical production *Stories from the Nerve Bible,* Anderson transformed the stage into a spectacular three-dimensional media landscape. Enveloped in the latest technology, the work included a holographic tornado, walls of video monitors, and songs such as "War is the Highest form of Modern Art" and "Alien Sex" that were both apocryphal and poignant in their description of the end of the twentieth century. *Stories from the Nerve Bible* toured fifteen cities from Seville to Jerusalem, and had its own website where Anderson kept a daily diary and responded to fans.

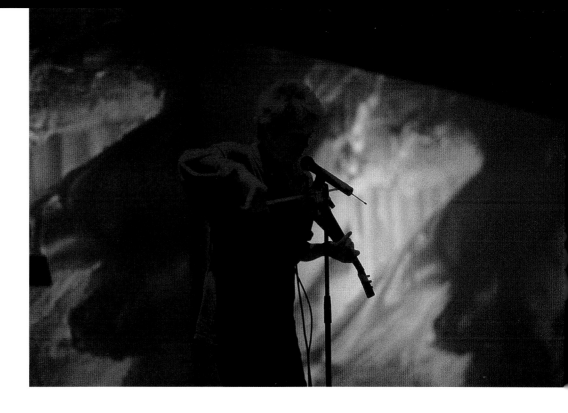

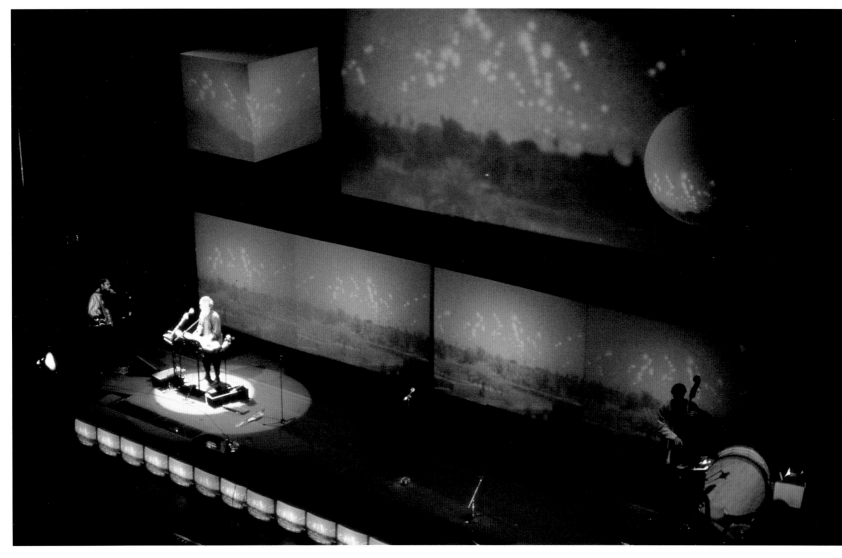

► **MEREDITH MONK**
Atlas: An Opera in Three Parts, 1991

▼ **JOHN ADAMS/PETER SELLARS/
ALICE GOODMAN**
Nixon in China, 1987

Since *Einstein on the Beach,* experimental opera
has increasingly offered powerful new ways
of approaching performance. Monk's *Atlas*
was constructed from a repertoire of vocal
techniques—glottal effects, ululation, and
animal sounds. Instead of a conventional
libretto, the voice textures and body movements
carried Monk's mythic stories of childhood,
youth and maturity. Five crucial days in
February 1972, when Richard Nixon visited
Beijing, are compellingly expressed in Adams's
layered musical language. These operas both
premiered at Houston Grand Opera House.

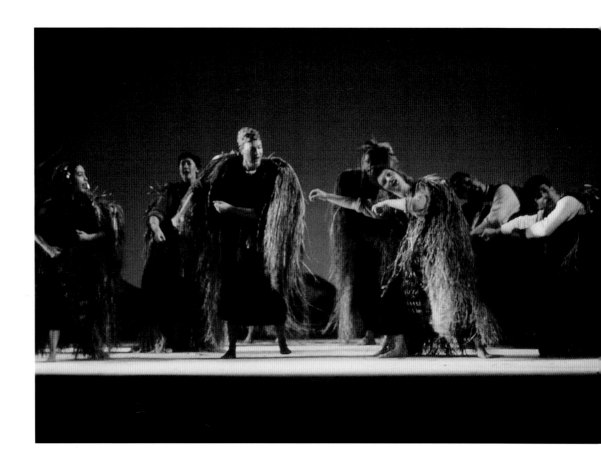

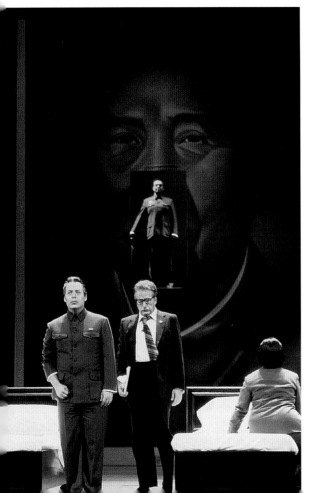

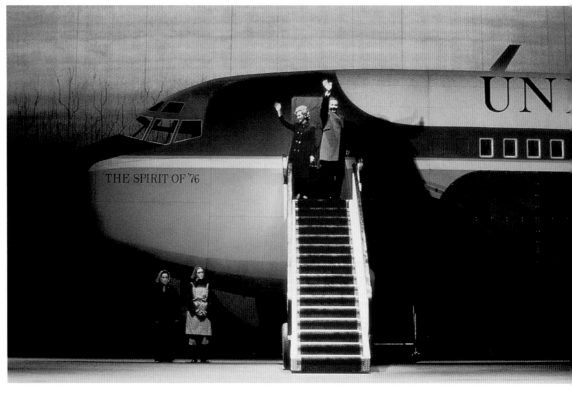

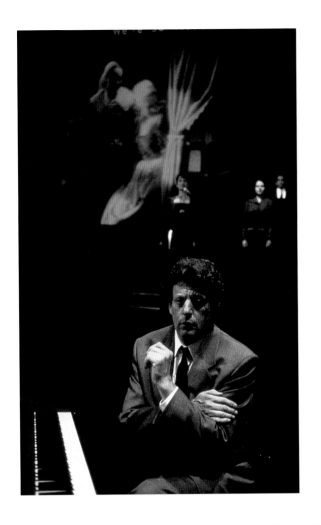

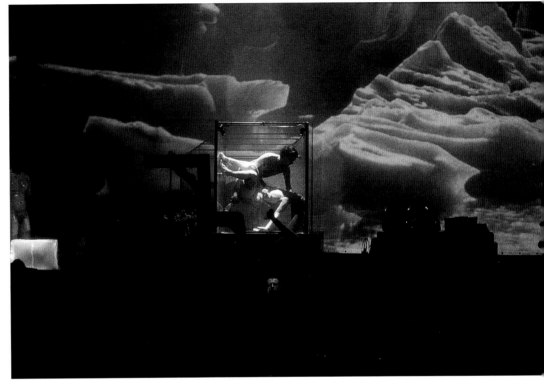

▼ **PHILIP GLASS**
La Belle et la Bête, 1995

▲ **PETER GREENAWAY/JEAN-BAPTISTE BARRIERE**
100 Objects to Represent the World, 1997

◄ **ROBERT ASHLEY**
Improvement, 1994

In Part 2 of Glass's trilogy on Jean Cocteau's early films, the music was played below a projection of *La Belle et la Bête.* Computer technology explored "the sonic dimension of words" in Greenaway's "prop opera" with "light, voice, and music." Ashley's spare allegory of the Jews' expulsion from fifteenth-century Spain focused on taped chants and the rhythms of speech rather than movement.

▼ PAUL KOEK AND HOLLANDIA/DICK RAAIJMAKERS
De val van Mussolini (The Fall of Mussolini), 1997

A former gasworks in Amsterdam was transformed into a make-believe 1930s film set for this work by the Hollandia Theater Group, known for performing in unusual settings and for using music as the starting point for highly collaged productions. Original steam engines and old motorized equipment provide both visual and aural effects, while electronic music, collapsible sets, and the mechanized movements of performers, suggest a futurist narrative. For Koek, a percussionist, theater begins with the sound of the human voice. "I very much want to make musical theater," he says, "but without music. Only with words that become music."

► CHRISTIAN MARCLAY
One Hundred Turntables, 1991

Performed in Tokyo's Panasonic National Hall, built as a showcase for the manufacturer's state-of-the-art sound system, Marclay's visually and aurally overwhelming hour-long performance was constructed from standard DJ equipment, but in multiples; 100 Technic MK2 turntables set on cinderblocks in a spiral; hundreds of specially pressed records that were a mix of Japanese *Shakuhachi* (flute) and spoken recordings (manuals, poetry, storytelling); and four DJs. Animating the walls were live video projections (by Perry Hoberman) of the DJs' hands and the light of tiny "beamers" trained on the record grooves.

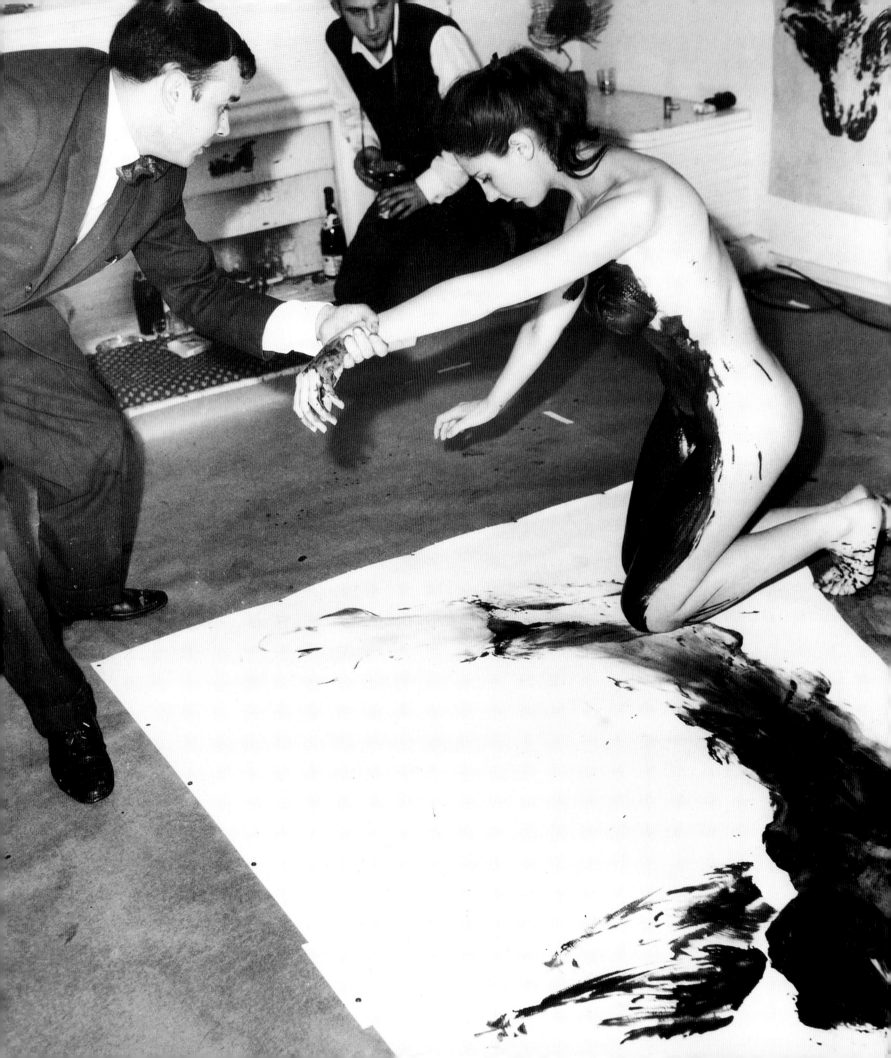

CHAPTER 3 *the body: ritual, living sculpture, performed photography*

In the early '60s, Yves Klein, Piero Manzoni, Carolee Schneemann, Yoko Ono, and Shigeko Kubota, among others, insisted on the body as the main locus of ideas about art. Provocative, disturbing, elemental, their often nude or partially nude performances in the artists' own lofts or alternative galleries were charged with meanings that functioned on both a visceral and intellectual level. On the one hand, viewers were transformed, willingly or not, into voyeurs, sucked into a vortex of contained eroticism surrounding the performers. On the other hand, many viewers quickly understood the intended ironies of the various surprising and sometimes shocking gestures. Shigeko Kubota executed her *Vagina Painting* (1965) squatting over a large sheet of paper, with a paint-drenched paintbrush pinned to her underwear; it could be read as a sharp attack on a male-dominated art world with its bravura action painting. Manzoni's earlier *Life Drawing* (1960), in which he cavalierly signed the back of a nude woman, provided proof for Kubota's critique. Commenting on the gap between an original and the artist's role in translating or re-presenting that original, Manzoni's gesture paralleled Yves Klein's *Anthropometries of the Blue Period* (1960), an event in which the artist used nude women performers as "living paint-brushes." Following his instructions the women drenched their breasts, bellies, and thighs with sponges dipped into the large pools of thick paint at their feet, and pressed their bodies firmly on to sheets of canvas like so many rubber stamps, all in full view of a well-dressed audience. Klein was celebrated for both the conceptual daring (his ironic commentary on the "real" material of painting) and the sly humor of this work. But when Carolee Schneemann appeared nude in her own work, *Eye Body* (1963), as a live extension of a painted assemblage, making much the same point as the male artists regarding the relationship of the live body to painting and canvas, she was rebuked or ignored by reviewers indignant that a female artist could insert her nude self into her art work. It seemed that a fully dressed intermediary was required to direct the action, as Klein, Manzoni, and Robert Morris (in *Site*, 1964) had done in their performances. Yoko Ono's *Cut Piece* (1964), in which the audience was invited to cut off her clothes as she sat unmoving before them, also broke through the invisible frame around the male artists' work, drawing the audience directly into contact with her, essentially defacing the artist in the process. At the time, Ono remembered, this

YVES KLEIN
Anthropometries of the Blue Period, 1960

Klein used a naked model as a "brush" to make paintings. Before an invited audience, the model pressed her body, covered with blue paint, on the prepared canvas.

work was rejected by several male colleagues "for being animalistic". Nevertheless, she was pleased by its impact and repeated *Cut Piece* several times.

Although it would take almost thirty years of feminist scholarship to unravel the very different uses of the body by male and female artists of this period, and properly to credit these women artists for their pioneering and highly considered examination of the body as a measure of identity, taboo, and the limits of masculine/feminine emancipation, their belief in the body as prime, raw material, opened numerous territories for artistic investigation. By the '70s, so many artists had turned to incorporating their bodies in their performances, that the term "Body Art" was broadly applied to a great variety of work. Some considered the body as material for ritual or "Aktions," such as the orgiastic and aggressive events of the Viennese artists Hermann Nitsch and Günter Brus. They viewed the body as so much flesh, draping intestines from eviscerated lamb carcasses over performers in rites connected with the primitive cult of Dionysus, in which the tearing of animals and eating of raw flesh generated a state of ecstasy and frenzy. Others treated the body more tenderly, like Ana Mendieta who used it in touching spiritual ceremonies with traces of *Santeria*. Like the Viennese, she used blood as a cleansing material, but, unlike them, she viewed blood as a substance with healing and connective properties and as a force of female creativity. Others saw Body Art as the "site" for formal art propositions, such as the spatially defining works of Vito Acconci, Dennis Oppenheim, or Monika Baumgartl. Others utilized it as a tool for transformation—often of appearances, particularly as they related to gender, and these transformations were recorded in image-rich photographs. Urs Lüthi, Katharina Sieverding, and Jürgen Klauke exhibited in a 1974 show entitled *Transformer: Aspekte der Trasvestie* which placed images of these artists alongside the similarly androgynous musicians and image-makers Brian Eno, David Bowie, and Lou Reed. Sieverding created photographic works with her partner Klaus Mettig, in which their male and female faces, similarly made up and coiffed, became almost indistinguishable, while Urs Lüthi had himself photographed in the process of transformation from male to female. Their association with the visionary theatricality and suggestive lyrics of the rock musicians gave these artists a seductive edge.

Sculptors, like Gilbert & George, presented themselves as Living Sculpture, painter Miranda Payne hung on a wall as a Living Painting, while Pat Oleszko used her body as a mannequin for her elaborately constructed costumes. Such extraordinary long-term commitment to their chosen guises showed an eagerness on the part of these artist to give daily form to the art-life equation. They actually lived inside their art, and for some, also created homes to match. Colette, Mr. Peanut, the Mud Man, Luigi Ontani, were all instantly recognizable in public as living, walking works of art, on permanent exhibition. At the other extreme, artists

such as Chris Burden, Marina Abramović and Ulay, Gina Pane and Valie Export, engaged in acts of extraordinary endurance, insisting that their unnerving and frequently dangerous undertakings were learning experiences of a deeply cathartic nature. For them, pain and fear could be understood as the material of the work. "What you are afraid of," Abramović has said, "is exactly what you are supposed to do. When you do things you like, you never change." They were just as demanding on viewers who, whether they liked it or not, found themselves witnessing and, in certain cases, abetting dangerous and harmful actions. Chris Burden had himself shot in the arm by a friend in a gallery in Santa Ana, California, in a work entitled *Shoot* (1971), and in 1974 in a Naples gallery, Marina Abramović in *Rhythm O* placed a loaded gun on a table among seventy-two other objects (a knife, scissors, a long-stemmed rose, among them) which the members of the public were invited to use on her as they pleased.

Body Art was a laboratory for studies of all sorts, from the psychoanalytical, to the behavioral to the spatial and perceptual. While the term "body language," was widely used by the media to refer to the signals that people unconsciously made to one another with their bodies, the academic community referred to "powerfields"—social psychologist Kurt Lewin, described the waves of psychological tension rippling through any inhabited space. Of more unnerving concern, was the material which French philosophers of the late '60s, led by Gilles Deleuze, revealed in rigorous studies of psychoanalysis and literature about the metaphorical nature of masochism. Vito Acconci created an original powerfield with his work *Seedbed* (1972) in which he masturbated under a wooden ramp built into a downtown gallery, over which visitors walked. Rubbing his body against the floorboards, "distributing semen across the floor," all the while talking into a microphone, Acconci thus "connected" with his audience through a space that was psychologically charged by his ongoing commentary and the sound effects of his actions. Dan Graham explored Bertolt Brecht's principles of alienation, connecting performer and viewer by designing situations that had discomfort built into the work. In *Performance, Audience, Mirror* (1977), the audience, seated on chairs in front of a large mirror, were forced to become witness to their own movements and to read each other's self-conscious body language. To increase their unease, Graham walked back and forth in front of them, scrutinizing their actions and commenting into a microphone on what he saw. Dennis Oppenheim used his body as a transmitter of sensations, particularly those that extended his understanding of painting or sculpture; in "Two-stage Transfer Drawing" (1971), his son Erik ran a marker along his back, which he then duplicated on a wall. Rebecca Horn and Bruce McLean, each in quite different ways, constructed "body machines"—instruments that would transform their bodies into objects of startling theatrical design. Horn's canvas "sails"

attached to her arms and legs, and McLean's body casts that held his body in poses copied from stylish actors of the '50s, resulted in symbolically rich tableaux. From the vantage point of the '90s, the radical work of the '70s has become a minefield for a new generation of artists. It is appreciated for its uncompromising realism and for the raw and unmediated ways in which artists confronted often brutal experiences in real time, in collusion with audiences, as if each event were designed to pry open new levels of understanding of extreme psychological or perceptual states. The intensity of this work, had a far-reaching effect on performance artists, on choreographers and on many younger artists working with photography. It was in direct contrast to the media-saturated art of the '80s, with its contrived aesthetic of high spectacle that acted as a scrim between artist and viewer. Combining the raw gestures of the '70s with the stylish media twist of the '80s, and directly inspired by Cindy Sherman's earliest photographs of herself in hundreds of constructed settings, the "performed photography" of the '90s, aptly named and curated in a recent exhibition by Jennifer Blessing at the Guggenheim Museum, is a direct descendant of live performance. Large scale, often life size, and brilliantly colored (employing the latest in digital photographic equipment) these theatrical and frequently autobiographical narratives by artists such as Catherine Opie, Yasumara Morimura, and Inez van Lamsweerde, draw viewers up close: looking at these photographs takes time and curiosity, and produces the sensation of watching an elaborate private performance of the kind that clearly lay behind these detailed images. They also pick up the thread of the earlier polymorphous sexuality and theatricality of the "transformer" artists.

The body as a dramatic field or as a tool for masquerade characterizes some of the most interesting work of the 1990s. Matthew Barney transforms his body and those of fellow performers, into half-human, half-animal creatures who romp in a strange wonderland of his own making. Luminous-skinned and desexed—their genitals decoratively altered or altogether obscured, hoofs and horns extending from feet and foreheads—these odd urchins play with fairytale grimness in and out of focus of a watchful camera lens. Presented as film or video tapes, Barney's performances nonetheless startle with the effect of live events. Mariko Mori, on the other hand, stages performances in which she appears as a character from a futuristic Japanese cartoon—vinyl-shiny, with pointy hats, plastic tutus, winged anklets and cat's eyes—on street corners in Tokyo, or on artificial beaches in one of Japan's fabled oceanariums. These performances are finally shown as room-sized, many-panelled photographs. Some are also presented as video installations. Like Barney, Vanessa Beecroft, Patty Chang, and others, Mori reels in an aesthetic that seems to be made in a post-media world: after MTV, after *Blade Runner*, after *Pulp Fiction*, their exquisitely presented figurines,

stitched, polished, and powdered with all the elegance of a school of seventeenth-century fops, lead the way in envisioning a *haute* cultural style for the *fin de siècle*.

In total contrast to the rampant hedonism that such post-media imagery implies, the notion of the body as a powerful weapon for redirecting our thoughts towards a preponderance of social ills—domestic violence, abuse, deathly plagues—has re-surfaced in the '90s, recalling similarly self-afflicting performances from the '70s. There have been extraordinary and breath-stopping actions by artists. Ron Athey in one performance carved letters into the back of a fellow performer who was HIV positive, rubbed paper towels over the wound, and hung the bloodied towels on clotheslines above the audience, exploiting the public's terror of AIDS. The late David Wojnarowicz sewed his lips together in a silent protest against that same epidemic. The late Bob Flanagan created a hospital room in the middle of an exhibition space where visitors could witness his painful daily battle with cystic fibrosis. These all have the same immediate shock of the real as Burden or Pane's early work, with the added jolt of blame for inept political machines that turn too slowly to contain the tragedies of modern diseases. It is termed "endurance art," as in an exhibition of photographs at New York gallery Exit Art, and "masochistic performance" by critic Kathy O'Dell, who has carefully analyzed its '70s origins in a socio-political context, ascribing its tendencies, in part, to the traumatic crises wrought by the Vietnam war. The body art that has re-emerged in the '90s is of a far more virulent and highly publicized strain than before. The close proximity to death that AIDS has forced on young people since 1981, the homophobia that blamed AIDS on the gay community, the mainstreaming of highly charged and previously private images in street and print advertising—of homosexuality, animal sex, even the "heroin chic" of fashion photography—have all upped the ante of the kind of art material which will attract attention and provoke outrage. Yet, no matter how such sensationalism is co-opted by the commercial world, the work of those artists using the body is aggressive, real, and *live:* the imagery they invent is not for the purpose of selling something else—a perfume, a pair of sneakers—but in order to open a disquieting discourse on contemporary politics and daily life.

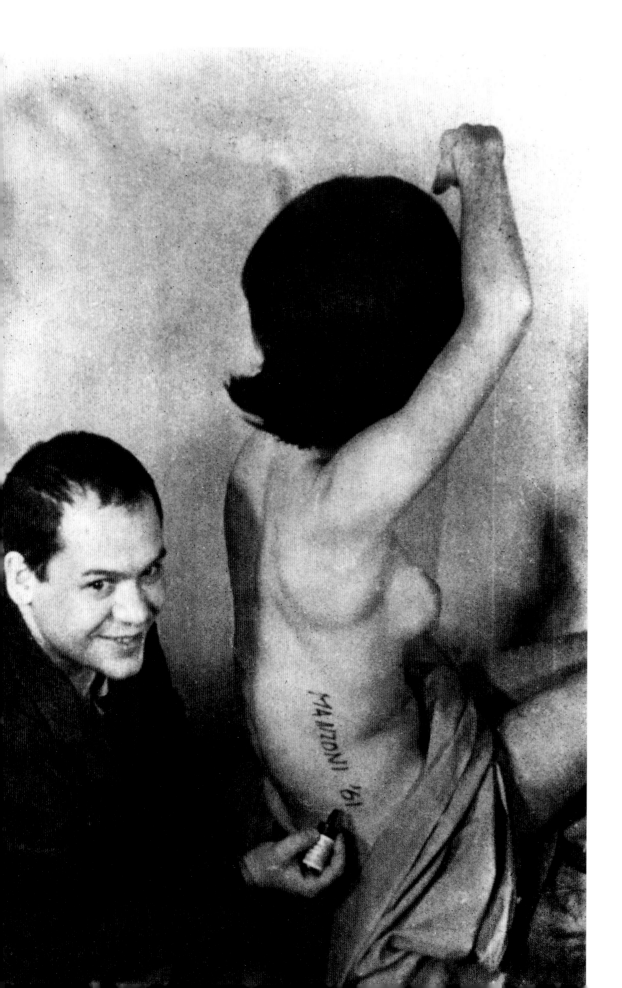

PIERO MANZONI
Living Sculpture, 1961

In 1957 the 24-year-old Manzoni encountered the monochrome paintings of Yves Klein in Milan and Alberto Burri's white "paintings" made of torn shirts. That same year he created his own highly conceptual and supremely elegant *Achromes*—made from gesso, kaolin, fur fabric—and from this time onward his gestural approach to art became more extreme. *Bodies of Air* (1959), made of balloons, became *Artist's Breath* when inflated by the artist. But it was his Living Sculpture, in which he signed the bodies of living people, that fully articulated his viewpoint of "life as art." He issued "a certificate of authenticity" from a printed block of receipts with different-coloured stamps: red for a person who was a complete work of art, yellow for part of a body that qualified as art, green for a body that became a work of art only during certain activities.

YOKO ONO
Cut Piece, 1964

Trained as a musician and composer, and
immersed in the Zen beliefs of her native Japan,
Ono described her events as "a dealing with
oneself," in contrast to the "get-togetherness"
of most Happenings. She moved easily between
the aesthetics of both East and West, travelling
regularly between Tokyo and New York, where
her Canal Street loft was a performance space
for artist-friends Yvonne Rainer, Ornette
Coleman, Jonas Mekas, Ay-O, and others.
Cut Piece, was an example of Ono's ability to
move viewers to surprising actions, and at the
same time disturb their sense of self and of
others. She kneeled on stage in the traditional
position of Japanese women, with a large pair
of scissors placed before her. Throughout the
performance, members of the audience
approached and cut off her clothes, piece by
piece. This work, lasting about half an hour,
was first performed in May 1964 in Kyoto,
the following month in Tokyo, and later in
London and New York.

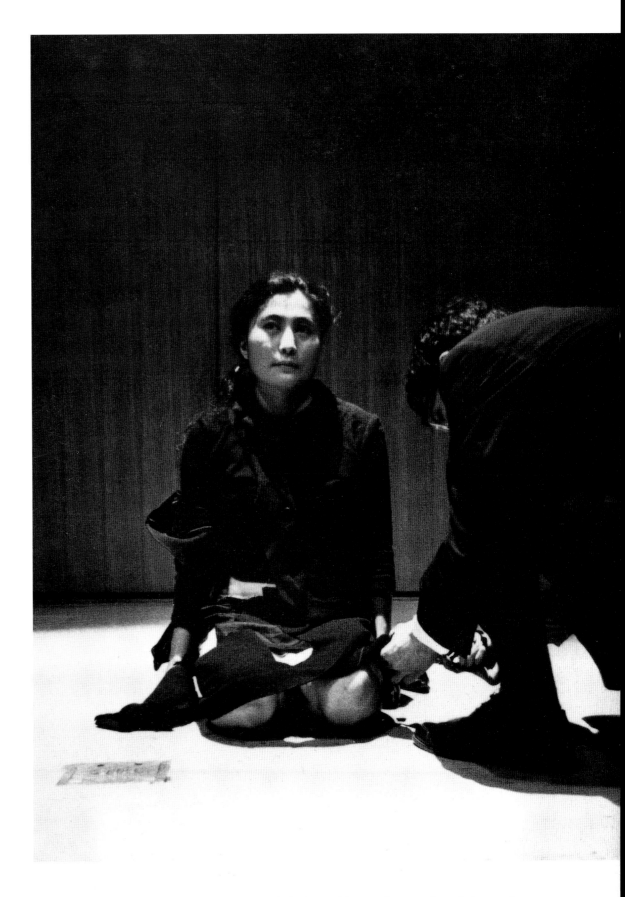

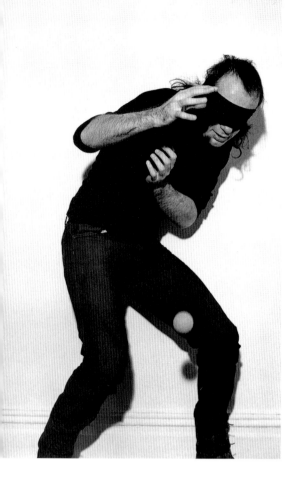

VITO ACCONCI
Blindfolded Catching, 1970
Seedbed, 1972

Acconci was a poet who began making his performance pieces in the early '60s. Many, such as *Blindfolded Catching,* (also a three-minute Super-8 film), depended on language—"alarm reaction" referring to his response to balls thrown at him. Others, like *Seedbed,* were based on research, in this case, into texts on the psychological content of a space. Installed under a ramp in New York's Sonnabend Gallery for six hours a day, five days a week, Acconci is said to have masturbated at intervals throughout. Those entering the space saw nothing, and heard only Acconci's breathing and his voice, through loudspeakers, describing people whom he imagined in the space.

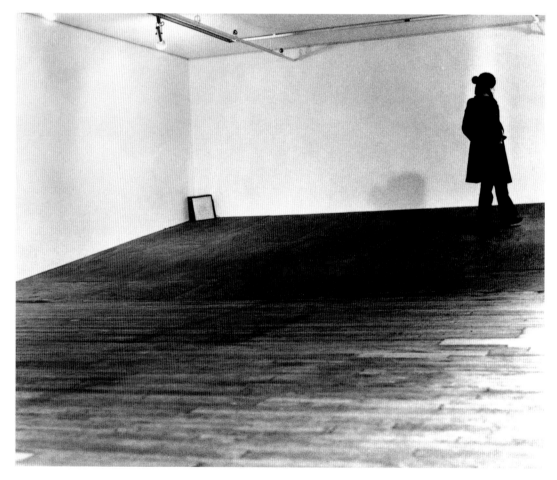

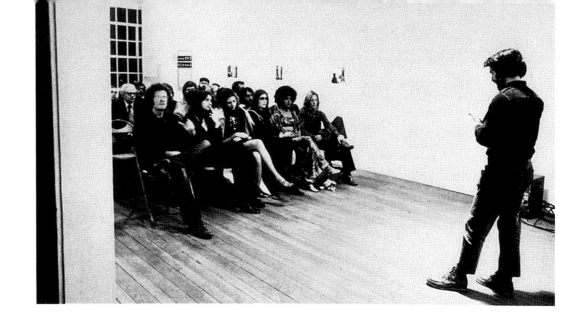

DAN GRAHAM
Performance/Audience/Mirror, 1977

Architecture as a container for social
engagement—the theme of Graham's most
recent installations—was evident in several of
his early works. In this piece the performer
faced a seated audience, reflected in a mirror
behind him. First Graham described the
audience, then he turned to face the mirror
and described his own movements. Finally he
described the audience as reflected in the
mirror. For Graham, this particular exercise
was intended to make viewers aware of their
presence as a "public mass," and yet at the
same time, to see themselves and their reactions
to the group "objectively," through the mirror.
His interest in inflicting a sense of extreme
self-consciousness on his viewers was inspired
by Brechtian theories on theatre.

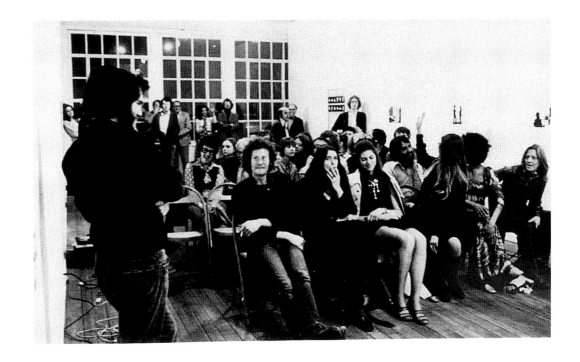

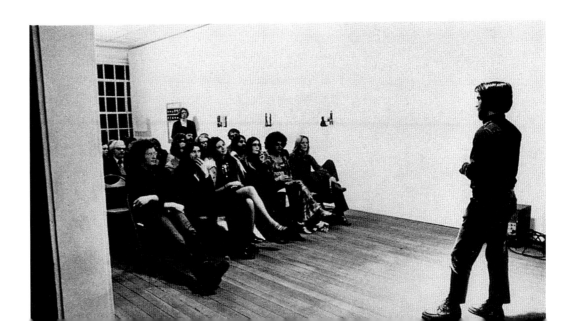

DENNIS OPPENHEIM
Parallel Stress, 1970

Oppenheim's early performances were quite literal illustrations of the physical sensations of making sculpture; the weight of gravity, the support of mass, and the artist's body as the force that shapes material. This work was first photographed at a point of extreme stress, when Oppenheim had been hanging between two walls of concrete blocks for ten minutes. The second photograph, taken at a different location, shows the artist in the same position, freed of the strain and demonstrating another "sensation" of sculpture. These documentary photographs were exhibited as essential components of the work.

► JOAN JONAS
Jones Beach Piece 1970

Jonas created several outdoor performances in which the viewers were placed some distance away so that everything seemed smaller and flattened against the natural setting, whether beach or empty parking lot. Sound—sometimes the clapping of wooden blocks or the banging of metal sheets—was also a delayed experience as it traveled across the landscape. Jonas always directed as well as performing in her own work, and constructed her performances with an awareness of film techniques, "the cut" and "montage" among them. Exploring time, space, the body, and the land, her work also showed her strong interest in folk culture and the curious ceremonies of everyday life.

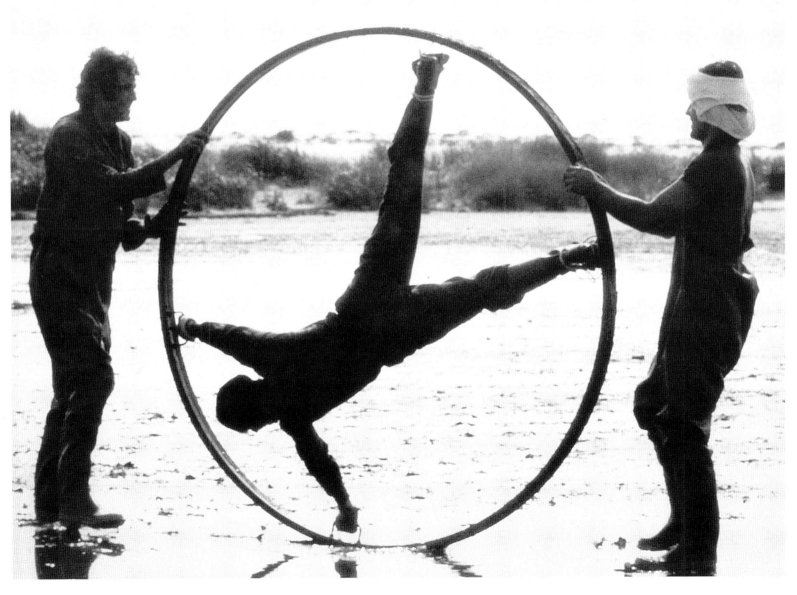

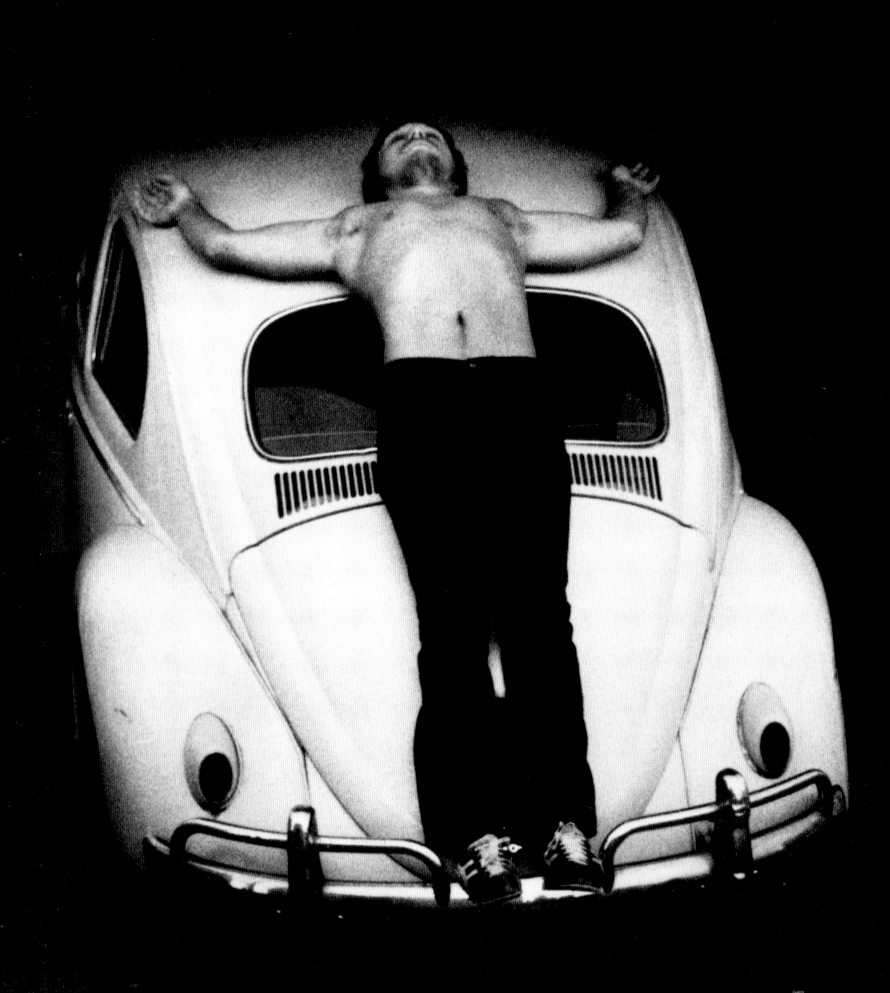

CHRIS BURDEN
Shoot, 1971
Trans-fixed, 1974

Burden's unforgettable dramas were shocking in their literalness. In *Shoot* he actually had a friend shoot him in the arm from a distance of 15 feet. Burden claimed that all those in the gallery where this took place were implicated in his act of self-inflicted violence through their failure to intervene. Performed in Los Angeles, a few miles from Hollywood's studios of make-believe, Burden's real act, with real blood and acute pain, seemed to probe the distancing effects of cinema with its overloaded violence. In *Trans-fixed,* also shocking in its realism, Burden was nailed through the palms of his hands to the roof of a Volkswagen; the car was pushed out of the garage, and remained in the road for two minutes with engine running at full speed, "screaming" for him. The work can be read as representing the sacrifice of people to automobiles in a city of freeways. These sensational events had a tremendous impact on other performance artists, in part because they emphasized the absolute reality of performance art over other forms of drama in theater. As iconic images, they seem to transcend the acts themselves.

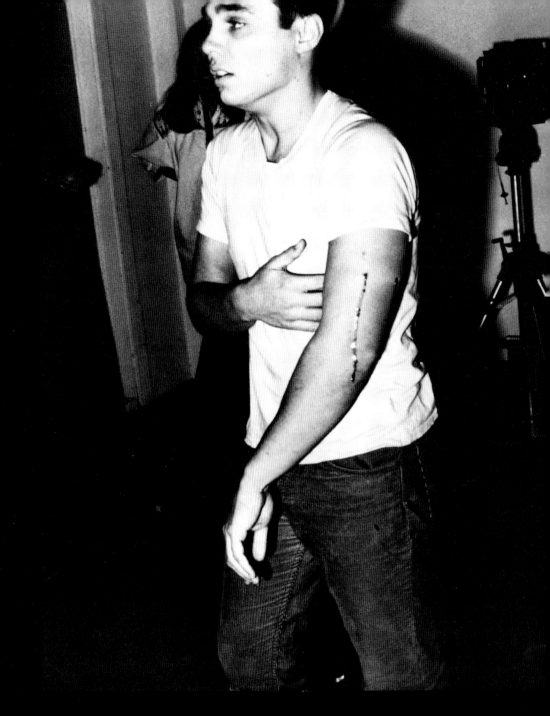

REBECCA HORN
Unicorn, 1971
White-Body-Fan, 1972

Horn's image-rich performances were created with sculptural garments that changed the performer's body into part masculine/feminine, part animal/bird, machine-like creatures. Her first, *Unicorn*, was performed near Hamburg shortly after she had spent over a year in a sanatorium, recovering from lung poisoning caused by resins used in her sculptural work. In this piece, a lone woman walks through forests and fields, bandaged as though she has stepped out of a surreal book on anatomy. *White-Body-Fan* elaborated on the idea of the body as a mechanical object, capable of transformation, even of flight, with its ropes, pulleys, and wing-like extensions, recalling earlier man-bird imagery from da Vinci to Max Ernst.

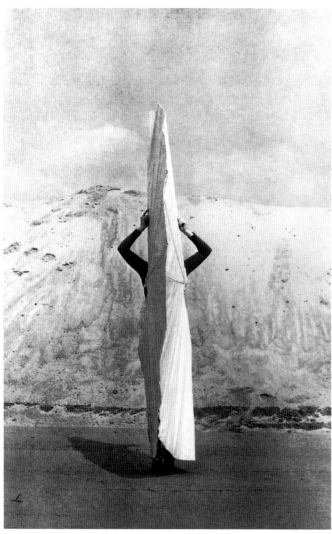

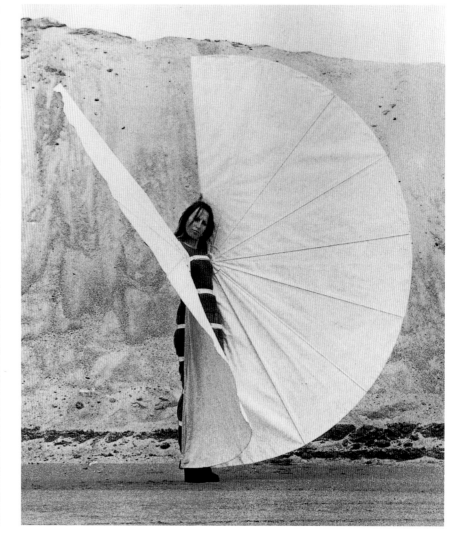

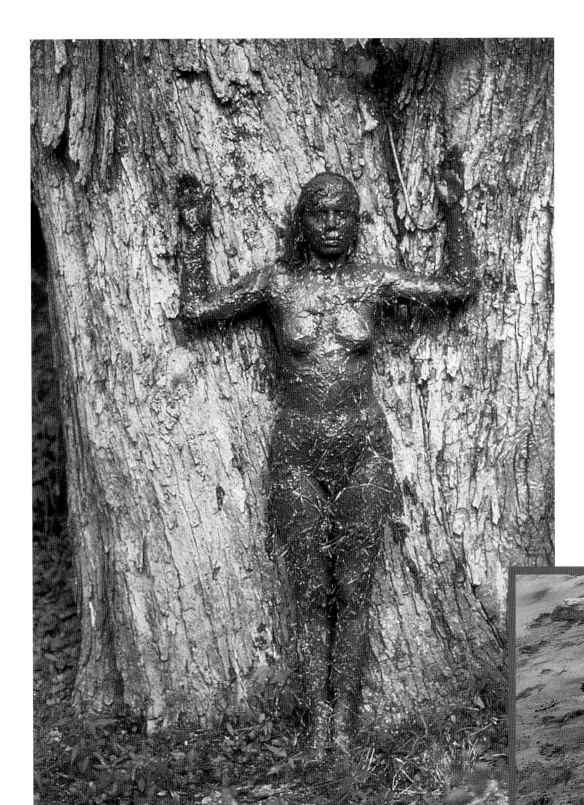

ANA MENDIETA
Untitled: Tree of Life series, Iowa, 1977
Untitled: Siluetas series, Mexico, 1976

During the Cuban revolution Mendieta was sent,
aged twelve, to the United States, where she
and her sister spent five years in foster homes.
Mendieta later used her art to re-establish
bonds with her past. She studied *Santeria,* the
Cuban fusion of Catholicism and African
Yoruba worship, and used her body in rituals
that seemed both sacred and surreal. "I started
immediately using blood,"she said, "because
it's a very powerful magical thing." Her strong
dialogue with the landscape was an expression
of her need to "return to the maternal source,"
and her *Tree of Life* series was an extension of
this (in *Santeria* a tree is the phallus planted in
Mother Earth, and is also an altarpiece used
by healers). In *Siluetas* her physical presence
is literally inscribed into the landscape in a
personal ritual of healing and purification.

KLAUS RINKE
Water-Lift/Body-Sculpture, 1976

Rinke described his "short, minimal gestures"
as "Demonstrations," in contrast to the
theatricality of Happenings. A painter and a
sculptor before turning to actions in the late
'60s, his main concern was with materials;
he used his body as a solid measure of time
and space, and water—"the opposite of stone"
—as a measure of fluidity.

BRUCE MCLEAN
High Up on a Baroque Palazzo, 1975

Since his earliest performances in the late
'60s—*Mary Waving Goodbye to the Trains,*
or *Take a Line for a Walk, Piece*—McLean's
ironic humour has been a critical component
of his work. He has consistently found the
wittiest way to parody conceptual art, and his
non-musical band, *Nice Style, The World's First
Pose Band,* which he founded in 1972, made
an art of it. Performers wore "stance moulds"
in their clothing and watched themselves in
mirrors installed on the sets to check for perfect
poses. *High Up on a Baroque Palazzo,* at the
Garage, London, was a comedy on "entrance
and exit" poses.

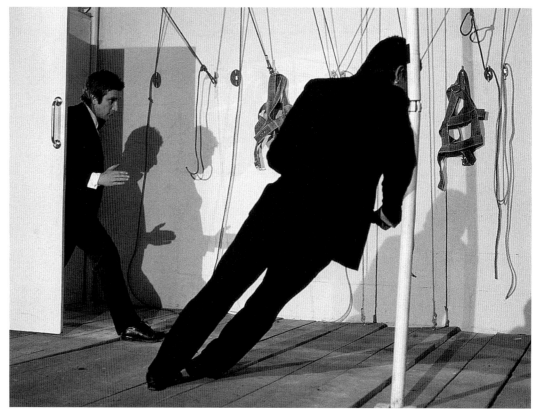

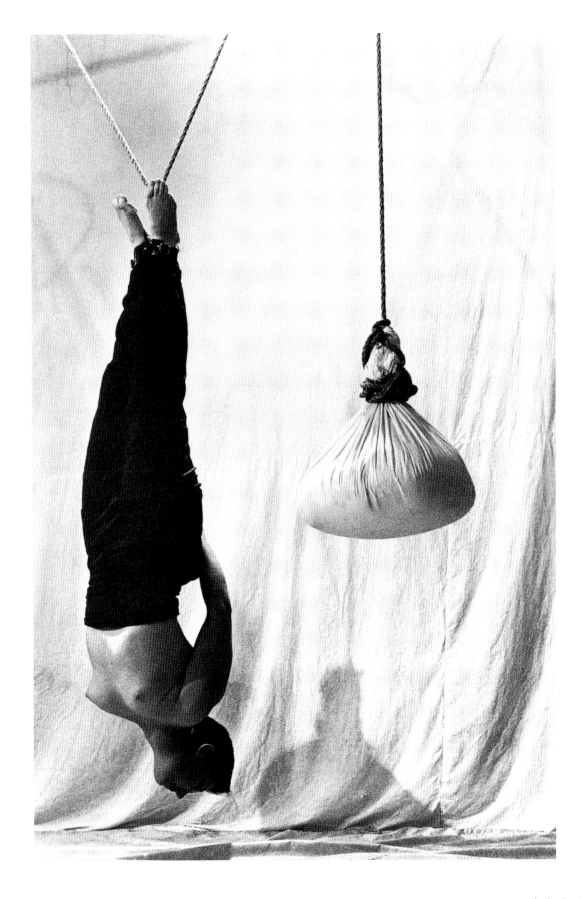

JILL ORR
Headed South, 1981

Throughout the '70s, performance art was
an important aspect of a small Australian art
community, which had grown up on the
multi-media events of groups such as *Tribe* at
La Mama in Melbourne and who were aware
of the radical reach of *Oz* magazine in the
'60s. They created street events and
Happenings, much like the earlier events by
artists in the UK and USA. Their actions were
both a means for Australian artists to connect
with the international scene, and for them to
explore beyond the "cultural cringe," which
writer Peter Kennedy called "the provincialism
problem" of living "down under." Alternative
spaces, such as The Yellow House in Sydney
and Inhibodress in Wooloomooloo, helped
performance art take root, and by the 1980s,
a strong generation of performers had
emerged. Jill Orr is an evocative image-maker,
whose dream-like performances make visceral
connections between her body and the
Australian landscape. *Headed South*, an
indoor work, here pictured at Salon O in
Leiden, showed the body in fragile balance
with a bag of earth.

GILBERT & GEORGE
The Red Sculpture, 1975

One of the two live works by the artists Gilbert & George, who call themselves Living Sculpture, *The Red Sculpture,* a nine-part, ninety-minute work performed in 1975, was a poignant and strangely disturbing tableau. The performers' hands and faces were painted a brilliant red, the symbolic color of totalitarianism, alerting viewers to the undertow of social commentary that was also evident (though disguised by considerable humor) in their famous student graduation project of 1969, *Singing Sculpture.* In the earlier work, with their faces and hands painted gold and mottled with dots of different colours, they performed on a table in ill-fitting suits—taking

turns to hold the glove, the walking stick—moving awkwardly like puppets, as Flanagan and Allen's 1932 song about homelessness "Underneath the Arches" played on tape. Both an ironic commentary on the formalist tendencies of the sculpture school at St. Martin's College, London, and a sincere determination to "be with art"— to locate themselves as objects and as content at the very center of all their work—it also parodied proper British behavior and its fixation with class. Gilbert & George's large-scale, many-paneled photographic murals, often depicting the couple almost life-size, maintain the spirit of their Living Sculpture.

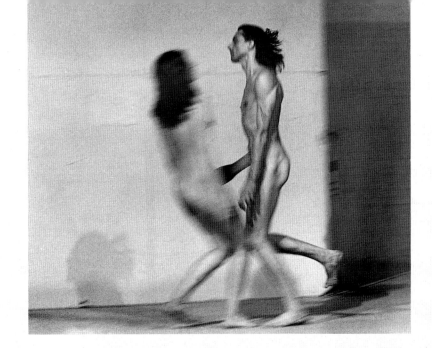

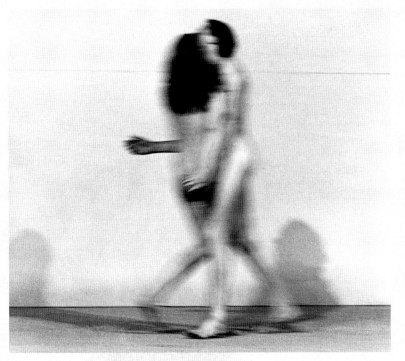

MARINA ABRAMOVIC AND ULAY
Relation in Space, Venice Biennale 1976

Marina Abramović and Ulay (Uwe Laysiepen) were both born on November 30, he in 1943 in Solingen, West Germany, she in 1946 in Belgrade. Their meeting in 1975 marked the beginning of a twelve-year liaison which resulted in powerful collaborative works, many loaded with the risk and aggression that came from exploring the power-play between two intensely driven artists. It began with *Relation in Space* in 1976—a live, hour-long work which involved two naked bodies crashing into one another at increasing speed, and was followed the next year with *Relation in Time*—for seventeen hours the artists sat back to back, their long hair tied together. It ended in June 1988 in an extraordinary finale entitled *The Lovers: Walk on the Great Wall*. Starting off three months earlier at opposite ends of the Great Wall of China—one crossed the Gobi desert, the other treacherous mountain tops—they met on a bridge in Shaanxi Province where they ended their long relationship.

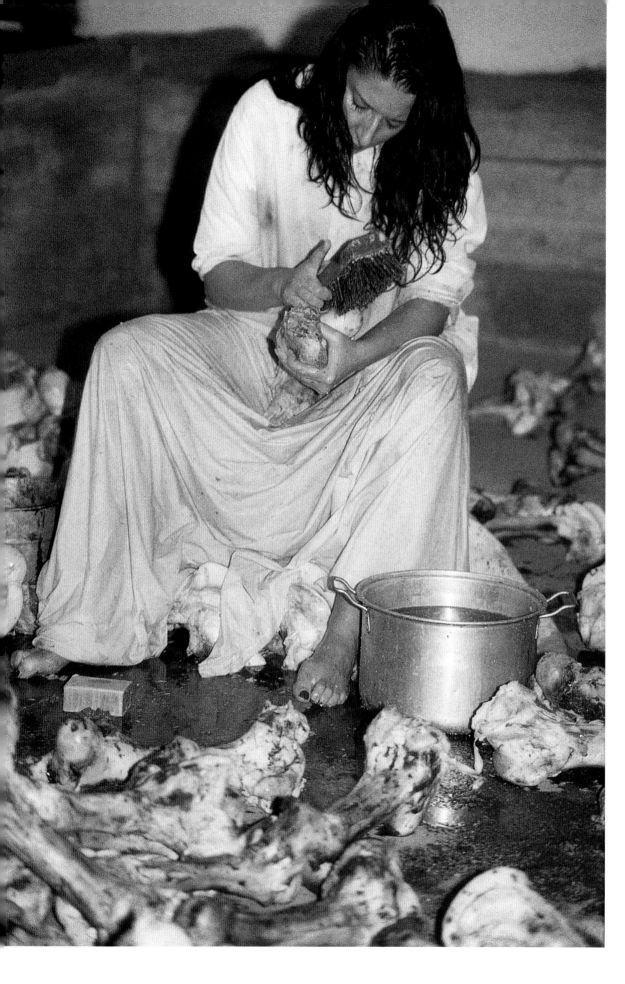

MARINA ABRAMOVIC
Cleaning the Mirror, 1995

For twenty years Abramović has made reference
to the Yugoslavia she left behind in the early
'70s, but none so forcefully as her most recent
performances *Cleaning the Mirror* (1995) and
Balkan Baroque (1997). Wearing a long white
shift, and seated in a dank, poorly lit basement
(in a New York gallery in *Cleaning,* and in a
cellar in *Balkan* for the '97 Venice Biennale)
Abramović scrubbed endlessly at massive
cowbones, removing the grit and blood with
a large scrubbing brush dipped regularly into
a large pail of water at her knees. Increasingly
bloody and distraught, Abramović, who began
the process as a kind of "religious rejuvenating
ritual," was soon mesmerized and overwhelmed
by the horror of her task. The metaphor for
ethnic cleansing in Bosnia was lost on none who
observed the artist sink uncontrollably into deep
sadness as the work progressed. Weeping and
exhausted, Abramović created an unforgettable
image of grief for her times.

ANN HAMILTON
suitability/positioned, 1984
malediction, 1992

Hamilton was deeply influenced by Meredith Monk, Robert Wilson, Yvonne Rainer, and other artists working in performance and dance. Their ability to create monumental spaces for the human figure became a yardstick for her own performance/installations. She created a series of "body objects," often using a form of camouflage to do so, such as the toothpick suit (right) in *suitability* which made the body into an "object of protection and aggression." *malediction* confronted social history and labour in a performance that incorporated repetitive actions and the spirit of the building (a former rag-trade sweatshop in New York's Soho). Hamilton, seated at a refectory table, filled her mouth with a ball of dough, and then put this impression of her mouth's hollow space into a large basket—a task performed for hours each day, over a period of weeks.

HERMANN NITSCH
Aktion Eindhoven, 1983

Nitsch, after seeing a show of Abstract Expressionism in 1959 in Vienna, wrote that he "immediately understood all the implications of this phenomenon." He identified the expressive process of pouring paint with his ideas for a dramatic, emotionally driven, non-literary theater, mingling Catholicism, Romanticism, and Dionysian myths. His first performance developed from a series of action paintings in 1962.

In a long white shirt, he was tied to a wall as if crucified, while Otto Mühl poured blood over him. Nitsch's actions, his Orgies Mystery Theater, with its cacophonous music and the carcasses of sheep or bulls, became increasingly complex. In the early days, the police often stopped the deeply unnerving events; thirty years later, they are watched with the reverence accorded to art works of historical significance.

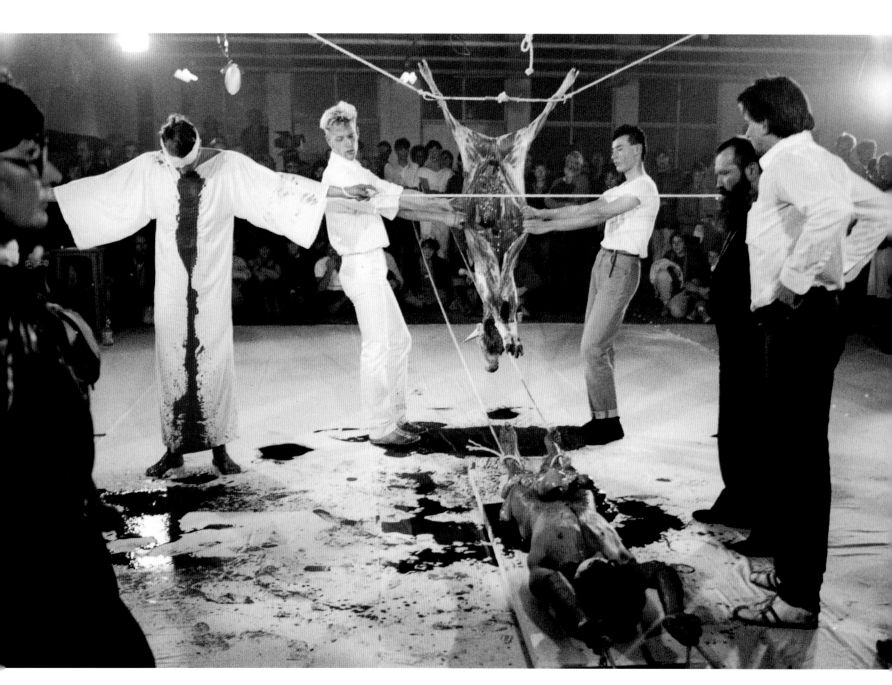

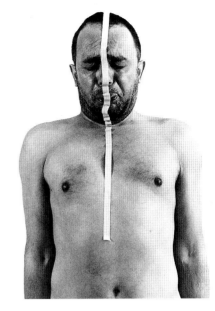

▲ ARNULF RAINER
Aktion, 1970

Rainer, in the '50s a monochrome painter, recreated in private performances the body language of children and of the psychotically disturbed, and then drew over photographs of the action. Nitsch was an early admirer of his.

▼ OTTO MUHL
Vietnam Party, 1966

In 1960 Mühl and Nitsch were the driving force behind the Vienna Actionists, who also included Günter Brus and Rudolf Schwarzkogler. Internationally very influential after the 1966 London Destruction in Art Symposium, they broke psychosexual taboos (Brus once urinating and defecating in public), and used horrific imagery to protest against political repression and social hypocrisy. They used film and photography very precisely to convey an aesthetic of excess and instability.

◄ ELKE KRYSTUFEK
Aktion, 1990

As Rainer's student, Krystufek is a direct descendant of actionism, although her pieces are more to do with her personal emancipation.

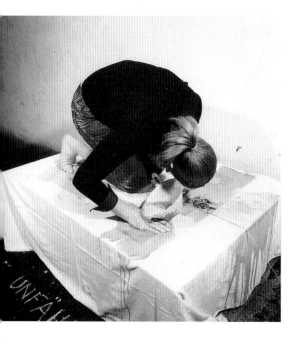

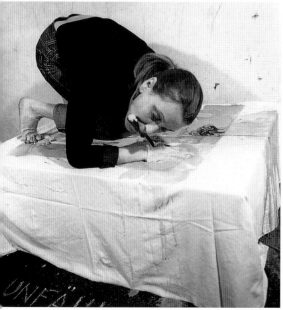

◄ VALIE EXPORT
Incapacity to Express Through Mimicry, 1973

In the late '60s, Export was one of the few European artists dealing with feminist issues. Her "expanded cinema," video, and performances critiqued "male spectatorship" in a most direct way. Less confrontational, and more psychologically analytical than some of her works, *Incapacity* was part of a museum installation. Export shared the platform with a dead bird, her "sculptural" metaphor for the paradox of art, both as free expression and a limited form of communication.

▼ COUM TRANSMISSIONS
Woman's Roll, 1976

In the same year as this live event in Paris, COUM (Cosey Fanni Tooti and Genesis P-Orridge) created a scandal with their exhibition "Prostitution" at the London ICA, which included pages from a porn magazine, showing Tooti in sexually engaged poses. Their performances were crude, frequently bloody, and quite grim. P-Orridge often had chains tied around his head and across his mouth; Tooti was usually nude, and in positions of masochistic submission.

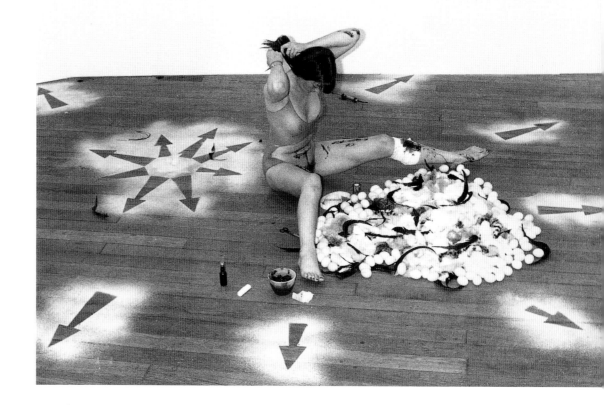

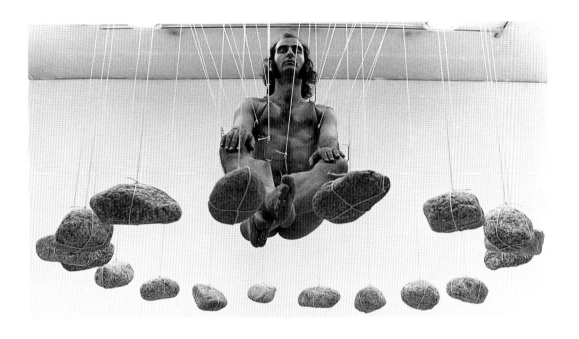

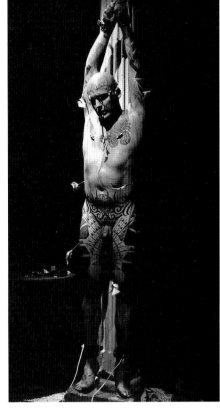

RON ATHEY
Martyrs and Saints, 1993

Athey performed in nightclubs for years before presenting *Martyrs and Saints* in an art space. "The heart of my work," he wrote, "has always been in bringing overdone gothic religious tableaux to life." Using "medical based s/m techniques," and a cast that "took pride in being marginalized (not only being s/m queers, but having hard-core physical appearances)" he created "a pageant of erotic torture and penance."

STELARC
Sitting/Swaying: Event for Rock Suspension, 1980

Stelarc's actions recall Indian fakir rituals for spiritual enlightenment. For him they concern the "cosmic and the superhuman." The artist, he believes, can combine biology and technology to become "an evolutionary guide" for the human body of the twenty-first century.

GINA PANE
L'Escalade, 1971

Pane's body was her "artistic material" in the most literal sense; she might burn it or cut it—in this piece she climbed a ladder whose rungs were embedded with blades. Yet each new level of self-induced pain was for her a metaphor for the social and political oppression she so keenly felt in post-'68 Europe.

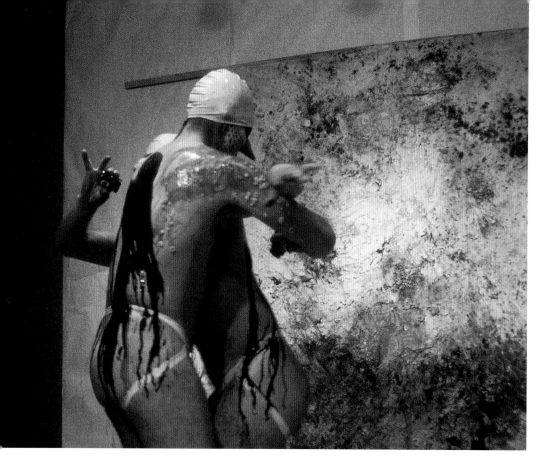

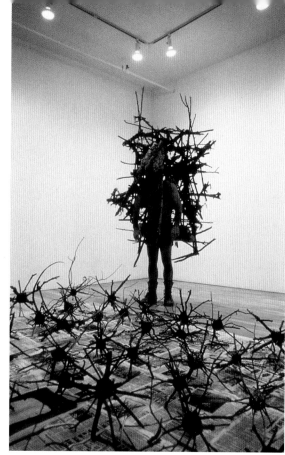

KEVIN MORTENSEN
Opening party of *Leg Show Bizarre*, 1971

A key player in Australian performance art since the late '60s, Mortensen's "animated sculptures" are dream-like tableaux that often refer to Aboriginal mythology. This work took place at an opening party for the performance space Pinacotheca in Melbourne. Mortensen wears a headdress of caged moths.

▼ **THE KIPPER KIDS**
In performance, 1978

The Kipper Kids' performances were raunchy, taboo-breaking, and thoroughly entertaining at the same time. Oversized, and naked but for jock straps, they sang old music hall songs, threw cans of food and paint over each other, and attacked the pretensions of the art world with wit and gusto.

▲ **KIM JONES**
***Mud Man*, 1990**

Jones's mud attire of combat boots, a stocking mask, and a superstructure of coagulated earth and sticks referred to his years of service in the Vietnam war, and so did his use of rats in another notorious performance.

▶ **PAT OLESZKO**
***Charles Patless*, 1976**

Oleszko has created hundreds of costumes, whose titles are a key to the humor that motivates her.

◄ **LUIGI ONTANI**
Christopher Columbus, 1976

Ontani used the history of art as a guide for his costume performances. In this performance, dressed as Christopher Columbus, he made the journey from Italy to New York's Columbus Circle, where he was photographed in this tableau vivant.

▼ **COLETTE**
Visits to the Normal World, 1990

Colette is better known for her voluminous costumes and for the environments that are extensions of them. In this work, a comment on art collecting, she wears a pink suit and veiled top hat, and sits at a table set with gold plates, aiming pistols at hovering black crows.

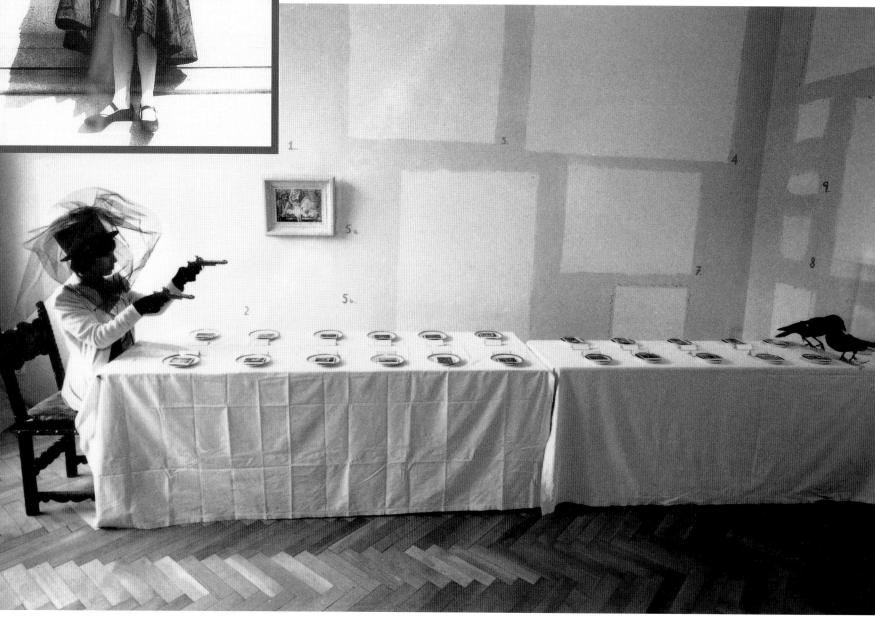

YASUMASA MORIMURA
Self-Portrait (Actress) after Vivien Leigh 1, 1996

Morimura entitled an exhibition at the Yokohama Museum of Art of his
Self-Portrait (Actress), "The Sickness unto Beauty," which captures the
cloying extravagance of his intensely colored and ornately constructed
photographs. Kabuki traditions of *onnagata* (men performing female roles)
and an obsession with Hollywood glamor fuel these pieces, created,
as in filmmaking, with location scouts, hairdressers, and make-up artists.

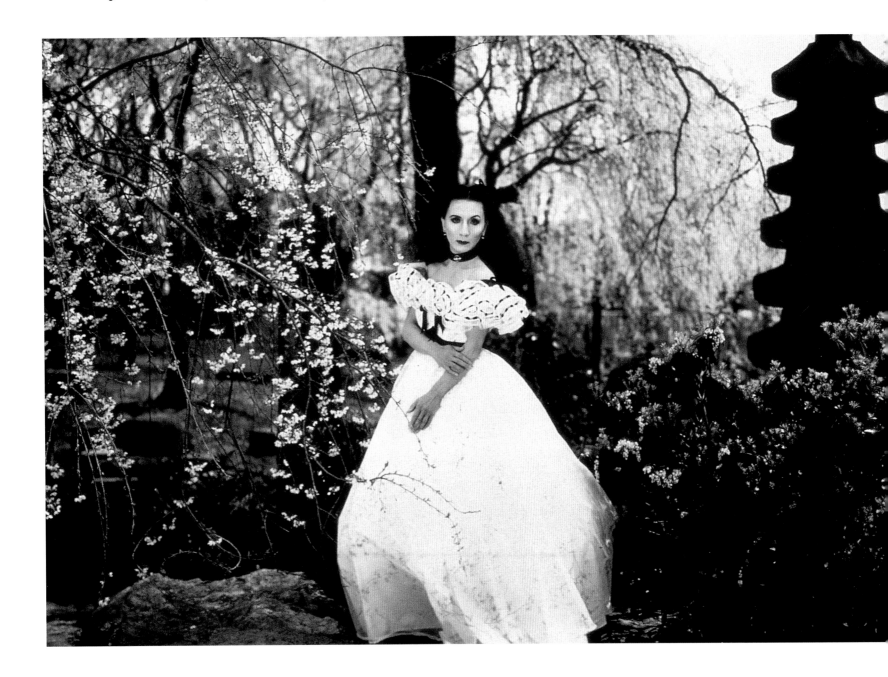

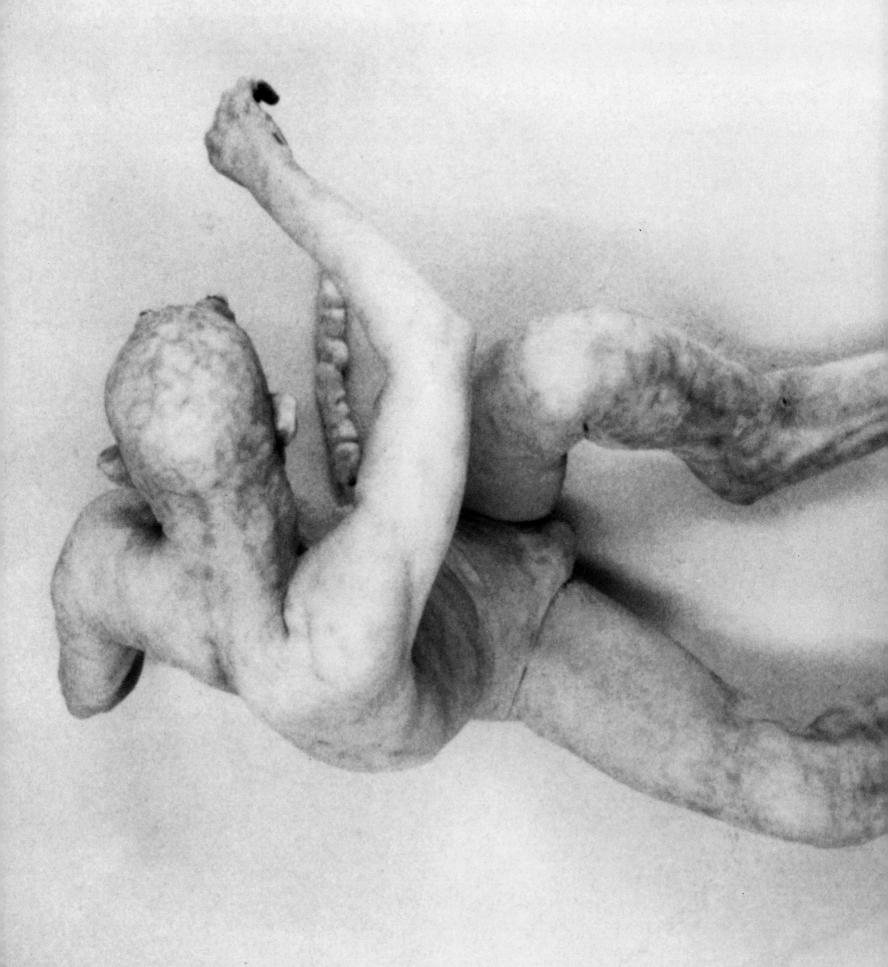

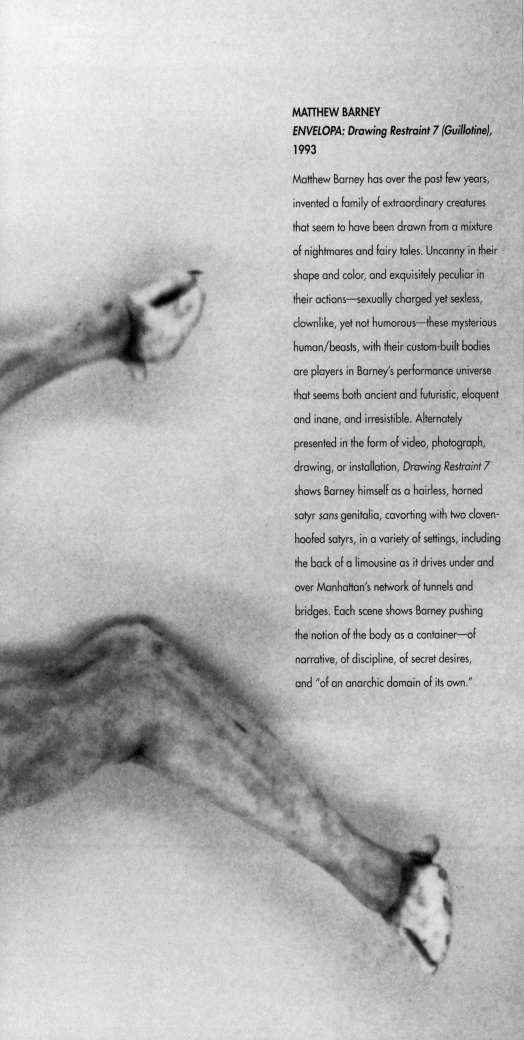

MATTHEW BARNEY
ENVELOPA: Drawing Restraint 7 (Guillotine),
1993

Matthew Barney has over the past few years, invented a family of extraordinary creatures that seem to have been drawn from a mixture of nightmares and fairy tales. Uncanny in their shape and color, and exquisitely peculiar in their actions—sexually charged yet sexless, clownlike, yet not humorous—these mysterious human/beasts, with their custom-built bodies are players in Barney's performance universe that seems both ancient and futuristic, eloquent and inane, and irresistible. Alternately presented in the form of video, photograph, drawing, or installation, *Drawing Restraint 7* shows Barney himself as a hairless, horned satyr *sans* genitalia, cavorting with two cloven-hoofed satyrs, in a variety of settings, including the back of a limousine as it drives under and over Manhattan's network of tunnels and bridges. Each scene shows Barney pushing the notion of the body as a container—of narrative, of discipline, of secret desires, and "of an anarchic domain of its own."

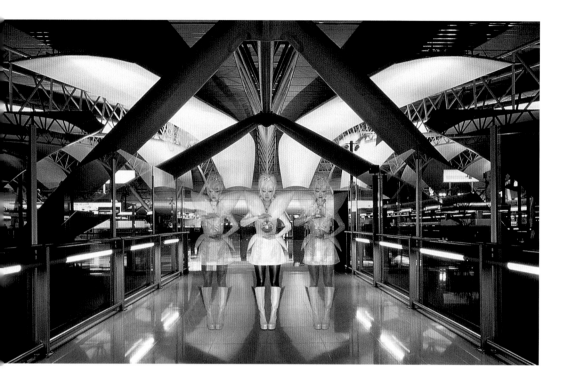

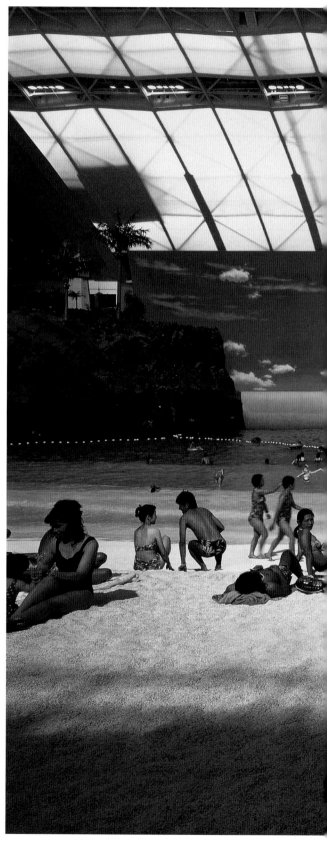

MARIKO MORI
Last Departure, 1996
Empty Dream, 1995

An aesthetic of precision connects Mori's high-tech cyborg world to her Japanese cultural roots—to the tea ceremony, for example, or to the sculpture of Buddhist temples, whose symmetrical, frontal elegance she mimics in her own poised performances. In large computer-enhanced photographs, she fuses Western-style technology and Eastern philosophy with the glue of pop culture. She seeks places and spaces where artifice reigns, and exaggerates it even further, In *Empty Dream* she is a sequinned mermaid sunbathing beneath an artificial sun on a fake indoor beach. In *Last Departure* she wears clothing designed in response to the futuristic fantasy that is the Kansai International Airport.

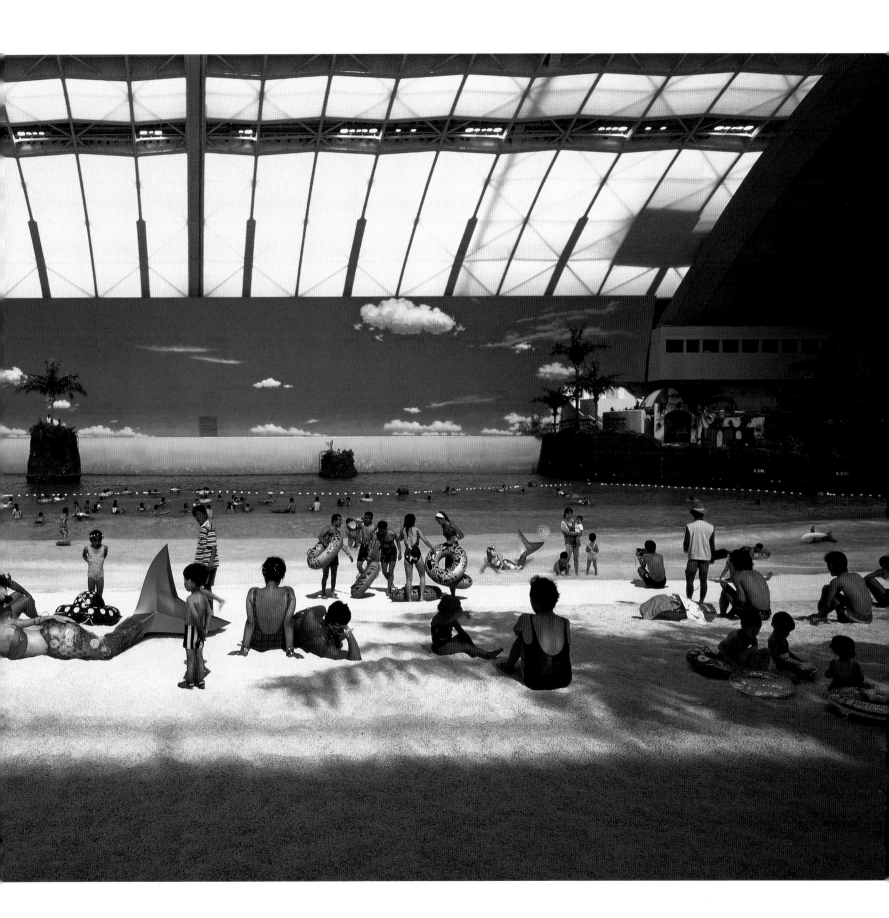

CHAPTER 4 *identities: feminism, multiculturalism, sexuality*

The feminism that took center stage in the US art world of the early '70s, was uniquely American. Local chapters of artists, from California to New York City, created meeting places and exhibition spaces in lofts and studios, and intellectual forums in colleges and universities that would have a radical impact on the discipline of art history, on the education of both male and female artists, and on the very nature of art-making itself. "Post-modernism," said Miriam Schapiro, painter and founder in 1971 of a feminist program at the California Institute of the Arts, "came into being in part as a result of the feminist art explosion." Their incorporation of all kinds of material—ceramics, embroidery, knitting, weaving—and forms such as pattern painting, previously thought of as "merely decorative," blurred the edges between art and craft, between "high" art and "low," and also mined new territories for content—autobiographical, highly personal, and even confessional narratives could usually be found in the new work. Unconcerned about the established art world, where they had little clout anyway, many women gravitated toward performance because it was a medium ungoverned by conventional art-world protocol: the studio visit, the gallery show, the critical review, and the curatorial nod. "In performance we found an art form that was young, without the tradition of painting or sculpture. Without the traditions governed by men," said Cheri Gaulke. It also felt right. "Performance is not a difficult concept to us," she added. "We're onstage every moment of our lives. Acting like women." And it also lent itself to protest. "Performance can be fueled by rage in a way that painting and sculpture cannot," said Judy Chicago.

Feminist performance was quite different from one coast to the other. In California, women artists created material from the ordinary rituals of daily life; they confronted the banality and the tedious repetition of domesticity in installations and performances. "Womanhouse," an exhibition organized by twenty-six students of Schapiro and Chicago's in a house in Los Angeles in 1972, included a "menstruation bathroom" (a pristine white space with a garbage can brimming with bloody tampons), a kitchen wallpapered with rubber moulds of women's breasts, and a performance "Waiting" by Faith Wilding, loosely based on Beckett's "Waiting for Godot," which referred to the markers that defined conventional womanhood; "waiting for my period…waiting to get married…waiting to have children…" On the East Coast, with its sophisticated gallery and museum structure

SHIGEKO KUBOTA
Vagina Painting, 1965

A year after arriving in New York, Japanese Fluxus artist Kubota made a red "vagina painting" during the Perpetual Fluxus Festival at the Cinemathèque on East 4th Street.

and competitive art schools, women artists operated far less collaboratively. Their group meetings were more likely to follow specific agendas—protesting on the dearth of women artists with work in museums, or of women faculty members at art schools. Performances were far more conceptually oriented; they referred less to the tedium of the everyday, and more to perception. Adrian Piper's "mythic being" wandering the streets in Afro-wig dressed as a young male, was a means for her to explore directly issues of gender and race in public. Laurie Anderson turned on any man who tried to talk to her in the street with her camera, thus reversing the power play in a typical male-accosts-female street encounter.

In Europe, feminist art and performance were rarely organized to the same degree as in the United States. The political upheaval of the '60s divided largely along economic, not gender or race lines, and the battles fought at the Renault factory outside Paris and at the London School of Economics were not a blueprint for activism of the same kind as that provided by the more targeted minority movements in the United States. Instead, artists made subtler references—usually of a metaphorical nature—to women's lives. In Britain, Carlyle Reedy, Rose English, Rose Garrard, and others created quietly reflective material, while across the English Channel Ulrike Rosenbach, Rebecca Horn, Marina Abramović, Valie Export, and Gina Pane presented more emotionally searing performances and tableaux.

For American women artists, the Civil Rights movement was a model for their own grassroots pressure groups. Just as American blacks had in the '60s established the notion of identity as power, women artists used the notion of "identity" to establish their collective visibility. The word "identity" even had a therapeutic edge. Identity as a declaration of the self; identity as claiming and naming common qualities; identity as pride. By the '80s, however, the media had declared a feminist backlash, and the Civil Rights dream of integration had all but disappeared. With the general demise of progressive liberalism, and an ever-widening gap between rich and poor, it was clear that fresh tactics were needed if minority groups were to be heard. Many black intellectuals sought another route to assert black presence in middle-class life; their historical roots. They reclaimed the term African-American (first used in the 1890s) because it described a group with its own continuous cultural history, its own rituals and its own diaspora. Other minority groups followed suit; American-Indians, Latino-American, Cuban Americans, and so on, and the term "multiculturalism" came to describe a society that was the complicated sum of many distinct parts.

In Europe, the term would mark the death throes of colonialism and an attempt to acknowledge the hundreds of thousands of immigrants from former colonies, firmly established in their host countries. Customs of dress and food, domestic and religious rituals were more publicly exercised in the schools and workplace. The meaning of "multiculturalism"

would soon be expanded to incorporate the very different value systems and cultural references of those living under communism and apartheid. The fall of the Berlin Wall and the release of Nelson Mandela in 1990 after twenty-seven years in prison in South Africa, signaled the beginning of a broad interest in a new form of internationalism which had little to do with the expansionism of previous colonial eras, and more with encounters with societies located at a great distance, in every sense of the word, from the central Western model.

In performance, artists such as Coco Fusco, Ishmael Houston Jones, and Jimmy Durham made work that targeted the mainstream's ignorance of the ethnic cultures within its midst. They underlined and embellished ethnic differences, producing a range of material that varied widely in quality and content, and was often heavily didactic. Live performance provided a face-to-face confrontation with the viewer that neither literature, nor even cinema, could equal. It was, wrote Guillermo Gomez-Peña, a way to be "active in the making of culture." It also provided a means for him and others to rethink ethnic customs, and to intrude them into modern life. "Performance art is the one place where ritual can be reinvented, and where boundaries can be crossed," he said.

Public display of privately held beliefs became its own political pressure point. Gay activist writers and artists dared the public to deny the civil liberties of individuals choosing a way of living or a sexual preference different from the heterosexual model. "Gay pride" forced a plethora of performance material to the surface, at locales such as Dixon Place or the WOW Cafe—a lesbian collective (Women's One World) that opened in the early '80s in the East Village. By the early '90s, a library of critical and theoretical texts, incorporating the arguments of Europeans from Simone de Beauvoir and Monique Wittig to Luce Irigaray and Julia Kristeva, covered a broad spectrum of feminist and lesbian issues. Writers such as Peggy Phelan, Judith Butler, and Eleanor Fuchs produced texts based on a wealth of feminist performance material, explored through political, aesthetic, and psychoanalytical theory. Less concerned with the '70s need to batter the social hierarchy, by the late '90s feminism has led women performance artists to turn their gaze more forcefully on one another and on themselves. As a result, feminist scholars and writers have, for the past decade, been confronted by performance material of a kind so startling, so disturbing and prescient, and so driven by a fierce and energetic sexuality, that feminist theory has taken off in entirely new directions. Visually seductive, aesthetically inventive, with explicit language and subtle asides, with movement and music that provide a strong punch, their work is also courageous for being presented in close-up in a public setting. For now, it would seem that there can be no further taboos to be broken, but it is still the overwhelming realism and immediacy of live performance that continues to shock.

◄ **MARY KELLY**
Post Partum Document, 1975, recording session

This close examination of mother and child in a public art context, at first ridiculed, is now considered a landmark of feminist history.

► **CAROLEE SCHNEEMANN**
Interior Scroll, 1975

Schneemann read out male criticism of her work's "personal clutter" and "persistence of feelings" from a scroll pulled from her vagina.

▼ **HANNAH WILKE**
My Count-ry 'Tis Of Thee, 1976

Wilke, believing that narcissism gave women power and identity, placed eleven-foot cut-outs of herself on the front of an art gallery.

◄ **ELEANOR ANTIN**
Nurse Eleanor, 1973

Antin developed multiple-costume personalities, that ridiculed
the cliches of women in subordinate roles.

▼ **SUZANNE LACY AND K. CHANG**
The Life and Times of Donaldina Cameron, 1977

This work referred to a nineteenth-century missionary who assisted
Asian women immigrants in California. Lacy's performances have
always been concerned with social issues, and each had a strategy
to reach a particular audience, whether women in old-age centers
or homeless families. She was ahead of her time in drawing attention
to the multicultural make up of Los Angeles.

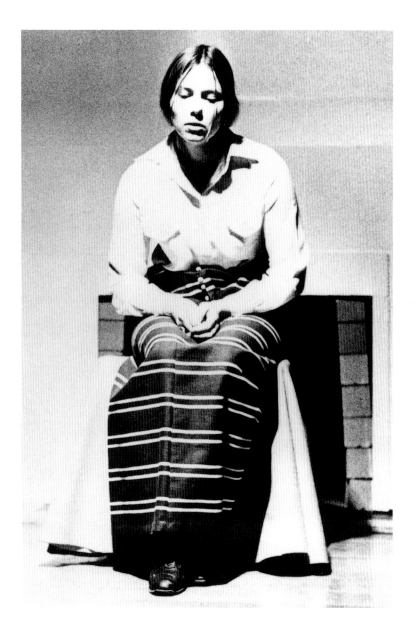

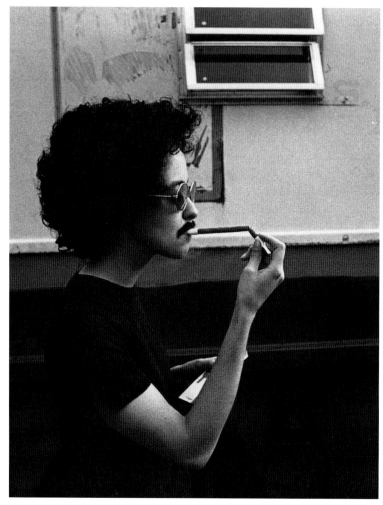

FAITH WILDING
Waiting, 1971

In the '70s, performance became the ideal vehicle for expressing the complex social, political, and psychological issues that emerged from feminist analysis and protest. In this work at Womanhouse in Los Angeles, Wilding sits immobile, apart from the rocking of her chair. She speaks in a low, monotonous voice, and lists the endless "waiting" of women. "Waiting to get married/waiting for my baby..."

ADRIAN PIPER
Light my fire Sweetie?, 1975

Performance art and conceptual art in the '70s were two sides of the same coin. Both rejected the aestheticized art object, critiqued the meaning of art, and attempted to find ways to take such polemical concerns beyond the confines of the art gallery. Piper's work cleverly straddled both forms, and her unsettling street performances were backed by significant political rhetoric—about race, about gender, and about how we encounter prejudice in daily life.

ORLAN
Le Baiser de l'artiste, 1977

In general, European feminist performance was far more metaphorical than its American or British counterparts. Its historical references were partly Surrealist (the objects of Meret Oppenheim and Louise Bourgeois, or the sexual imagery of filmmaker Luis Buñuel, for instance), and partly literary (Antonin Artaud) and psychological (Freud). On the other hand, French artist Orlan made performances from the literal meaning of the roles that women were expected to play, as in this work where viewers were encouraged to pay for a kiss.

LORRAINE O'GRADY
Mlle. Bourgeoise Noire Beats Herself with the Whip-That-Made-Plantations-Move,
1981

Early feminist protest took the Civil Rights movement as a model for civil disobedience. In turn, feminist performance showed '80s minority groups ways of expressing ethnic identity and shaping cultural politics. O'Grady was a journalist who turned to performance art precisely because it was a much more direct way of entering the fray. In this work she wore a gown sewn from 180 pairs of secondhand gloves and carried a whip studded with chrysanthemums. "The gloves were a sign of internalized oppression, the whip that of external oppression," she explained.

ROSE ENGLISH AND SALLY POTTER
Berlin, Part Two: The Spectacle (on Ice), 1976

Potter and English's early collaboration was a four-part work, performed in four different London locations, over four weeks. Focusing on place, narrative, and the juxtaposition of imagery, this part took place in an ice-skating rink. It was almost cinematic in the way one scene faded into the next—woman in black carrying a stool, a cradle bursting into flame, skating men, and a naked boy.

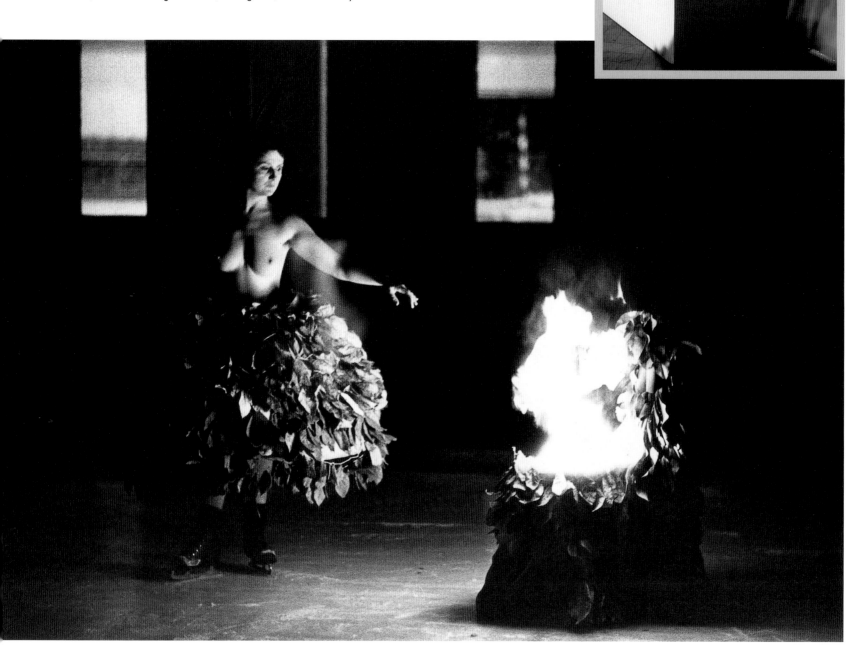

◄ **ROSE GARRARD**
Openings, 1985

Garrard's fifty-minute work, shown in Newcastle upon Tyne, examined the role of the ballerina, a profession that she felt had been demeaned by "feminist theory" for being stereotypically female. Performing with two ballet dancers, she used a variety of filmic and theatrical conventions—lighting, sound effects, costumes, and characters—to "inhabit" a dancer's theatrical image.

▼ **JANINE ANTONI**
Loving Care, 1992–96

In this strenuous performance, Antoni gradually "painted" an entire gallery floor with her long hair, dipping it frequently into a large plastic bucket of Loving Care's "Natural Black" dye. For her it was an ironic provocation of male-dominated legacies (in this case that of Pollock and Klein), a frequent theme in her work. "I feel attached to my artistic heritage and I want to destroy it," she said.

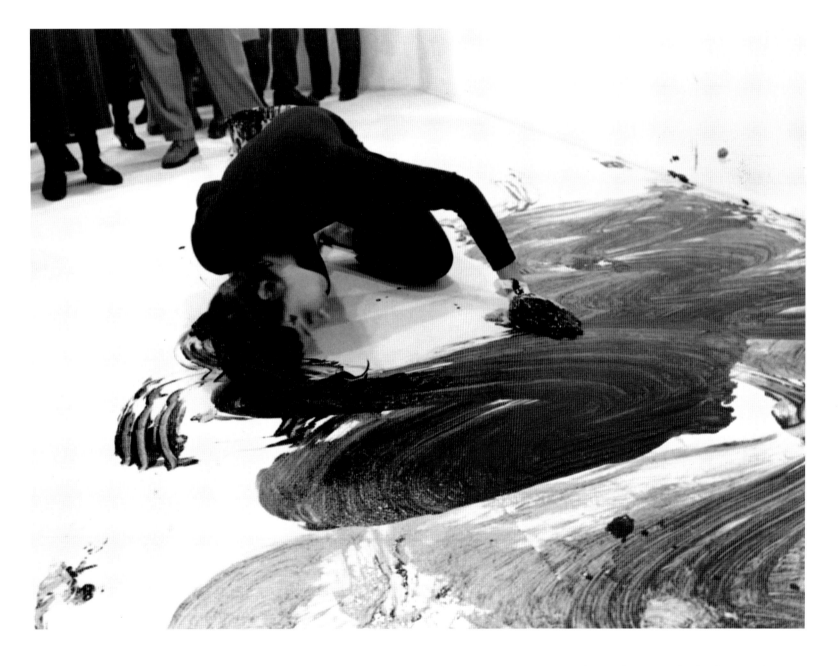

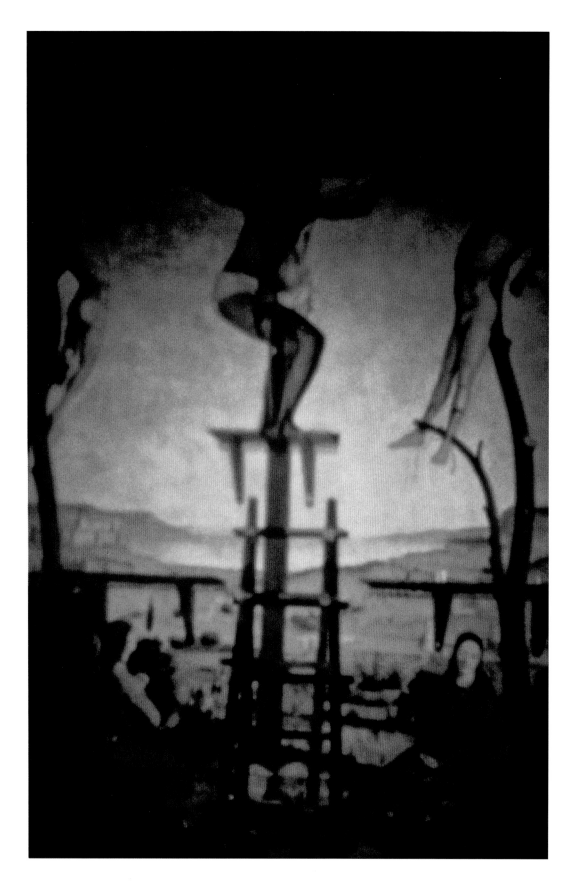

◄ **CHERI GAULKE**
This is My Body, 1982

First performed in 1982 on Good Friday, this Easter piece was deeply cathartic for Gaulke, who came from four generations of Lutheran ministers. She climbed wooden platforms to place herself naked inside projections of famous paintings of scenes from the life of Christ.

▼ **MARTHA WILSON**
Mudpie, 1976

Wilson shouted excerpts from Carroll's *Alice In Wonderland,* while a naked woman swept flour into a heap, added water, kneaded the dough into a strip, and formed it into a circle. "The goal of this piece was to retell a fantastic story, while showing feminine drudgery at work."

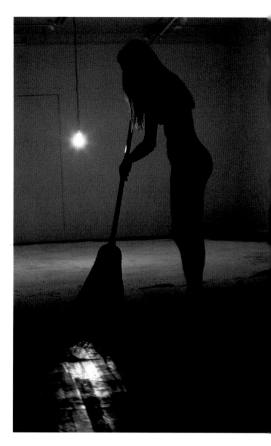

► **JACKI APPLE**
The Amazon, the Mekong, the Missouri,
and the Nile: Act 4, The Amazon, 1985

A collaboration by Apple (visual artist, writer, audio
composer), Mary Jane Eisenberg (choreographer)
and Bruce Fowler (composer/musician), this work
exemplified the 1980s both in the large scale of
its production and its theme of cultural diasporas.

▼ **RACHEL ROSENTHAL**
L.O.W. in Gaia, 1986

Rosenthal's work deals with political issues like
ecology and feminism, as in this piece that was
"a sort of meditation on a trip to the Mojave Desert."
With powerful visual imagery she conjured up a
mysterious landscape, through which she moved
with the confidence of a trained dancer.

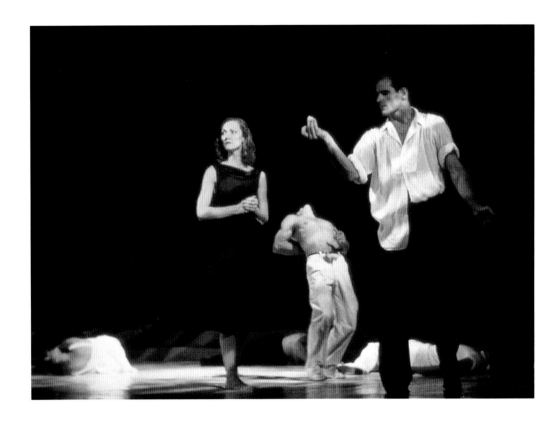

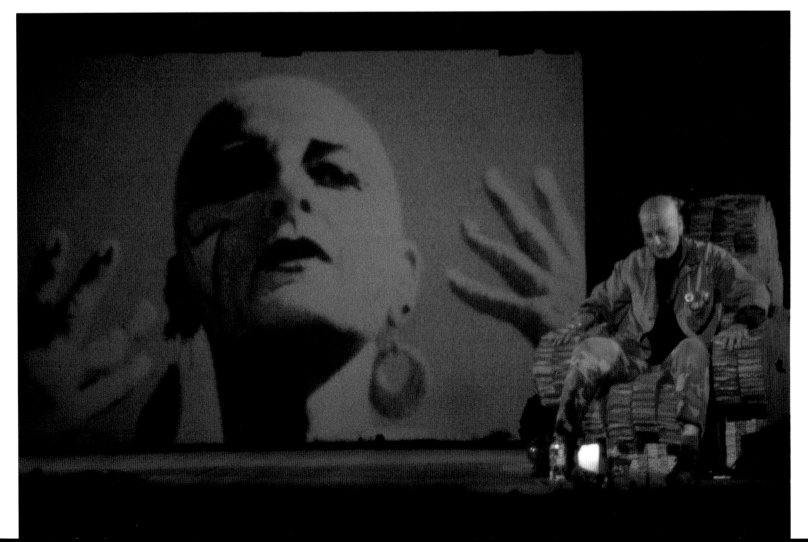

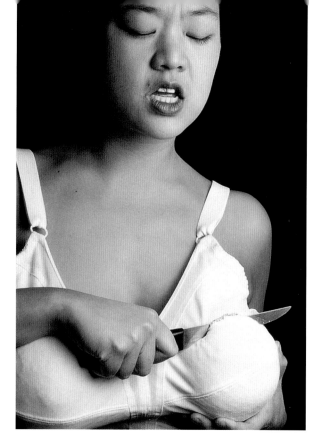

▲ PATTY CHANG
At a Loss, 1995

Chang's startling performances involve the constantly changing identity of women. They are about "the dramatization of memory" and each piece entails constructing an image that is rich enough to contain and to hold images from the past for recall in the future. This work has several narratives running through it, one of them being a reference to a "commemoration plate" for her late grandmother.

◄ CLAUDE WAMPLER
Costume from *She is High. True or False?*, 1995

Wampler's performances are slyly seductive and impeccably styled. Trained in Butoh, opera, and dance, she has a keen awareness of her peers in contemporary art, and captures in her performances the aesthetic mood of the present, particularly its high-fashion photographic quality and its languorous sexuality. She designs her costumes as she might a piece of sculpture or furniture, building spaces in which to place her body.

▲ **ANNIE SPRINKLE**
Post Porn Modernist, 1990

Before she was "discovered" in a 42nd Street porno theater, and invited to perform at Franklin Furnace and the Performing Garage, Sprinkle represented the demeaned object of male desire. Her designation as a performance artist transformed her into a heroine of emancipation. Performing on her own terms was a means for her to "claim" her sexuality, and to redress the balance of male/female power.

► **LINDA MONTANO**
The Back: Seven Chakras, 1987, from *14 Years of Living Art,* 1984–98

In her early twenties, Montano spent two years as a novice in a convent, and much of her work since has been concerned with an extreme renunciation that can verge on religious ecstasy. She has combined her interest in transgression and taboo with a study of tantric philosophy. Seven *chakras,* the Hindu energy centers, are tattooed on her back. This photograph was taken by Annie Sprinkle, with whom she has collaborated on several projects since 1987.

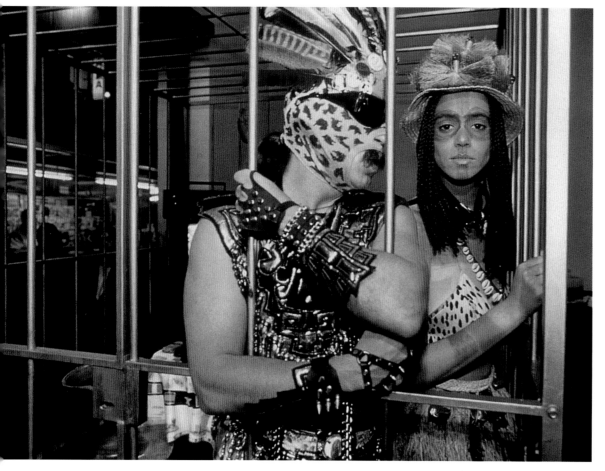

▲ TANIA BRUGUERA
What belongs to me, 1996

In this two-hour silent piece on censorship, Cuban artist Bruguera, in animal headdress and holding a pig's heart, was constrained by steel bands round head, mouth, chest, and legs.

▼ GUILLERMO GOMEZ-PENA
Walking through Streets by Greektown in Detroit, 1994

"I rapidly learned that to be a 'Mexican Artist' in the United States meant—whether I liked it or not—being a member of a culture of resistance."

◄ COCO FUSCO AND GOMEZ-PENA
Two Undiscovered Amerindians, 1992–94

Fusco and Peña spent days at a time exhibited in a cage, doing "traditional tasks"—"sewing voodoo dolls and lifting weights, watching television and working on a laptop computer."

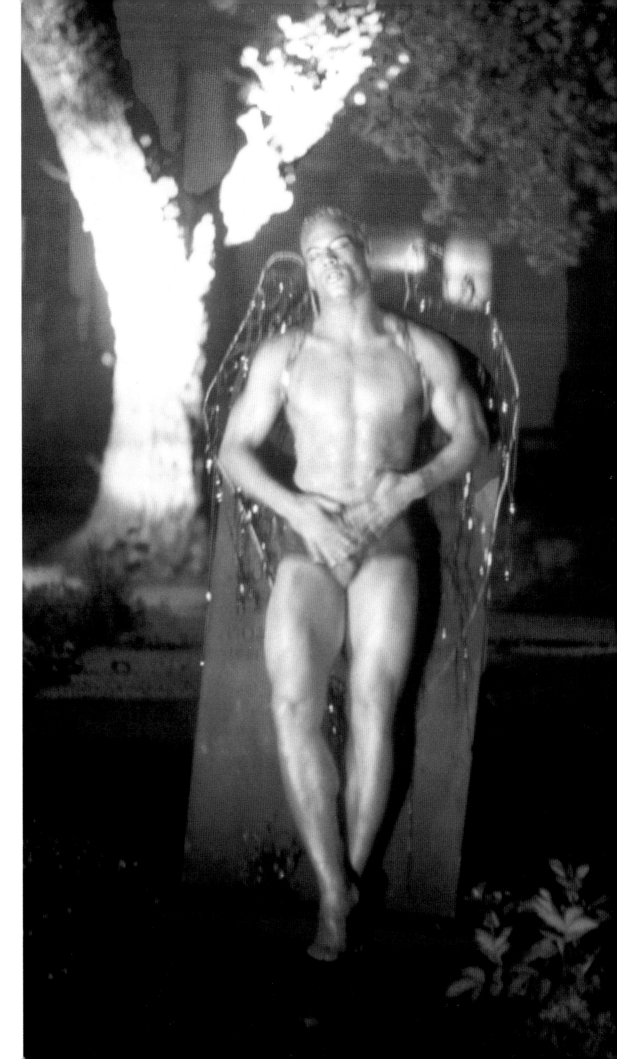

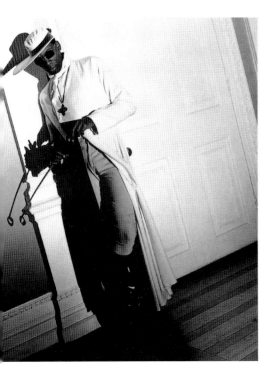

▲ **RONALD FRASER-MUNRO**
Cesare Cappucino, 1995

Fraser-Munro made a series of "action tableaux" in London's ICA for the exhibition on psychiatrist and radical political analyst Frantz Fanon. In this scene he poses as a black cardinal, ridiculing the church as a pillar of the white establishment.

► **ISAAC JULIEN**
Looking for Langston, 1990

Julien's meditation on the poet Langston Hughes and other black artists of the Harlem Renaissance took the form of a guided night walk along the main gay cruising strip in Newcastle upon Tyne. At certain places, bright lights signaled a brief performance of stylized gay seductions by twenty performers in tuxedos. A "gay angel" in a graveyard formed the final tableau. The work was based on Julien's 1989 film of the same title.

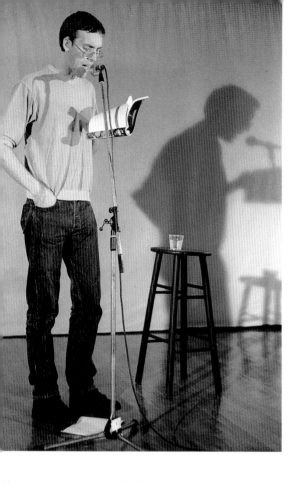

◄ DAVID WOJNAROWICZ
Tongues of Flame, 1990

Wojnarowicz, here reading *Tongues of Flame* at the Studio Museum of Harlem, used performance and poetry as a form of political agitation at a time when grassroots activism had lost its romance and effectiveness. He sewed his mouth closed in the ACT-UP film, *Silence=Death* in a protest of silence for the inadequacy of AIDS research and treatment. In his last poems before his death in 1992, he described himself as "glass ...clear empty glass," yet performance was also a means for him to declare his visibility and his presence.

▼ TIM MILLER
Democracy in America, 1984

In collaboration with photographer Dona Ann McAdams and painter Mike Glier, Tim Miller created a performance from the imagery and political rhetoric of the media-presidency of Ronald Reagan. Performed at the Brooklyn Academy of Music, it was imbued with the frustrations and despair of artists and activists attempting to counter the brutalizing effects of the conservative policies of the times, especially as they related to AIDS treatment and research.

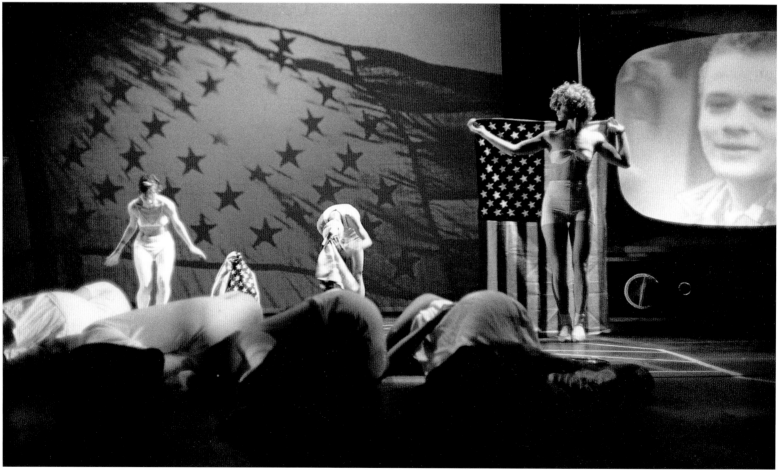

LAPD/JOHN MALPEDE
LAPD inspects America: Chicago, 1990

Malpede's Los Angeles Poverty Department uses collaborative improvisations in an attempt to create communities from groups of itinerants in Los Angeles (since 1985), San Francisco, Chicago, Cleveland, and London. In Chicago, six company members worked with homeless people at a day center making an hour-long performance. One narrative that emerged was about a janitor fired from his job, the ex-janitor reading his side of the case while his "alter-ego" voiced his own doubts. Angry confrontations are often barely contained.

LAURIE CARLOS
White Chocolate, 1992

First performed in 1990 at BACA Downtown, this view is from the performance at P.S.122, New York. Carlos uses words, the body, and music to probe the meaning of Africanness for African-Americans. "Is we still black? Still black?" asks one of her characters in an earlier work. Written in the voice of a twelve-year-old, *White Chocolate* begins with a parade of church ladies in tiered dresses and elaborate hats and smartly dressed young girls with tightly braided hair: they represent Carlos's matriarchal line. A "spirit"—the last African ancestor—moves about the stage as a story of persecution unfolds with an accompaniment of stamping, chanting, laughing, and shouting. The spirit is last seen as a junkie on the street.

CHAPTER 5 *dance*

The great American innovators of modern dance in the first half of twentieth century —Ruth St. Denis, Isadora Duncan, and Martha Graham—liberated the dancer's body from the restraints of a classical repertoire and dance vocabulary—and of restrictive attire, such as point shoes and tutus, which limited the dancer to stylized and unnatural movements. In the 1950s, barefoot, and charged with innovative fervor, Graham's protégé Merce Cunningham introduced "walking" into his dance steps, radically affecting the evolution of dance for the next forty years. Working with university students in 1952, Cunningham suggested that they begin with ordinary gestures—"These were accepted as movement in daily life, why not on stage?" he wrote.

Natural, everyday movements, and the emotions that drive them, were investigated by choreographer Ann Halprin in the '60s at her experimental dance workshops on the West Coast, that included young dancers Trisha Brown, Simone Forti, Yvonne Rainer, as well as the artist Robert Morris. Together they explored kinaesthethic awareness; they talked of the intelligence of bodies and of movement, intellectually exploring their own exclusive "terrains" for clues as to how the new dance might look. Moving to New York in the early '60s, several to attend classes at the Cunningham studios on East 14th street, they also enrolled in the composition class of Robert Dunn—a music accompanist for the Cunningham dancers and a "graduate" of John Cage's now legendary class in "Composition of Experimental Music" (1956–60) at the New School for Social Research. To natural movement, these dancers now added "chance" as a structural device, and the Duchamp model of "found" material—in this case "found sound" and "found movement"—as a method of inventing new dance forms. Responding to Cage, they also separated music from movement, allowing each an entirely separate attention, thereby focusing even more on the shape of bodies, their movement, and their relationships to one another. In summer 1962, the group, including Trisha Brown, Deborah Hay, Steve Paxton, Yvonne Rainer, David Gordon, Judith Dunn, and Ruth Emerson, presented a concert of twenty-three works made for Dunn's class, at the Judson Memorial Church on Washington Square, and the Judson Dance Theater was born. "A three-hour marathon for a capacity audience of about 300 sitting from beginning to end in the un-airconditioned 90°-degree heat," according to Rainer, this first concert would set off two years of experimentation that would come to represent one of the richest and most collaborative periods in the history of American dance.

TRISHA BROWN

Walking Down the Side of a Building, 1970

A dancer supported by climbing equipment walks down a New York building, illustrating Brown's focus on gravity as an essential element in dance.

Inevitably the democratic ideals "of group activity, of making pieces, and sharing ideas," (in Rauschenberg's words) shifted as choreographers pursued their own maturing styles, consolidated into small companies, and accepted invitations to perform elsewhere. But newcomers like Meredith Monk and Lucinda Childs were drawn to perform at Judson Church. In 1970 nine of the original Judson choreographers formed Grand Union, pursuing at a more sophisticated level their concerns for spontaneity, collaboration, and the contrast between learned and ordinary gestures. Instigated by Rainer, who clearly thrived on the push and pull of its highly individualistic members, Grand Union was the springboard for another six years of exploration into the body in space, its language, humor, and phrasing, and as a vehicle for commentary on the Vietnam war and other social/political issues.

Alternative art spaces of the '70s, such as 112 Greene Street or The Kitchen, provided venues for the new dance, reinforcing the connections between the preoccupations of the time in dance, music, and fine art. Like many conceptual artists—Vito Acconci, Dennis Oppenheim, or Sol LeWitt, for example—these choreographers were similarly concerned that the *idea* behind their art should be as important as the actual execution of a work. Dance was used to investigate the meaning of the form itself, and this highly conceptual approach produced a broad range of radical proposals. Trisha Brown devised a series of "equipment pieces" to illustrate that dance is, in essence, a matter of gravity. In Walking *on the Wall* (1971), her dancers literally walked along the walls of a gallery, suspended from the ceiling by mountaineering equipment. Lucinda Childs, seeing dance as a kind of constantly moving architecture, used intricate notation to determine the paths her dancers would take, while Laura Dean, working from elegant compass-drawn circles and an elaborate counting system, introduced a distinctive spinning movement, reminiscent of whirling dervishes.

By 1980, a new generation of media-oriented artists such as Robert Longo, David Salle, and Cindy Sherman, themselves the students of conceptual artists, were making work that was stylish, carefully crafted, and thematically responsive to popular culture. Dancers too showed an energetic rebound from conceptual art's purist approach. Molissa Fenley created high-speed dances with levels of stamina built up in a gym-training regime, Karole Armitage re-introduced the perfectionism of ballet technique into her post-modern pop material, and Bill T. Jones and Arnie Zane built on the improvisation exercises of their predecessors in exploring the psyches of dancers in relationships, creating provocative works that foregrounded their own relationship, and also resulted in a breakthrough in partnering conventions. These young choreographers even returned to theatrical devices such as costuming, sets, and non-serial music which the '70s choreographers had rejected. Jane Comfort used spoken texts and sign language as the basic rhythms for her choreography of current affairs,

while Jawole Willa Jo Zollar, Ishmael Houston Jones, or David Rousseve, used dance in the late '80s not only to probe the history of racism in America, but also to find in their African heritage the roots of movements embedded in American bodies. "This country is more Africanized than we realize," Zollar said, noting the different ways in which Europeans and Americans walk their streets.

For European choreographers, '80 Dance Theater was the culmination of several threads of modern dance history. Its expressionistic and eurythmic roots lay in Mary Wigman and Rudolf Laban's teaching in the early years of the century, while its dramatic theatrical thrust came from the rigorous schools of dance established by Kurt Jooss's Folkswangschule in Essen, and Maurice Béjart's school Mudra in Brussels in the '50s and '60s. The new world of American dance provided the radical ingredients that would allow choreographers like Pina Bausch and William Forsythe to soar into previously unimagined realms while maintaining the technical brilliance of classical training. Bausch created vivid landscapes on stage—flooding it with water, or covering it with a deep layer of earth—in which male and female dancers reached for one another in a tangle of demonstrative movement. Forsythe created a complex movement vocabulary of his own, only to explode its conceptual boundaries with material inspired by a choreographer such as Trisha Brown, or a director like Robert Wilson.

Dance as theater—in which the physicality of violently charged bodies resulted in emotional and visual narratives—animated every part of the stage space in breathtaking ways. The early '80s saw innovative material, layered with spoken words, song, music, film, and video projections, of choreographers such as Anne Teresa De Keersmaeker or Jan Fabre as well as Bausch and Forsythe, that generated a high level of excitement later in the decade, and led to a choreographic explosion in France, Germany, Belgium, and the UK. It was a métier that suited a generation raised on plenty, financially secure, media-literate, and highly educated, especially about the '60s and '70s avant-garde. The new choreographers scratched persistently at our fast-paced, image-wracked, *fin de siècle*, bringing to the surface unforgettable images of contemporary culture.

In addition, these young European companies were soundly supported by government programs, vying for cultural leadership. Opera-scale theaters and fully employed dance companies in Brussels, Frankfurt, Berlin, Paris, (unheard of in the United States) and annual dance festivals, in turn expanded audiences for choreographers such as Meg Stuart, Wim Vanderkeybus, Susanne Linke, Maguy Marin, Philippe Decoufle, Jérôme Bel, Sasha Waltz, Jo Fabian, Neuer Tanz, DV8, and many more. The choreographers of the '90s continue to experiment with movement, text, media, and architecture, and to explore race, sexuality, and politics. For them, dance is an eloquent medium for showing us the truth about ourselves.

MERCE CUNNINGHAM
Exchange, 1978

Cunningham (far right in the picture) was principal dancer with Martha Graham in 1940 and formed his own company in 1953, playing a seminal role in the history of the arts in postwar America and Europe during his remarkable fifty-year career. Collaborating with many of the most innovative artists of this century, from John Cage to Robert Rauschenberg, Andy Warhol to Rei Kawakubo, from one creation to the next he pushed himself and his dancers into new territoriest. *Exchange* was a large-scale piece, lasting 37 minutes, and contained several of his choreographic signatures, including chance operations and recurring phrases. It was created for his newly enlarged company of fourteen dancers, with "old" members and "new" "exchanging" movement passages. "His physical presence made everything possible," remarked former student and Judson Dance Theater pioneer Yvonne Rainer. "You must love the daily work," he always told them.

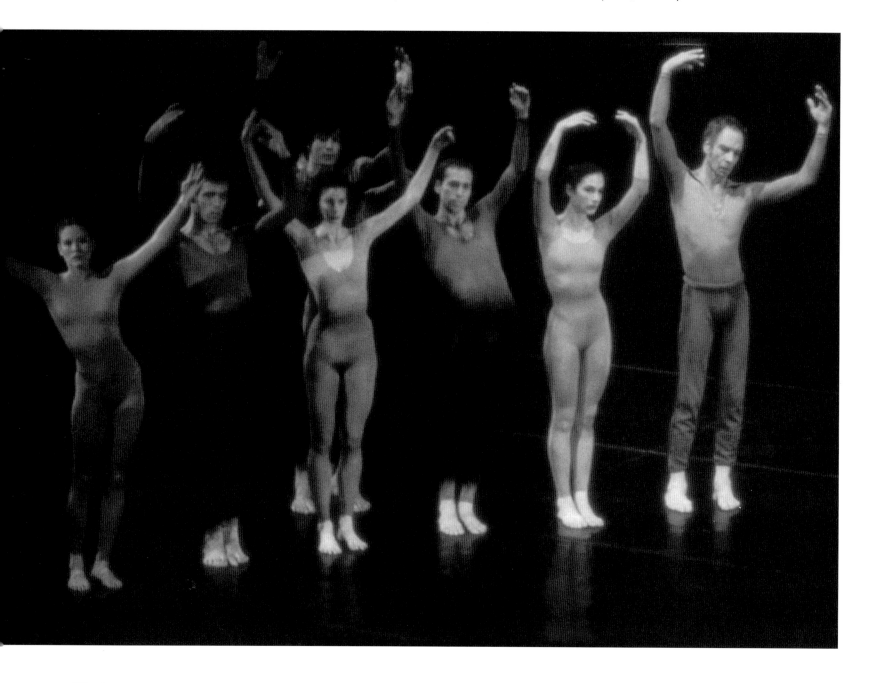

◄ **ANN HALPRIN**
Esposizione, 1963

▼ **SIMONE FORTI**
The Zero and *Crawling*, 1974

The movement "explorations" of Ann Halprin, the seminal West Coast teacher, attracted dancers and artists to her open-air studio—a platform deck built in the woods outside San Francisco. For *Esposizione* at the Venice Opera House, five dancers performed on a suspended web of rope netting. "Our basic way of working," wrote Simone Forti, who began with Halprin in 1956, "was improvisation, following the stream of consciousness." Forti moved to New York in 1960, where she developed her own material, focusing on three "movement themes"— crawling, animal movements, and circling. She gave regular concerts in her downtown loft, and in 1974 performed at the Sonnabend Gallery.

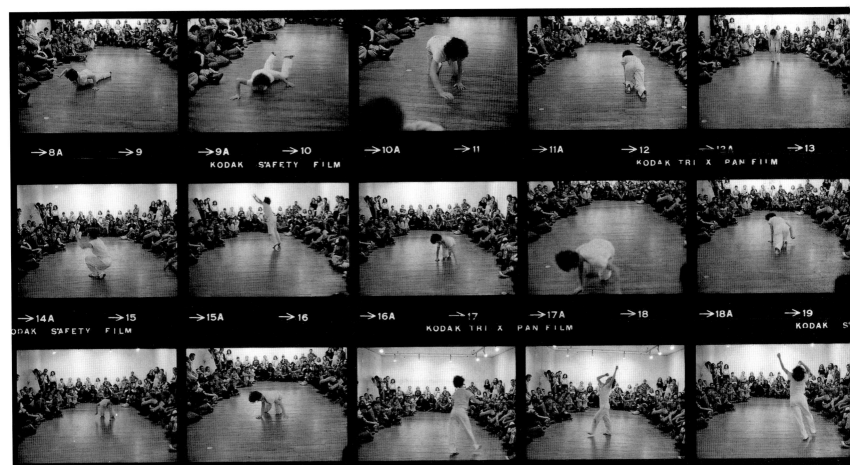

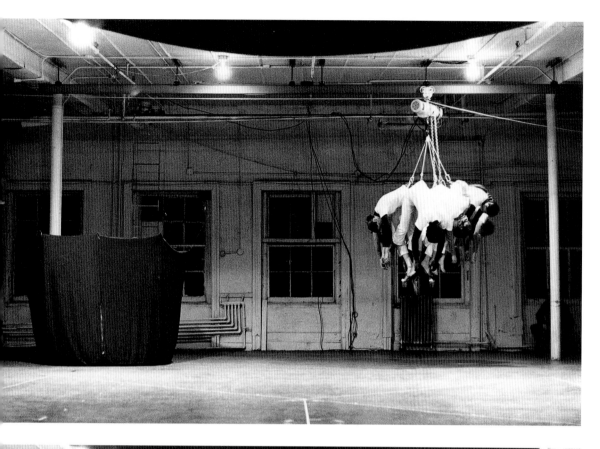

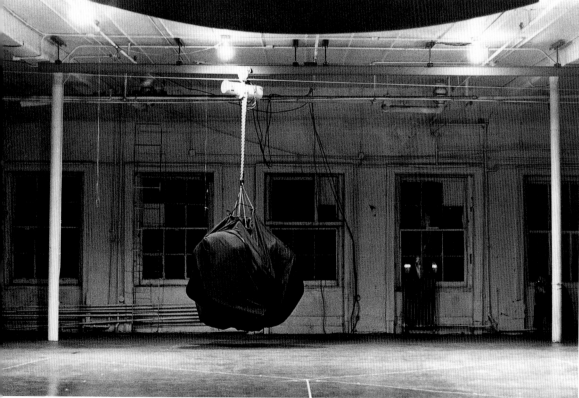

SYLVIA WHITMAN
Untitled, 1975

The Idea Warehouse was one of New York's many downtown loft spaces taken over by artists for evenings of dance, music, and performance experiments. Small audiences, mostly fellow artists, sat on the floor on foam cushions in expectation of one surprise after another. Sylvia Whitman's untitled event was a slow-motion "huddle"; suspended by ropes and connected to a pulley, dancers were picked off the floor, slowly moved across the loft, and "bagged" when they reached the other side.

► GRAND UNION
Trisha Brown, Steve Paxton, Douglas Dunn, David Gordon, Barbara Dilley, 1976

Grand Union evenings were marked by a supportive inventiveness that came from nine dancers having worked together for over a decade in various combinations at Judson Dance Theater, Cunningham Studios, or Halprin workshops. They were committed to pushing each other even further in improvisation and the "process of dance-making." The work was conversational, funny, always performed in casual clothes. They constantly checked the balance between professional dancer and amateur, between technical polish and ordinary gestures, commenting to one another as they worked. "Is this the best you've ever had it, Trisha?" from the top of a ladder was a typical Brown non-dance question. Another dancer might shoot back, "Is this your first time?"

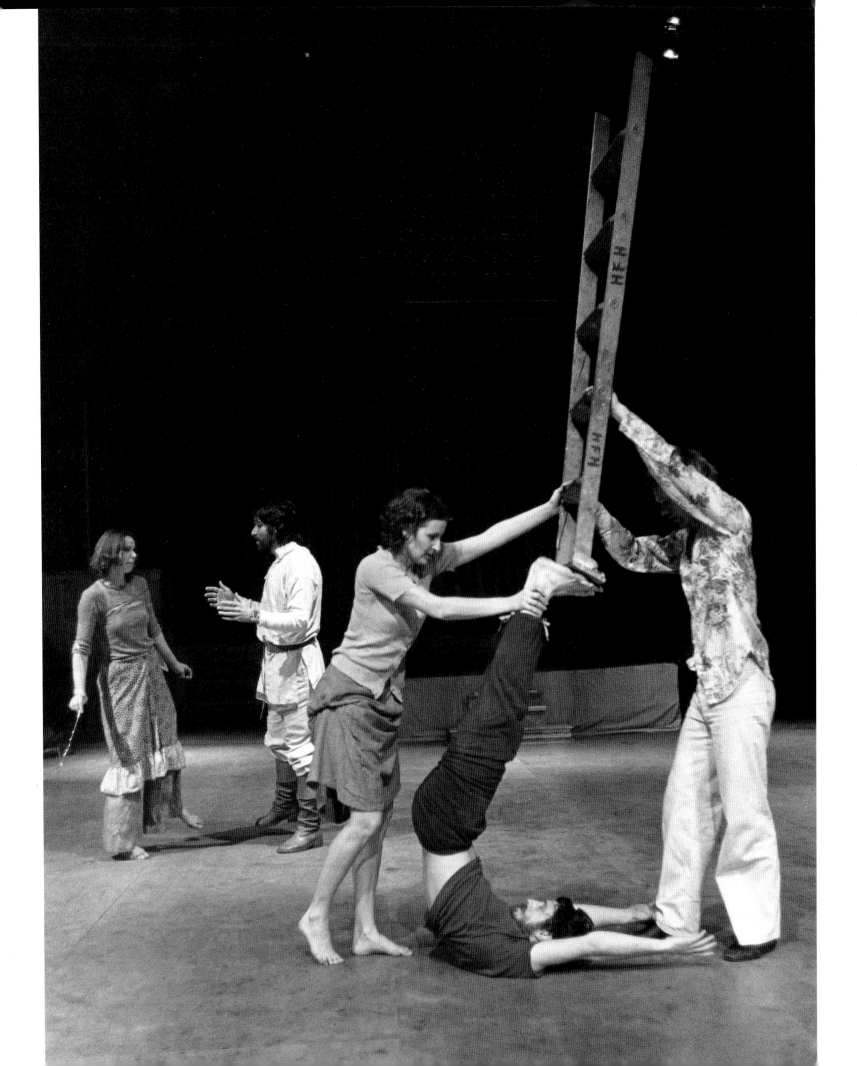

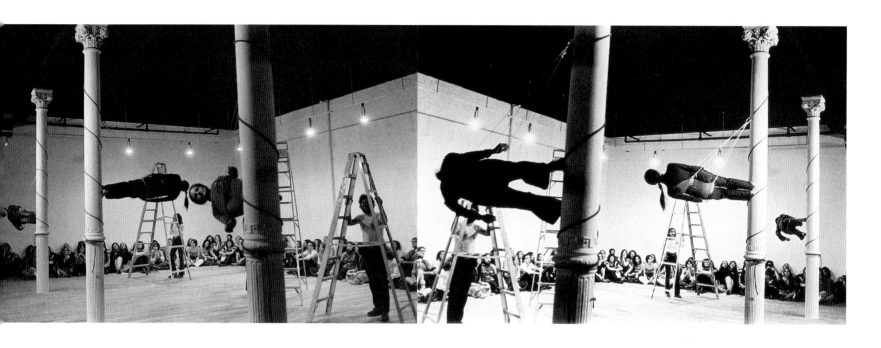

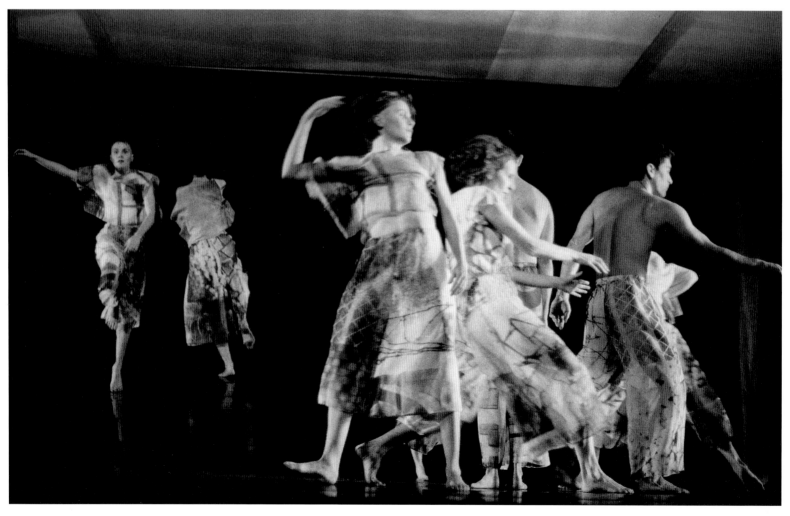

TRISHA BROWN
Walking on the Wall, 1974
Set and Reset, 1983
Astral Convertible, 1989

From the start, Brown questioned the meaning of movements and their consequences. *Accumulations* (1971) dealt with repetitions, and "equipment pieces" like *Walking on the Wall* pitted natural movement against gravity. *Set and Reset* played with her desire to use the whole stage—ceilings and walls—and to fill the space with music unrelated to the dance; Anderson's music was composed after the choreography, and Rauschenberg's sets had an overhead screen but no wings. *Astral Convertible,* here shown at City Center, New York, premiered in Moscow in 1989; Rauschenberg designed the costumes and set so that the piece could be performed outdoors.

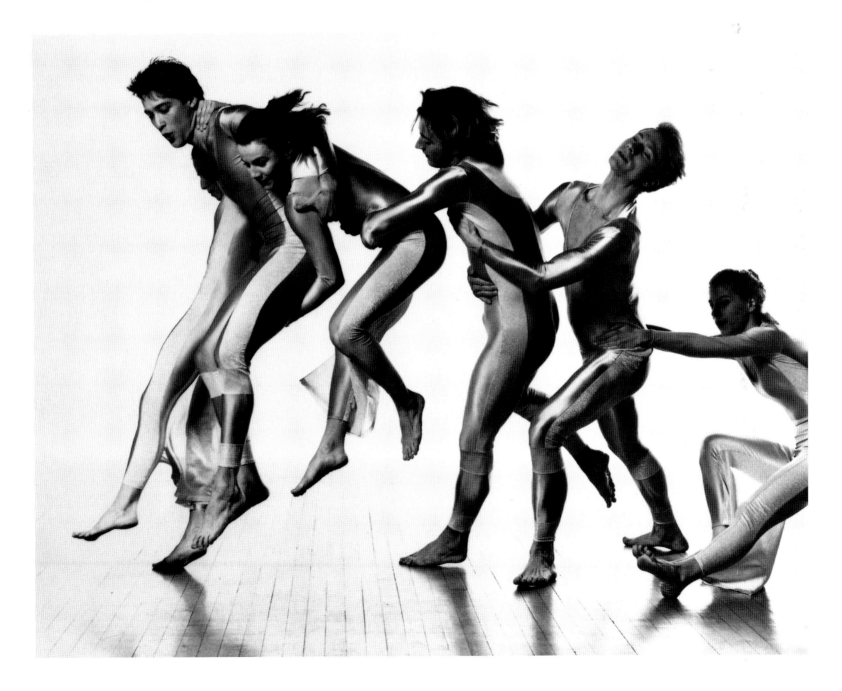

▼ LAURA DEAN
Changing Pattern Steady Pulse, 1973

Dean's characteristic spinning was the result of simply walking in a circle. "If you lean your body in," she has said, "you automatically begin to spiral." An elaborate counting system, geometric drawings, and an acquired resistance to dizziness, provided dancers with spinning basics; from there she developed the form over a period of twenty years into an elaborate kaleidoscope of movement. Her dance vocabulary included a simple heel, step, heel, step; a dervish-like spin (solo or in formation); and a sideways bounce (knees bent, feet wide apart) like a boxer readying for the punch. Dean has also composed almost all of the complex and pulsing scores for her more than forty works.

► LUCINDA CHILDS
Available Light, 1983

Childs's choreography evolved from intimate, object-focused gestures at Judson Dance Theater in the '60s into elegant three-dimensional designs in the '70s in which dancers covered large blocks of space . The choreographic masterplan was based on intricate and beautiful drawings, and Childs's dancers found a rhythmic "pulse" in the "architecture" of the space, rather than, say, through counting systems or musical phrasing. In *Available Light,* performed at the Brooklyn Academy of Music, architect Frank Gehry's rugged two-level set with trademark wire fence, and the layered and structured music of John Adams heightened Childs's rigorous sensibility. Ronaldus Shamask designed the costumes for this unusual collaboration.

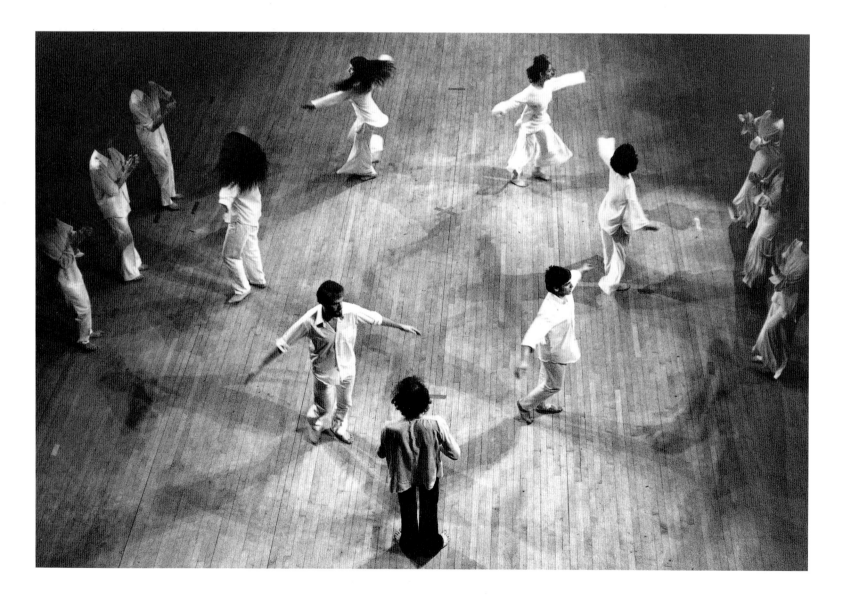

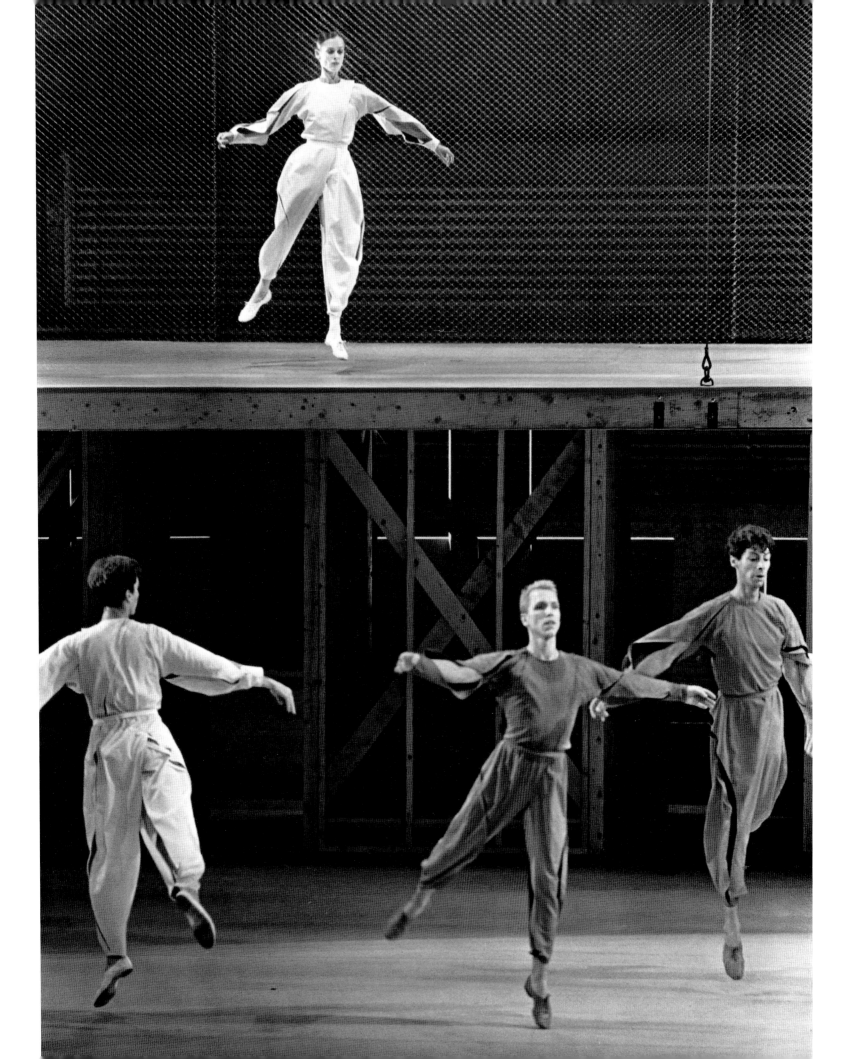

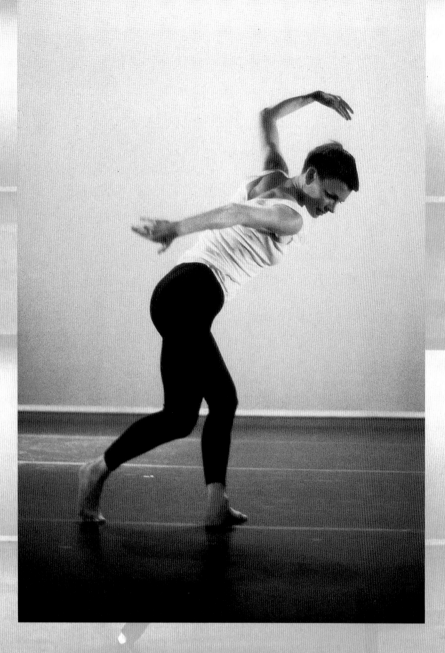

MOLISSA FENLEY
Energizer, 1980
Bardo, 1990

In the 1980s, virtuosity, costumes, lighting, and music were reintroduced into avant-garde dance after almost two decades. Young choreographers took advantage of their mentors' licence to explore new movement, but spiked their material with the current everyday: media, spectacle, and new music. Fenley's dancers even did sports training to build the stamina for works such as *Energizer,* in which they catapulted across the stage at breakneck speed. In 1987 Fenley went solo, and since then has created a remarkable series of works that demand absolute concentration if the viewer is to see the underlying patterns of her choreography. *Bardo,* for example, performed to chants composed by Somei Satoh, took place on a stage which the dancer envisaged as "a rectangle sliced diagonally from upstage to down."

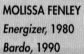

BILL T. JONES AND ARNIE ZANE
Valley Cottage, 1981
Still Here, 1994

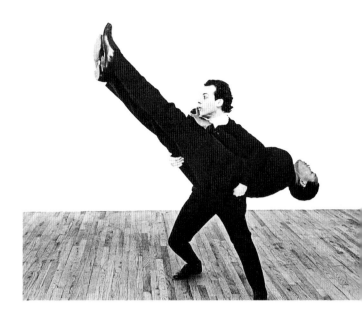

With their earliest work, Jones and Zane broke the barriers of partnering traditions between men, adding impromptu conversations about their domestic relationship. They went on to create a dance company that would be celebrated for its canny commentary on American popular culture and politics. *Still Here,* a disturbing work on death and dying, combined on-screen video interviews of critically ill patients, Gretchen Bender's projections of them, and dancers who moved in heart-rending choruses as though in a silent requiem for the dead.

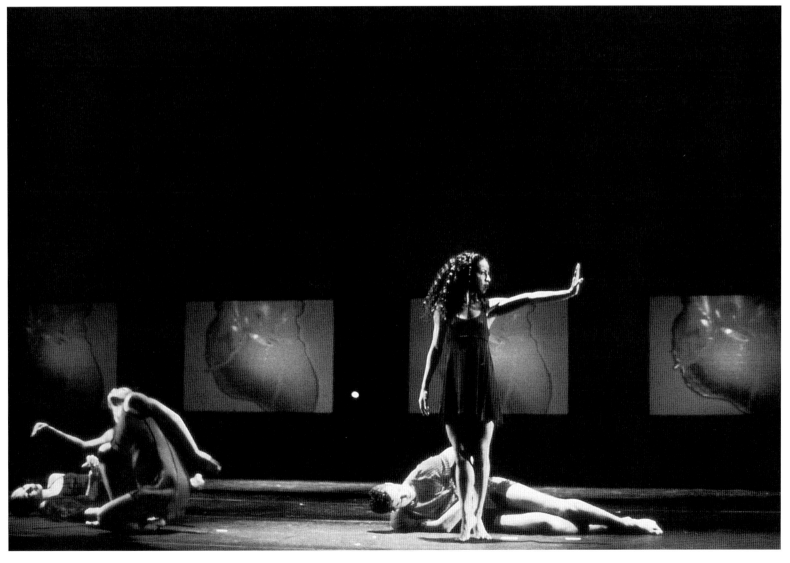

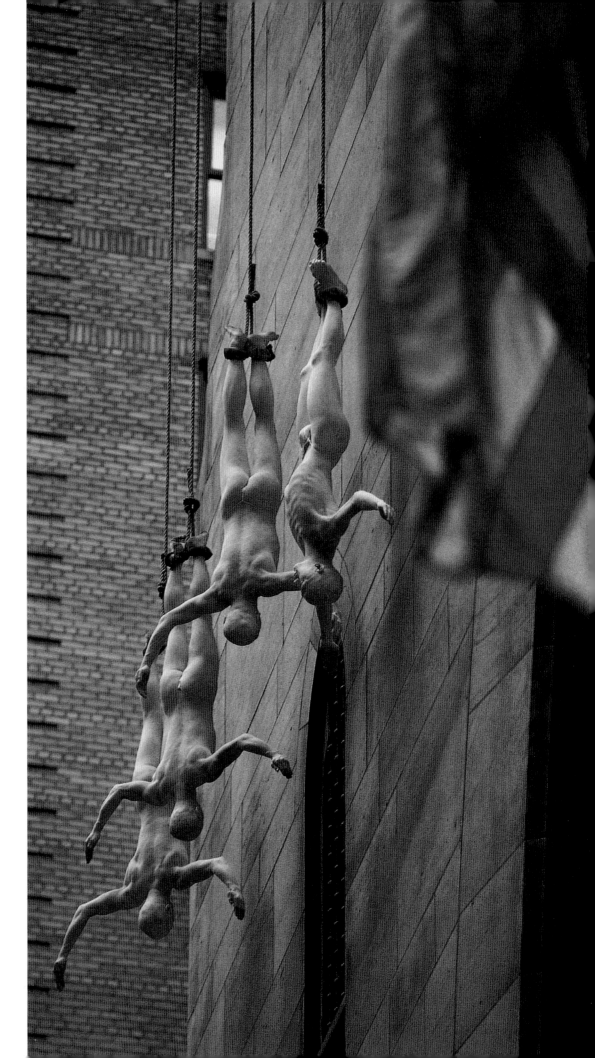

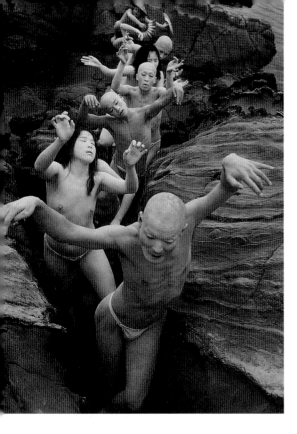

▲ DAI RAKUDA KAN
The North Sea, 1975

► SANKAI JUKU
Homage to Pre-History, 1984

Akaji Maro, a disciple of Butoh co-founder
Tatsumi Hijikata, went on to form the group
Dai Rakuda Kan (the Great Camel Battleship),
and created works connected to the primeval
myths of ancient Japan. It was he who instigated
the white body paint and shaved heads that
came to be considered a hallmark of this form.
Ushio Amagatsu, a former member of Dai
Rakuda Kan and founder of Sankai Juku
(the Studio of Mountain and Sea), wrote,
"When I think of dance, the image of a
prehistoric painting comes to mind." In their
early works, performers hung in the air in a
breathtaking unfurling of bodies that suggested
the passage between birth and death.

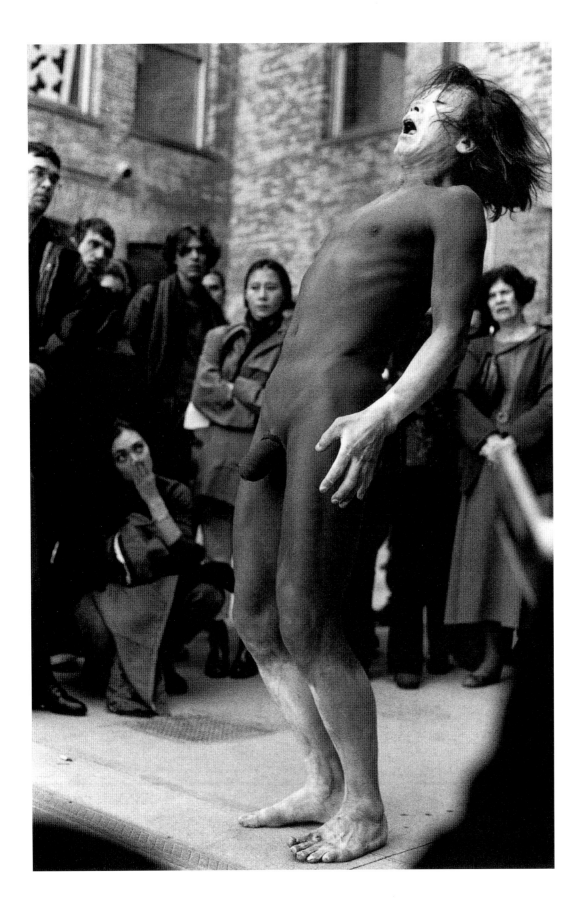

MIN TANAKA
Solo Dance, 1998

In 1977 Tanaka traveled the length of Japan from Kyushu to Hokkaido, dancing every day, sometimes two or three times a day, usually naked. He wished to feel the difference in the ground at different places—"I dance not in the place, I dance the place"—he said. Distinguishing his work from that of the master Hijikata, highly expressionistic and dramatic, he created material that was minimalist and sculptural. He improvises each solo work based on the setting of an individual performance, and in 1998 he performed on the steps of the newly re-opened exhibition space P.S.1 in Long Island City, New York, in homage to the artist Jack Smith.

ELIZABETH STREB
Up!, 1996

Streb's early performances mixed a brute athleticism with a highly sculptural approach to the body in space—throwing herself into small boxes, pivoting on one hand, and low to the floor, each movement twisting the body into new shapes. In the '90s, Streb built a company of high-flying dancers who crash through space with the daring of stunt artists. The result is a series of works that mix acrobatic synchronization with a Road Warrior-style romantic violence.

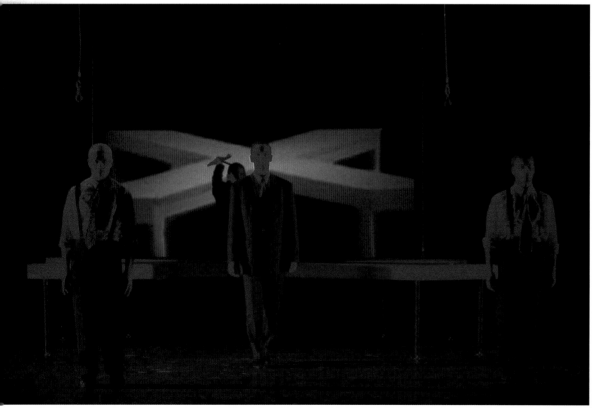

KAROLE ARMITAGE
Predators' Ball, 1996

Armitage has aggressively taken her dance into the pulp-fiction world. *Predators' Ball* is an original work of dance theater about the jailed junk-bond king Michael Milkin. With sets by David Salle, animation videos by Erica Beckman, and a chorus of rappers and poppers, her frenetic choreography matches the drive of Wall Street's operators.

STEPHEN PETRONIO
Drawn that Way, 1997

Known for the brash physicality of his choreography, and the provocative sensuality
of his work's content, Petronio's theatrical and highly styled dances also capture
the edginess of contemporary art. Collaborations with musicians Yoko Ono or
Diamanda Galás, and visual artists such as Cindy Sherman, make important
connections between contemporary visual, aural, and spatial viewpoints.

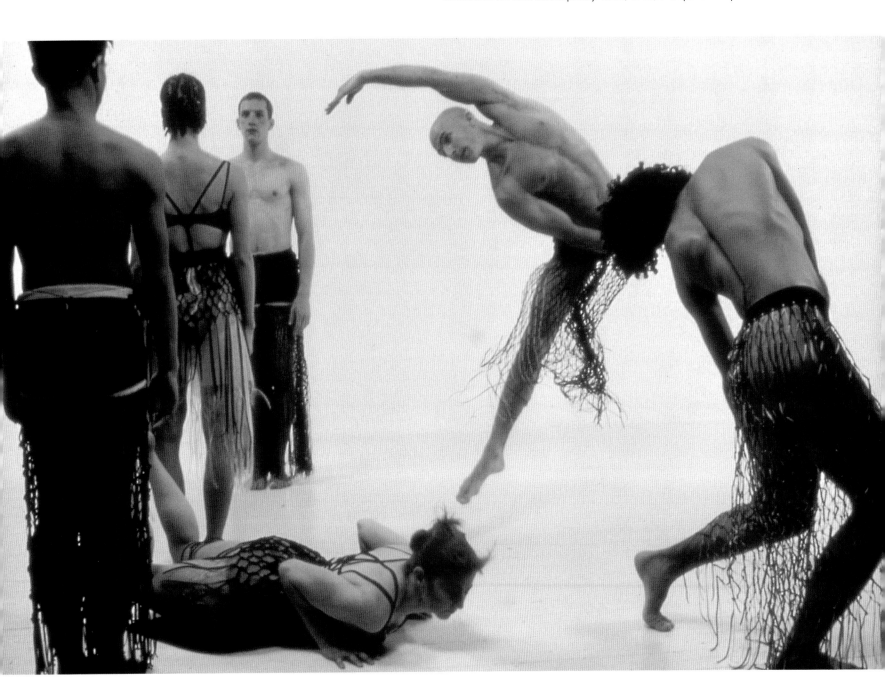

TERE O'CONNOR
BOY, BOY, GIANT, BABY, 1985

One of O'Connor's earliest performances (at St. Marks Church, New York), *Boy,* investigated "the repressed voice of a gay man" and set the central theme for many of his later works. With a vocabulary of balletic gestures, hand signing, and "street moves" of swiveling hips and athletic leaps, O'Connor uses dance "as a text" to articulate deeply personal and emotional content. His most recent works use spoken words—"dance plays" he calls them—and have an underlying social commentary.

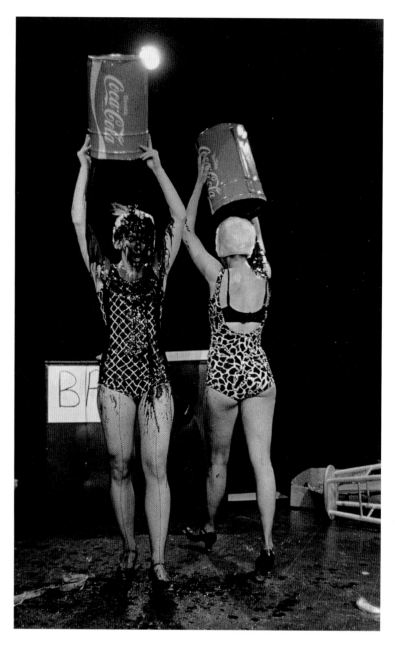

DANCE NOISE
½ a Brain, 1992

Anne Iobst and Lucy Sexton's fast-paced barrages of colorful costume, comic dialogue, and aggressive dancing have an agenda: to parody fiercely everything that their alert minds and finely tuned bodies find pompous and absurd—in politics, the art world, or the media. "It was the summer when infected needles and medical waste was coming up on the beaches," explained Sexton. "We used Bobby Darrin's 'Sand and Sea' for our soundtrack."

JANE COMFORT
Deportment, 1991

Comfort builds her choreography on the
rhythms of language, making intriguing visual
connections between meaning and physical
mannerisms. Her dancers talk in a patter that,
through repetition, becomes a movement
pattern. In this work, four of them show
that good deportment hides an undertow
of aggression, racial hatred, and social
back-biting.

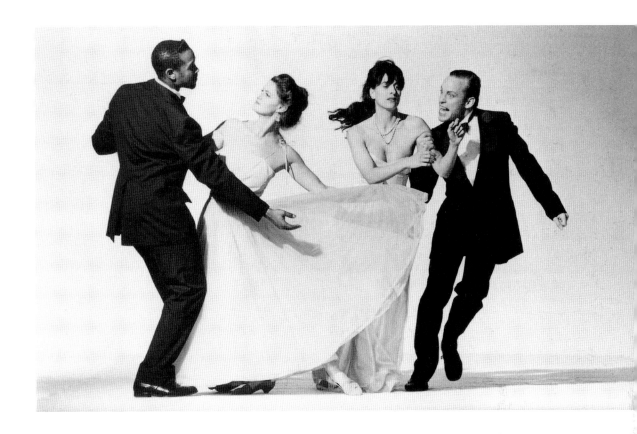

URBAN BUSH WOMEN
Nyabinghi Dreamtime, 1993

Choreographer Jawole Willa Zo Zollar seeks
out the African roots in art, music, dance, and
religion of contemporary America, creating
performances that are an encyclopedia of
African-American imagery and movement.
Nyabinghi is a ceremony of dancing,
drumming, and singing in the Rastafarian
tradition, lasting anything from three to
twenty-one days, and also carries the drama
of Rastafarian protest and resistance. Produced
after the company's research trip to Jamaica,
it carries the rhythms, songs and politics of
a significant outpost of the black diaspora.

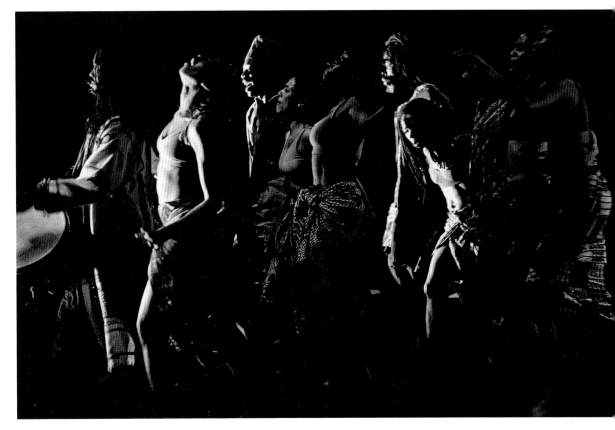

► **DANCE FOR THE CAMERA**
The Rime of the Ancient Mariner, 1993, first series
Dwell Time, 1995, third series

The Arts Council/BBC2's *Dance for the Camera,* choreographed for television, has produced a series of short films exploring bodies in space in highly original ways. *The Ancient Mariner* was a classically based work choreographed by William Tuckett. *Dwell Time,* choreographer Siobhan Davies, showed how different spaces— a roof top, an empty room—affect the way people move. The classical elegance of one and the low, broad movements of the other made very different visual narratives.

▼ **DAVID ROUSSEVE**
The Whispers of Angels, 1995

Part 2 of Rousseve's *Dream Series,* the story of a young, gay African-American man, dying of AIDS, is told in dance, with house and gospel music, rap, poetry, and jazz.

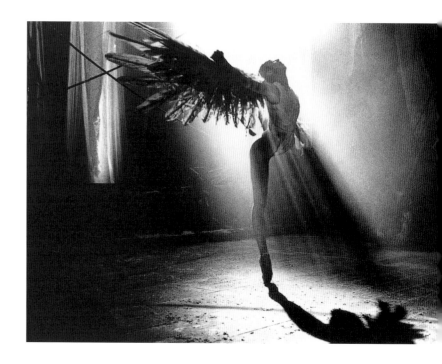

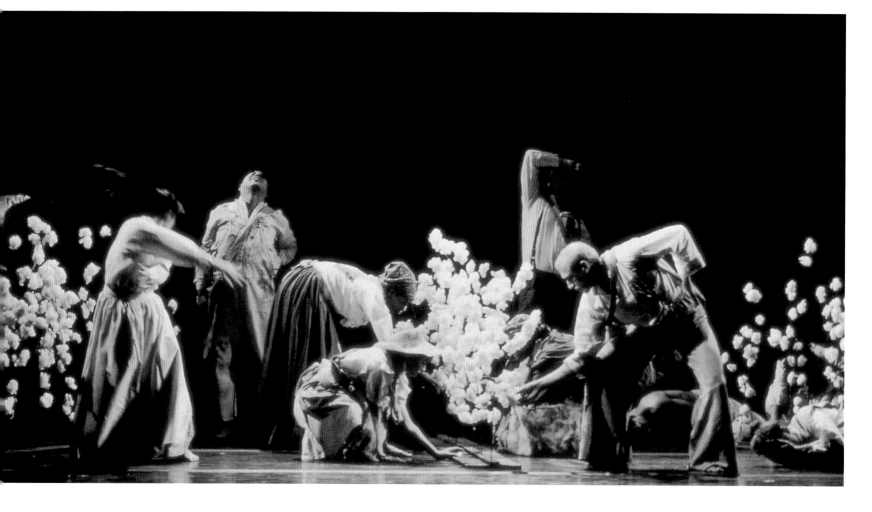

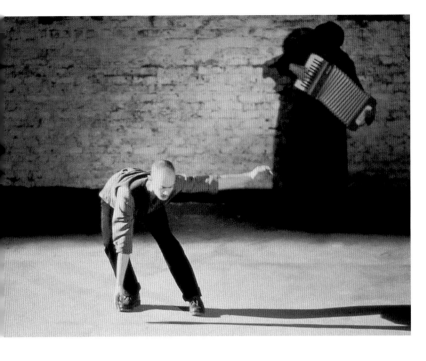

▼ **DV8**
Enter Achilles, 1996

The Arts Council/BBC2 film version of Lloyd Newson's work, a strong narrative of masculinity and its excesses, was made by Dutch director Clara van Gool and shot on location in a London pub and on the towpath of the Grand Union Canal. It was remarkable for the visually rhythmic camera work which captured and translated Newson's compelling choreography and the fierce physicality of the dancers' bodies for the small frame of television.

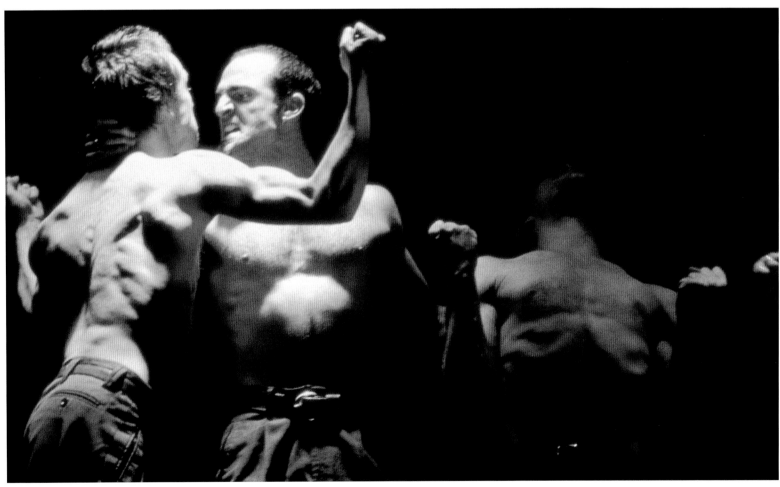

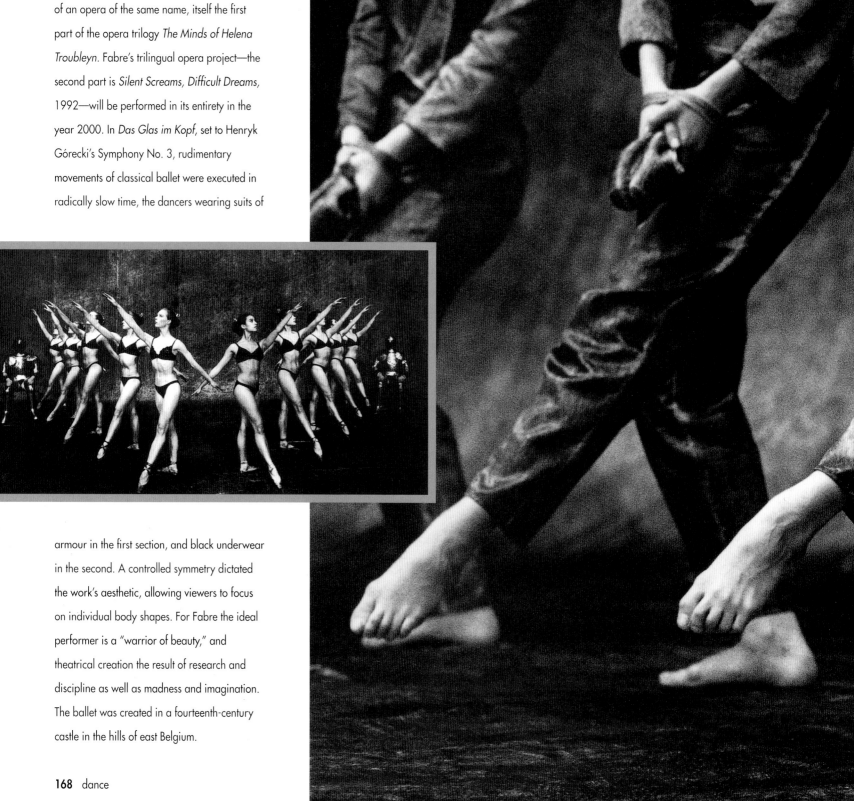

JAN FABRE
Das Glas im Kopf wird vom Glas: The Dance Sections, 1987

Fabre's first full-length ballet is the first section of an opera of the same name, itself the first part of the opera trilogy *The Minds of Helena Troubleyn*. Fabre's trilingual opera project—the second part is *Silent Screams, Difficult Dreams*, 1992—will be performed in its entirety in the year 2000. In *Das Glas im Kopf*, set to Henryk Górecki's Symphony No. 3, rudimentary movements of classical ballet were executed in radically slow time, the dancers wearing suits of armour in the first section, and black underwear in the second. A controlled symmetry dictated the work's aesthetic, allowing viewers to focus on individual body shapes. For Fabre the ideal performer is a "warrior of beauty," and theatrical creation the result of research and discipline as well as madness and imagination. The ballet was created in a fourteenth-century castle in the hills of east Belgium.

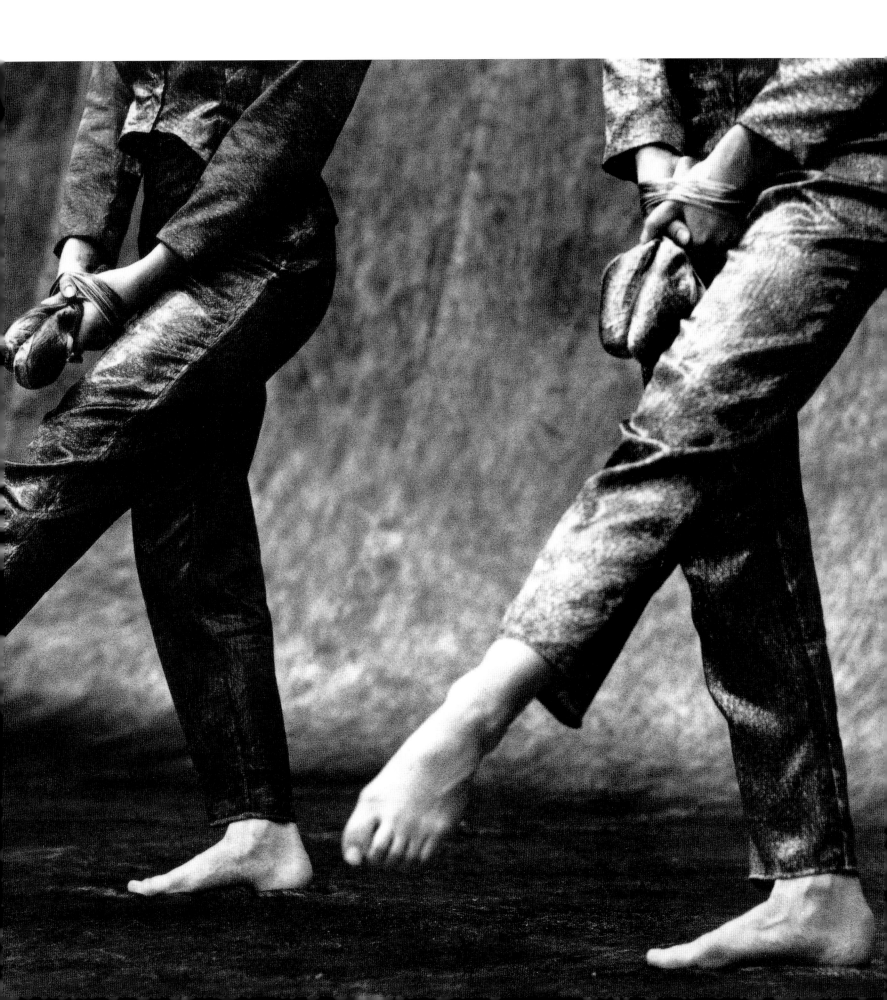

WILLIAM FORSYTHE
Loss of Small Detail, 1991
Eidos: Telos, 1995

Forsythe's brilliance lies in his ability to contrast techniques of classical ballet and modern dance with investigations into the roots and rhythms of dance from around the world. He further stretches the aesthetic of his productions with the latest technology—CDs as notation and choreographic tool, as well as image- and music-bank for projections and custom-made sound. *Loss of Small Detail*, with costumes by Issey Miyake, includes texts by Yukio Mishima and Jerome Rothernberg. *Eidos: Telos* has a monologue by Dana Caspersen, and video projections by Richard Caon. Both these works were performed in the Ballett Frankfurt Opera House.

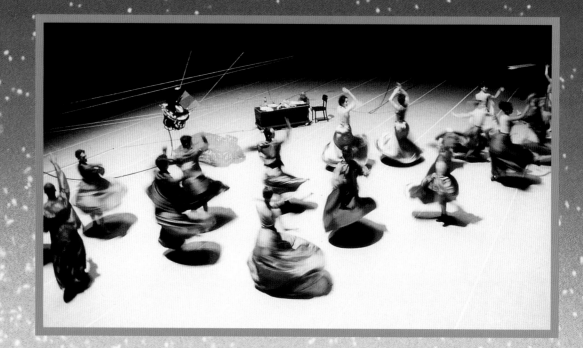

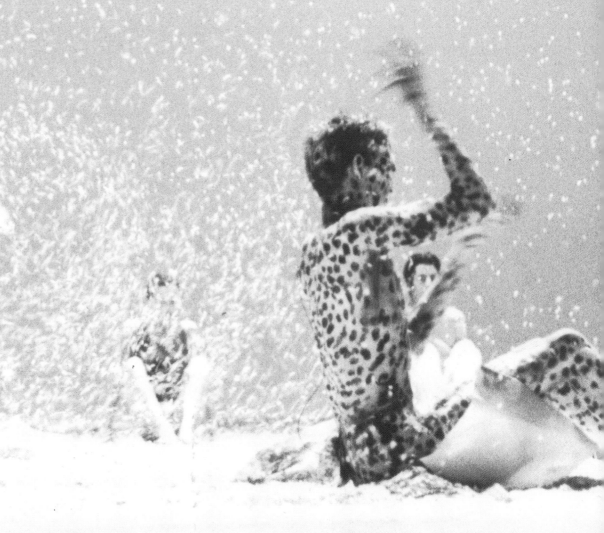

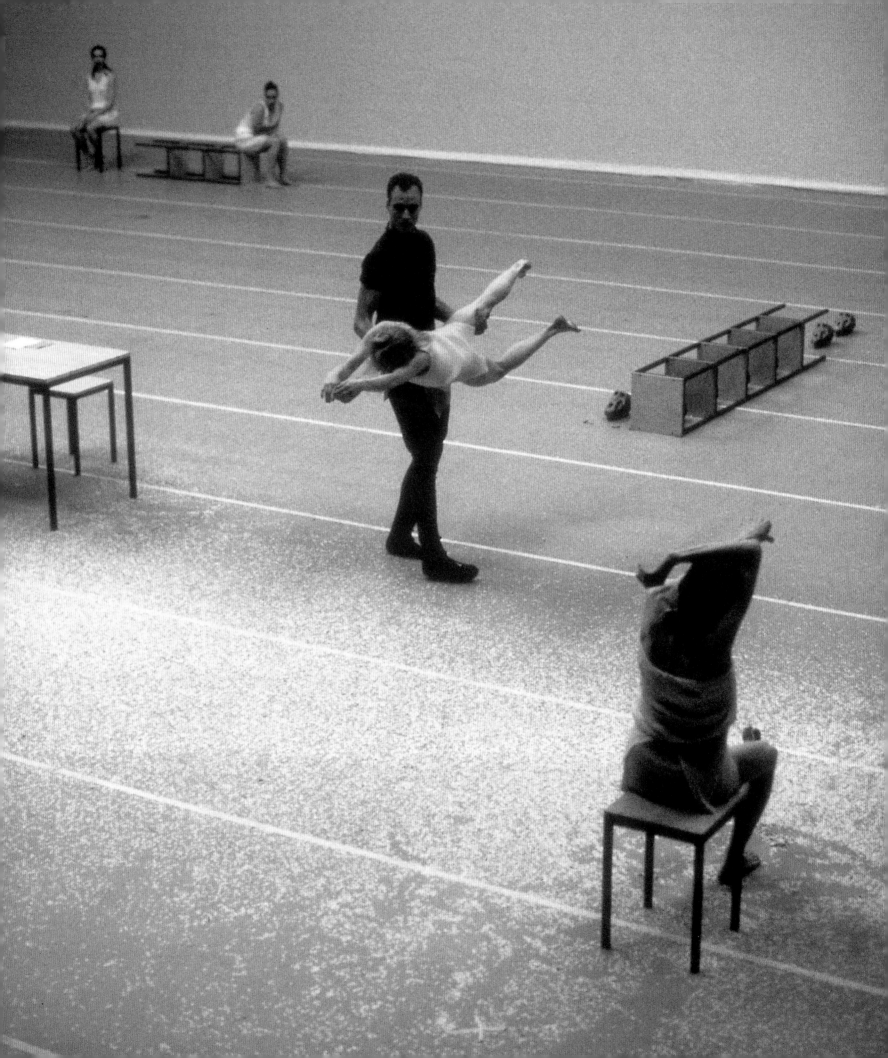

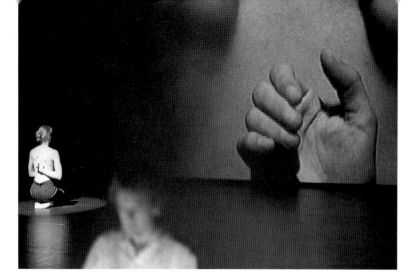

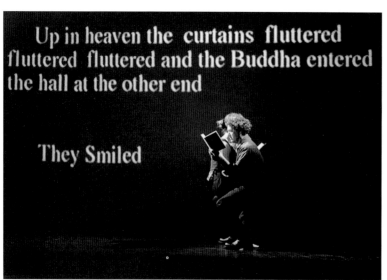

Up in heaven the curtains fluttered fluttered fluttered and the Buddha entered the hall at the other end

They Smiled

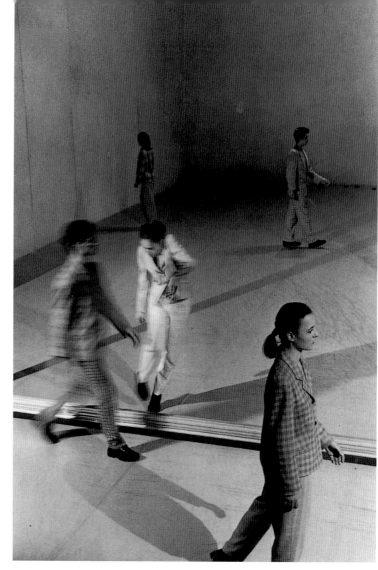

▲ MEG STUART AND GARY HILL
Splayed Mind Out, 1997

This collaboration between choreographer and artist was created in a three-week workshop to avoid splitting the creative process into "choreography" and "video." Stuart and Hill found common ground in their fascination for the body—his for the body as readable visual surface, hers as visceral spatial object.

◄ NEUER TANZ
XYZ, 1996

Choreographed by visual artist VA Wölfl for a company known for its focus on the body as sculptural form, *XYZ* recalls the geometric "stick dance" of Oskar Schlemmer's 1920 performance; dancers carry fluorescent light tubes instead of wooden poles, and create moving pictures for the eyes that are eloquently minimalist. This was performed at the 1996 World Theater Festival in Dresden.

► ANNE TERESA DE KEERSMAEKER/ROSAS
Achterland, 1990

The kamikaze physicality of De Keersmaeker's fast-paced choreography for the Rosas company of Brussels had the dancers leaping off platforms and tumbling across the floor. Sometimes barefoot, sometimes wearing Barbie Doll-style pumps, their airborne bodies made fierce contact with the ground, like break-dancers on the street. Now and then they stilled their manic movements to wind themselves quietly around beautiful and emblematic chairs, which appear regularly in the company's productions. In *Achterland*, in alternating sections, five women and five men danced to live music. The men were accompanied by a violinist on stage playing Eugène Ysaÿe's *Three Sonatas for Solo Violin*, and the women by a pianist playing György Ligeti's *Eight Studies for Piano*, an expression of a sensual and modern battle between the sexes.

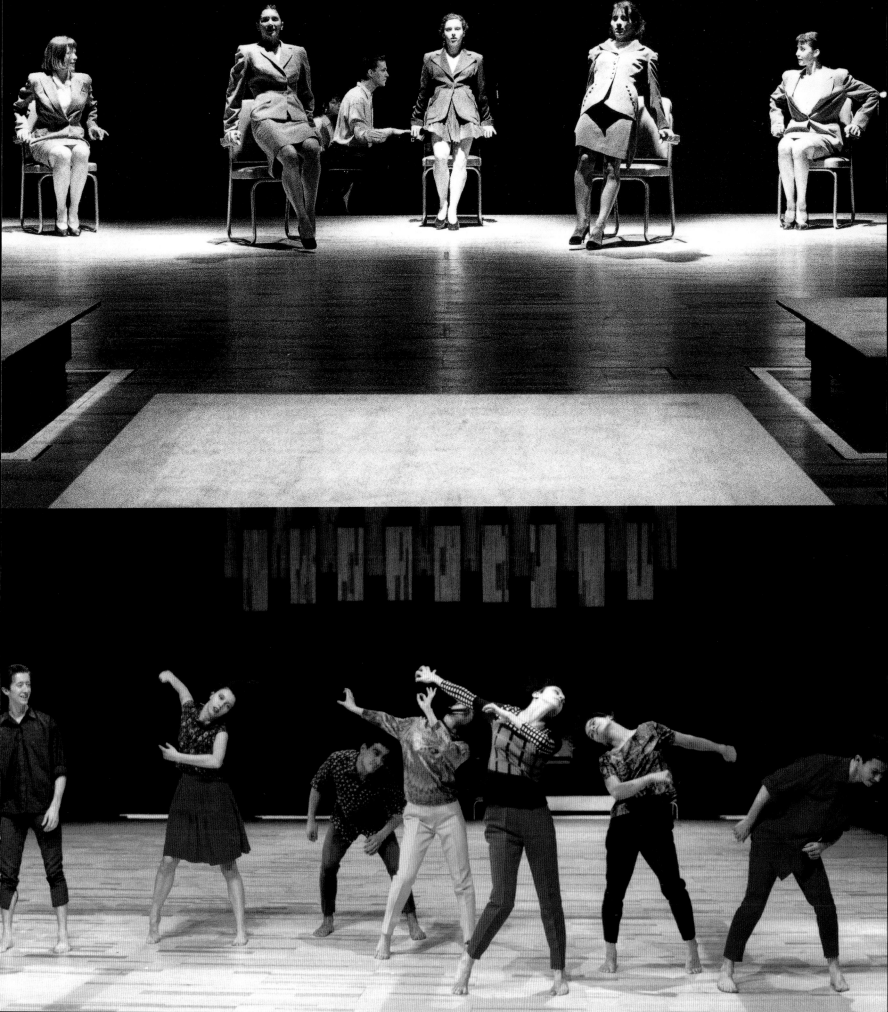

GARTH FAGAN
Griot New York, 1991

This exquisitely eloquent work, both a narrative and a collection of abstract choreographic shapes, was performed at the Brooklyn Academy of Music, with music by Wynton Marsalis and sculpture by Martin Puryear.

RALPH LEMON
Geography, 1997

A music and dance-theater exploration of African heritage, with performers from the Côte d'Ivoire, Guinea and the USA (bottom). Paul D. Miller (aka DJ Spooky) composed the music, Nari Ward designed the set.

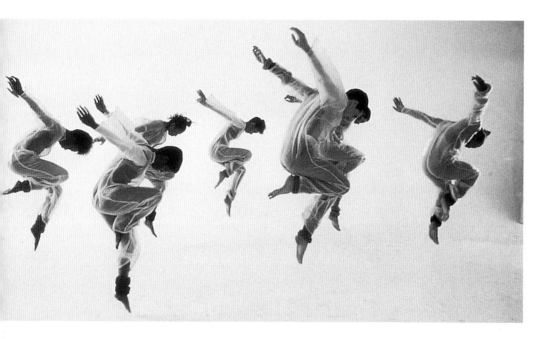

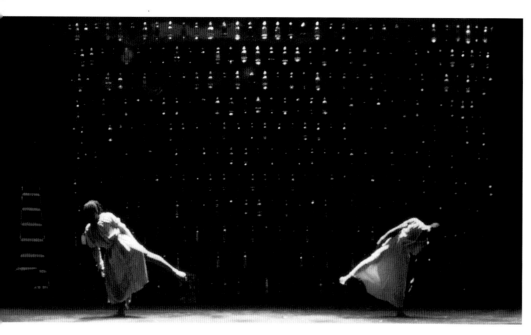

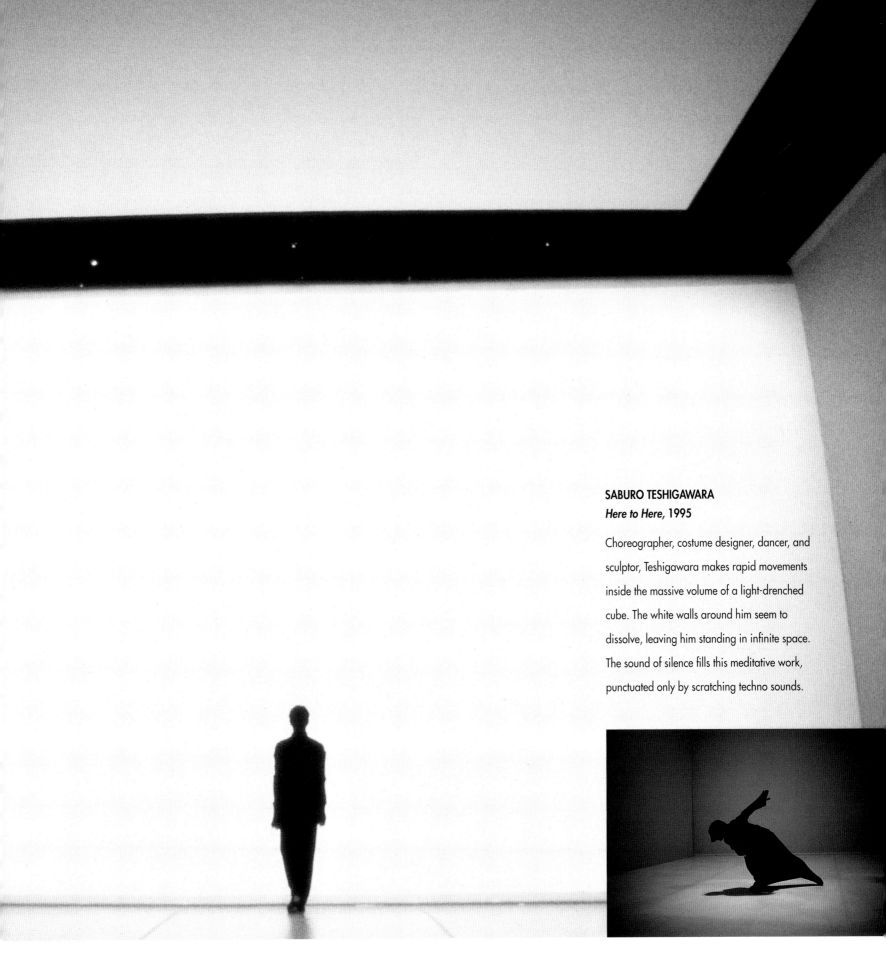

SABURO TESHIGAWARA
Here to Here, 1995

Choreographer, costume designer, dancer, and sculptor, Teshigawara makes rapid movements inside the massive volume of a light-drenched cube. The white walls around him seem to dissolve, leaving him standing in infinite space. The sound of silence fills this meditative work, punctuated only by scratching techno sounds.

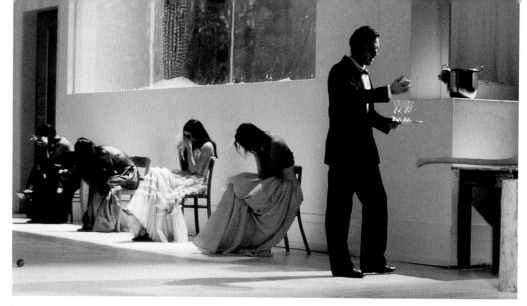

PINA BAUSCH
Two Cigarettes in the Dark, 1994

Pina Bausch, appointed director of the
Tanztheater Wuppertal in 1973, immediately
began to alter the repertoire of the company to
include her own visionary approach to modern
dance. By the end of the '70s she had created
such formidable works as *Kontakthof* (1978)
and *Arien* (1979), dazzling the European
dance, theater, and art worlds, and awakening
a generation of choreographers to the
possibilities of placing the extraordinary
physical discipline of the trained dancer at
the very center of theatrical works. *Palermo,
Palermo* (1990), commissioned for a festival in
that city, had an Italian mis-en-scène. It was a
comedy of well-worn manners, with men and
women struggling to fit together. *Two Cigarettes
in the Dark,* first performed at Wuppertal in
1985, was a far more emotionally grueling
work. The set resembled an indoor pavilion at
a zoo, while the male and female dancers
appeared as specimens in a behavioral study;
particularly unrelenting was the cruelty of male
tormentors, dressed in tuxedos, towards
long-haired, long-gowned distraught women.
A technically splendid production, exhibiting
Bausch's genius for theatrical effect, it was
remarkable as a work of dance-theater for
the strong emotions it aroused in its audiences.

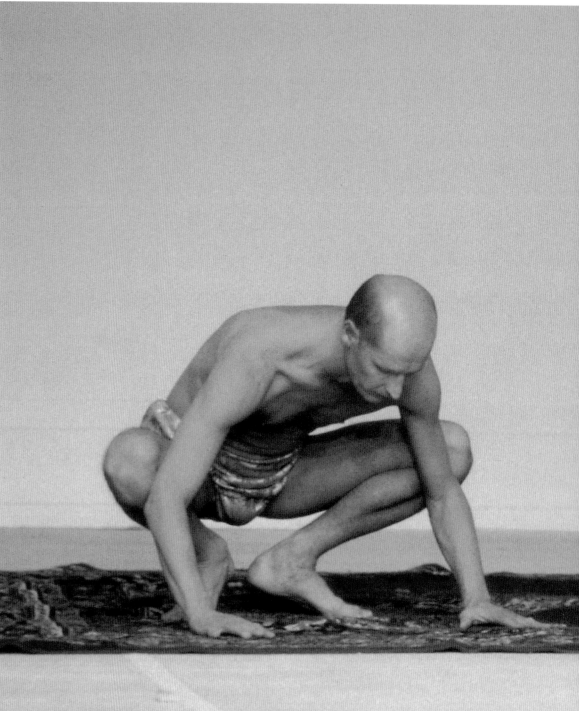

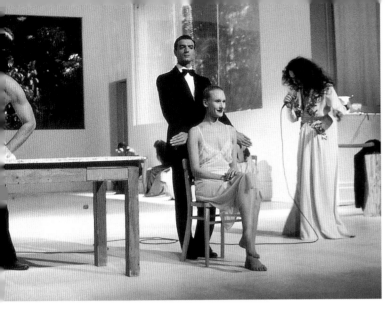

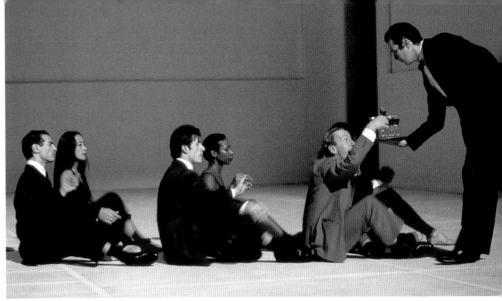

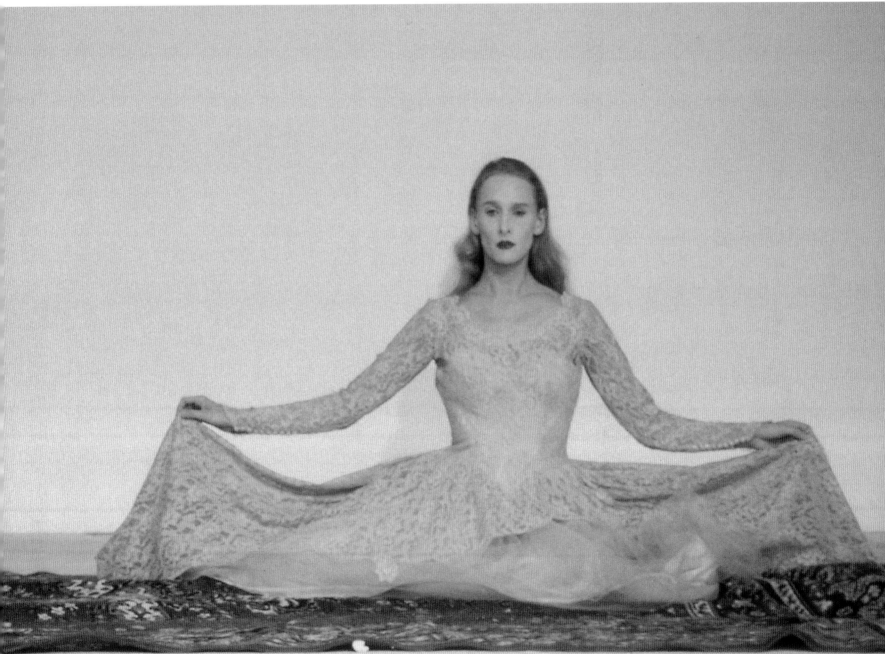

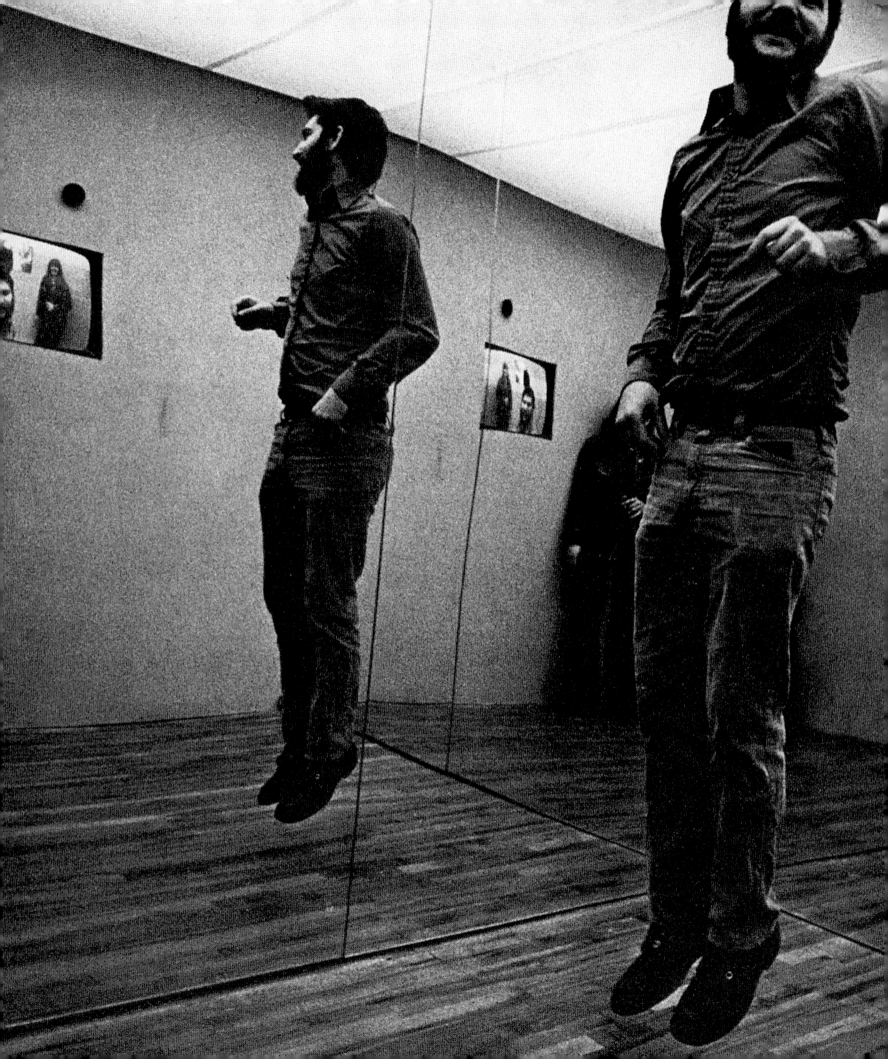

CHAPTER 6 *video, rock 'n' roll, the spoken word*

In the early 1960s, Pop Art introduced imagery from television, photojournalism, comic books, and commercial advertising into the art museum. Roy Lichtenstein, Claes Oldenburg, James Rosenquist, Andy Warhol, and others were intrigued by the fact that vast audiences, across social and economic lines, were deeply familiar with the subject matter of their ironic and emblematic paintings. The elevation to "high art" of mass culture, previously considered nothing more than a by-product of consumerism on a giant scale, would trigger early studies of "low art" by a handful of writers and critics. But for another two decades, a desire to tap into the significance of mass culture, to extricate its aesthetics, and to replicate its ability to create lasting iconic pictures of the times, would remain a preoccupation of a few artists in the downtown art world of New York and Los Angeles before it surfaced in the '80s in the art of the media generation. Popular culture entered mainstream education in the form of media studies in colleges in Europe and United States, inspiring at the same time a flood of theoretical texts on its meaning and motifs.

Andy Warhol's "Factory" on East 47th Street and from 1967 on Union Square was not only the space where he made his movies, took polaroid photographs of celebrities, and later generated ideas for *Interview* magazine, but was also a venue for stylish parties and where The Velvet Underground was launched. The eloquent boredom of those who spent hours daily in each other's company at the Factory, was captured by Warhol in several films that seamlessly joined performance and the real life of underground New York. In Warhol's world, real time had its own overriding aesthetic: a twenty-four-hour shot of the Empire State Building, *Empire* (1964), or a film of the poet John Giorno sleeping, *Sleep* (1963), was a revelatory encounter with daily existence, minute by minute, hour by hour.

Around the same time, Sony's Portopac, a hand-held video-camera designed and priced for the non-professional, became widely available. Several artists whose work involved performance, like Nam June Paik, Joan Jonas, Vito Acconci, and Bruce Nauman, incorporated the video camera and monitor into their work. Making a video or making a performance

DAN GRAHAM
Past Continuous Pasts, 1974

In a New York gallery, Graham built mirrored spaces and installed time-delay video devices. Viewers were caught watching themselves in the present, and, several seconds later, in the past.

involved more or less the same process, although the latter usually included an audience—for many artists in the '70s, the two were interchangeable. According to Joan Jonas, the main structuring element of her work was the simultaneity of live performance and video imagery. "One could take the place of the other, live activity switching to an image or vice versa," she said. Similarly, Vito Acconci's *Undertone* (1972) in which he sits at a table looking directly into the camera addressing the viewer, or his performance-installation *Airtime* (1972), were two sides of the same coin. Dan Graham's delay devices, in works such as *Two Consciousness Projection(s)* (1976) or *Present Continuous Pasts* (1974), both dealt with the experience of real time and time passing, although one involved performers and the other a video installation. Some artists developed a more precisely crafted aesthetic for their video material, yet retained the gestural quality of live performance, as did Peter Campus in *Three Transitions* (1973) when he burnt a sheet of paper on to which his live image was projected. Bruce Nauman and Paul McCarthy used video as a distancing device to record intensely private performances that were extremely strange and disturbing. For example, in *Clown Torture*, (1987), Nauman, a sad clown with painted face and large red nose, sits on a toilet in a tight stall, his baggy trousers around his ankles, sobbing and rocking from side to side. In *Santa's Chocolate Shop* (1996), McCarthy and his elves prepare a chocolate batter that ends up smeared over all of them and the small house in which they work.

Venues such as The Kitchen, founded in 1971 by video pioneers Steina and Woody Vesulka, specifically in order to screen artists' videos, showed a broad range of tapes, many of which implied a polemical counterpoint to television, and contributed significantly to the "high versus low" debate. *Made for TV?* (1979) a program at The Kitchen, including work by Lynda Benglis, Bill Viola, Nancy Holt, Robert Wilson, Julia Heyward, and William Wegman, was chosen to illuminate the differences between artists' videos and commercial videos. It also reflected the anticipation, to be short-lived, that cable television might provide independent airwaves for video art. Soon The Kitchen program included performances by conceptual artists, musicians, and dancers as well, becoming a magnet in the late '70s for those intent on making work that could move easily between the art world and "real life," in this case between so-called alternative spaces (The Kitchen, Franklin Furnace, Artists' Space) and the late-night music clubs (CBGB's, the Mudd Club, and TR3). Celebrating both the theatricality of rock and roll and its late '70s re-incarnation punk-rock, as well as the intellectual underpinnings of conceptual art, these artists exhibited a shrewd awareness of recent cultural history. They were absorbed by the ways in which the underground and mainstream crossed paths in the work of Warhol, and were just as intrigued by the criss-crossing sensibilities of '50s Beat Poetry and late '70s New Music. Several events in New York captured this particular

direction. The Nova Convention (1978), two evenings of performances and readings dedicated to William Burroughs, was remarkable for the range of styles and ages of the artists who participated, and New Music/New York (1979) at The Kitchen brought together artists' bands and composers whose work straddled new jazz rock and art-music, among them Sonic Youth, The Contortions, "Blue" Gene Tyranny, and Jill Kroesen.

By the early '80s, the influence of sit-coms, B-movies, and the satire of *Saturday Night Live* could be seen at the new cafés and bars in New York's East Village for artists' cabaret. John Kelly might perform as the diva Maria Callas one evening at the Pyramid Club or the Limbo Lounge, or, in a line-up of a dozen artists at P.S.122, as the painter Egon Schiele on another. John Jesurun wrote and directed serial plays—*Chang in a Void Moon* was over a year's worth of thirty-minute weekly instalments. Performance artist Ann Magnuson opened her own space, Club 57, providing a tiny stage for late-night events where party-goers were indistinguishable from the elaborately costumed performers. The aesthetic of the moment was a kind of trashy camp, which recalled the warped wonderlands of maverick performer Jack Smith in his eccentric performances, such as *Rehearsal for the Destruction of Atlantis* (1964), and in his film *Flaming Creatures* (1963) which had so pleased Warhol and other artists and so displeased New York's Criminal Court (it was declared obscene). East Village cabaret clubs provided an informal setting for artists to perform regularly, which resulted in surprisingly accomplished solo performances once they moved on to the marginally more formal venues of P.S.122 and The Kitchen.

Monologue performances, so popular throughout the '80s and '90s, and rapidly spreading out to Europe and Australia from the USA, began with Eric Bogosian and Spalding Gray, who each introduced his own then radical style of the genre in 1979. Bogosian created a gallery of "male portraits," and Gray separated his monologues from the Wooster Group's productions, presenting them as plain-spoken descriptions of (his) everyday life.

In the late 90s, video and film have become the medium of choice for many younger artists, especially in Britain, where they have added highly crafted new dimensions to both art forms. Large wall-size moving pictures or standard monitors are used to establish the strong physical presence of bodies in a room, seen through the mesmerizing scrim of the media. Whether close-up self portraits of personal trauma (Georgina Starr), wrap-around narratives with several players (Sam Taylor-Wood), new feminist criticism (Catherine Elwes), a three-dimensional architecture of film images (Douglas Gordon) or a salute to silent-screen comedy (Steve McQueen), all contain traces of sensibilities explored by performance artists over the past two decades. Cathartic self-analysis, endurance, visceral engagement with viewers, as well as the use of language, frequently as monologue, are evidence of this direct connection.

**ANDY WARHOL
AND THE VELVET UNDERGROUND**
Warhol with *Silver Cloud*, 1966
The Velvet Underground; Nico; and Warhol,
Edie Sedgwick, Chuck Wein, Paul Morrissey,
on set (opposite)

Warhol once remarked that the people who spent their days and nights at the Factory—his studio on New York's East 47th Street—were not hanging around him, he was hanging around them. It was here that he spent hours making unscripted films, silkscreening, taking photographs, and here that, from December 1965, The Velvet Underground (John Cale, Lou Reed, Sterling Morrison, Maureen Tucker, opposite) kept their amplifiers and spent much of their time. Already a celebrity by the mid-'60s, Warhol thought it would be amusing, and perhaps lucrative, to manage a rock band. Two months after he and the Velvets met at Café Bizarre, they presented their first collaboration, *Andy Warhol, Up-Tight* in February 1966, at the Film-Maker's Cinemathèque. It was a multimedia rock show with music by the band, and film, slides, and dance. It ran for a week, and rumor of its excitement secured gigs for the group, including Warhol and his media team (twelve people in all), appearing as *The Exploding Plastic Inevitable* on campuses, in music clubs, and in museums across the country. "I always believed that the art world, anyway, had it over any other industry in the world as far as imagination is concerned," John Cale remarked. Lou Reed said about the early years with Warhol, "You could think of us as a piece of art-in-progess."

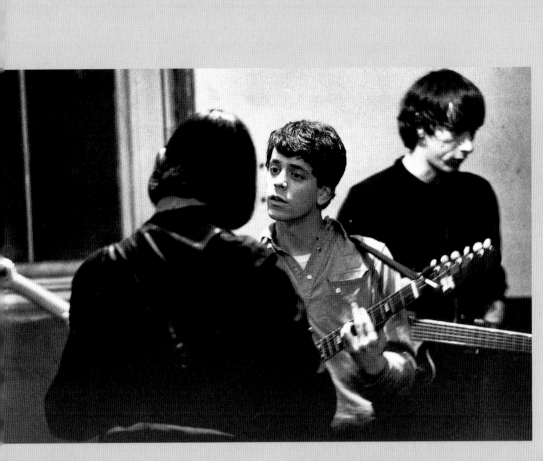

CHARLES LUDLAM
Bluebeard, 1973
The Grand Tarot, 1971

Ludlam's famous Ridiculous Theatrical Company was initially known as the company that broke away in 1967 from John Vaccaro's Play-House of the Ridiculous. It soon found its stride and became one of the funniest, bawdiest, and most wildly imaginative alternative theater companies in '70s New York, filling its own intimate theater on the corner of Sheridan Square in New York's West Village with material that plundered the classics of bravura theater—Grand Guignol, French farce, Elizabethan drama, opera, and vaudeville. Ludlam wrote, starred in and directed twenty-nine plays in twenty years.

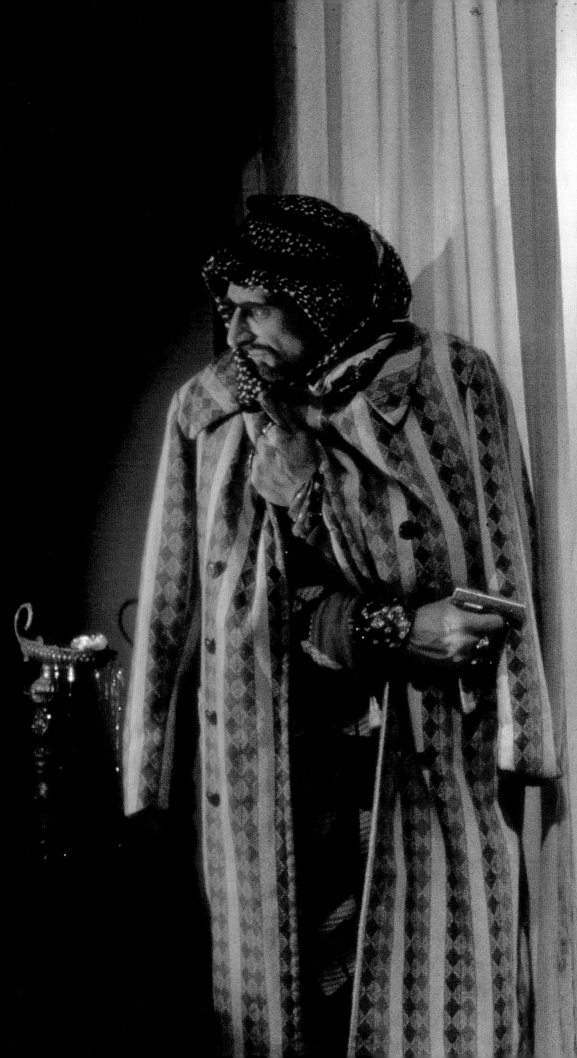

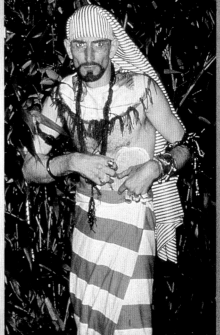

JACK SMITH
Moses, 1974
Secret of Rented Island, 1976–77

In 1962, Jack Smith, performer, writer, filmmaker, and stylist extraordinaire, shot his film *Flaming Creatures* on the roof of a New York theater. Made with a hand-held camera and intentionally disjointed, Smith's wild movie, a frank celebration of homosexual love, had its midnight première on 29 April 1963 at the Bleecker Street Cinema. The film, confiscated by the police, and declared obscene by the New York Criminal Court, was admired for its extravagance by the avant-garde, notably Robert Wilson, Jonas Mekas, Richard Foreman, Susan Sontag, and Andy Warhol. Smith made many erratic, visually lush performances. *Moses* (inset) was a series of tableaux vivants, photographed for a slide show by German filmmaker Wilhelm Hein. *Secret of Rented Island*, an adaptation of Ibsen's *Ghosts*, also made for a slide show, included toy monkeys and a toy hippopotamus as the main characters, with voice-overs recorded by Smith.

ETHYL EICHELBERGER
Fiasco, 1988

Briefly a member of The Ridiculous Theater Company and of the Trockadero Gloxinia Ballet Company, Eichelberger was best known and loved for his thirty-four "operas" that he wrote for the "great women of history," beginning with *Nefert-iti* (1976), and performed at New York's East Village clubs like Frieda's Disco, The Pyramid, King Tut's Wah Wah Hut, 8 B.C., and the Limbo Lounge. His "maximalist" style— massive wigs, voluptuous costumes, and a broad performance manner—was developed to override the noise of beer bottles and bar-chat, and included rhymed cadences, alliterations, and warbled songs. *Fiasco*, performed at the New York gallery P.S.122, was dedicated to "the photographer of penguins and filmer of miracles...Jack Smith."

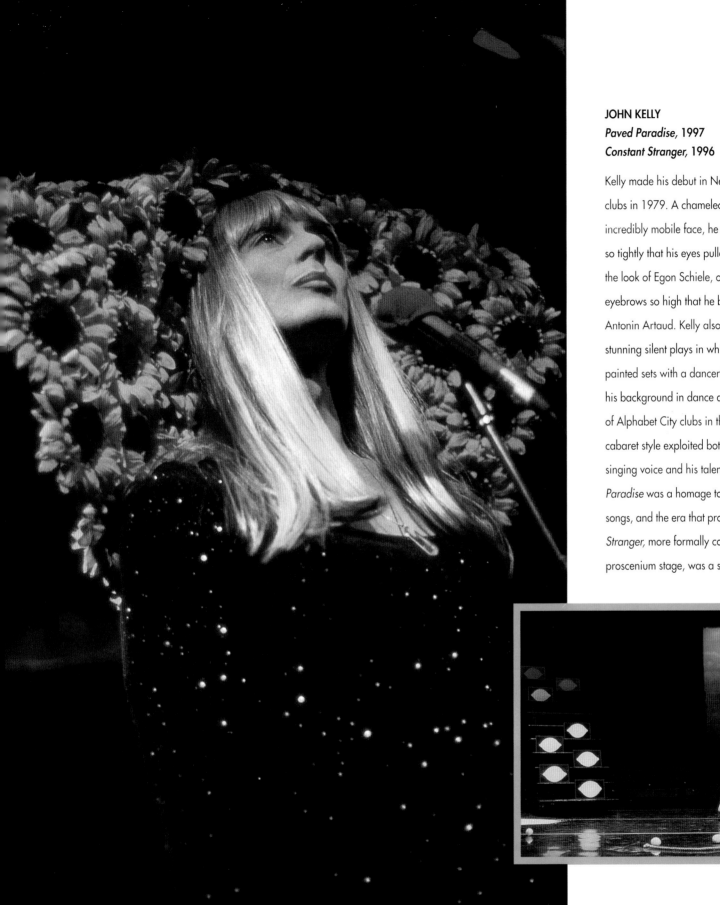

JOHN KELLY
Paved Paradise, 1997
Constant Stranger, 1996

Kelly made his debut in New York's East Village clubs in 1979. A chameleon performer with an incredibly mobile face, he would purse his lips so tightly that his eyes pulled shut to give him the look of Egon Schiele, or he would raise his eyebrows so high that he became a chiseled Antonin Artaud. Kelly also created visually stunning silent plays in which he moved through painted sets with a dancer's elegance, revealing his background in dance and visual arts. A star of Alphabet City clubs in the '80s, Kelly's cabaret style exploited both his counter-tenor singing voice and his talent as a mimic. *Paved Paradise* was a homage to Joni Mitchell, her songs, and the era that produced them. *Constant Stranger,* more formally constructed for the proscenium stage, was a solo show on AIDS.

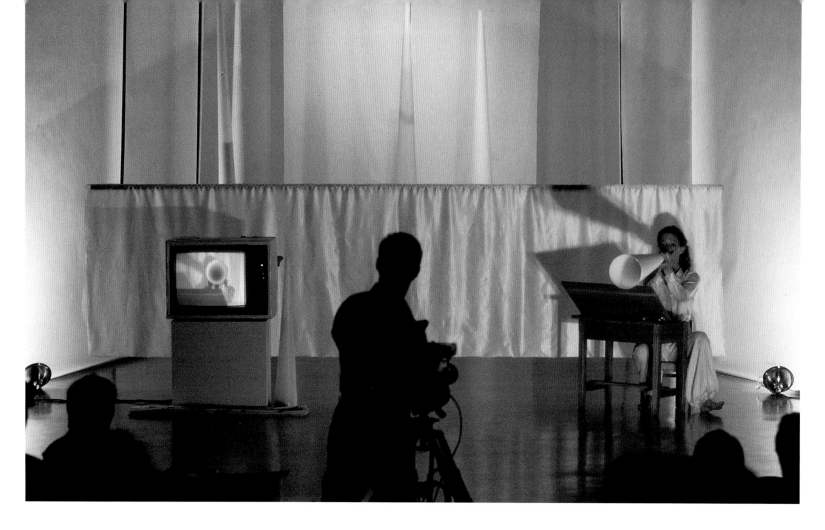

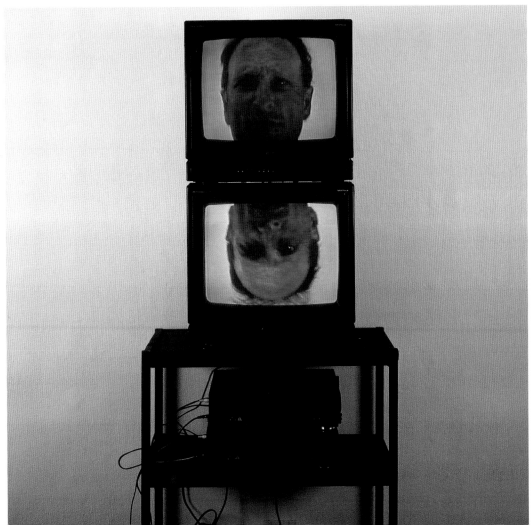

JOAN JONAS
Funnel, 1974

Jonas set this piece (opposite above) in a funnel-shaped space made of paper. With props, drawings, a collage of sound and music, and layers of real and taped images, it showed the distancing effects of video on time and space.

NAM JUNE PAIK
Sistine Chapel, 1993

Sistine Chapel (opposite below) was Paik's homage to the '60s. In the gallery, huge speakers on scaffolding blasted out music, and video projectors threw images of Paik's collaborators (John Cage, Charlotte Moorman, Lou Reed, and others), on the walls and ceiling.

ULRIKE ROSENBACH
Don't Believe I am an Amazon, 1975

Rosenbach was among the few Europeans to give form to a powerful feminism in her video and performances. Live and on camera, she shoots arrows at an image of the Madonna (above left).

BRUCE NAUMAN
Video *Jump*, 1993

Since the late '60s, Nauman combined video and live performance. He recorded human activities in "real-time," and appeared more or less lifesize on the monitor or projection screen, as if trapped inside the machine and doomed to repeat himself endlessly, inducing an unbearable claustrophobia (left). For Nauman, physical experience was a vehicle to push at the boundaries of self-awareness.

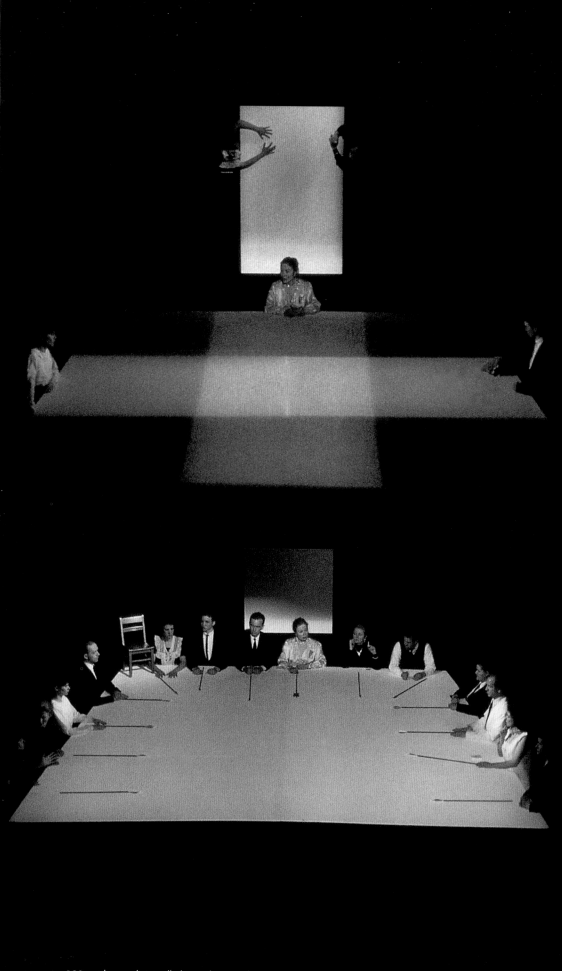

JOHN JESURUN
Chang in a Void Moon: Episode 43, 1988

Jesurun's first live performance was *Chang in a Void Moon,* a "living film serial" of forty related half-hour episodes. He wrote the script each week in one session, giving the actors just three rehearsals before showtime. Presented on a small elevated stage at the back of the Pyramid Club on New York's Avenue A, each scene simulated the techniques of filmmaking, which was Jesurun's background: camera pans, overhead views, cross-cutting in time and space, as well as flash-backs. First presented in June 1982, it ran for a year, every Monday night. Since then, *Chang* has continued to grow, in length, cast size, and set design. *Episode 43* took place at the Performing Garage and included twenty-five performers; the most recent, *Episode 52* in 1997, included dance, video cameras, and projections. Many of the original actors—Steve Buscemi, Valerie Charles, and Donna Herman among them—perform in current episodes of *Chang.*

WILLIAM BURROUGHS, PATTI SMITH, LAURIE ANDERSON, JULIA HEYWARD, JOHN CAGE (clockwise)
The Nova Convention, 1978

The Nova Convention was a two-day festival at the Entermedia Theater in downtown New York in celebration of the writer William Burroughs, revered for his liberation of the written form from "thought control." Among the many artists who participated, from several generations of the avant-garde, were Allen Ginsberg, Merce Cunningham, Frank Zappa, Anne Waldman, Susan Sontag, and John Giorno.

ROCK STEADY CREW, 1981 (clockwise from opposite below)

GLENN BRANCA, *The Ascension*, **1981**

KESTUTIS NAKAS, *Titus Andronicus*, **1983**

JOHN SEX, between performances, **1985**

ALIEN COMIC, *Pope Dream*, **1988**

In New York in the late '70s, The Kitchen was the showcase for new talent, from Laurie Anderson to Peter Gordon, John Lurie to Cindy Sherman, and put on one of the first break-dance shows by Rock Steady Crew. The artists all hung out in late-night music clubs like CBGB's and the Mudd Club, where Glenn Branca, Eric Bogosian, Julia Heyward, and others regularly performed. In the early '80s, performance spilled into the East Village, and "artists' cabaret" was the rage. Kestutis Nakas directed serial "punk" shows with large casts, like *Titus* at the Pyramid Club with Ann Magnuson, Steve Buscemi, and John Sex; Sex, like Alien Comic, also had a following for his outrageous solos.

BLUE MAN GROUP, Franklin Furnace, 1990 (clockwise from below left)

MIKE BIDLO, recreating Yves Klein's *Anthropometries*, The Palladium, 1985

AFRIKA BAMBAATAA, The Ritz, 1984

JOEY ARIAS AND KLAUS NOMI, in costume after The Mudd Club, 1979

Artists' performances became standard at the many new clubs that opened in New York throughout the '80s: Bonds, the Peppermint Lounge, Area, the Palladium, the Ritz, the Tunnel, the Limelight. The locations of these clubs were fantastic—one was in in an old theater, another in a de-consecrated church, a third in an auto warehouse. Special stages and alcoves were built, and programs of new dance, music, and live tableaux organized to fill them.

In 1987 the Knitting Factory opened in a small dilapidated office on Houston Street, and by the '90s had established itself as the home base for some of the most interesting art-music talents—John Lurie, John Zorn, David Van Tieghem, and DJ Spooky. The owner Michael Dorf, from the mid-West, has also created a CD label, radio show, and touring program (in the United States and Europe) in his enthusiasm to build new music audiences.

DJ SPOOKY (PAUL MILLER) with SOUNDLAB, 1997
(clockwise from below left)

PHILIP GLASS ENSEMBLE, Peppermint Lounge, 1980

DAVID VAN TIEGHEM, Peppermint Lounge, 1982

STUART SHERMAN, at Franklin Furnace, 1977 (clockwise from below left)

ERIC BOGOSIAN, *Sex, Drugs, Rock 'n' Roll*, 1990

SPALDING GRAY, *Slippery Slope*, 1997

In the mid-'70s, many artists made solo pieces that were autobiographical, with slides, music, and text (or silent like Sherman's). But in the late '70s Eric Bogosian and Spalding Gray, both trained actors, introduced a very different form: the monologue. They used language to describe a particular landscape—Bogosian, a world of male archetypes from suburban America to the urban homeless, and Gray, a personal tell-all tour of his life from age fourteen. Bogosian's "portraits" and Gray's "poetic journalism" established the form as a genre within performance art.

KAREN FINLEY, *I'm An Ass Man,* **Cat Club, 1987** (clockwise from below left)

DANNY HOCH, at P.S.122, 1995

ROBBIE MCCAULEY, at Franklin Furnace, 1985

CARMELITA TROPICANA as PINGALITO BETANCOURT, *Memories of the Revolution,* **1988**

DAVID CALE, *Red Throats,* **1987**

Karen Finley's highly textured and expressionist prose explored sexual abuse and misogyny in women's lives from infancy to death. Her performances were upsetting, and adverse reactions from certain politicians to rumor of her work showed that the monologue could be an effective political tool. Soft-spoken David Cale added a surreal sexuality to his slippery tales of fact and fiction, Carmelita Tropicana a fierce and funny political rhetoric, Danny Hoch a manic critique of Hip Hop, and Robbie McCauley heart-wrenching narratives of black history and identity in the United States.

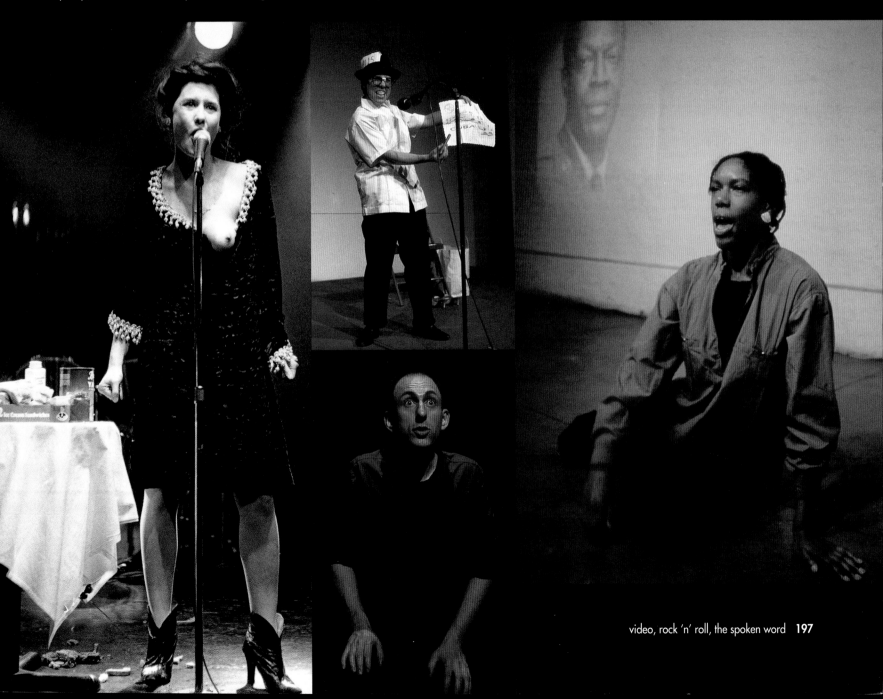

HOLLY HUGHES
Clit Notes, 1994 (clockwise from below left)

DIAMANDA GALAS
There are no more tickets to the funeral, 1990

PENNY ARCADE
Bitch! Dyke! Faghag! Whore!, 1993

BOBBY BAKER
Take a Peek, 1995

Holly Hughes's autobiographical texts were verbal roller-coasters through gay feminist life. Diamanda Galás expanded the monologue form to include passionate song cycles of laments and spirituals, and Penny Arcade added a backdrop of male and female erotic dancers. Bobby Baker invited audiences to *Take a Peek!* underlining the humiliations of a visit to a healthcare center.

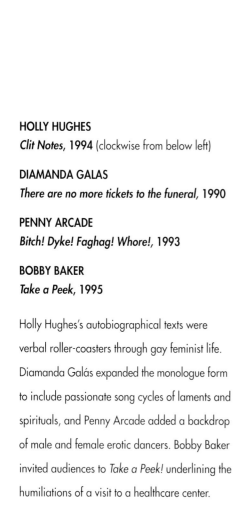

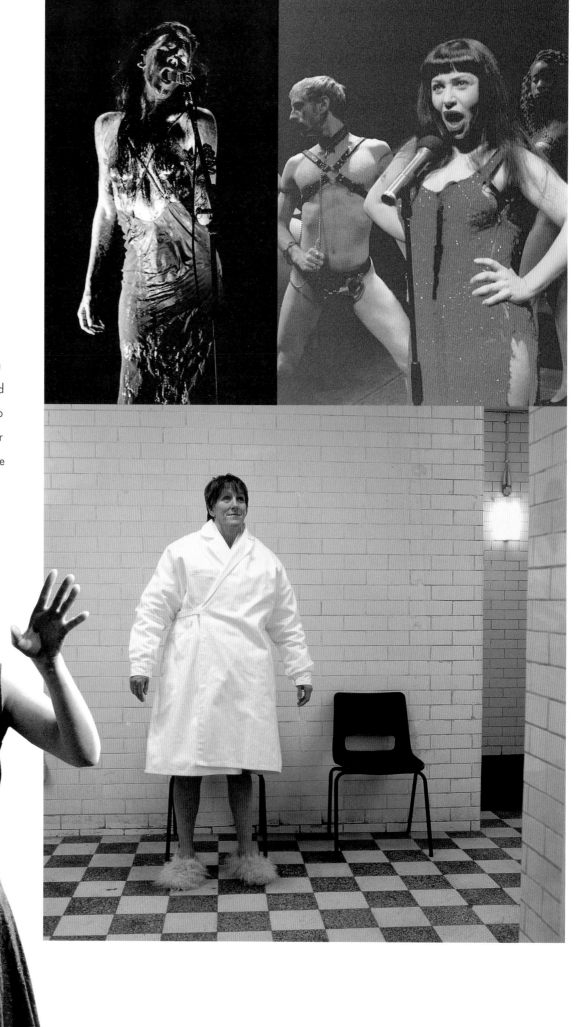

◄ **STEVE MCQUEEN**
Deadpan, still from film/video, 1997

Video and film in the '90s were greatly influenced by twenty years of performance, especially work which focused on the artist's body, like that of Abramović and Burden. McQueen's wall-size video installations give the viewer the feeling of being inside his cinematic space. A silent homage to Buster Keaton, *Deadpan,* 4.03 minutes long, features McQueen with a house that falls around him.

▼ **VANESSA BEECROFT**
Piano Americano, 1996

Beecroft does not appear in her own works; instead she instructs groups of women to "think of themselves as objects in a painting." She also makes drawings, paintings, and films of female stereotypes from fashion, art history, and the movies. Beecroft cites Helmut Newton as a favorite photographer: "He makes [women] into beautiful objects which are horrible at the same time."

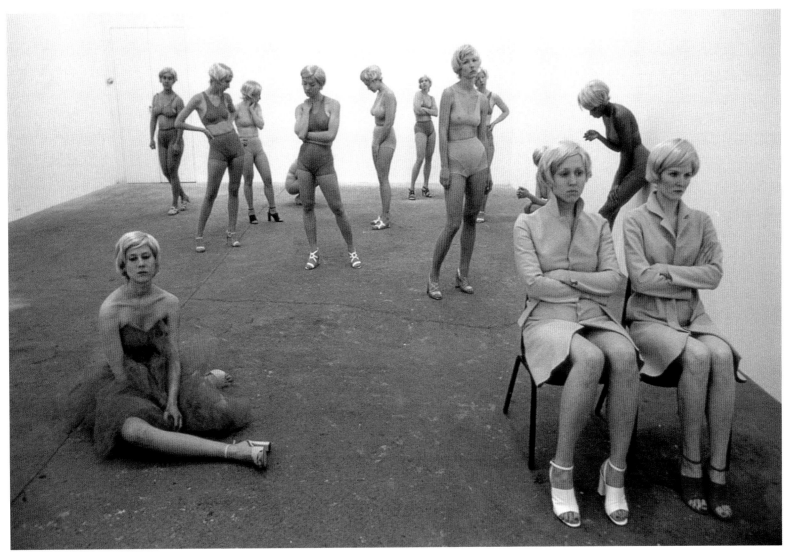

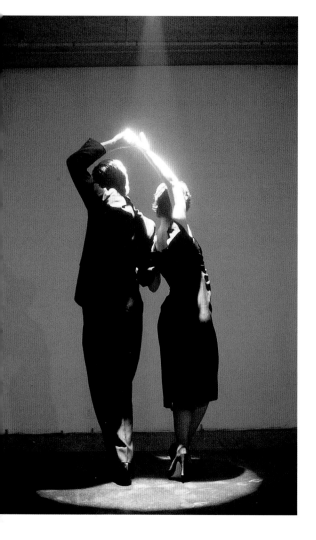

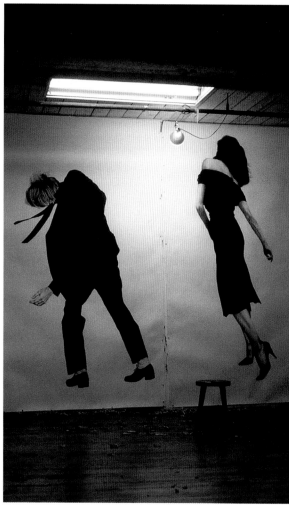

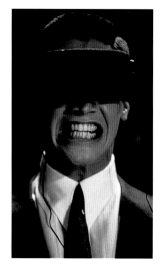

ROBERT LONGO
Surrender, The Kitchen, 1979
Two drawings from *Men in the Cities*, 1981, studio view
Songs of Silent Running, No. 5, cast aluminum wall relief, 1981
Johnny Mnemonic, 1995, film still

Longo makes precise connections between his drawings, relief sculptures, performances, and film. The viewer can actually follow a progression from flat one-dimensional images to performances, as though the live figures serve to bring his artwork to life. A passion for film—its scale, visually seductive surface and narrative—has always driven Longo's work. In 1995, his Hollywood feature-length action movie set in the future, *Johnny Mnemonic*, contained many direct references to the themes and style of his art in other media.

CINDY SHERMAN
Untitled, 1994
Office Killer, 1997, film still

Sherman's earliest works were performances. Dressed up as a housewife or a clerk in an unemployment office (and once as a well-known art collector), she would pass unnoticed at museum openings or at her job as a receptionist in a downtown New York gallery. Later, she photographed herself in various outfits in her small bedroom-studio. These black-and-white pictures had the feeling of stills from '60s French films, while her color photographs exaggerated the particular light, camera angles, and frequently clichéd narratives of Hollywood's B-movies. Sherman's feature film, *Office Killer*, which she directed, is remarkably close in color, aesthetic, and dark humor to her art.

▼ SAM TAYLOR-WOOD
Atlantic, 1997

Taylor-Wood's installations examine the correlation between live performance and film. They show a sophisticated understanding of Warhol's underground movie innovations—particularly his exploration of "real-time"—as well as those of method actors, such as Harvey Keitel or Robert De Niro, who seek to diminish the gap between "performance" in real life and "acting." For them, as for Taylor-Wood, the performer's body is the pivotal narrative element in their work. Standing in the gallery or walking past Taylor-Wood's cinematic, wall-size triptychs, the viewer becomes incorporated in the performance space of her film. In *Atlantic*, the woman on the left and the man whose hands are shown on the right, eventually meet in the bar scene in the center.

◄ **MATTHEW BARNEY**
Cremaster 5, 1997, film stills

Barney plays the Magician, naked beneath his black cape, in this
voluptuous work with its rococo fanfare and magical imagery.
With score by Jonathan Bepler and libretto by Barney, this operatic
film was shot in Budapest, birthplace of Barney's hero Ehrich Weiss,
better known as Harry Houdini, with Ursula Andress in the lead.

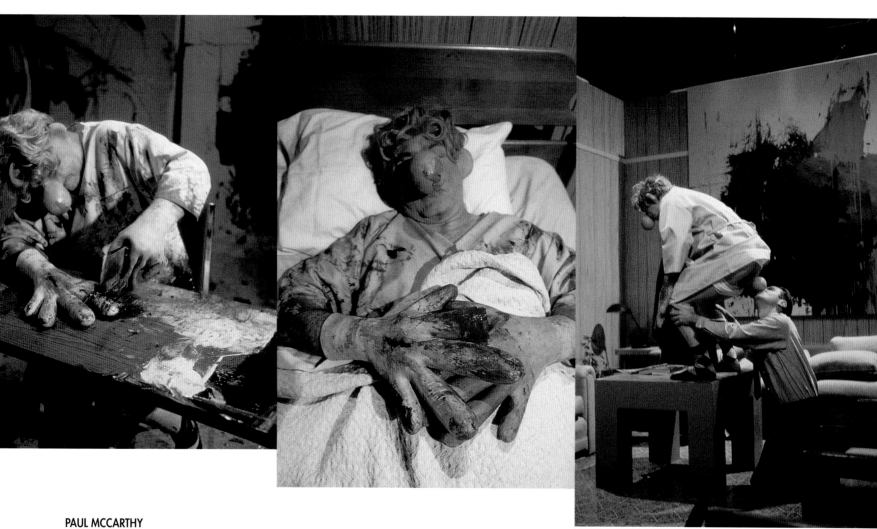

PAUL MCCARTHY
Painter, 1995, stills from video-performance

McCarthy, who began with "actions" in the late '60s, gave up performing live in the '80s, and created performances exclusively for videotaping. Using trunkfuls of props collected over ten years—masks, stuffed animals, broken dolls—and ketchup, mayonnaise, and mustard as substitutes for blood, semen, and excrement, McCarthy's orgiastic and taboo-smashing pantomimes were intentionally repulsive and deranged; he violently explodes the myth of pristine family life in America as endlessly conveyed by the media. *Painter* also parodies psychological interpretations of abstract painting.

MIKE KELLEY
Manipulating Mass-Produced Idealized Objects, 1990

Kelley and McCarthy both trade in "bad taste"—"the leitmotif of Kelley's work is failure," wrote one critic—and both have a sophisticated take on American society, from "blue collar" urbanism, to suburban boredom, to pop culture and intellectual life. Kim Gordon of *Sonic Youth*, who has used Kelley's art on an album cover, said that the image shocks because the man and woman "are stimulating themselves with inanimate objects. And someone saw it. That's very rock and roll."

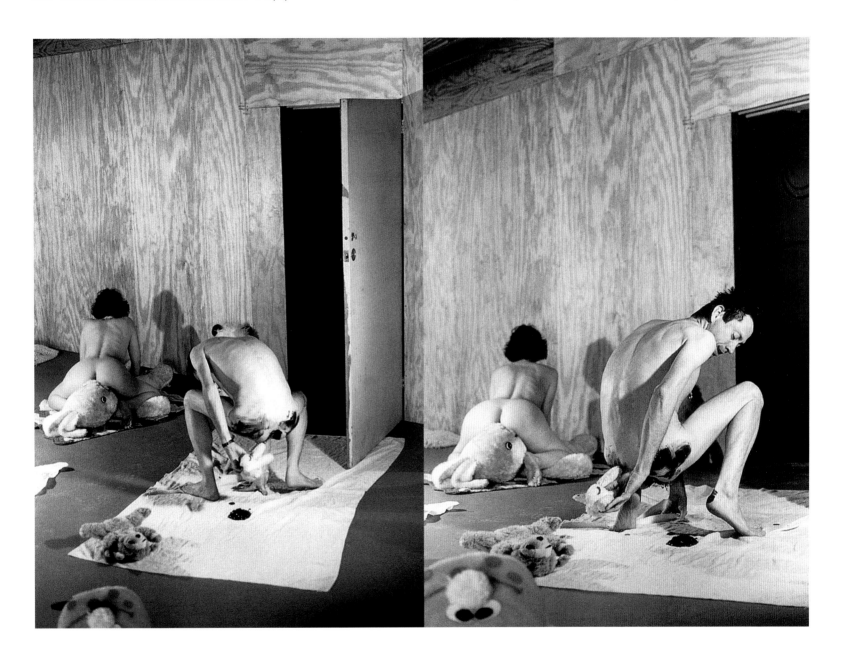

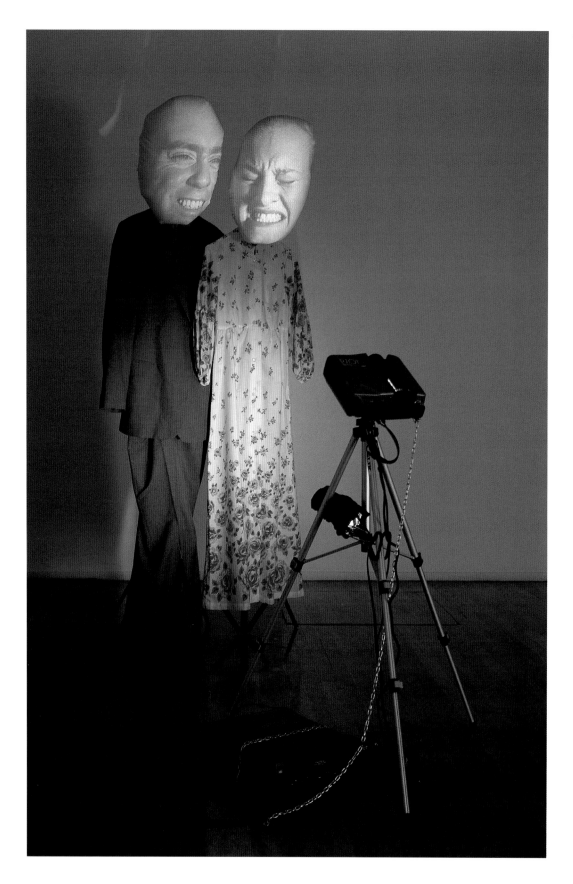

◄ **TONY OURSLER**
I Can't Hear You, 1995

In Oursler's poignant video-sculptures, life-size talking heads are projected on to figures made of scraps of cloth, animating their corpse-like limpness. Viewers must stand close in order to hear their soft cries: "Oh, no! Oh, no!" one says. "That's part of their sad beauty," Oursler explains," What they are cannot be. It's part of their design; provocation through absence."

▼ **ALEX BAG**
6th Semester Art School Girl, 1995,
still from color video *Fall 95*

In this hour-long fictional video diary of an art student, Bag plays with stereotypes. She mimics television's deadpan combination of advertising and life style with the circular questioning of a young artist trying to find her way into the art world. She abandons notions of authenticity, and uses instead the mawkish language of her peer group as a mark of belonging.

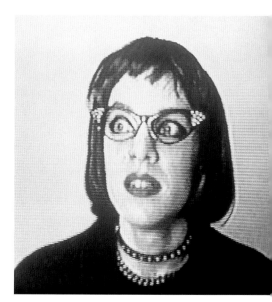

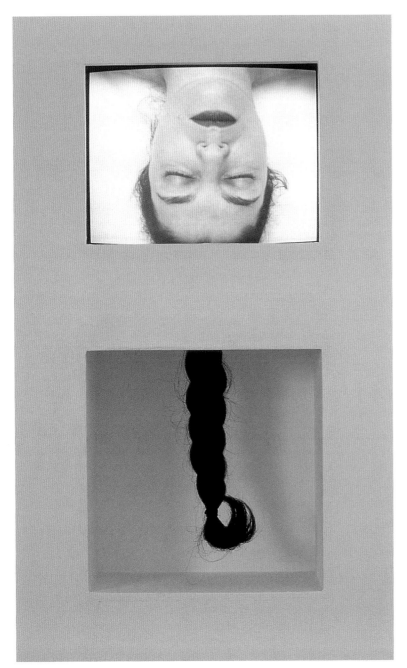
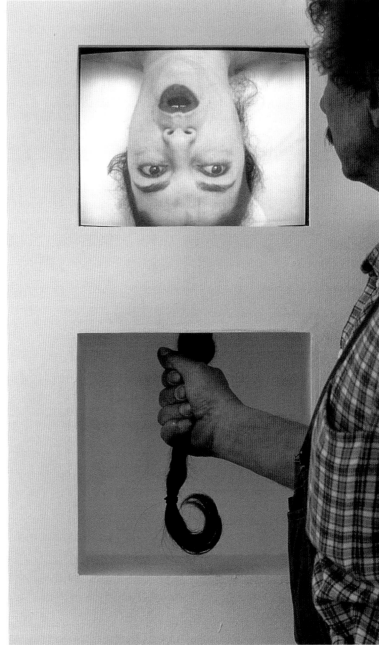

MONA HATOUM
Pull, 1995

This was a two-hour live work with video, and the surprise lay in the fact that Hatoum was actually present during the three-day installation. Viewers were invited to pull a braid of hair hanging below a specially constructed video monitor, and then witnessed Hatoum's reaction. An amusing twist to interactivity, *Pull* is a model for the frustrated, passive television viewer's revenge on technology—an action that has emotional and physical consequences for what's inside the box. It also reinforces the concept of live performance as the humanistic loophole that subverts the omnipresent media.

chronology

a select chronology of events in the history of performance since 1960

1960

Yves Klein, *The Painter of Space Hurls Himself into the Void*, Paris

Claes Oldenburg, *The Street* and *Snapshots from the City*

Andy Warhol, *Dick Tracy*, Warhol's first comic-strip painting

Allan Kaprow, *Four Evenings* (Happenings); Red Grooms *The Magic Train Ride*; Robert Whitman, *Small Cannon*, Reuben Gallery, New York

"Ray-Gun" exhibition, Judson Gallery, New York: Jim Dine's *The House*, and Claes Oldenburg's *The Street*

Nam June Paik, *Etude for Piano Forte*

Pierre Restany, *New Realist Manifesto*

Piero Manzoni, *Life Drawing*

An Evening of Sound Theater—Happenings, Reuben Gallery, New York: participants include George Brecht, Jim Dine, Allan Kaprow, Robert Whitman, Richard Maxfield

Gustav Metzger, *Manifesto of Auto-Destructive Art*, London, first lecture-demonstration

New Music Festival at The Living Theater, New York, works by Al Hansen, Dick Higgins, Ray Johnson, Larry Poons, Jackson Mac Low

Ray Gun Spex, Judson Gallery, New York: Happenings include Jim Dine's *The Smiling Workman*, Robert Whitman's *Duet for a Small Smell*

Nouveaux Réalistes group exhibition, Palais des Expositions, Paris

Hermann Nitsch, *1st Action Painting*, Vienna

1961

La Mama Experimental Theater, New York, founded by Ellen Stewart

Piero Manzoni, *Magic Base*

Fluxus group formed

First Fluxus festival, AG Gallery, New York, organized by Maciunas, with Trisha Brown, John Cage, Walter de Maria, Flynt, Forti, Higgins, Maxfield, Morris, Rainer

Concert series organized by La Monte Young at Yoko Ono's loft, New York: performances, dance and music by Jackson Mac Low, Robert Morris, and La Monte Young

Yoko Ono, *A Grapefruit in the World of Park*, Carnegie Hall, New York

Claes Oldenburg, *The Store*

Niki de Saint Phalle, first shooting action, Paris

Festival of Electronic Music and Concert of New Sounds and Noises, AG Gallery, New York, works by John Cage, Dick Higgins, Jackson Mac Low, Robert Morris, Yvonne Rainer

"The Art of Assemblage," exhibition, Museum of Modern Art, New York

1962

Judson Dance Theater founded in New York

Robert Rauschenberg, Niki de Saint Phalle, and Kenneth Koch, *The Construction of Boston*

Claes Oldenburg, *Ray Gun Theater* (Happenings): *Store Days, Store Days II, Nekropolis, Nekropolis II*

Ben Vautier, *Living Sculpture*

Neo-Dada in der Musik, Düsseldorf, program organized by Nam June Paik, with George Maciunas, Ben Patterson, Tomas Schmit, Wolf Vostell and others

Hi Red Center event. Natsuyuki Nakanishi's *Lecture on Art*, illustrated with pipe smoke, Tokyo

Festival of Misfits, Victor Musgrave's Gallery One, London, organized by Daniel Spoerri and Robert Filliou

9 Evenings Theatre & Engineering, New York, presented by Foundation for Contemporary Performance Arts Inc., in co-operation with Experiments in Art and Technology, Inc.; works by John Cage, Yvonne Rainer, Robert Rauschenberg, David Tudor, and Robert Whitman

Kazakura Sho, "The Real Thing," exhibition, Tokyo

Fluxus Tournée starts in Wiesbaden with Alison Knowles, Nam June Paik, John Cage, La Monte Young, George Brecht, George Maciunas, Dick Higgins, Ben Patterson, and Wolf Vostell

Jack Smith films *Flaming Creatures* on the roof of the Windsor Theater, New York

Andy Warhol, first *Campbell's Soup Cans* and *Marilyns*

Yves Klein, *Immaterial Transfer Ceremony*, exchanging gold for a "zone of immaterial pictorial sensitivity," Paris

Piero Manzoni signs Marcel Broodthaers as a living work of art

1963

Claes Oldenburg, *Autobodys* (Happening), Los Angeles

New York Avant-Garde Festival, organized by Charlotte Moorman

Festum Fluxorum Fluxus (Musik, Antimusik, Das Instrumentale Theater), Düsseldorf: Joseph Beuys, George Brecht, Al Hansen, Dick Higgins, George Maciunas, Jackson Mac Low, Nam June Paik, Ben Patterson, Tomas Schmit, Daniel Spoerri, Wolf Vostell, Emmett Williams, and La Monte Young

Festum Fluxorum, Copenhagen; includes: Filliou, Higgins, Knowles, Mac Low, Maciunas, Paik, Vostell, Williams

Festum Fluxorum, Paris; includes: Filliou, Higgins, Knowles, Maciunas, Schmit, Spoerri, Vostell, Williams

Carolee Schneemann, *Eye Body*, New York

La Monte Young founds the Dream Syndicate, *The Theater for Eternal Music*, and develops the idea for his *Dream House*

New York Audiovisual Group event, *Happenings—Events—Advanced Musics*, New Brunswick, NJ, organized by Al Hansen, includes George Brecht, Hansen, Dick Higgins, Ray Johnson, Alison Knowles, Ben Patterson, Emmett Williams, and La Monte Young

Allan Kaprow, *Push and Pull: A Furniture Comedy for Hans Hofman*, environment, New York

Yvonne Rainer, *Terrain* and *The Mind is a Muscle*, dance peformance, New York

Yam Festival, Smolin Gallery, New York; George Segal's Farm, New Brunswick, NJ; and Hardware Poat's Playhouse, New York. Happenings, performances, dance, music, events, organized by

George Brecht and Ben Watts, includes Brecht, John Cage, Lucinda Childs, Philip Corner

Warhol establishes the Factory, and produces films *Eat* and *Kiss*

Sigmar Polke and Gerhard Richter, "Demonstration for Capitalist Realism," exhibition, Furniture-house Bergen, Düsseldorf

Hermann Nitsch, *1st action*, with Otto Mühl, at Mühl's studio apartment, Vienna

Rudolf Schwarzkogler makes paintings and sculptures derived from Yves Klein's theories on the use of the color blue

1964

Yoko Ono, *Cut Piece*, Yamaichi Concert Hall, Kyoto

Wolf Vostell, *You*, his first performance in New York

Allan Kaprow, *Household*, Happening, Ithaca, New York

Festival de la Libre Expression, Paris, organized by Jean-Jacques Lebel, includes George Brecht, Tetsumi Kudo, Lebel, Carolee Schneemann, and Ben Vautier

Carolee Schneemann, *Meat Joy*, Paris and New York

A Collage Happening, London, initiated by Lebel and organized by Michael White; includes Mark Boyle, Lebel, and Schneemann

2nd Annual New York Avant-Garde Festival, Judson Memorial Church, New York, organized by Charlotte Moorman and N. Seaman; performances of Stockhausen's *Originale*, starring Robert Delford Brown and directed by Allan Kaprow; Nam June Paik performs *Robot Opera* with Charlotte Moorman and *Robot K-456*

Wolf Vostell, *In Ulm, um Ulm und um Ulm herum*, Ulm, 6-hour happening at over 20 sites in Ulm

La Monte Young, *The Well-Tuned Piano*

Maciunas opens the Fluxhall/Fluxshop shop and performance place in New York

1965

Hermann Nitsch creates the Orgies Mysteries Theater

Shigeko Kubota, *Vagina Painting*, Perpetual Fluxus Festival

John Cage, Merce Cunningham, Barbara Lloyd, David Tudor, and Gordon Mumma, *Variations V*

Robert Rauschenberg, *Spring Training*, performance, Ann Arbor

Robert Rauschenberg, *Impromptu tire-painting*, performance, Frederick Kiesler's funeral, New York

Joseph Beuys, *Twenty-Four Hours*, Wuppertal

Joseph Beuys, *How to Explain Pictures to a Dead Hare*, Düsseldorf

Robert Whitman, *Prune Flat*, Film-maker's Cinematheque, New York

Nam June Paik, first artist to use video, tapes shown at the Café à Go Go, New York

Second Festival de la Libre Expression, Paris, organized by Lebel; includes Filliou, Williams, Paik, Moorman, and Vautier

Jack Smith, *Rehearsals for the Destruction of Atlantis*, performance as part of the expanded film festival, New York, organized by Jonas Mekas, also includes Oldenburg, Rauschenberg, La Monte Young, Marian Zazeela, and Warhol

First New York Theater Rally: Dance Concert III, organized by Steve
 Paxton and Alan Solomon; includes Jim Dine (*Natural History*),
 Robert Morris and Carolee Schneemann (*Site*), Claes Oldenburg
 (*Washes,* Happening at Swimming Pool, *Piece for Telephone*),
 Robert Rauschenberg (*Spring Training, Pelican*), and Robert
 Whitman (*The Night Time Sky, Shower*)
Günter Brus, *Silber* (*Siver*), *Self-painting II, Self-mutilation* (with Anni
 Brus), Vienna
Otto Mühl begins 14-day prison sentence for role in *Fest des
 psycho-physischen Naturalismus*
Otto Mühl, *Rumpsti-Pumpsti,* material action, Vienna
Wolf Vostell, *Phänomene,* Happening, Berlin
Robert Morris, with Lucinda Childs and Yvonne Rainer, *Waterman
 Switch* at Judson Dance Theater, New York

1966
Destruction in Art Symposium (DIAS) London, organized by Gustav
 Metzger
First land-art projects by Richard Long, Robert Smithon, and Robert
 Morris
Paik and Moorman perform *Avant-Garde Music Pieces,* Philadelphia,
 by George Brecht, John Cage, Dick Higgins, Jackson Mac Low,
 Paik, Dieter Roth, Wolf Vostell, and Emmett Williams
Hi Red Center, *Be Clean!* (event performed by members of Fluxus),
 Grand Army Plaza, New York
9 Evenings organized by Billy Klüever: the first marriage of art and
 technology by Bell engineers working with artists including
 Rauschenberg, Fahlstroem, Cage, Childs, Hay, Paxton, Rainer,
 Tudor, and Whitman
Nam June Paik and Charlotte Moorman perform John Cage's *26'1.
 1499" for a String Player* as part of Gondola Happening, Venice
Yayoi Kusama, *Kusama's Peep Show: Endless Love Show* (mirrored
 sound and light environment)
NOW Festival. National Arena, Washington D.C. includes
 Rauschenberg's *Pelican* and *Linoleum,* Whitman's *Prune Flat,* and
 Untitled Pieces, and an appearance by the Velvet Underground
 and Warhol
Joseph Beuys, Action *Eurasia* and *32nd Movement of the Siberian
 Symphony 1963,* Berlin
Exploding Plastic Inevitable, psychedelic show with Velvet
 Underground and Nico, organized by Warhol in New York

1967
Allen Kaprow, *Fluids,* Pasadena Art Museum
Carolee Schneemann, *Snows,* kinetic theater, New York
Nam June Paik, *Opera Sextronique,* performed by Charlotte
 Moorman, Film-maker's Cinemathèque, New York
Joseph Beuys, Action *Eurasienstab,* Vienna
Maciunas founds first artist-cooperative in SoHo, New York
Velvet Underground and Nico album released
Tadeusz Kantor, *Lettre,* Galeria Foaskal, Warsaw

1968
Joan Jonas, *Mirror Performance*
"Arte Povera, Azione Povera," exhibition curated by Germano Celant
John Cage, *Reunion,* Toronto
Rebecca Horn, *Arm Extensionen* (*Arm extensions*)
Walter de Maria, *EarthRoom,* fills Munich gallery with earth

Paul McCarthy, *Leap,* Salt Lake City, and *Too Steep, Too Fast,*
 Marin County, California
Christo wraps Kunsthalle, Berne
Fabio Sargentini founds L'Attico, performance space in Rome
Valie Export, *Tapp und Tast Kino* (Touch Cinema), Vienna
Boltanski's film *La vie impossible de Christian Boltanski,* Cinéma le
 Ranelagh, Paris

1969
Meredith Monk, *Juice: a Theater Cantata,* Guggenheim Museum,
 Barnard College, and the artist's loft, New York
Nam June Paik and Charlotte Moorman, *TV Bra for Living Sculpture,*
 New York
Robert Wilson, *The Life and Times of Sigmund Freud*
"When Attitudes Become Form," exhibition curated by Harald
 Szeemann, Kunsthalle, Berne
Gilbert & George, *The Singing Sculpture*
Joseph Beuys, *Iphigenie/Titus Andronicus,* Experimenta III, Frankfurt
Robert Smithon begins *Spiral Jetty* at Great Salt Lake, Utah
Dan Graham, *Lax/Relax* performance
Richard Schechner, *Dionysus,* New York

1970
Allan Kaprow's book, *Assemblage, Environments & Happenings*
Adrian Piper, *Streetworks,* New York
Trisha Brown, *Walking Down the Side of a Building,* New York
Judy Chicago's first feminist art workshop at Fresno State College,
 California
"Happening and Fluxus," curated by Harald Szeemann,
 Kunstverein, Cologne
"Information," MOMA, New York, exhibition curated by Kynaston
 McShine
Museum of Conceptual Art (MOCA), San Francisco, founded as an
 alternative art space
Gery Schum, "Identifications" exhibition, TV-Gallery, Düsseldorf
Günter Brus, *Aktionsraum,* Munich
Min Tanaka travels Japan from Kyushu to Hokkaido, dancing every
 day
Anthology Film Archives founded by Jonas Mekas, Peter Kubelka,
 and others

1971
Chris Burden, *Shoot,* F. Space, Santa Ana, California
The Kitchen Center for Video and Music founded in New York by
 Steina and Woody Vasulka; Dance, Performance added 1978,
 Film and Literature 1989
Steve Reich, *Drumming,* New York
Chris Burden, *Five-Day Locker Piece,* University of California, Irvine
Laurie Anderson, *Automotive* (first performance), Vermont
Terry Fox, *Hospital,* installation, San Francisco
P.S.1, Long Island City, NY, founded by Alanna Heiss
Yoko Ono and John Lennon, *Bed Peace,* Amsterdam
Mabou Mines, *The Red Horse*
Dennis Oppenheim, *Two-Stage Transfer Drawing*

1972
Vito Acconci, *Seedbed,* Sonnabend Gallery, New York
Paul McCarthy, *Face Painting, Meat Cake,* Los Angeles

Judy Chicago, Suzanne Lacy, Sandra Orgel, and Aviva Rahmani,
 Ablutions, collaborative performance, Womanhouse,
 Los Angeles
Marcel Broodthaers, *Musée d'Art Moderne, Departement des Aigles*
documenta 5, *Individuelle Mythologien—Selbstdarstellungsprozesse*
 (*Individual Myths—Parallel Picture*), curated by Harald
 Szeemann, Kassel
Christian Boltanski, performance, Royal College of Art, London
Jannis Kounellis, *Apollon,* Sonnabend Gallery, New York
Meredith Monk, *The Education of a Girlchild,* New York
Californian Institute for the Arts (Cal Arts) founded in Los Angeles:
 conceptual art, media, and performance

1973
Womanspace, Los Angeles, inaugural performance works by Aviva
 Rahmani, Vicki Hall, and Barbara Smith
Linda Montano, *Home Endurance,* in which the artist stays home for
 one week, documenting all thoughts and actions, San Francisco
"All Night Sculptures," Museum of Conceptual Art, San Francisco,
 curated by Tom Marioni, includes Terry Fox, Bonnie Sherk, and
 Barbara Smith
Jannis Kounellis, *Table,* one of the "frozen performances" exploring
 the formal qualities of poses and gestures of tableaux vivants
Katharina Sieverding, *Transformer,* series of photographs
 (1973–74)
Chris Burden, *Icarus* (studio-performance), Venice, California
Artists Space founded in New York
Nam June Paik founds Global Groove, laboratory to research the
 technical possibilities of video
Carolee Schneemann, *Up to and Including her Limits,* New York

1974
Joseph Beuys, *Coyote: I like America and America Likes Me,*
 René Block Gallery, New York
Dan Graham, *Present Continuous Pasts,* New York
Robert Wilson, *A Letter for Queen Victoria,* New York
Joan Jonas, *Funnel,* University of Massachusetts
Marina Abramović, *Rhythm O,* Naples
Rebecca Horn, *Mechanical Body-Fan,* Hamburg
Soup and Tart performance program, The Kitchen, New York, with
 Laurie Anderson, Philip Glass, Gordon Matta Clark, Yvonne
 Rainer, Richard Serra, Hannah Wilke
La Monte Young, *The Well-Tuned Piano,* Rome
Paul McCarthy, *Hot Dog,* performance videotape, Odd Fellows
 Temple, Pasadena
"Transformer—Aspekte der Travestie," exhibition curated by
 Jean-Christophe Ammann, Kunstmuseum, Lucerne, images of
 David Bowie, Brian Eno, Mick Jagger, Urs Lüthi, Jürgen Klauke,
 Marco, The New York Dolls, Katharina Sieverding, and Andy
 Warhol, making connections between transvestite rock and
 gender performance
Philip Glass, *Music in 12 Parts*

1975
Carolee Schneemann, *Interior Scroll,* for the *Women Here and Now*
 series, East Hampton, Long Island
Richard Foreman, *Pandering to the Masses: A Misinterpretation,*
 New York

Wooster Group founded: first performance *Three Places in Rhode Island,* 1975–79, New York

Paul McCarthy, *Sailor's Meat* and *Tubing* performance, videotapes, Pasadena

Adrian Piper, *The Mythic Being,* performance, Cambridge, Mass. 1975–76

Adrian Piper, *Some Reflective Surfaces,* performance, The Fine Arts Building, New York

"The Video Show," Serpentine Gallery, London, including performance work

Gilbert & George, *The Red Sculpture,* first performed in Tokyo

Bruce McLean and Nice Style, the World's First Pose Band, Royal College of Art, London

Stuart Brisley, *Moments of Decision/Indecision,* Warsaw

Trisha Brown, *Locus*

Gary Hill, *Synergism,* Woodstock, New York

Meredith Monk, *Quarry,* New York

Ulrike Rosenbach, *Don't Believe I am an Amazon,* video-live-performance in Paris

Opening of CBGB's on the Bowery, New York, a popular punk club of the art-world, showcased Television, Patti Smith, Allan Suicide, David Byrne

The Kipper Kids, performance, Royal College of Art, London

1976

Marina Abramović and Ulay, *Relation in Space,* Venice Biennale

Four Evenings, Whitney Museum, performance festival, with work by Laurie Anderson, Julia Heyward, Michael Smith, Adrian Piper, Robert Wilson, Stuart Sherman

Franklin Furnace Archive, New York, opened by Martha Wilson

Philip Glass, Robert Wilson, and Lucinda Childs, *Einstein on the Beach,* Paris and New York

Mike Kelley, *Dancing Partner,* performance Cal Arts

Richard Foreman, *Book of Splendors: Part Two (Book of Levers) Action at a Distance,* New York

Acme Gallery, Covent Garden, London, opened for performance and installation

Paul McCarthy, *Class Fool,* performance-video tape, University of California at San Diego

Festival d'Automne, Paris, *Composers Inside Electronics* includes Cage, Kosugi, Ishiyaga, Tudor

Ulrike Rosenbach, *10,000 Years I Have Been Sleeping,* video-live-performance, Neue Galerie, Aachen

1977

Dan Graham, *Performer/Audience/Mirror,* P.S.1, New York

Marina Abramović and Ulay, *Interruption in Space,* Düsseldorf, Amsterdam, and Bologna

Walter de Maria, *Lightning Field,* New Mexico

Cindy Sherman's first *Film-Stills*

Nan Goldin *The Ballad of Sexual Dependency* (1974–84)

Opening of Studio 54, New York, disco in former theater. Marks the beginning of art and fashion crossover

Opening of the Centre Georges Pompidou, Paris

"Künstlerinnen 1877–1977," feminist exhibition, Schloss Charlottenburg, Berlin, organized by Valie Export

Ulrike Rosenbach, *Frauenkultur—Kontaktversuch (Womanculture—Try to Contact),* video-live performance, Essen and Vienna

1978

Club 57 opens in St. Mark's Place, New York's East Village

Robert Longo, *Sound Distance of a Good Man,* 8-minute performance with film, opera singer and live performers

The Nova Convention, celebration of William Burroughs, New York

Monte Video founded by Rene Coelho in Amsterdam as a gallery for video and time-based arts

Mudd Club opens in New York

New Music/New York Festival, The Kitchen, New York

Rebecca Horn, *Body Extensions* and *The Feathered Prison*

Pina Bausch, *Kontakthof,* Wuppertal

1979

Eric Bogosian, *Ricky Paul,* New York

Spalding Gray, *Sex and Death to Age 14,* New York

La Monte Young's and Marion Zazeela's *Dream House,* permanent musical installation in Tribeca, New York

"Joseph Beuys Retrospective," Guggenheim Museum, New York

The Kipper Kids, University Art Museum

Lucinda Childs, *Dance,* film by Sol LeWitt, and music by Philip Glass

Chris Burden, *The Big Wheel,* action, Los Angeles

Judy Chicago, *The Dinner Party,* Los Angeles

Rebecca Horn *The Machine-Peacock,* Berlin

Warhol–Beuys Event, performance in Düsseldorf

The Basement, performance venue founded by John Kippin, Belinda Williams, Ken Gill, Richard Grayson, John Adams, Jon Bewley in Newcastle upon Tyne

Journées interdisciplinaire sur l'art corporel et la performance, organized by Jorge Glusberg, Centre Georges Pompidou, Paris

Polyphonix 1, international festival for performance, poetry, music, and video, organized by Jean-Jacques Lebel, American Center, Paris

Performance; Live Art 1909 to the Present, first history of performance art, by RoseLee Goldberg

P.S.122 (Performance Space 122) opened in the East Village by Charles Moulton, Charles Dennis, Peter Rose, and Tim Miller

1980

Marina Abramović and Ulay, *Rest Energy*

Für Augen und Ohren (For Eyes and Ears), Akademie der Künste, Berlin, organized by René Block, environment-objects, performances, and installation, artists include Ben, Beuys, Cage, Filliou, Kounnellis, Man Ray, Nauman, Paik, Rauschenberg, Sarkis, Satie, Tinguely

"About Time," ICA, London, exhibition organized by Catherine Elwes, Rose Garrard, and Sandy Nairne on women artists working in time-based media and performance

Festival international des artistes, Montréal, organized by Chantal Pontbriand, and including Daniel Buren, Dan Graham, Robert Wilson, Laurie Anderson, Richard Foreman

Karole Armitage, *Drastic Classicism,* with live music by Rhys Chatham, New York

Molissa Fenley, *Energizer,* New York

1981

Laurie Anderson, "O Superman," a single that reached #2 on the British pop charts, and brought performance art into mainstream

Wooster Group, *Route 1 & 9*

The Performance Space, Sydney, opens, director Angharad Wynne-Jones, dedicated to new theater, dance, and time-based art, and publishing a quarterly magazine

Ann Magnuson, *Christmas Special,* The Kitchen, New York

Eric Bogosian, *Men Inside,* New York

London International Festival of Theater (LIFT), biennial performance and dance festival, directed by Rose de Wend Fenton and Lucy Neal

Guillermo Gomez-Peña, Sara Jo Berman, and Poyesis Genetica found an "interethnic" performance group, Cal Arts, California

1982

John Jesurun, *Chang in a Void Moon,* New York

Cheri Gaulke, *This is my Body*

Anne Teresa De Keersmaeker, *Fase: Four Movements to the Music of Steve Reich*

Next Wave Festival established at the Brooklyn Academy of Music (BAM)

"Eight Artists—The Anxious Edge," Walker Art Center, Minneapolis, on exhibition on pessimism in American art; includes: Cindy Sherman, Robert Longo, and Chris Burden

The Sprectacolor-Board, Times Square, New York, begins showing artists' work, including that of Jenny Holzer, in a program initiated by the Public Art Fund

1983

Laurie Anderson, *United States Parts I Through IV,* Brooklyn Academy of Music, New York

Trisha Brown, *Set and Reset,* set by Robert Rauschenberg, music by Laurie Anderson

Robert Morris, *The House of the Vetti 2*

"Language, Drama, Source, and Vision," exhibition New Museum, New York, includes: Acconci, Weiner, Wegman, and Prince

"Der Hang zum Gesamtkunstwerk," curated by Harald Szeemann at the Kunsthaus, Zurich, exhibition on *Gesamtkunstwerk* in the tradition of Wagner; includes Beuys, Cage, and Duchamp

Projects UK, founded by Jon Bewley and Ken Gill in Newcastle upon Tyne to produce performance and time-based art

Tehching Hsieh and Linda Montano begin a one-year performance event, tied together at the waist by an 8-foot rope

Alastair MacLennan, *Healing Wounds,* a performance in a disused hospital wing at the Fri-Son Hospital in Fribourg, Switzerland

Mary Kelly publishes *Post Partum Document*

Peter Brook, *Mahabharata*

Le Lieu, an archive and center for contemporary performance founded in Québec by director Richard Martel

Anne Teresa De Keersmaeker forms her company Rosas

1984

Robert Wilson, *the CIVIL warS,* Los Angeles

Pina Bausch, *Bluebeard,* Wuppertal

Philip Glass, *Akhnaten,* New York

The Wooster Group, *L.S.D. just the high points,* New York

Romeo Castellucci/Societas Raffaelo Sanzio, *La Generalissima*

Michel Laub/Remote Control, *Return of Sensation*

Deep Inside Porn Stars, 7 live performances by 7 top film stars (Carnival Knowledge) from the sex industry, sponsored by Franklin Furnace

"Blam, the Explosion of Pop, Minimalism, and Performance," Hirshhorn Museum in Washington D.C. and the Whitney Museum, organized by Barbara Haskell; includes Kaprow, Oldenburg, Rauschenberg

Bonjour Mr Orwell, Happening, televised event organized by Paik between Paris, Cologne, New York, with Cage, Beuys, Cunningham, Anderson ,and others, to celebrate the first year of global television

Bill T. Jones and Arnie Zane, *Secret Pastures*

William Forsythe, *Artifact*, ballet, Frankfurt

Linda Montano begins *7 Years of Living Art* (1984–91), later to become *14 Years of Living Art*

Diamanda Galás, *Masque of the Red Death*, song trilogy on AIDS

Formation of Border Arts Workshop, with Guillermo Gomez-Peña, Victor Ochao, David Avalos, Sara Jo Berman, Isaac Artenstien, to deal with bi-national concerns on the Tijuana/San Diego border

"Primitivism in Twentieth-Century Art," MOMA, New York, marked new "multicultural" approach to scholarship

Forced Entertainment, Sheffield-based performance ensemble is formed, and perform *Jessica in the Room of Lights*

The Guerilla Girls begin their campaign against racism and sexism within the art world

1985

Richard Foreman, *Birth of the Poet*, with Kathy Acker, sets by David Salle

Robert Lepage, *The Dragon's Trilogy*

"Raum, Zeit, Still/ Space, Time, Silence," Kunstverein, Cologne, exhibition curated by Wulf Herzogenrath, includes: Beuys, Cage, Duchamp, Kounellis, Rainer

Station House Opera, *A Split Second of Paradise*

John Malpede founds the Los Angeles Poverty Department (LAPD) involving homeless people in performance workshops

National Review of Live Arts, annual festival of performance art in the UK, artistic director Nikki Milican

Mona Hatoum, *Position Suspended*, day-long performance-installation

Bruce Nauman, *Sex and Death/Double 69*

Pina Bausch, *Two Cigarettes in the Dark*, Wuppertal

Black Market International performance-network is established

1986

"Chambres d'Amis," Ghent, curated by Jan Hoet

Jan Fabre, *The Power of Theatrical Madness*

Miranda Payne, *Saint Gargoyle*, Living Art Festival, Riverside Studios, London

DV8, an independent collective of dancers is founded, with Lloyd Newson

Rachel Rosenthal, *L.O.W. in Gaia*

1987

Peter Sellars and John Adams, *Nixon in China*, Houston

Romeo Castellucci/Societas Raffaelo Sanzio, *I Miserabili*

William Forsythe, *The Loss of the Small Detail*, ballet with costumes by Issey Miyake, Frankfurt

Peter Greenaway, *The Belly of An Architect*, film

Jan Fabre, *Das Glas im Kopf wird vom Glas*, Brussels

1988

Marina Abramović and Ulay, *The Lovers: Walk on the Great Wall*

James Lee Byars, *This This*

"Freeze," exhibition curated by Damien Hirst in London, with fellow Goldsmiths' students

Tomáš Ruller, *8.8.88.*, Prague

Venice Biennale, "Aperto '88"

"Duchamp and the Avant-garde since 1950," Ludwig Museum, Cologne, exhibition organized by A. Fischer and D. Daniels; includes Beuys, Filliou, Klein, Nauman, Paik, Rauschenberg, Tinguely, and Vostell

Molissa Fenley, *State of Darkness*

Edge 88, England's first Biennale of performance and experimental art in London, director Rob La Fresnais

Brian Catling, *Shivering Dish*, Oxford

Bobby Baker, *Drawing on Mother's Experience*

Cleveland Performance Art Festival initiated

1989

Dan Graham's lecture-series, *Rock My Religion*

"Sur le passage de quelques personnes à travers une assez courte unité de temps.…1957–72," Centre Georges Pompidou, Paris, first retrospective of the Situationists

Trisha Brown, *Astral Convertible*, sets by Rauschenberg, Moscow

Holly Hughes, *World Without End*

US Congress debates on censorship, focusing on Robert Mapplethorpe, Andreas Serrano, Karen Finley, and Tim Miller

"Magiciens de la Terre," Centre Georges Pompidou, Paris, exhibiting work from around the world, showing the heterogenity of art, but also answering charges of Eurocentrism

1990

Rebecca Horn, *Buster's Bedroom*, feature-length film

Robert Wilson, Tom Waits, and William Burroughs, *The Black Rider*, Thalia Theater, Hamburg

Bill T. Jones/Arnie Zane & Co., *Last Supper at Uncle Tom's Cabin/ The Promised Land*

"High and Low—Modern Art and Popular Culture," exhibition curated by Kirk Varnedoe and Adam Gopnik, MOMA, New York; includes performance series "Six Evenings: Laurie Anderson, Eric Bogosian, David Cale, Brian Eno, Spalding Gray, Ann Magnuson," curated by RoseLee Goldberg.

Heiner Goebbels and Michael Simon, *Roman Dogs*, Theater am Turm, Frankfurt

Isaac Julien, *Looking for Langston*, Newcastle upon Tyne

1991

The Wooster Group, *BRACE UP!*, New York

Jan Fabre, *Sweet Temptations*, Antwerp

Paul McCarthy, *Bossy Burger*, video-performance, Los Angeles

Heiner Goebbels, *Newton's Casino*, Theater am Turm, Frankfurt

Richard Foreman, *Eddie Goes to Poetry City*, New York

"Metropolis," Martin Gropius Bau, Berlin, curated by Christoph Joachimedes

1992

Jan Fabre, *Silent Screams, Difficult Dreams*, Antwerp

Anne Teresa de Keersmaeker/ROSAS, *Mozart/Concert Arias*, Brussels

Saburo Teshigawara, *Noiject*, Frankfurt

"Désordres (Disorders)", Jeu de Paume, Paris, exhibition curated by Catherine David, includes Nan Goldin, Mike Kelley, Kiki Smith

Mike Kelley and Paul McCarthy, *Heidi*, video-performance

Root, artist-run performance space founded in Kingston upon Hull, director Mike Stubbs

DV8, *Strange Fish*

"Post-Human," Musée d'art Contemporain, Lausanne, exhibition curated by Jeffrey Deitch; includes: Barney, Gober, Hirst, Kelley, McCarthey, Ray Sherman, K. Smith

1993

Reza Abdoh, *Law of Remains*, New York

Beryl Korot and Steve Reich, *The Cave*, Vienna, Berlin, New York

Heiner Goebbels, *Ou bien le débarquement désastreux ...*, Paris

"Mike Kelley: Catholic Taste," Whitney Museum of American Art, New York, exhibition organized by Elisabeth Sussmann

"Chambre 763," exhibition created by Hans Ulrich Obrist in a hotel room at the Hotel Carlton, Montparnasse, Paris, includes 60 artists

Bobby Baker, *How to Shop*

Locus+, founded by Jon Bewely and Simon Herbert in Newcastle upon Tyne, archive and production organization

Douglas Gordon, *24-Hour Psycho*, in the exhibition "37 Räume (37 Rooms)," curated by Klaus Biesenbach, Kunstwerke, Berlin

1994

"Japanese Art After 1945: Scream Against the Sky," Guggenheim Museum, New York, curated by Alexandra Munroe

Matthew Barney, *Cremaster 4*

"Hors-Limites, l'art et la vie 1952–94," Centre Georges Pompidou, Paris, exhibition organized by Jean de Loisy; includes Abramović/ Ulay, Acconci, Barney, Burden, Cage, Export, Gilbert & George, Kaprow, Kelley, McCarthy, Nitsch, Nauman, Paik, Schneemann, West

Jan Lauwers/Needcompany, *Snakesong Trilogy*, 1994–97, Amsterdam

Robert Lepage, *7 Streams of the River Ota*, 1994–96

Pippilotti Rist, *Zip My Ocean*, video-installation

1995

Phase 2, Theater am Turm, Frankfurt, an evening, curated by Hortensia Völckers and Noemi Smolik, of visual artists who have created perormative situations

Tony Oursler, *Couch Piece* and *I Can't Hear You*, New York

Forced Entertainment, *Speak Bitterness*

DV8, *Enter Achilles*

First Johannesburg Biennale, South Africa

"Rites of Passages: Art for the End of the Century," Tate Gallery, London

Jan Fabre, *Universal Copyrights*, Antwerp

William Forsythe, *Eidos: Telos*, Frankfurt

Saburo Teshigawara, *Here to Here*

Marina Abramović, *Cleaning the Mirror*, New York

David Bowie and Brian Eno, *Outside*, album with reference to Viennese Actionism, Chris Burden, body art, and mutilation in general

1996

"Body as Membrane," Kunsthalle Odense, Denmark, exhibition
 includes: Valie Export, Joan Jonas, Orlan

"L'Art au Corps," MAC Galeries Contemporaines, Marseilles,
 exhibition organized by Philippe Vergne, includes Abramović,
 Acconci, Barney, Burden, Clark, Gober, Goldin, Hatoum, Kelley,
 Longo, McCarthy, Nauman, Nitsch, Oppenheim, Oursler, Rainer,
 Sherman, Serra, West

Stephen Petronio, *Drawn That Way*, New York

Alain Platel, *Bernadetje*, Ghent

Stephan Pucher, *Ganz Nah Dran*, Theater am Turm, Frankfurt

Gob Squad, *Work*, Nottingham

1997

theaterskizzen, curated by Hortensia Völckers and Tom Stromberg
 as part of documenta X, Kassel, presenting Gob Squad and
 Stefan Pucher, Jan Lauwers/Needcompany, Meg Stuart, Heiner
 Goebbels, Michael Simon, Christoph Marthaler, and others

Michel Laub/Remote Control, *Planet LULU*, Denmark

"Looking at Fashion," Venice Biennale exhibition, curated by
 Germano Celant, Luigi Settembri, and Ingrid Sischy

Marina Abramović, *Balkan Baroque*, Venice Biennale

"life/live," Musée d'Art Moderne, Paris, exhibition curated by Hans
 Ulrich Obrist and Laurence Bossé, portraying the British art-scene
 and the working-structures of the places involved with art

Peter Greenaway, *100 Objects to Represent the World—Prop
 Opera*, Salzburg

Matthew Barney, *Cremaster 5*

"Rrose is a Rrose is a Rrose—Gender Performance in Photography,"
 Guggenheim Museum, New York, exhibition curated by Jennifer
 Blessing

1998

"Out of Actions; between performance and the object, 1949–1979,"
 Museum of Contemporary Art, Los Angeles, exhibition organized
 by Paul Schimmel

Forced Entertainment, *Frozen Piano*, an interactive work on CD ROM
 in collaboration with photographer Hugo Glendinning

The year of the Global Biennale:

Johannesburg Biennale curated by Okwi Enwezor, Octavio Zaya,
 and others

Istanbul Biennale curated by Rosa Martinez

Venice Biennale curated by Germano Celant

Havana Biennale curated by Llian LLanes Godoy

Kwang-Ju Biennale curated by Lee Yung-Chu

Hong Kong Biennale curated by Gerard C. Tsang

Tai Pai Biennale curated by Fumio Nanjo

Manifesta, Luxemburg, curated by Barbara Vanderlinden

Berlin Biennale, curated by Klaus Biesenbach, Hans-Ulrich Obrist,
 and Nancy Spector

artists' biographies

biographies of the artists featured in this book

Abbreviations used:
Cal Arts: California Institute of Arts
CCNY: City College of New York
Goldsmiths': Goldsmiths' College, University of London
ICA: Institute of Contemporary Arts, London
MOMA NY: Museum of Modern Art, New York
MOMA Oxford: Museum of Modern Art, Oxford
NEA: National Endowment for the Arts (USA)
NYU: New York University
RCA: Royal College of Art, London
Sch.: School
Slade: Slade School of Fine Art, London
St. Martin's: St. Martin's School of Art, London
 (Central St. Martins College of Art and Design since 1989)
SUNY: State University of New York
UCLA: University of California at Los Angeles
USC: University of Southern California
U: University

REZA ABDOH

Born 1963 Iran. Joined National Youth Theater, London (1974), directed student production of Ibsen's *Peer Gynt* (1977). Studied Kathakali dancing in India, staged Noh plays in London, directed his own production of *Orfeo* (Edinburgh Festival, 1980). Studied film at USC (1981). For the next ten years he directed extravagant versions of Shakespeare, Beckett, David Henry Hwang. Founded his company Dar A Luz (1991), creating productions from scratch. Obsessed with "American culture"—"it makes me angry"—his performances were a brash concoction of racism, sexuality, political liberation, Hollywood, American theater-history, and tabloid journalism. His works include *The Hip-Hop Waltz of Eurydice* (1991), *Bogeyman* (1991), *The Law of Remains* (1992), *Tight Right White* (1993). His last work before his death from AIDS at 35 (1995), *Quotations from a Ruined City* (1994), was a juxtaposition of the "ruined" cities of New York, Los Angeles, and Sarajevo, and the deteriorization of bodies "ruined" by the HIV virus.

MARINA ABRAMOVIC

Born 1946 Belgrade. Studied at Acad. Fine Arts, Belgrade (1965–70), Acad. Fine Arts, Zagreb (1970–72) where she created her earliest performances and sound environments. She began using her body in performance in 1972, exploring themes of pain and duration, at the Student Center in Belgrade, which was visited by international performance artists in the early '70s. An important solo piece was *Rhythm 0* (1974, Naples), in which visitors were invited to use on her a range of instruments including knives and a gun. She moved to Amsterdam (1975), where she met Uwe Laysiepen (known as Ulay). Their collaborative works included *Relation in Space* (1976), *Thomas's Lips* (1975), *Freeing the Body* (1975), and finally *The Lovers: Walk on the Great Wall* (1988). Subsequent solo performances were *Sur la Voie* (1990), *Boat Emptying—Stream Entering* (1990), and *Biography* (1992–96), a theatrical retrospective of 25 years of her performances. Awarded the Venice Biennale "Golden Lion"(1997).

VITO ACCONCI

Born 1940 the Bronx, New York. MFA in literature at U of Iowa (1964). He switched to performance from poetry in the late '60s, moving "from the page" of poetry, "to the body as the page." His early interest was in the psychology of public and private spaces, and his research centered Kurt Lewin's notions of "field theory" and "topological psychology," explored in important early works, such as *Street Works I–IV* (1969), *Conversion* (1970), and *Seedbed* (1972). In the late '70s he created environments in which his recorded voice was the only remnant of his presence. In the '80s in works such as *Instant House* (1980) and *High Rise* (1980) he actively involved the viewer as performer. Acconci's performances and environments, such as *Info-System/Bookstore for documenta X* (1997), also implied a social and political critique.

ACT-UP

Formed 1987, AIDS Coalition to Unleash Power. Initally an ad-hoc committee organized to create a window-installation at the New Museum of Contemporary Art, New York, ACT-UP has since stopped Wall St. traffic, disrupted the New York Stock Exchange, demonstrated at the Center for Disease Control in Atlanta, and staged "die-ins," in front of pharmaceutical companies. An art sub-committee, "Gran Fury," makes provocative posters, such as the bloody handprint with: "The Government has Blood On Its Hands. One AIDS Death Every Half Hour."

JOHN ADAMS

Born 1947 Worcester, Mass. BA (1969) and MA (1971) at Harvard U. Taught at San Francisco Conservatory of Music (1972–83) and was composer-in-residence with San Francisco Symphony Orchestra (1978–85). His work for orchestra, opera, video, film, dance, and electronic music took minimalism in a dramatic direction, particularly with his operas *Nixon in China* (1987) and *The Death of Klinghoffer* (1991)—both in collaboration with director Peter Sellars.

ALIEN COMIC (TOM MURRIN)

Born Los Angeles. Graduated in law at USC and NYU. Became involved in performance after visits to La Mama Theater, first performing in Seattle in 1975 with Para-Troupe, later touring with Johanna Went and Craig Olander in The World's Greatest Theater Company. Settled in New York in 1979, performing in downtown clubs and art galleries, including P.S.122 and King Tut's Wah-Wah Hut. Known for his outrageous costumes put together from found clothing.

LAURIE ANDERSON

Born 1947 Chicago. MFA in sculpture at Columbia U (1972), trained in classical violin. Her first performance, *Automotive* (1972), was a composition played on the horns of cars in an outdoor space. *United States*, an 8-hour opus of song, narrative, and sleight of hand and eye (1983), made the landmark crossing of the "high"/"low" border, and used electronic music, visual imagery, and a strong stage presence to communicate cultural politics to a broad audience. The featured song "O Superman," (released in 1981) was a British pop hit, and led to a recording contract with Warner Brothers. Her film *Home of the Brave* (1986) was followed by tour *Natural History* (1986), performance evening *Empty Places* (1991), and tour *Stories from the Nerve Bible* (1992–93). She composed the score for Jonathan Demme's film of Spalding Gray's *Swimming to Cambodia* (1986). Her albums include *Big Science* (1982) and *Strange Angels* (1989), and she has produced a CD ROM, *Puppet Motel* (1995). *Moby Dick*, an electronic opera, was performed at the Massachusetts International Festival of the Arts in 1999.

ELEANOR ANTIN

Born 1935 New York. BA at CCNY. Performances include *Carving: A Traditional Sculpture* (1973), *The King of Solana Beach with Surfers* (1979), *The Angel of Mercy* (1980), *Recollections or My Life with Diaghilev* (1981). Antin is best known for performances that examine historical archetypes as allegories for explorations of the self. Her work includes performance, video, writing, drawing, painting, and photography.

JANINE ANTONI

Born 1964 Freeport, Bahamas. MFA at Rhode Island Sch. of Design (1989). Solo shows, featuring sculpture and installation, include *Gnaw* (1992)—two cubes, one chocolate, the other lard, which she gnawed until physically ill; *Lick and Lather* (1993) self-portraits in chocolate and in soap; *Loving Care,* performed 1992–96, referred to action paintings by Jackson Pollock and body works by Yves Klein. Antoni views everyday activities like eating, cleaning, or bathing as art-making processes, and her work is a commentary on eating disorders, self-effacement, and female identity.

JACKI APPLE

Born 1941 New York. Syracuse U (1959–60) and Parsons School of Design (1960–63). Apple has also been active as a media artist, audio composer, curator, writer, director, and producer. Performances include: *Woman Rising/Spirit* (1974), *Black Holes/Blue Sky Dreams* (1977), and *Mexican Tapes* (1979). Worked as curator of exhibitions and performances at Franklin Furnace, New York (1977–80), and author of *Doing it Right in LA: Self-Producing for Performing Artists* (1990).

PENNY ARCADE

Born 1951 New Britain, Connecticut. At 17 she joined John Vaccaro's Play-House of the Ridiculous in New York. A regular at Warhol's Factory, she appeared in his film *Women in Revolt*. Her bawdy and brash solo performances, with attacks on the art-world, politics, and the media, include *While You Were Out* (1985), *Invisible on the Street* (1986), *A Quiet Night with Sid and Nancy* (1989), and *Bitch! Dyke! Faghag! Whore! The Penny Arcade Sex and Censorship Show* (1990).

JOEY ARIAS

Born 1955, N. Carolina. A drag performer, Arias was a regular presence with Klaus Nomi in late '70s artists' cabaret. He has collaborated on stage productions, music, TV, and appeared in films such as *Big Top Pee-Wee* and *To Wong Fu, Thanks for Everything, Julie Newmar.*

KAROLE ARMITAGE

Born 1954 Madison, Wisconsin. Trained at N. Carolina School of the Arts, School of American Ballet, and began her career as a dancer in Balanchine's Geneva Ballet (1972–75). She joined the Merce Cunningham company (1976–80), and founded her own company in New York (1980). Her style embraces contemporary movement trends, such as voguing, rapping, and popping, and juxtaposes them with classical ballet and modern dance. She is also known for her collaborations with artists such as David Linton, John Zorn, David Salle, Christian Lacroix, and Jeff Koons.

ROBERT ASHLEY

Born 1930 Ann Arbor, Michigan. U of Michigan and Manhattan School of Music. Ashley organized the ONCE Festival, 1961–69, an annual Ann Arbor-based festival of contemporary performing art and music. He pioneered several opera-related TV works, among them *Music with Roots in the Aether: Video Portraits of Composers and Their Music* (1976), a 14-hour television/opera documentary, and *Perfect Lives* (1978–84). In the '90s, he continues to develop new forms of opera and to record contemporary music that explores language.

RON ATHEY

Born 1961 Groton, Connecticut. Spent his teenage years in California in a strongly religious household with a grandmother who insisted that he had a "calling" for the ministry. At Pentecostal churches he encountered faith healers and mystics, and became

fascinated by miracles, such as "the stigmata, wherein the gifted spontaneously bleed from the same parts of the body that Christ bled." Athey performed in nightclubs—"though low tech, they have the most energy"—before doing *Martyrs and Saints* (1993) at LACE in Los Angeles. This work included nude strippers, a drag queen, drummers, an intravenous drug-user, causing a furor in the NEA and other funding circles. Later he created *Excerpts from Four Scenes in a Harsh Life* (1994).

ALEX BAG

Born 1969 New York. BFA Cooper Union (1991). Combining autobiography with TV youth stereotypes, Bag explores the inauthenticity of media, mixing home video, music video, talk shows, fashion clips, news, and TV, and uses their trade-mark words—"like" and "stuff" punctuate each sentence. Videotapes include *Untitled (Project for Andy Warhol Museum)*, *His Girlfriend is a Robot*, and *The Artist's Mind* (all 1996). Her work has been included in group shows, such as *Does Television Inform the Way the Art is Made?* (Graz, 1996), *Up Close and Personal* (Philadelphia Art Museum, 1997), and *Young and Restless* (MOMA, NY, 1997).

BOBBY BAKER

Born 1950 UK. Studied painting at St. Martin's at the same time as Gilbert & George. Started performing in the early '70s when she discovered "that I just made people laugh." Her eccentric, self-deprecating performance, often about food, include *An Edible Family in a Mobile Home* (1976), *Packed Lunch* (1979), *About Time* (1980), *Drawings Mother's Experience* (1988), *Cook Dreams* (1990), the five-part series of performances *Daily Life* was followed by *How to Shop* (1993) and *Take a Peek* (1995). In 1997 she made the film *Spitting Mad* for BBC TV.

MATTHEW BARNEY

Born 1967 San Francisco. Ex-athlete and fashion model, also studied medicine at Yale U. First noticed by the art world for his climbing-performance at the Barbara Gladstone Gallery in New York (1991). He integrates performance, video and sculpture, creating multi-media pieces that explore gender, sexuality, and athleticism in mythical works such as *OTTOshaft* (1992). Video- and film-projects include *Cremaster 1–5*, produced over 4 years and presented at international exhibitions, film festivals, and on TV.

PINA BAUSCH

Born 1940 Solingen, Germany. Studied dance at Folkswangschule, Essen, from age 14 with Kurt Jooss, and from 19 at the Juilliard School, New York, with José Limon, Paul Taylor, and others. After her return to Germany (1961), she was a member of Jooss's dance company for 13 years. Founded her company Tanztheater Wuppertal in 1974, and gained international recognition as a leader of modern dance theater. Bausch's choreography is an eclectic mix of musical comedy, vaudeville, and political cabaret, and her main themes are the impossible quest for intimacy between men and women, and the training of the modern dancer, marked by repetition of dialogue and action. Her key pieces, with stunning sets by Rolf Borzik until 1980, later by Peter Pabst, are *The Rite of Spring* (1975), *Bluebeard* (1977), *Kontakthof* (1978), *Café Müller* (1978), *Arien* (1979), *Bandoneon* (1980), *Walzer* (1982), *Viktor* (1986), *Palermo, Palermo* (1990), and *The Window Washer* (1997).

ANNE BEAN

Born 1950 Zambia. Studied art at U of Cape Town and Reading U, UK (1968–3). Bean's first performance piece was a collaborative event held in the Piazza del Duomo in Florence (1970). She has continued to produce collaborative projects in unusual spaces (a derelict house in London's East End, punk clubs in Hollywood, an empty fish factory in Norway, etc.) In 1983 she co-founded the Bow Gamelan Ensemble. Her solo works include *Available Resources* (N. Ireland and London, 1991), *Tribute to Yves Klein* (London, 1995) and *A ROSE AROSE A ROSE* (London, 1997).

VANESSA BEECROFT

Born 1969 Genoa. Lives in New York. Her earliest work dealt with her own eating-disorders, documented in diaries and on film. She has created performances (in which she does not appear), involving groups of women whom she considers as objects in a painting. Recorded on video, the tapes are exhibited in galleries. Since her first solo exhibition (Cologne 1994), she has had several other solo and group exhibitions in Europe and the USA. Performances include *Everything That's Interesting is New* (Cologne, 1996), and *Show* (Guggenheim Museum, New York, 1998) in which a group of mostly undressed women were installed like objects on view.

JOSEPH BEUYS

Born 1921 Germany. Düsseldorf Acad. of Art (1947–54). Beuys believed that there was no separation between art and life, and that creativity was a crucial element for social change. He combined "actions" with his installations, sculptures, and politics, which were rich in metaphorical references to his personal history and German politics. Performances include *How to Explain Pictures to a Dead Hare* (1965), *Coyote: I Like America and America Likes Me* (1974), and *7,000 Oaks* (1982–87). In the '60s he participated in many Fluxus concerts. At the Düsseldorf Academy of Art (1961–62) Beuys insisted on opening his classes to all students, which led to his dismissal. Beuys was a charismatic figure, whose active combination of art and politics was instrumental in founding the Free International University for Creativity and Interdisciplinary Research in Ireland and the Green Party of Germany. Died 1986.

BLACK MARKET INTERNATIONAL

Formed 1985, the loose collective included Boris Nieslony (Germany), Jürgen Fritz (Switzerland), Norbert Klassen (Germany), Tomáš Ruller (former Czechoslovakia), Jacques van Poppel (Netherlands), Roi Vaara (Finland), and Zbigniew Warpechowski (Poland). They meet from time to time to make collaborative works. British artists Brian Catling, Nigel Rolf, and Alastair MacLennan have joined the group on occasion, while others, like Ruller, are no longer members.

ERIC BOGOSIAN

Born 1953 Woburn, Mass. Degree in drama at Oberlin College (1975). Bogosian's career began in New York's late-night music clubs and art spaces, where he first presented belligerent cabaret singer "Ricky Paul" (1979). His male characters *Men in the Cities* (1981) reflected the shared interests of his artist friends Robert Longo, Cindy Sherman, and Jack Goldstein in "appropriation" and media cliches. With Lenny Bruce and Brother Theodore as early role models, his key pieces include *Drinking in America* (1985–86), and *Sex, Drugs, Rock 'n' Roll* (1990), which marked his emergence from

the downtown art world into the spotlight of mainstream media. He has written stage and screenplays, including *Talk Radio* (1987–88) and *subUrbia* (1994), both made into feature-length films.

GLENN BRANCA

Born 1948 Harrisburg, Pennsylvania. Degree in stage direction Emerson College, Boston, Mass. (1971). Moved to New York (1976) and formed a highly theatrical rock band, Theoretical Girls, which played in the downtown clubs of the early art-rock period (late '70s). By 1979, with no formal musical training, he was writing and conducting pieces for groups of electric guitars, which moved beyond rock, crossing the boundaries of both minimalism and the avant-garde. In 1981, he began writing large ensemble pieces of high volume, using retuned guitars, and in 1983 wrote his first symphony. *Symphony No. 7* (1989) was written for full orchestra, and was followed by the choral work *Gates of Heaven*. He has also written music for dance and film, including the music for Peter Greenaway's *The Belly of an Architect* (1986).

STUART BRISLEY

Born 1933 in Haslemere, Surrey. Guildford Sch. of Art and Craft (1949–54), RCA (1956–59), Akad. der Bildenden Künste, Munich (1959–69), and Florida State U, Tallahassee (1969–62). Describing his performances as "living pieces of work," Brisley often explored philosophical or socio-political issues through deprivation, physical endurance, and repetition of mundane actions. Among his earliest pieces were *Celebration for Due Process* (1970), and *10 Days* (1973)—a statement against consumerism as related to religious and pagan ceremonies, in which the artist remained in a room for 10 days with uneaten food laid out on a table, gorging on the last day. Other key works include *Moments of Decision/Indecision* (1975), *180 Hours* (1978), *Leaching Out at the Intersection* (1981), *From the Fourth to the Third World* (1985), *Small Obscenities in Relation to Big Tragedies* (1989), *Tangencies* (1992), and *Dark Passing* (1998).

TRISHA BROWN

Born 1937 Aberdeen, Washington. BA in Dance at Mills College, California, where she later taught. She was a founding member of Judson Dance Theater and Grand Union, where her work was noted for its humor and inventiveness. In 1970, she formed her own company, and used her mostly untrained dancers to explore natural dance movements, especially those concerned with gravity such as *Walking Down the Side of a Building* (1970). *Accumulation* (1971) was a key solo that dealt with choreography as repetition. By the mid-'70s Brown was working with professional dancers, involving them in more complex choreographic works, such as *Locus* (1975) and *Glacial Decoy* (1979). She has collaborated frequently with artists and composers, including Rauschenberg, Robert Ashley, Donald Judd, Richard Landry, and Laurie Anderson. Other important works include *Son of Gone Fishin* (1981), *Set and Reset* (1983), *Newark*, (1987), *Astral Convertible* (1989), *M.O.* (1995), and *Twelve Ton Rose* (1996).

TANIA BRUGUERA

Born 1968 Havana. Escula de Arte San Alejandro (1983–87) and Instituto Superior de Arte (1987–92), Havana. A sculptor and installation artist, Bruguera's performances include *What Belongs to*

Me (Wifredo Lam Center, Havana, 1996), *Body of Silence* (Havana Biennale, 1997), and *Angola* (Johannesburg Biennale,1997). Her work deals with Cuban culture and heritage, including political issues such as the revolution, the civil war, and Cuban immigration. She has been in residence at the Sch. of Art Institute of Chicago, Western Front (Canada), Gasork Studio and the Slade (UK). Professor of Art at the Instituto Superior de Arte in Havana.

GUNTER BRUS
Born 1938 Ardning, Austria. Attended Sch. of Applied Arts, Graz, and studied graphic design and painting in Vienna (1956). Interested in early Austrian Expressionism and in Arnulf Rainer's work, he was then influenced by Franz Kline's work on show at the 1960 Venice Biennale. Late 1960 he met Otto Mühl, and they exchanged studio visits. In his *Painting in a Labyrinth-like Space* (1963), an "environmental painting," he covered the walls and ceiling of a room with fabric, and stretched string from wall to wall. In 1964 he made his first "action" *Ana*, situating his body at the center of the process, filmed by Kurt Kren. He worked exclusively in actions after a piece with his daughter, *Action with Diana* (1967). He called the new material *Body Analysis*, and his work became more and more extreme. His 30th action, *The Architecture of Total Madness,* was the first "feces action" in which he publicly defecated, urinated, and cut himself with a razor-blade. On 7 June 1968, he performed action No. 33 in a group event, *Art and Revolution.* He undressed, cut into his chest and thighs, and urinated into a glass and drank from it, finally lying down to masturbate while singing the Austrian national anthem. A storm of protest ended in his arrest and 6-month prison sentence, which he avoided by leaving for Berlin. Since his action No. 43 *Breaking Test* (1970), he has produced graphic and literary works.

CHRIS BURDEN
Born 1946 Boston, Mass. MFA at U of California, Irvine. A conceptual artist whose performance work used the artist's body as the medium, Burden's earliest performances were shocking for their realism and danger. His best-known works raised questions about public acts of extreme masochism, and the role of viewers who watched his self-inflicted pain—*Shoot* (1971), *Five-Day Locker Piece* (1971), *Back To You* (1974), *Doomed* (1975), and *Samson* (1985). Now works in Los Angeles, and teaches at UCLA.

BUTOH
Established in postwar Japan by Tatsumi Hijikata, who was determined to invent a national and contemporary style of dance. Butoh, a term approximating to "black dance or step," is deeply rooted in Japanese philosophy and creation-mythology, and incorporates Zen notions of the passage between birth and death. Slow-motion and exaggerated expressionistic gestures, taken from Japanese ritual and everyday custom, performed to very loud music or in utter silence, characterize this highly concentrated dance form. Hijikata scandalized with his first official performance in 1959, an adaptation of Yukio Mishima's novel *Forbidden Colors.* Butoh performers known to Western audiences include Kazuo Ono, Min Tanaka, and the groups Sankai Juku, and Dai Rakuda Kan. They all have in common a fascination with the body as an instrument of transcendental metamorphosis.

JOHN CAGE
Born 1912 Los Angeles. Briefly attended Pomona College, California, and studied with composers Adolph Weiss, Henry Cowell, and Arnold Schoenberg. By the late '30s, Cage was experimenting with unusual sounds, creating music with found objects, such as tin cans and radios, giving form to Futurist composer Luigi Russolo's manifesto *The Art of Noise* (1913), and continued with the exploration of everyday noise as music. He met Merce Cunningham in the late '30s during his residency as accompanist at the Cornish School in Seattle. He arrived in New York in 1943, the year of his first concert at MOMA, and was soon recognized as an innovator in the New York music scene. He studied Eastern philosophy and brought Zen into the art world, including "chance" as a creative device. *Music of Changes* (1951) was his first composition to use chance, silence, and indeterminacy. Notable works include his notorious silent piece, *4'33''* (1952), *Winter Music* (1957), *Atlas eclipticalis* (1961), *Variations V* (1965), and the five *Europeras* (1987–91). He was a close friend of Marcel Duchamp, and his influence on younger artists was immense. Died 1992 New York.

CAI GUO-QIANG
Born 1957 Wuanzhou City, Fujian, China. Studied in Fine Art Dept. of the Shanghai Theatrical U. Cai is best known in Europe and Japan for his public gunpowder explosions designed for particular sites, executed since 1989 under the title *Projects for Extraterrestrials.* Into each work he incorporates aspects of the historical and social circumstances of each location. In 1996 he was a finalist in the Hugo Boss Prize exhibit, Guggenheim Museum, New York. Lives and works in New York City.

DAVID CALE
Born 1958 Luton, Bedfordshire. Moved to New York 1979, and started performing at P.S.122 and The Kitchen. Cale's work is linked to song-writing—the starting point for his performance material. He has performed solo and also accompanied by musicians throughout the USA. His works include *Red Throats* (1987) and *The Nature of Things* (1990).

LAURIE CARLOS
Born 1949 Queens, New York. Attended Performing Arts High School. She received the Obie Award for her portrayal of Lady in the play *For Colored Girls Who Have Considered Suicide When The Rainbow Is Enuf,* and a Bessie Award for her work in *Heat* (1988) with Urban Bush Women and Thought Music in New York. Plays that she has both written and directed include *White Chocolate for My Father* (1992), *Monkey Dances (1990),* and *Fur on the Belly* (1993). Artist Fellow at Penumbra Theater.

ROMEO CASTELLUCCI
Born 1960 Cesena, Italy. Founded the Societas Raffaello Sanzio (1981) with his sister, Claudia Castellucci, and Paolo and Chiara Guidi. *La generalissima* (1984) was presented at the Venice Biennale, and *I Miserabili* (1987) at documenta 8. Other performances include *Gilgamesh* (1990), *Amleto* (1992), *Oresteia* (1996). The group has also created plays for children, taking place in "real-time" and "real space." Lives and works in Cesena, where he also founded a school for dramatic arts.

BRIAN CATLING
Born 1948 London. Graduated in sculpture RCA. Poet, sculptor, and performance artist, he works live and with video, creating *I Quequeg; a sermon in drowning* (Bristol, 1980), *At the Lighthouse* (London, 1991), *The Blindings* (London, 1994), *Cyclos,* a video-installation (London, 1996). He has also worked with Black Market International. Catling is Head of Sculpture at the Ruskin School of Drawing and Fine Art, Oxford.

PATTY CHANG
Born 1972 San Fransisco. BA at U of California, San Diego (1994). Her work includes performance, installation, film, and video. Her first piece *Half-n-Half,* was performed at the Deviant Playground in New York (1995). Since then she has performed at many New York events, with pieces such as *Isadora Duncan: Baptised Myth* (1996), *Gong Li with the Wind* (1996), *Alter Ergo* (1996–97), and *TKO: Better to give than to receive* (1997). Her film and video work includes *Alive and Kicking* (1996) and *Paradice* (1996).

JUDY CHICAGO
Born 1939 Chicago. Founded the first Feminist Art Program at Fresno State College, California, 1970. Joined Miriam Schapiro in 1971 to initiate a similar program at the California Institute of the Arts, Valencia. Performance workshops were included from the start, and among her collaborative works were *Cock and Cunt Play* (1970) with Faith Wilding and Janice Lester, and *Ablutions* (1972) with Suzanne Lacy, Sandra Orgel, and Aviva Rahmani. With Schapiro and others, she founded Womanhouse, a feminist art space in Los Angeles (1972). Chicago's work encompasses painting, sculpture, and needlepoint, such as *The Dinner Party* (1979), *The Birth Project* (1980–85), and *The Holocaust Project: from Darkness into Light* (1985–93).

LUCINDA CHILDS
Born 1940 New York. Studied at Hanya Holm Sch. of Dance in New York (1959), and with Merce Cunningham, where she met Yvonne Rainer. She began her career as dancer/choreographer in 1963 as an original member of the Judson Dance Theater. Ten years later she formed the Lucinda Childs Company. Her choreography uses sequential repetition with slight variations, allowing the spatial relationships of the dancers to remain consistent. Peformances include *Einstein on the Beach* (1976) in collaboration with Philip Glass and Robert Wilson, *Dance* (1978) with music by Philip Glass and film by Sol LeWitt, *Available Light* (1983) with music by John Adams and sets by Frank Gehry. She lives and works in New York.

COLETTE
Born 1947 Tunis. Colette has portrayed female heroines from mythology, literature, and art history from her first performance *Hommage to Delacroix* (1970). She creates and photographs tableaux vivant in museums and galleries, as well as in shop windows, streets, and clubs, in which she herself is "living sculpture." She also performs in storefront windows, as in *Beautiful Dreamer* (1980–84) and *The House of Olympia* (1996).

JANE COMFORT
Born 1946 Oak Ridge, Tennessee. BA in painting at U of N. Carolina, Chapel Hill. She has been exploring social,

psychological, and political issues through dance theater since 1978. With her dance group, Jane Comfort and Company, she has performed works such as *Faith Healing* (1993); *S/he* (1994); and *Three Bagatelles for the Righteous* (1996), a suite of three dances to music that incorporates sound-bites from the speeches of political and religious leaders. She has choreographed several theater and film productions, including Stephen Sondheim and James Lapine's Broadway show *Passion* (1994), *Francesca Page* (1997), and an off-Broadway show *Tell-Tale* (1998).

COUM TRANSMISSIONS
Founded 1969 in London and active in the '70s. Members Cosey Fanni Tooti, P. Christopherson, and Genesis P-Orridge combined pornography, photography, prostitution, and performance as means to express sexual transgression and challenge viewer perception.

MERCE CUNNINGHAM
Born 1919 Centralia, Washington. Studied dance at the Cornish School in Seattle (1937), Mills College in Oakland (1938–39). He described dancing as "movement in time and space," and used chance operations in creating dance. He started his career with the Martha Graham Dance Company in 1939, where he remained until the mid-1940s. He began a long-term collaboration with John Cage in 1942, co-composing *Credo in Us* that year, and developed a vision of performance in which set designer, composer, and choreographer worked independently, knowing the climate of the dance but not the particulars, uniting the elements only after they had been completed. Key works include *Sixteen Dances for Soloist and Company of Three* (1951), *Suite for Five in Space and Time* (1956), *Summerspace* (1958), *Walkaround* (1968), *Rainforest* (1968), *Canfield* (1969), *Second Hand* (1970), and *Changing Steps* (1975). From the early '50s Cunningham frequently worked with Rauschenberg and continued to collaborate with other artists and designers, including Warhol, Dine, Jasper Johns, Marc Lancaster, and Rei Kawakubo (*Scenario*, 1997). Cunningham is a pioneer in the use of video as an instrument of dance-documentation. His latest work *Hand-Drawn Spaces* (1998) uses optical sensors to create computer-installations. He is also using computer-technology as a notation method for recording and developing choreography.

DANCE FOR THE CAMERA
Dance for the Camera, initiated in 1993 by BBC2 and the Arts Council of Great Britain, aims to combine the talents of choreographers and directors to create original and inventive television. The short films, all made by independent production companies, range from 5 to 15 minutes, and many have won international film and dance/film prizes.

DANCE NOISE
Founded 1983 by Anne Iobst (born 1960, New York) and Lucy Sexton (born 1959, Pennsylvania). Both BFA in Dance at Ohio U (1982). They started performing in New York nightclubs (the Pyramid, 8 B.C.) and put on their first full-length shows at Franklin Furnace, The Kitchen, and P.S.122, also hosting cabaret nights at King Tut's Wah Wah Hut. *Club Bent,* part of the Queer Up North Festival in Manchester, toured the UK (May 1988).

ANNE TERESA DE KEERSMAEKER
Born 1960 Mechelen, Belgium. Graduate of the Mudra School, Brussels. Made her first piece *Asch* in 1980. Studied at Tisch Sch. of the Arts, NYU. She returned to Brussels in 1983, and that year staged *Fase, Four Movements to the Music of Steve Reich.* With Michèle Anne De Mey, Fumiyo Ikeda, and Adriana Borriello she founded the dance company Rosas in 1983, which had its debut at the Kaaitheater, Brussels with *Rosas danst Rosas.* Performances include *Elena's Aria* (1984), *Bartok/Aantekeningen* (1986), *Mikrokosmos* (1987), *Ottone Ottone* (1988), *Stella* (1990), *Achterland*, 1990. In 1992 Rosas became the company-in-residence of the Théâtre Royal de la Monnaie in Brussels. In 1995 De Keersmaeker opened the Performing Arts Research and Training Studios (P.A.R.T.S.) in Brussels.

LAURA DEAN
Born 1945 New York. Dance and music training Third Street Music School, with Lucas Hoving (dance) and Marion Mills (music). Studied at the School of American Ballet, the High School of Performing Arts, and the Joffrey Ballet School, and jazz with Matt Mattox. Was a member of the Paul Taylor Dance Company, and formed her own company Laura Dean Musicians and Dancers (1972). Spinning was a major breakthrough in her dance-vocabulary, and led to more than 40 works, for most of which she also created the music. Performances include *An Hour Silence* (1970), *Changing Pattern Steady Pulse* (1973), *Jumping Dance* (1973), *Spinning Dance* (1973, solo), *Response Dance* (1974), *Changing* (1974). *Drumming*, 1975, was a collaboration with Steve Reich. She has also choreographed works for the Royal Danish Ballet, the Frankfurt Ballet, and the John Curry Skaters.

JIM DINE
Born 1935 Cincinnati. Studied at U of Cincinnati, Boston Sch. of Fine and Applied Arts, Mass. BA Ohio U, Athens (1957). Dine moved to New York 1959, and staged his first Happening with Oldenburg and Kaprow at the Judson Gallery. The notorious *The Smiling Workman* (1960), lasting 40 seconds, showed Dine wearing a paint-splattered smock, with his face painted red and his mouth black, drinking from jars of paint. A photograph appeared in *Time Magazine*. Dine produced three other Happenings, *The Vaudeville Show*, *Car Crash*, and *A Shining Bed*, all at the Reuben Gallery in 1960, before returning to painting, sculpture, and assemblages.

DJ SPOOKY (PAUL D. MILLER)
Born 1970 Washington, D.C. Studied philosophy and French literature at Bowdoin College, Brunswick, Maine. A writer and conceptual artist, he curated several art events before he became known as DJ Spooky. His music ranges over the musical territory of urban youth culture, including hip hop, ambient, dub, and drum 'n' base. He sees his work as "conceptual expressionism" in the tradition of Dadaist Raoul Hausmann and conceptual artist Joseph Kosuth. In collaboration with Cultural Alchemy, he performed with SoundLab (1995), an event that was a mixture of live electronic images and sound. He lives in New York.

DV8 PHYSICAL THEATRE
Formed in 1986 in the UK, led by Australian-born Lloyd Newson, the group came together as an independent collective of dancers who wanted to break the borders between dance, theater,

architecture, music, and communication. Their work is about taking risks, aesthetically and physically. Since the late '80s, they have developed both popular and controversial works for stage and TV. Performances include *Dead Dreams of Monochrome Men* (1988), *Strange Fish* (1992); *Enter Achilles* (1995, filmed for Dance for the Camera 1996), and *Bound to Please* (1997).

ETHYL EICHELBERGER
Born 1945 in Pekin, Illinois. Attended Knox College, Galesburg, Illinois (1963–65). Graduate of American Academy of the Dramatic Arts, New York (1967). Created cut-and-paste adaptions of Robert Lowell's *Phaedra* that he performed in several lofts in 1972. Worked with the Ridiculous Theatrical Company, and in 1977 started his writing-performing career, becoming a famous Drag Diva with his first play *Nefert-iti* (1976). He performed at clubs like Frieda's Disco, the Paradise Garage, the Pyramid, and the Limbo Lounge. Before his death in 1990 he created 32 works, which included *Medea* (1980), *King Lear* (1985), *Klytemnestra* (1987), *Fiasco* (1988), *Das Vedanya Mama* (1990).

CATHERINE ELWES
Born 1952 St. Maxient, France. BA in Fine Art at the Slade (1979), MA in Environmental Media at RCA (1982). A member of the Women Artists' Collective (1976–81), Elwes has worked in both performance and video. Performances include *Voice Over*, *Menstruation II*, and *Each Fine Strand* (1981) which explored the way that ideology is passed down from mother to daughter. Videos *With Child* and *There is a Myth* (both 1984) confront the complexities of bearing and suckling a child, while critiquing conventional notions of the mother-child relationship. In collaboration with Rose Garrard and Sandy Nairne, she organized a seminal group exhibition "About Time," (ICA, 1980) which brought together works in video, performance, and installation by women artists.

ROSE ENGLISH
Born 1950 Hereford. Studied Fine Arts at Leeds Polytechnic. A performance artist since the mid-'70s. Among her early works are *Berlin* (1976) in collaboration with Sally Potter, *Plato's Chair* (1983), *The Beloved* (1985), and *Moses* (1987). Her first large-scale theater performance was *Walks on Water* (Hackney Empire, London, 1988), followed by *The Double Wedding* (Royal Court, London, 1991). *My Mathematics* (1992) included a golden stallion, and a new production, *Rosita Clavel* will involve seven horses and a Bulgarian Orchestra. Lives and works in London.

BRIAN ENO
Born 1948 in Woodbridge, Suffolk. Studied Fine Art at Ipswich and Winchester art schools before joining Roxy Music in 1971. A leading creative force in new music, Eno pioneered "ambient" music with his album *Discreet Music* (1975), establishing at the same time his ability to cross back and forth between the rock 'n' roll and classical worlds. Composer, synthesizer, and producer, he has collaborated with musicans, including Robert Fripp, David Bowie, and David Byrne, as well as with classical and experimental composers. In 1979 he began making non-narrative videos, such as *Mistaken Memories of Medieval Manhattan* (1980–81), and *Thursday Afternoon* (1984) which used his own ambient music as the soundtrack.

VALIE EXPORT

Born 1940 Linz. A founder of the Austrian Film-Cooperative in 1968, of the Grazer Autorenversammlung (writers convention), and, with Susan Sontag and Agnès Varda, of Film Women International in 1975. Her first performance *Cutting* (1968) was a commentary on expanded cinema, and from 1970 she made video-performances and video tapes. She produced her first 16mm movie *Unsichtbarer Gegner (Invisible Enemy)* in 1977. Exhibitions and projects include *Viennale,* (Vienna, 1970), *Körpersprache—Bodylanguage* (Graz, 1973), *Projekt '74* (1974), *Körperfigurationen 1972–76* (1977), and documenta 6 (Kassel, 1977).

JAN FABRE

Born 1958 Antwerp. Studied at Royal Acad. of Fine Arts, Antwerp. Visual artist, performance artist, choreographer, and theatre director. Key performances include *Theatre as it was to be expected and foreseen* (1982), *The Power of Theatrical Madness* (1984), *Das Glas im Kopf wird vom Glas* (1987), *Silent Screams, Difficult Dreams* (1992), *The Trilogy of the Body: Sweet Temptations* (1991), *Universal Copyrights 1 and 9* (1995), and *Glowing Icons* (1997). As a visual artist Fabre has had several solo exhibitions, and participated in a number of group shows, including the Venice Biennale (1990 and 1997) documenta 8 and 9 (1988 and 1992). In 1997, in collaboration with Ilya Kabakov, he made the video film *Een ontmoeting/Vstrecha—a meeting.* Fabre lives and works in Antwerp, and is a leading force in the Belgian New Wave of the '90s.

GARTH FAGAN

Born 1940 in Kingston, Jamaica. Danced with the National Dance Theater of Jamaica. Studied at Wayne State U, Detroit and later moved to Rochester, New York, where he founded the Garth Fagan Dance Company (1970). He has developed a movement language that combines modern, Afro-Caribbean, post-modern styles, a raw emotional sensuality always at its core, and with much autobiographical content. *Untitled* (1977), a plaintive work with music by Keith Jarrett, was a dance narrative about the dissolution of his marriage. *Griot New York* (1991) was a 90-minute tour de force with score by Wynton Marsalis and bold sculptural elements by Martin Puryear. Choreographer for the Broadway musical hit *The Lion King.*

FALSO MOVIMENTO

Founded 1977 by Mario Martone and his collaborators, a Naples-based theater group. The principal members were in their late teens, and came from diverse artistic backgrounds. Falso Movimento emphasized visuality, while making reference to popular films and comedy. Often performing in art galleries, the group produced works such as *L'apprendista stregone* (1978), *Total Control* (1981), *Tango Glaciale* (1982), and *Knives in the Heart* (1985).

FEMINIST ART WORKERS

Founded 1976 in California by Cherie Gaulke, Nancy Angelo, Candace Compton, and Laurel Klick, and later joined by Vanalyn Green. This collaborative performance group was formed to combine feminist theory with art, education, and activism. They first toured women's conventions and exhibitions in the Midwest and Northern California in 1977, offering performances and workshops on equal rights, violence against women, women in the workplace,

and women's culture. *Traffic in Women: A Feminist Vehicle* aimed to convert women's experiences of fear and victimization into positive feelings of power. Other works included *Bill of Rites* and *This Aint No Heavy Breathing.* The group worked together from 1976 to 1980.

MOLISSA FENLEY

Born 1954 Las Vegas. Degree in Dance at Mills College (1975). She moved to New York 1977, and formed her dance company, Molissa Fenley and Dancers. She first gained critical acclaim with works such as *Energizer* (1980), *Hemispheres* (1983), *Cenotaph* (1985), and *Esperanto* (1985). Their breakneck speed embodied the fast-paced mood of the '80s. She often appropriated gestures from dance history, creating aggressive and dramatic choreography, and collaborated with a wide range of artists and composers, including Francesco Clemente, Richard Serra, Tatsuo Miyajima, Philip Glass, the Kronos Quartet, and Anthony Davis. Other works have included *Feral* (1986), choreographed for the Ohio Ballet; *Descent into the Maelstrom* (1986) for the Australian Dance Theater; and *Inner Enchantments* (1996) for the National Ballet School of Canada.

KAREN FINLEY

Born 1956 in Chicago. MFA San Francisco Art Institute (1982). Her first performance was *Deathcakes and Autism* (1979), and others include *The Constant State of Desire* (1986), *We Keep Our Victims Ready* (1990), and *An American Chestnut* (1997). Finley addresses taboo subjects, such as domestic abuse, rape, and suicide, as well as homophobia, racial intolerance, and AIDS. Her provocative solos (she once covered her body in chocolate), have drawn press attention and attacks from conservative politicians who demanded the withdrawal of federal funding from those institutions which supported her work. Known as one of the NEA Four—artists whose grants were withdrawn because of their "obscene" material—she has countered with legal action—the case is scheduled to be heard by the Supreme Court in 1998.

FORCED ENTERTAINMENT

Founded 1984 Sheffield. A core group of six artists—Robin Arthur, Tim Etchells, Richard Lowdon, Claire Marshall, Cathy Naden, and Tere O'Connor—open to collaboration with other artists. Performances include *Jessica in the Room of Lights* (1984), *200% & Bloody Thirsty* (1987), *Welcome to Dreamland* (1991), *Red Room* (1993), *Speak Bitterness* (1994), *Quizoola* (1996).

RICHARD FOREMAN

Born 1937 New York. BA at Brown U (1959) and MFA at Yale U (1962). Foreman founded the Ontological Hysteric Theater in 1968, establishing his own style of intellectual theater in which he focused on writing and performing as a continuous process. Querulous texts recorded on tape were spliced with the live words of the actors. In *Pandering to the Masses; A Misrepresentation* (1975) four recorded voices came from loudspeakers in four corners of the performance space, so that each sentence of dialogue "would seem to circle the audience." These tape techniques were inspired by the sound manipulations of musicians like La Monte Young, Philip Glass, and Steve Reich. Foreman was also strongly influenced by the extravagant free-association performances of Jack Smith, as well as by Bertolt Brecht and Gertrude Stein. Key works include *Rhoda in Potatoland* (1975), *The Cure* (1986), *Symphony of Rats* (1988),

Lava (1989), and *Eddie Goes to Poetry City* (1991). Since the late '80s, Foreman's material has been co-produced with such groups as the New York Shakespeare Festival and the Wooster Group. Since 1991, the Ontological company has been installed in a permanent space in St. Mark's Church in the Bowery, New York, where *My Head was a Sledgehammer* (1994) and *I've Got the Shakes* (1995) were produced. Foreman has also designed and directed works by Brecht, Buchner, Gertrude Stein, Kathy Acker, and Václav Havel.

WILLIAM FORSYTHE

Born 1949 New York. Joffrey Ballet School, and American Ballet School (1968–73). A member of the Joffrey (1970-73) and the Stuttgart Ballet (1973–80). Artistic director of the Ballet Frankfurt (1984–95), and then of Theater am Turm, Frankfurt (TAT) since 1996. Among his earliest pieces are *Urlicht* (1976) and *From the Most Distant Time* (1978). His complex dance language combines the skills of classical dancers with investigations of non-Western dance movement. Collaborations with artists, such as designer Issey Miyake (costumes), Riverbed Media (multi-media installation), and stage designer Michael Simon (light-design), have resulted in innovative and dramatic works, among them *In the Middle, Somewhat Elevated,* (1987), *Limb's Theorem* (1990), *The Loss of Small Detail* (1987 and 1991), *Ali/na(c)tion* (1992–93), *Eidos: Telos* (1995), and *Sleepers Guts* (1996).

SIMONE FORTI

Born 1935 Florence. Forti's Italian-Jewish family left Italy in 1939, and then moved to the USA. She grew up in Los Angeles, and studied psychology and sociology at Reed College, Oregon. In 1956 she and her husband Robert Morris dropped out of school and moved to San Francisco. She studied dance for four years with Ann Halprin, meeting La Monte Young and actor John Graham. Deeply influenced by Dada, Kurt Schwitters, Zen, as well as Halprin, Forti moved to New York in 1959, taking classes at the Merce Cunningham and Martha Graham studios, and attended Robert Dunn's composition class. In 1960 she contributed *See-Saw* and *Rollers* to a program of Happenings at the Reuben gallery. Her "concert" *Five Dance Constructions and Some Other Things,* (1961) took place at Yoko Ono's loft. She was married to Robert Whitman 1962–66, assisting him with his Happenings, such as *Night Time Sky* and *Prune Flat.* Other works include *Huddle* (1961), *Fan Dance* (1975) *and Planet* (1976). She has collaborated with Trisha Brown, Charlemagne Palestine, and Peter von Riper.

RONALD FRASER-MUNRO

Born 1965 Cheshire. Fraser-Munro is a writer, performer and media artist. He uses humor, costume, text, and video to subvert dominant stereotypes and media images of black people. Co-founder of and contributor to the publication "le shovelle diplomatique." "Live Art has a unique opportunity to voice progressive ideas and break nasty old traditions and ignorance," he wrote. Recent works include *La Chaise-Longue Dangereuse* and *Bruder C'est Grim* (1994–5), *Quack FM* (1994), *Hey Up, Oswald* (1993), and *Old Blue Eyes is Black* (1992).

COCO FUSCO

Born 1960 New York. Writer and artist living and working in New York, and professor at the Tyler Sch. of Art, Temple U. Her book *English is Broken Here: Notes on Cultural Fusion in the Americas*

(1994), includes essays, scripts, and poems about cultural relations between N. and S. America, in collaboration with Guillermo Gómez-Peña. Her videos include *The Couple in the Cage: A Guatinaui Odyssey*, a video-documentary on her performances in cage with Gómez-Peña (1993), and *Pochonovela* (1995). In 1996, she and Nao Bustamante created *STUFF*, that looks at "the cultural myths that link Latin women and food to the erotic in the Western popular imagination."

DIAMANDA GALAS
Born 1952 San Diego, California. A vocalist, composer, and performer, Galás began performing in Europe in 1979, touring her earliest solo works, *Tragouthia ap to Aima Exoun Fonos (Song from the Blood of those murdered)* and *Wild Women With Steak Knives* (both 1979). She began *Plague Mass*, a requiem for those dead and dying of AIDS, in San Francisco in 1984. In 1990, she added a new section to it entitled *There Are No More Tickets to the Funeral*. Other works include *Vena Cava* (1992) exploring the destruction of the mind by clinical depression and AIDS dementia, *Insekta* (1993), *Schrei X* (1995), *Malediction and Prayer—Concert for the Damned* (1996).

GARHEL AND GALINDO
Pedro Garhel born 1951 Tenerife. Degrees in Interior Architecture (1971) and Design (1974), ICAE. Rosa Galindo born 1952 Tenerife. Studied Landscape Gardening at Escuela de Batres in Madrid (1976). They began working together in 1968. Their multimedia and performance work use religious images of pain, ecstasy, and death, drawing upon elements of daily ritual. Works include *Escultura Viva* (*Living Sculpture*, 1977). They founded Espacio P. (1981), the first center for performance and video work in Spain. *O.K.—O.K*, portraying their private life, was a shift of focus from external exploration of form to introspection. Garhel and Galindo live and work in Spain.

ROSE GARRARD
Born 1946 Bewdley, Worcestershire. MA in Sculpture at Chelsea Sch. of Art (1970), and attended Ecole de Beaux Arts in Paris (1970–71). Her piece *Universal Man in Forty-Five Tasks* (1974) was censored by the Victoria and Albert Museum because it depicted male genitalia. Other important works include *Incidents in a Garden* (Acme Gallery, London 1977, her first solo exhibition), *Casting Room One: An Historical Experiment—Actions to Reveal the Distortion Process* (1986), and *Talisman* (1988).

CHERI GAULKE
Born 1954 St. Louis, Missouri. BFA at Minneapolis Coll. of Art and Design (1975) and MA in Feminist Art/Education at Goddard College (1978). She began performing in 1974 with Sally Potter in the UK. Since then Gaulke has explored feminist and religious material in video, installations, artists' books, and public art. She was involved with the Women's Building in Los Angeles (1975–77), where she met Suzanne Lacy, Arlene Raven, and Sheila de Bretteville. In 1976 she co-founded the Feminist Art Workers with Nancy Angelo, Candace Compton, and Laurel Klick. In 1981, she co-founded an anti-nuclear group, Sisters of Survival, with Jerri Allyn, Nancy Angelo, Anne Gauldin, and Sue Maberry. Important solo works have included *This is My Body* (1982–83), *Revelations of the Flesh* (1985), and *Virgin* (1987).

GILBERT & GEORGE
Gilbert Proesch born 1943 the Dolomites, Italy. George Passmore born 1942 Devon. They met as students in 1967 at St. Martin's. Since 1968 they have worked together and presented themselves as Living Sculpture, intimately connecting their art with their lives. They have exhibited widely throughout Europe and the USA, and have participated in a number of international shows including documenta 5 (1972); documenta 6 (1977), and documenta 7 (1982) in Kassel. They live in London.

PHILIP GLASS
Born 1937 Baltimore. Studied at Juilliard School, New York (1962), Ford Foundation composer-in-residence (1962–64), and Fulbright Fellow (1964–66). He worked with Nadia Boulanger, Karlheinz Stockhausen, and Ravi Shankar in Paris (1965–66), returning to New York 1967. He then developed his best-known work *Music in 12 Parts* (1971–74), breaking with classical music by reducing his compositions to repetition and slight variations, from which the term minimalism derived. His ground-breaking collaboration with Robert Wilson, *Einstein on the Beach* (1976) stirred the worlds of opera, art, and music, and inspired a new generation of composers to write avant-garde operas. Glass's other operas include *Satyagraha* (1980), *Akhnaten* (1984), and *The Voyage* (1992), and a trilogy of experimental works based on the early films of Jean Cocteau: *Orphée* (1992), *La Belle et la Bête* (1994), and *Les Enfants Terribles* (1996).

GOB SQUAD
Founded 1994 Nottingham, with members Johanna Freiburg, Alex Large, Sean Patton, Liane Sommers, Berit Stumpf, and Sarah Thom. Studied at Department of Visual and Performing Arts, U of Trent, Nottingham, and Justus Liebig U, Giessen, Germany. Important performances include *House* (1994), *Work* (1995), *An effortless transaction* (1996), *Close enough to kiss* (1997), *Ganz Nah Dran* (1997), *15 minutes to comply* (1997) for documenta X in collaboration with Stefan Pucher.

HEINER GOEBBELS
Born 1952 Neustadt an der Weinstrasse, Germany. Studied sociology and music in Frankfurt. Worked with Das Sogenannte Linksradikale Blasorchester (1976–81), and the art-rock trio Cassiber. Since the mid-'80s he has composed and staged his own radio dramas. After the scenic concerts *The man in the elevator* (1987) and *Prometheus* (1991), he started creating music-theater pieces: *Roman Dogs* (1990), *Newton's Casino* (1991), both in collaboration with Michael Simon at the Theater am Turm in Frankfurt; *Ou bien le debarquement désastreux...* (1993), *Black on White* (1996). Since 1988 he has also composed music for the Ensemble Modern and the Ensemble InterContemporain.

GUILLERMO GOMEZ-PENA
Born 1957 Mexico City. Moved to California 1978, attended Cal Arts. Moved to the San Diego/Tijuana area where he became one of the founders of the Border Arts Workshop/Taller de Arts Fronterizo in 1985. He works in performance, spoken word, poetry, video, radio-art, literature, and computer art. His most significant works are his hybrid performance installations that draw from pop culture, journalism, politics, anthropology, and post-colonial thought. In collaboration with the Cuban-American writer Coco

Fusco, he has developed "living dioramas" that parody and subvert colonial practices of representation, such as the ethnographic tableaux vivants, peformed in shopping malls and other public places. Performances include *The Loneliness of the Immigrant* (1979), *The Guatinaui World Tour* (1992–93), *Mexarcane International (Ethnic Talent for Export* 1994–95), *The Crici-Fiction Project* (1994), *Activist Dioramas*, performance as reverse anthropology (1996).

DAN GRAHAM
Born 1942 Illinois, raised in New Jersey and moved to New York in the mid-'60s. He ran the John Daniels Gallery (1964), but soon became more interested in creating his own conceptual work using a synthesis of film, video, performance, architecture, glass, and mirrors. Exploring the relationship between public and private space and the human psyche, his work often incorporates the viewer, as in *Rooftop Urban Park Project* (1991), installation at New York's Dia Center for the Arts, and *Past Continuous Pasts* (1974). Key performance-related pieces include *Past/Future/Split Presentation* (1972), *Public Space/Two Audiences* (1976), and in collaboration with Glenn Branca *Performance and Stage-Set Utilizing Two-Way Mirror and Video Time Delay* (1983) .

GRAND UNION
In 1970, Yvonne Rainer invited dancers with whom she had worked in Judson Dance Theater to form a non-hierarchical, improvisational dance company—David Gordon, Steve Paxton, Barbara Dilley, Nancy Lewis, Lincoln Scott, Trisha Brown, Becky Arnold, and Douglas Dunn. Inspired by Rainer's *Continuous Project—Altered Daily* (1969), peformances were spontaneous and egalitarian. Dancers walked, climbed ladders, ate, and talked to each other in a collage of emotional and physical interactions that represent human relations. Grand Union responded to political issues of the day, organizing a benefit for the Committee to Defend the Black Panthers at NYU Loeb Student Center (1971). Grand Unon's last performances took place in Missoula, Montana, 1976.

SPALDING GRAY
Born 1941 Providence, Rhode Island. Attended Emerson College and performed in traditional theater before moving to New York with Elizabeth LeCompte 1967. He attended workshops at Joseph Chaikin's Open Theater, Robert Wilson's Byrdd Hoffman Foundation, and in 1969 joined Schechner's Performance Group, appearing in *Commune* at the Performing Garage. Gray co-founded the Wooster Group with LeCompte (1975), and his biographical material formed the basis of their first collaboration, the trilogy *Three Places in Rhode Island*. In 1977, Gray began a series of monologues which he called "poetic journalism," straightforward accounts of his daily adventures. He also made works out of conversations with audiences, as in *Interviewing the Audience* (The Kitchen, 1981). Important pieces include *Sex and Death to Age 14* (1980), *Swimming to Cambodia* (1984), and *Monster in a Box* (1990). Died 2004.

PETER GREENAWAY
Born 1942 England. Trained as a painter, from 1965 he worked as a film editor for 11 years for the Central Office of Information. In 1966 he began making his own films, and has continued to produce paintings, novels, illustrated books, exhibitions, and operas. *The*

Draughtsman's Contract (1982) brought him recognition as an important contemporary filmmaker, followed by notable films such as *A Zed and Two Noughts* (1986), *The Belly of an Architect* (1987), *The Cook, the Thief, his Wife and her Lover* (1989), and *The Pillow Book* (1996). His two operas are *Rosa; A Horse Drama* (1994) with music by Louis Andriessen, and *100 Objects to Represent the World—A Prop Opera,* (1997) with music by Jean-Baptiste Barrière.

RED GROOMS

Born 1937 Nashville. Studied at New School for Social Research, Chicago Art Institute, and Hans Hofmann School, Provincetown. *A Play Called Fire*, a Happening (1958) was staged in a Provincetown gallery. *The Burning Building* (1959) was performed at the Delancey Street Museum—his loft in New York where he exhibited his environments and figurative paintings. Grooms painted sets, and his costumed actors performed fast-paced 10-minute pantomimes.

GUERRILLA ART ACTION GROUP (GAAG)

Founded 1969 New York by Jon Hendricks, Jean Toche, Poppy Johnson, Joanne Stamerra, and Virginia Toche. GAAG was based on the idea of artists collaboratively taking action for political and social change. Their performed actions were well planned, theatrical, and accompanied by press releases and manifestos. Actions such as *Bloodbath* (MOMA, NY, 18 Nov., 1969), in which they astonished watchers by ripping at each others' clothes and spewing concealed bags of animal blood over each other in the lobby of the museum, underlined the carnage of modern warfare. The group was active until 1976.

GUERRILLA GIRLS

First emerging 1985 during the "backlash" against feminism with posters plastered all round lower Manhattan, this is an activist organization with a changing roster of anonymous women artists, who always wear gorilla masks at public appearances. Their posters use statistical evidence to criticize individuals, galleries, and museums that under-represent or exclude women and minorities from exhibitions, collection, and funding. The Guerrilla Girls are still active, and regularly appear on panel discussions in the USA.

GUTAI GROUP (CONCRETE GROUP)

Founded 1954 Japan, led by Jiro Yoshihara (1904–72). Those associated with the group came from various disciplines, including the visual arts, law, literature, and economics. They created unconventional theater events and site-specific outdoor installations, using the body as material and emphasizing process over product. The First Gutai Exhibition (Tokyo, Oct. 1955) included Saburo Murakami's *Paper Tearing* and Kazuo Shiraga's *Challenging Mud*, both of which have near-mythical status today. In 1957, they created the Gutai On Stage Art Exhibition in Tokyo and Osaka. Gutai events were reported in the New York *Times* (Sept. 1957), and their action paintings were exhibited at the Martha Jackson Gallery, New York (1958). Photographs of their actions were included in Kaprow's *Assemblage, Environments & Happenings* (1966). Yoshihara also edited *Gutai* (1955–65), a journal that documented the group's history, theories, and performances. *The Gutai Manifesto* was published in 1956. Gutai ended in 1972 with the death of Jiro Yoshihara.

ANN HALPRIN

Born 1920 Winnetka, Chicago suburb. Married architect Lawrence Halprin at 20, and moved to Wisconsin. BA in Dance at U of Wisconsin (1943), the first American university to offer dance as a major, where she studied with Margaret D'Houbler. The Halprins moved to New York where she danced in the Broadway musical *Sing Out Sweet Land*, studied with Hanya Holm and Martha Graham, and joined the Doris Humphrey/Charles Weidman dance company. They moved to San Francisco in 1947, and the following year she set up the Halprin-Lathrop Foundation for dance, began a magazine *Impulse* and created a traveling exhibition "Everyone Can Dance" (1952), stressing Halprin's belief in the importance of dance in daily life. Her outdoor stage and innovative teaching methods—warm ups were called "movement rituals"—attracted dancers and non-dancers alike, including Robert Morris, Simone Forti, Yvonne Rainer, Trisiha Brown. Key works include *Five-Legged Stool* (1965), *Parades and Changes* (1967), and *Lunch* (1968)

ANN HAMILTON

Born 1956 Lima, Ohio. BFA in Textile Design at U of Kansas, MFA in sculpture at Yale U (1985). Performances involve repetitive and often compulsive domestic labor. In certain exhibitions she has spent days and weeks in her installations; for example, in *tropos* at the Dia Center for the Arts, New York, in 1993, she sat at a table on a huge horsehair carpet, with a glowing pen slowly burning lines from the book she was reading. Many works, such as *Privation and Excesses* (1989), *malediction* (1991), *Indigo Blue* (1991), *a round* (1993), and *tropos* (1993), deal with metamorphosis through accumulation.

MONA HATOUM

Born 1952 Beirut. Studied at the Slade. Performances include *Under Siege* (1983) and *Roadworks* (1985). *Measures of Distance* (1988), a 15-minute video piece, was a direct reference to the artist's experience of exile. Hatoum's work deals with issues of culture and identity, specifically experiences of displacement. Her work includes performance, video, installation, and sculpture. Lives in London.

JULIA HEYWARD

Born 1949 Raeford, N. Carolina. BFA in painting at Washington U, St Louis (1972), and MFA in electronic arts Rensselaer Polytechnic Institute (1999). Moved to New York 1973 to attend the Whitney Independent Study Program. First performed at The Kitchen, New York, *It's a Son! Fame by Association* (1975), a work that began with visual puns and included autobiographical material, as did *Shake! Daddy, Shake!* (1976). In the '80s Heyward moved into music-television and video, and had several multi-media concert-bands such as *Mood Music* (1988). *Miracles in Reverse* (1997) was a live performance with 3-D film and singers. Heyward is currently working on a Digital Video Disc—a visual album of *Miracles in Reverse.*

HI RED CENTER

Active Tokyo 1962–64. The three founding members were Genpei Akasegawa, Jiro Takamatsu, and Natsuyuki Nakanishi. Hi Red Center is an English acronym for the first character of each artist's name in the group, which emphasized the anonymity of its members. They staged Happenings, which they called "agitations," throughout Tokyo. They shared much with the Fluxus Artists, who

later re-enacted certain of their pieces in New York. Key works include *Miniature Restaurant*, in which they served food on toy plates to visitors to an exhibition; *Movement to Promote the Cleanup of the Metropolitan Area (Be Clean!),* an event staged to clean up a street corner in Tokyo; and *Shelter Plan.*

DANNY HOCH

Born 1970 Queens, New York. Graduated from New York City's High School of Performing Arts, and attended British-American Drama Academy and N. Carolina Sch. of the Arts. An actor, writer, and teacher, Hoch's first solo show was *Some People* (1994) at P.S.122, later broadcast on HBO (1996). He has collaborated on many other theatrical and broadcast productions, including HBO's *Subway Stories* (1997) and Anna Delfina's *Pieces of the Quilt.* His third solo performance, *Jails, Hospitals & Hip-Hop* (1997) was written after spending several years performing for prisoners in detention. Hoch explores urban life through language, culture, race, and economic situation.

REBECCA HORN

Born 1944 Michelstadt. Studied at Hochschule für Bildende Künste in Hamburg (1964–69), and at St. Martin's (1969–71). Lived in New York 1972–81, and since 1989 has taught at Hochschule der Künste, Berlin. She used artificial extensions of her body from 1968, made of feathers, cotton, and canvas. Later she developed mechanically supported installation-like works, such as *Overflowing Blood Machine* (1970) where the performer stood on a glass container with tubes wrapped around his body, through which blood was slowly pumped. Horn documented her work on video and film, and in 1974 began working in 16mm. Her key feature-length film is *Buster's Bedroom* (1990).

HOLLY HUGHES

Born 1955 Saginaw, Michigan. B.A. at Kalamazoo College. Moved to New York 1979 to continue painting at the Feminist Art Institute. In 1981, she began writing and performing plays for New York's WOW café, a lesbian/feminist performance club (*The Well of Horniness, The Lady Dick*). No longer painting, she concentrates on performances, such as *World without End* (1989), a monologue that caused a furor in Congress for its openly lesbian content.

JOHN JESURUN

Born 1951 Battle Creek, Michigan. BFA at Philadelphia Coll. of Art (1972), MFA at Yale U (1974). A playwright, director, and designer, he began his career as a film director, and later incorporated film techniques, media, and technology into live performance. In 1979, he embarked on *Chang in a Void Moon*, a "living film serial," one episode a week shown at the Pyramid Club (1982–83, 1984–85), and also at Limbo Theater and the Performance Garage. Other works include *Dog's Eye View* (1984), *Deep Sleep* (1986), *Everything that Rises Must Converge* (1990). *The End of Cinematics*, a video opera, will take place at the Brooklyn Academy of Music in 1999.

JOAN JONAS

Born 1936 New York. MFA at Columbia U (1964). First performance was *Oad Lau* (1968), and others include *Organic Honey's Visual Telepathy* (1972), *Mirage* (1976), *Volcano Saga* (1987), and *Variations on a Scene* (1993). Her work is concerned

with perceptions of movement in space and the process of change, and she is one of the first visual artists who turned to performance precisely to explore these issues.

BILL T. JONES AND ARNIE ZANE
Jones born 1952 Wayland, New York. Zane born 1948 the Bronx, New York. Both attended SUNY Binghamton, where they met in 1971, soon performing their first duet *Begin the Beguine*. In 1973, they co-founded, with Lois Welk and Jill Becker, a dance collective called the American Dance Asylum. In 1982, Jones and Zane formed the Bill T. Jones/Arnie Zane Dance Company. Throughout their 17-year collaboration their personal relationship frequently provided the material for performances. Together they created 17 co-productions, including *Intuitive Momentum* (1982), *Secret Pastures* (1984) with sets by Keith Haring, and *History of Collage* (1988), dealing with issues ranging from sexuality to racism to political power structures. After Zane's death from AIDS in 1988, Jones became the sole artistic director, choreographer, and spokesman for the company, and important works since include *Last Supper at Uncle Tom's Cabin/Promised Land* (1990), *The Mother of Three Sons* (1990), and *Still Here* (1994).

KIM JONES
Born 1944 San Bernadino, California. BFA at Cal Arts (1971), MFA at Otis Art Institute (1973). He is known best as Mud Man (first performance 1974), a primordial wanderer covered with dried mud and sticks, often appearing in SoHo streets and galleries. He draws upon his memories and the legacy of his service as a Marine in Vietnam, his performances and installations often including iconography and documentation of that period. In a 1990 gallery installation, Mudman's performance gear hung on one gallery wall near drawings alluding to battle plans and sculptural works, such as a mud-caked table collaged with photographs of Jones in Vietnam. In 1976 he provoked public criticism for *Rat Piece*, in which he torched live rodents, a further reference to practices in war-torn Vietnam.

ISAAC JULIEN
Born 1960 London. An independent filmmaker and co-founder of Sankofa Film and Video. His work frequently explores themes of black gay identity, and intercultural conflict and dialogue. Among his films are *Who Killed Colin Roach* (1983), *Territories* (1984), *The Passion of Remembrance* (1986), *Media Fictions* (1987), *This is Not an AIDS Advertisement* (1987), *Dreaming Rivers* (1988), and *Looking for Langston* (1989). An adaptation of *Looking for Langston* was a site-specific performance (London and Newcastle, 1990 Edge Festival) with 20 performers, in 6 different tableaux, including a cemetery, alleyway, canal bridge, and gay nightclub.

ALLAN KAPROW
Born 1927 Atlantic City. BA at NYU (1945), MA in Art History at Columbia U (1951). He studied music composition with John Cage, Jackson Mac Low, Al Held, and others (1957–58). In 1952 he co-founded the Hansa Gallery, New York, where he exhibited his early combine paintings. By 1957, his work had become exclusively environmental, involving lights, odors, electronic sounds, unusual materials, based on the concept that art is experiential. Kaprow changed from "action painter" to "action artist" with his first event,

Untitled (Hansa Gallery, March 1957). In 1959, at the Reuben Gallery, he presented *Intermission Piece*, a sound Happening (June), and *18 Happenings in 6 Parts* (October) which led to the term "Happening" being taken up by the media to describe the many live events by artists throughout the '60s. His seminal book *Assemblage, Environments & Happenings* (1966) was an extraordinary anthology of happenings and events by many artists including Rauschenberg, Dine, Oldenburg, the Gutai Group, and Wolf Vostell.

MIKE KELLEY
Born 1954 Detroit. Attended U of Michigan, Ann Arbor, and Cal Arts where he studied with David Askevold (1978). Moved to Los Angeles 1976, where he currently lives and works. Until 1986 he created and exhibited pieces that explore various media, including sculpture, drawing, video, writing, perfomance, and painting. Among these are *The Poltergeist*, a collaboration with David Askevold, (1979), *Monkey Island* (1982–83), and *Plato's Cave, Rothko's Chapel, Lincoln's Profile* (1985–86). Since 1986, when he stopped giving performances, he has exhibited such pieces as *Half a Man* (1988) and *Pay for Your Pleasure* (1988). He also created several videos and installations in collaboration with Paul McCarthy and Tony Oursler.

JOHN KELLY
Born 1954 Jersey City, NJ. Studied Dance at American Ballet Theater School, James Waring Studio, and Charles Weidman Expression of Two Arts Studio. He also enrolled in drawing and painting classes at Parsons Sch. of Design, voice at the Academia Musicale Ottorino Respighi in Assisi, and Decroux corporeal mime Théâtre de l'Ange Fou in Paris. His vocal repertoire ranges from Monteverdi to Cage to Joni Mitchell. He has received many awards for his multilayered performance art, which incorporates choreography, song, film, and visual design. Works include *Love of a Poet* (1990), *Pass the Blutwurst Bitte* (1995), *Maybe it's Cold Outside* (1991), and *Constant Stranger* (1996).

MARY KELLY
Born 1941 Minnesota. Studied Fine Art and music at College of St. Teresa in Minnesota; MA at Pius XII Institute, Florence. Postgraduate certificate in painting from St. Martin's, London. Kelly's work is conceptually concerned with the condition of women in Western capitalist society and with critical theory. Her best-known works include the large-scale installation *Post Partum Document* (1973–79), an autobiographical analysis of the relationship between mother and child, and *Interim* (1984–89) based on more than 100 conversations with women.

KIPPER KIDS
Brian Routh born 1948 Gateshead, Co. Durham. Martin von Haselberg born 1949 Buenos Aires. They met at East 15 Acting School in London 1970, and began performing 1971. Known for their long and pointy latex chins and noses, the Kippers performed a series of untitled actions 1971–75, and developed a distinct style which incorporated violence, bizarre costumes, odd objects, funny noises, and a boxing ring that doubled as an art installation. Other performances include *Up Yer Bum* (1976) and *Silly Ceremonies* (1979). Their savage ceremonies mock etiquette, social convention, male bonding, and art, but at the same time pay homage to vaudeville, Commedia dell'Arte, Alfred Jarry, and Hugo Ball.

YVES KLEIN
Born 1928 Nice. Studied at L'Ecole Nationale de la Marine Marchande, and at L'Ecole Nationale des Langues Orientales, Nice, where he also attended judo classes and started to paint. Klein chose the sky with its dimension of infinity as his theme, and began his blue monochrome adventure in 1946. He was later known for his "Yves-Klein Blue." In 1947 he invented the *Symphonie Monotone*, making mono prints with his hands and feet on his shirt. While living in Japan (1952–53), he became a judo black belt. In *Le Vide* (Paris, 1958) Klein exhibited nothing but his aura, and that same year began his *Epoche Pneumatique*. In 1960, the first public demonstration of *Anthropométries* (blue monochromes made by nude models) took place in Paris. Klein was a founder member of the Nouveau Réalistes (1960) with Restany, Arman, Spoerri, and others. Died 1962 of a heart attack.

MILAN KNIZAK
Born 1940 Prague. Attended the Art School (1958–59) and Art Academy in Prague (1963–64). Expelled from both. He was involved in dissident politics throughout his life, and co-founded Aktual in Prague with Jan Mach and Robert Wittman (1964). In 1966 he first met Fluxus members in Prague. He organized two Fluxus concerts, and was imprisoned when at one of them Serge Oldenbourg gave a soldier Knížák's passport as well as his own. He participated in Fluxus West during his travels in the USA (1968–70). In 1973, he was arrested in Prague for a book that he had published with Vice Verstand, but appealed against his sentence and was released.

ALISON KNOWLES
Born 1933 New York. BFA at Pratt Institute (1957), and attended Syracuse U (1957–59). A visual artist, composer and poet, she began her long-standing involvement in Fluxus activities during the European Fluxus festivals of 1962. Returning to the USA, she organized the Yam Hat Sale at the Smolin Gallery as a part of Fluxus's year-long Yam Festival. Her portable constructed environments, often exploring the participatory role of the viewer, included *The Big Book* (1966), *The House of Dust* (1968), and *The Book of Bean* (1981).

PAUL KOEK
Born 1954 Netherlands. Studied percussion at the Hague Conservatory. In 1986 he founded the Theatergroup Hollandia, based in Zaandam, with the Johan Simons. He also taught at DasArts, Amsterdam. Important performances include *Prometheus* (1989), *Persians* (1994), *Euripides* (1996), *The fall of Mussolini* (1997).

BERYL KOROT
Born 1945 New York. Founder and co-editor of *Radical Software* (1970), the first publication to document artists' work and ideas concerning video. In 1976 she co-edited *Video Art* with Ira Schneider. Best known for her multiple-channel video installations, including the four-channel *Dachau 1974* (1974), and *Text and Commentary* (1977), a five-channel work incorporating drawings, weavings, and notations. She pioneered non-verbal narrative works for multiple channels by working with specific image/time/sound sequences. In 1989 she began collaborating with Steve Reich on the

multi-channel video theater piece, *The Cave* (performed in Vienna, Berlin and New York, 1993). *Three Tales: Act I, Hindenburg* (Spoleto Festival, S. Carolina, 1998) is part of Reich and Korot's video opera *Three Tales*, to be performed in 2001.

JANNIS KOUNELLIS

Born 1936 Piraeus, Greece. Studied at Accademia di Belle Arti in Rome. A painter, performance artist, and sculptor, the focus of much of his work has been on the tensions and alienation of contemporary society, and the fragmentation of language. Performances in the '60s, for example, involved Kounellis "singing" the numbers and letters painted on his canvases.

SHIGEKO KUBOTA

Born 1937 Nigata, Japan. Studied at Tokyo U, and NYU, New School for Social Research, and Art School of the Brooklyn Museum. Moved to the USA in 1964 and became involved in the Fluxus movement. Kubota is best known for her innovative video installations that combine sculptural forms with video technology. Lives in New York.

YAYOI KUSAMA

Born 1929 Nagano, Japan. Moved to New York 1958. She gained increasing recognition in the '60s for her orgiastic Happenings which featured naked dancers dotted with paint. Kusama's numerous sculptures and paintings, filled with her obsessive images of dots and phallic shapes, have been exhibited widely throughout the USA and Europe. In 1973, suffering from mental exhaustion, she returned to Tokyo where she continues to work and lives voluntarily in a psychiatric hospital.

LESLIE LABOWITZ

Born 1946 Uniontown, Pennsylvania. MFA at Otis Art Institute of Parsons Sch. of Design, Los Angeles (1972). Performances include *Menstruation Wait* (1971), *Record Companies Drag Their Feet* (1977), and *Sprouttime* (1980–81). Closely allied with the women's movement in Los Angeles, her early works centered on violence against women. She also worked on a number of collaborative performances, primarily with Suzanne Lacy.

SUZANNE LACY

Born 1945 in Waco, California. MFA at Cal Arts, Valencia, 1973, where she studied under Kaprow. Her first performance was *Ablutions* (1972), a collaboration with Judy Chicago, Sandra Orgel, and Aviva Rahmani. Other performances include *Three Weeks in May* (1977), *She Who Would Fly* (1977), *In Mourning and in Rage* (1977) in collaboration with Leslie Labowitz, and *The Crystal Quilt* (1987). Lacy was one of the first artists who used performance specifically to address the question of violence against women.

LA FURA DELS BAUS

Founded in Barcelona. An extremist theater-group whose works dealt with danger and violence, and were performed in sheds, factories, shopping centers, funeral parlors (*Galileo St.*, Madrid, 1983), disused prisons (*Badajoz*, 1985), buildings under construction, marquees, building sites, bus depots (*Almeria* 1986), fairgrounds, etc.

JOHN LATHAM

Born 1921 Zimbabwe, formerly Rhodesia. Studied art in London 1946–51. In 1954 he founded the Institute for Study of Mental Images (ISMI). In 1964 he began using the book as sculpture and made "Skoob Towers" ("skoob": books spelt backwards) which he burnt as a demonstration of the fragility of intellectual life. The first ceremonies took place in Oxford, Edinburgh, and Bangor, and were repeated in 1966 in London outside the British Museum during the Destruction in Art Symposium. In 1965 he co-founded the Artist-Placement Group (APG) with Barbara Steveni, to place artists in work environments from factories to dockfronts. He taught at St. Martin's (1965–67) and was dismissed after an event in which friends and students chewed a copy of Clement Greenberg's revered book *Art and Culture*, spat the pulp into a bottle, and returned the soggy remains to the library (exhibited at MOMA NY, 1970). Later performances combined with political demonstrations, including *Performance: Government of the 1st and 13th chair* (London, 1978, and Oxford, 1991), and *Notification of the Historical Convergence* (10 Downing Street, London, 1988).

MICHEL LAUB

Born 1953 Antwerp. Started as a performance and video artist in 1974. Formed the group Maniac Production (1975–79) and in 1981 founded Remote Control Productions with the performance *Snapping, Computing and Performing*. Important performances include *White Out* (1982), *Return of Sensation* (1984), *Rewind Song* (1989), *Fast Forward/Bad Air and so…* (1991), *Jack's Travelogue/La Prison des Femmes* (1992), *Rough* (1993), *Planet LULU* (1996). Lives in Amsterdam.

JAN LAUWERS

Born 1957 Antwerp. Studied painting at Royal Academy of Art, Ghent, 1976–80. Founded the Epigonenensemble in 1979, which became the Epigonentheater zlv in 1981. In 1986 he formed the Needcompany. Performances with Epigonentheater zlv include *Incident* (1985), and with the Needcompany *Need to Know* (1987), *Julius Caesar* (1990), *Antonius and Cleopatra* (1992), *The Snaksong Trilogy* (1994–96), *No beauty for me there, where human life is rare* (documenta X, Kassel, 1997).

JEAN-JACQUES LEBEL

Born 1936 Paris. An activist as much in his art work as in promoting art events and Happenings, Lebel was instrumental in popularizing the genre, which he studied at firsthand in New York (Nov. 1961 to Feb.1962), participating in Oldenburg's *Store Days* at the Ray Gun Theater. He tied Happenings to leftist political values, and celebrated the psychosexual and political liberation that actionism implied. Starting in Paris in 1964, he organized festivals of Free Expression in cities throughout Europe. For him Happenings were "an artistic *and* political revolution." Works include *Movie* (Ibiza, 1958), *L'anti-Procès*, (Paris, 1960, *Incidents* (Biennale Paris, 1963), *Dechirex* (Festival de la Libre Expression, Paris 1965), *Fluxus: une conférence-demonstration* (Nanterre, 1967). He described his Street Plays of 1969, as "Political Street Theatre."

RALPH LEMON

Born 1952 Ohio. BA English Literature and Theater Arts at U of Minnesota (1975). A founding member of the Mixed Blood Theater

Company of Minneapolis, he was also a member of the Wigman-inspired Nancy Hauser Dance Company. On moving to New York (1985) he founded his own dance company, which he maintained for ten years. Lemon's subsequent work combined dance, film, video, and theater, and, in collaboration with writers and visual artists, addressed socio-political issues. In 1997, he created *Geography; Part 1: Africa*, a collaboration with Francisco Lopez, Paul D. Miller (DJ Spooky), Tracie Morris, and Nari Ward, in which he examined his African heritage. *Geography Trilogy*, commissioned by the Yale Repertory Theatre, is to be developed over a 6-year span. *Part II: Asia* and *Part III: America* will be presented spring 2000 and winter 2002 respectively.

ROBERT LEPAGE

Born 1957 Québec. Studied at Conservatoire d'Art Dramatique (1975–78) and at Alain Knapp's theater school in Paris. In 1981 joined the Théâtre Repère in Québec. *Circulations* (1984) his first production, won Best Canadian Production Award. In 1985 *The Dragon's Trilogy* gained him international recognition. His cinematic approach, with highly visual staging, use of bilingual texts and appropriation of acting styles and traditions from Kabuki, Hoh, and Japanese puppetry, characterized his increasingly large-scale productions. In 1994 he founded his own multi-disciplinary company, Ex Machina, which developed his seven-hour epic *7 Streams of the River Ota* (1994–96). That year he also directed his first film, *Le Confessional*, shown at the Cannes Festival. Other works include: *Polygraph* (1989), *Tectonic Plates* (1989), *Needles and Opium* (1991), *The Shakespeare Trilogy: Macbeth, Coriolanus, The Tempest* (1992).

ROBERT LONGO

Born 1953 New York. BFA at State U College, Buffalo, where he and Cindy Sherman, Nancy Dwyer, and Charles Clough initiated the alternative gallery Hallwalls. Returning to New York in 1977, he worked briefly at The Kitchen, organizing video exhibitions, and later that year produced his own video-performance at Artists Space. His cast-aluminum wall relief *American Soldier* (1977) was included in the seminal "Pictures" exhibition (Artists Space, fall 1977). *Sound Distance of a Good Man* (1978) a 7-minute performance with film, live dancers, and an opera singer, was close in theme and imagery to his drawings and sculpture, as was *Empire* (1979) a performance trilogy. A leading member of the '80s media-generation, Longo's art makes connections between rock 'n' roll, punk music (he played in downtown clubs with his own band Menthol Wars), TV, and film. In the late '80s he became increasingly involved in making films, among them *Arena Brains* (1988), which depicted life in downtown Manhattan. In 1995, he directed his first feature-length Hollywood film, *Johny Mnemonic*, for Columbia/Tristar.

CHARLES LUDLAM

Born 1943 Long Island. Studied drama at high school and formed his own Students' Repertory Theater 1961. Studied drama at Hofstra U (1965), and moved to New York, where he met John Vaccaro and joined his new company the Play-House of the Ridiculous, performing in Ronald Tavel's *The Life of Lady Godiva* (1966). His first work *Big Hotel* (1967) was a compendium of quotes and extracts from dozens of sources, including Marshall McLuhan,

Shakespeare, James Joyce, and Strindberg. *Conquest of the Universe* (1967) was an expression of his break with Vaccaro. Ludlam left with 7 members of the Play-House (including Mario Montez and Black-Eyed Susan) to form the Ridiculous Theatrical Company (named by Jack Smith). *Bluebeard* (1970) was the company's first hit. By 1978, the company had its own theater at One Sheridan Square where *Eunuchs of the Forbidden City* (1972), *The Mystery of Irma Vep* (1984), and *The Bells* (1992), and many other outrageously costumed and hilarious pieces were shown. Ludlam wrote, directed, and performed in 29 plays in 20 years. When he died in 1987, the New York *Times* proclaimed him "one of the most innovative and prolific artists in the theater of the avant-garde."

MABOU MINES
Founded 1970 New York, a collaborative theater company. Members include Lee Breuer, Ruth Maleczech, Frederick Neumann, and Terry O'Reilly. Past members have included JoAnne Akalaitis, William Raymond, Greg Mehrten, Ellen McElduff, L.B. Dallas, Philip Glass, and David Warrilow. From the theory that life is a performance, works have merged religion, politics, sociology, anthropology, and biology. The company's works include *The Red Horse Animation* (1970), *Dressed Like an Egg* (1977), *A Prelude to Death in Venice* (1980), *Through the Leaves* (1984), *An Epidog* (1995), and *Peter and Wendy* (1996).

PAUL MCCARTHY
Born 1945 Los Angeles. BFA at San Francisco Art Institute (1969), MFA at USC (1973). First solo exhibition was *Contemporary Cure-All* and *Deadening,* Los Angeles Institute of Contemporary Exhibitions. Using food products as his trademark medium, he creates unnerving works whose atmosphere of violence and perversion, are a critique of American culture and its obsession with TV and the media. These include memorable works such as *Hot Dog* (1974), *Grand Pop* (1977), *Doctor* (1977), *Death Ship* (1981). In 1984 he gave up performance, but continued to produce videotaped performances such as *Family Tyranny* and *Cultural Soup* (both 1987). *Heidi* (1992) was a collaboration with Mike Kelley.

ROBBIE MCCAULEY
Born 1942 Virginia. BA at Howard U, MA in Educational Theater at NYU. Her work deals with issues of sex, class and power centered on the African-American experience. Performances such as *Sally's Rape* (1990), *My Father and the Wars* (1992), and *Mother's Work* (1995)—"I am talking about my mother, most of the words are hers"—are autobiographical portraits that show external influences on identity as well as her fascination with history. Musical references and choreography are an extension of the work's content, hence, "the content is the aesthetic."

GEORGE MACIUNAS
Born 1931 Lithuania. BA in Architecture at Carnegie Institute of Technology (1954), and attended Institute of Fine Arts, NYU (1955–60). In 1961, Maciunas coined the title Fluxus for a growing body of collaborative work by many artists involved in performance, conceptual art, and new music at that time, centering on closing the gap between art and life. From 1961 until his death in 1978, he was the chief co-ordinator and promoter of the activities and philosophy of Fluxus, including editing and printing a magazine,

archiving ephemeral objects of idea art (such as Fluxboxes, Fluxgames and Fluxfood), and documenting the group's Actions and Events. In 1960, he founded the AG Gallery.

BRUCE MCLEAN
Born 1944 Glasgow. Studied sculpture at Glasgow Sch. of Art (1961–63), and St. Martin's (1963–66). McLean's student performances were comic gestures such as *Mary Waving Goodbye to the Trains* (1965). In 1972, he formed Nice Style, the World's First Pose Band, with Gary Chitty, Robin Fletcher, and Paul Richards, performing *Deep Freeze: The Pose that took us to the Top* (Hanover Grand Hotel, 1973), *Modern Posture and Stance Moulds* (RCA), and *A Problem of Positioning* (Architectural Association, London, 1978). *Sorry the Minimal Musical* was a collaboration with Sylvia Ziranek (1977). During the '80s McLean focused on painting, but he made several performances for video, including a "sculptural dance" *Pull* for BBC2's Dance for the Camera series (1997).

ALASTAIR MACLENNAN
Born 1943 Blairatholl, Scotland. Studied at Duncan of Jordanstone Coll. of Art in Dundee (1960–65), attended Art Institute of Chicago (1966–68), and studied Buddhism (1973–75). Then he began to use his body in ritualized daily acts of long duration, in 1977, cleaning and weeding a public area for several hours. In *Days and Nights* (1981), he walked around the Acme Gallery in London for 6 days and nights. In *Healing Wounds* (1983), performed in an abandoned wing of a hospital in Switzerland, he pushed a heavy sink down a corridor with two doors and a ladder attached to his naked body. He performs wearing all black or a balaclava, or with nail bombs and batons found in his Belfast environment.

STEVE MCQUEEN
Born 1969 London. Studied at Chelsea Sch. of Art, at Goldsmiths', and at Tisch Sch. for the Arts, NYU. In 1996 he was awarded the ICA Award. In his videos he creates situations using simple actions and unexpected framings, that repeat over and over again, questioning the cinematic language. He is also concerned with ideas of identity and breaking with conventional cinematic narration. Exhibited in video installations, works include *Bear* (1993), *My Head* (1996), and *Catch,* (1997) presented at documenta X. He lives in London and Amsterdam.

ANN MAGNUSON
Born 1956 Charleston, West Virginia. Degree in Theater and Cinema at Denison U, Granville, Ohio (1978). Attended the British and European Studies Group, London (1977). Moved to New York and took up an internship with the Ensemble Studio Theater 1978. An important force in the emergence of Lower East Side artist venues in the '80s, she opened Club 57 on St. Mark's Place, where she created collaborative performance events, as well as one-woman shows, that captured the post-punk, alternative ethos of the times. Writer, actress, and performer, she appeared in the movie *Making Mr. Right,* and in the TV series *Anything but Love.* She lives in New York and Los Angeles.

JOHN MALPEDE
Born 1945 Wichita Falls, Texas, and raised in Chicago. Studied philosophy at U of Wisconsin (1965–68) and at Columbia U

(1969–70) For Malpede an exchange between disciplines is an index of artistic vitality that fuses in performance art. A director, performance artist, actor, and writer, he founded the Los Angeles Poverty Department in 1985, comprised primarily of homeless people, with whom he has fused avant-garde performance techniques with the energy of the streets. Performances include *Dead Dog and Lonely Horse,* ongoing collaboration with Bill Gordth (1977–80), *Inappropriate Laughing Responses* (1981), *Generic Performance* (1982), *Olympic Update; Homeless in Los Angeles* (1984–85), *LAPD Inspects Amsterdam* (1991), *Bronx Train* (1995), *Avec Moutard* (1996).

PIERO MANZONI
Born 1933 Soncino. A leading avant-garde artist of the '50s and '60s in Italy, he was seeking to blur the boundaries between painting, sculpture, artist, and audience. The questions of what defines an art object or an artist, and how a museum confers value and meaning lie at the core of his challenging legacy. His most famous piece is *Artist's Shit* (1961). In 1959 he created a pneumatic sculpture from balloons *Artist's Breath,* and in 1961–62 he signed 71 "living sculptures," among them artist Marcel Broodthaers and writer-philosopher Umberto Eco. Manzoni joined the ranks of highly conceptual artists such as Duchamp, Klein, and Broodthaers, whose paradoxical and polemical gestures continue to raise questions about the nature of art and culture. Died 1963 Milan.

CHRISTIAN MARCLAY
Born 1955 San Rafael, California. Marclay was raised in Geneva, where he studied at the Ecole Supérieure d'Art Visuel (1975–77). He moved to the USA 1977, and studied sculpture at the Massachusetts Coll. of Art, Boston. Marclay's work focuses on in the relationships between the visual and the aural. In his performance art of the late '70s, Marclay cut up and synthesized pieces of musical records and then played the results before an audience. His later performances continue his musical explorations, as in *Record Players* (New York, 1982), *David Bowie* (New York, 1991), and *One Hundred Turntables* (Tokyo, 1991). Marclay lives and works in New York City.

CHRISTOPH MARTHALER
Born 1951 Switzerland. Studied music at Lecoq Theater School in Paris, and elsewhere. After several projects with actors and musicians, including *Indeed* (1980) and *Blanc et Immobile* which was produced in collaboration with the Harald Szeemann exhibition *Der Hang zum Gesamtkunstwerk,* Marthaler started to work continuously on theater productions for the Theater Basel in Switzerland from 1988. For the 700th anniversary of the Swiss Confederation in 1990, he staged the legendary performance *Stägli uf, Stägli ab, juhee, Murx den Europäer! Murx ihn! Murx ihn! Murx ihn! Murx ihn ab!* He has since directed several theater and opera productions, *Goethes Faust Wurzel aus 1 + 2* (1993), *Hochzeit* (1994), *Sturm nach Shakespeare* (1995), *Die Stunde Null oder die Kunst des Servierens* (1995), *Pelleas and Melisande* (1997) *Kasimir und Karoline* (1997). Performed at documenta X, in Kassel in 1997.

ANA MENDIETA
Born 1948 Havana. MFA in painting at U of Iowa (1972), MFA from the university's then new multi-media and video program. Performances include *Silueta series* (mid-1970s), *Blood Writing*

(1973), *Body Tracks* (1982). Mendieta's works often stemmed from the pressure to forget her cultural heritage, resulting in often haunting images of effigies traced from her own body and carved into limestone, sand, wood, mud, or chiseled into cave walls, or set to burn in flames. Through her art, she hoped to re-connect herself to Cuba, which she left as a 12-year-old. Died 1985.

GUSTAV METZGER

Born 1926 Nuremberg. Arrived in Britain 1939 as a refugee from Hitler's Europe. Since 1948 he has been registered as a stateless person. A student and associate of David Bomberg (1945–53), he acted as a witness of his times in his adoption of destruction and violence in his art, creating what he has termed an "aesthetic of revulsion," closely tangled with his political beliefs. At the end of the '50s he was involved in the nuclear disarmament movement, and was one of the founding members of the Committee of 100 (who were prepared to commit acts of civil disobedience). Meanwhile he developed the theory and practice of auto-destructive art that could simultaneously embody the forces of creation and destruction, attacking the capitalist system and its market forces. He was responsible for organizing the hugely influential Destruction in Art Symposium in London (1966).

TIM MILLER

Born 1958 Los Angeles. In 1979, after moving to New York, he co-founded Performance Space 122 (P.S.122) with Charles Moulton, Charles Dennis, and Peter Rose. A performance artist, composer, choreographer, and videomaker, Miller's works include *Postwar* (1982), *Cost of Living* (1983), *Democracy In America* (1984), *Buddy Systems* (1985), *Some Golden States* (1987), *Stretch Marks* (1989), *Sex/Love/Stories* (1991), and *My Queer Body* (1992). He has taught performance art at NYU and UCLA. After moving back to California, Miller founded Highways, a performance art space. He has described his work as a "weird journey throught Sex and Love, the AIDS Crisis, confronting the State, and trying to make sense of the world."

MEREDITH MONK

Born 1944 New York. BA at Sarah Lawrence (1964). A visionary performer, composer, choreographer, filmmaker, singer, and dancer, Monk has, since the early '60s, helped define the American avant-garde. In 1964 she took Robert Dunn's composition class, and met the members of the Judson Dance Theater, where she presented *16 Millimeter Earrings* (1966) a work combining film and performance, and showing her early interest in theatricality and emotional narrative. Key performances include *Juice* (1969), a 3-part work in several sites around the city, the audience traveling with her; and *Vessel* (1971), in which the audience traveled by bus from Monk's loft to the Performing Garage, and on foot to the parking lot. *Education of the Girlchild* (complete version, 1973), was followed by her most important '70s work, *Quarry: An opera* (1975), images of the Holocaust as seen by a 12-year-old girl. Other key works were *Dolmen Music* (1979), *Turtle Dreams* (1981), and *The Games* with Ping Chong (1983). *Atlas: An Opera in Three Parts* (1991), a collaboration with Yoshio Yabara (scenario and storyboards, costumes and sets,) was on a grand scale with 18 singer/performers and 10 orchestra members, showcasing Monk's repertoire of vocal techniques.

LINDA MONTANO

Born 1942 Kingston, New York. Became a novice at the Maryknoll Sisters Missionary, 1960. MFA at U of Wisconsin, Madison (1969). For her final exhibition, she showed chickens on the roof of the art department and elsewhere in the city of Madison. Her performances involved the transformation of her persona through endurance, meditation, and ritual. They include *Chicken Woman* (1970–71), *Handcuff: Linda Montano and Tom Marioni* (three-day action in which the two artists were handcuffed together), *Mitchell's Death* (1978), and *14 Years of Living Art* (1984–98). In 1983, she and Tehching Hsieh were tied together by an eight-foot piece of rope, in a year-long action entitled *One Year Art, Life Performance*. Montano's recent work is an evolution from her study of Zen Buddhism, and the seven chakras of Indian philosophy.

CHARLOTTE MOORMAN

Born 1933 Arkansas. MA in Music at U of Texas (1957), Julliard School, New York (1957–58), trained as a classical cellist. In 1963, she co-founded the New York Avant-Garde Festival at Carnegie Music Hall with John Cage and Earle Brown. Living sculptures, action music, and video-art were among her diverse compositions and performances. In 1964, she began her long-term creative collaborations with Nam June Paik, among them a notorious 1967 performance of *Opera Sextronique* at the Filmmakers' Cinemathèque, during which Moorman and Paik were arrested and charged with obscenity. Died 1991.

MARIKO MORI

Born 1967 Tokyo. Studied at Chelsea Coll. of Art, London, and Whitney Museum of American Art, New York. She combines performance with painting, sculpture, and photography, documenting herself in scenarios where she is dressed as a futuristic figure in typical urban settings. For example, in *The Beginning of the End*, in a space cadet outfit, she lay in a plastic capsule in one of Tokyo's busiest public places. Works include: *Empty Dream* (1995), *Last Departure* (1996). She lives in New York and Tokyo.

YASUMASA MORIMURA

Born 1951 Osaka, Japan. Through photography and performance, he transgresses and deconstructs catagories of race, gender, age, and culture. He explores issues surrounding the self and desire while masquerading as female Western film stars (Marilyn Monroe, Faye Dunaway, Audrey Hepburn). Morimura's work has toured internationally, including Japan, the USA, France, and Australia.

KEVIN MORTENSEN

Born 1939 Melbourne. Motivated by his Australian-Danish heritage and the richly complex meanings in Aboriginal and Viking mythology, he works closely with audiences, creating situations where their participation is inevitable. Performances include *The Seagull Salesman* (Melbourne, 1971), *Even the Hairs on your Fore-arms Grow in the same Direction as their Feathers* (Venice Biennale, 1980), and *The Ibis and the Song*, (Victoria, 1993).

OTTO MUHL

Born 1925. Studied German and History at U of Vienna, then studied at Acad. of Fine Arts, Vienna. In 1961 Mühl switched from painting to material actions, and became a member of the Viennese Actionism, with its heavy existential and psychoanalytical tendencies. In 1970 he started a commune that developed into an experimental society. The synthesis of Viennese Actionism and Wilhelm Reich's vegetotherapy resulted in the development of so-called "Actionsanalysis" and, from 1974, the "Selbstdarstellung" (self-expression): the pure self-creation of the actionist, emotional expression without any direction. This led to "Actionism" created with material and the human body, to "Actionsdance" and "Actionstheater," to environments, and to material opera as a total work of art to combine life and art and reality.

BRUCE NAUMAN

Born 1941 Fort Wayne, Indiana. BA in Mathematics and Art at U of Wisconsin (1964), MFA at U of California at Davis (1966). A sculptor and painter, Nauman began applying his conceptual theories to film and performance pieces in 1965, emphasizing the process of the creation rather than the product. His first solo exhibition was in 1968 at the Leo Castelli Gallery, New York. Since his earliest performance works, such as *Cardboard Floor Piece with Foot Hole* (1966), he has explored the relationship between the body and space; human and object; viewer and artist; private and public domain. Other works include *Manipulating a Fluorescent Tube* (1966), *Bouncing Two Balls between the Floor and Ceiling with Changing Rhythms* (1968), *Get Out of My Mind, Get Out of This room* (1972), *South American Triangle* (1981), and *Shadow Puppets and Instructed Mime* (1990).

KESTUTIS NAKAS

Born 1953 Detroit. BA in Film and Performing Arts at Michigan State U (1975). MFA in Acting at NYU (1979). Nakas moved to New York's East Village 1976, to be close to the clubs and small theaters. His first work, *Titus Andronicus* (1983), with Ann Magnuson, Steve Buscemi, John Sex, and others, was presented on Monday nights at the Pyramid Club. Associate Professor of Theater, U of New Mexico, and Visiting Associate Professor, UCLA, Department of World Arts and Culture. *Rheumatic Fever—a Love Story*, was presented at Highways, Santa Monica in 1998.

NEUER TANZ

Founded 1986 by performance artist VA Wölfl and choreographer and dancer Wanda Golonka. Wölfl had studied with Kokoschka and Soucek in Salzburg (1961–66), and with Otte Steinert at the Folkwangschule, Essen, (1966–72), and performed throughout the '70s. He and Golonka created multi-layered dance performances including *LEITZ—dem Nachlass verfallen* (*LEITZ—Addicted to the Heritage*, 1988), *Räumen* (1989), *Ballet No 5… to dance by nose* (1991), *RCA—going the work* (1992), *ELIPSIE… Die Künstler sind anwesend* (*Ellipse— The Artists are Present*, 1994), *xyz—Bewegtes Opfer* (*xyz—Moved Victim*, 1996).

HERMANN NITSCH

Born 1938 Vienna. He created his Orgies Mysteries Theater in 1957. A principal member of Viennese Actionism, his goal has always been to invent modern rituals that put men and women in touch with their emotional and sexual sensibilities. Based on Dionysian mythology, Catholic liturgy, and psychoanalytical theory, his ritualized and highly theatrical performances last several days,

and have included animal carcasses and evisceration, and cathartic bathing of performers in animal blood. These *Existenzfeste,* or existence-feasts, have radical political as well as sexual overtones. He first performed in London at the Destruction in Art Symposium (1966), and in New York when invited by Jonas Mekas (1968). Nitsch's most recent 6-day O.M.Theater play took place from sunrise on Aug. 3 to sunrise on Aug. 9, 1998, at his castle in Prinzendorf, Austria.

TERE O'CONNOR

Born 1958, Rochester, New York. Degree in Dance and Theater at SUNY Purchase. After performing solo for two years, he formed his own company, developing highly personal works that he says are metaphors for the marginalized voices in society. His recent "dance-plays" are less autobiographical and focus on broader social issues. Performances include *The Organization of Sadness* (1988), *Unlocked Memory Drawing with Humans* (1990) and *I Love You, There's so Much Trouble in the World* (1994). Teaches at NYU's Tisch Sch. of the Arts.

LORRAINE O'GRADY

Born 1940 Boston, Mass. Degrees in Spanish Literature, Economics, and Fiction. She worked as an English teacher, a rock critic (for *The Village Voice* and *Rolling Stone*), and made her debut as Mlle. Bourgeoise Noire in 1980, as a cry for "Black Art To Take More Risks!" O'Grady's work includes photomontages, site-specific performances, and an "avant-garde float" for an African-American Day Parade in Harlem. It is critical of mainstream ideas of race, class, and gender as well as black bourgeois values and aesthetics.

CLAES OLDENBURG

Born 1929 Stockholm. Moved with his family from New York to Rye (NY) to Oslo, settling in Chicago 1936. Yale U (1946–50). Returned to Chicago, where he worked as apprentice reporter and studied at the Art Institute of Chicago. He became an American citizen in 1953. Moved to New York 1956, and, except for travels to Europe and Japan, and a year and a half in the Netherlands, has lived there ever since. Married Coosje van Bruggen, with whom he has worked on large-scale public projects since 1976. Soon after his first solo exhibition (Judson Gallery, New York, 1959), he became an active Happening-maker, creating events in his Store Front on the Lower East Side. Performances include *Fotodeath (Circus)* (1961), *Injun* (1962), *Store Days* (1962), and *Washes* (Al Roon's Health Club, 1965). His '60s soft sculptures of everyday objects, and his monumental sculptures of "real" objects, installed in public spaces, are icons of Pop Art.

PAT OLESZKO

Born 1947 Detroit. BFA at U of Michigan. Olezko's work includes performances, films, installations, and special-events—from performances at MOMA NY to her annual appearance in New York's Easter Day Parade. Known for her elaborate disguises, Olezko has designed many hundreds of costumes and, only occasionally with the help of an assistant, sewn thousands of miles of material. The title of each costume is an intended pun, such as *Patty Cake* (1974), *Coat of Arms* (1976) and *New Yuck Womun* (1977). Her latest works are inflatable characters, some 50-feet tall.

PAULINE OLIVEROS

Born 1932 Houston. Studied composition at U of Houston and San Francisco State U. Moved on to musical improvisation and electronic music, "sonic meditations" and theater/performance pieces. A highly influential musician and composer, her works include the acclaimed and widely performed *Sound Patterns* (1962). Taught at U of California at San Diego as director of the Center for Music Experiment (1976–79).

YOKO ONO

Born 1933 Tokyo. Gakushuin U, Sarah Lawrence Coll., and Harvard U. A trained composer and musician, her studies included opera and German lieder. Her compositions, such as *Voice Piece for Soprano* (1961), explored the formal and conceptual use of the voice, undermining classical orchestral structure. Zen experience was evident in her earliest works, such as *Lighting Piece* (1955) and *Sweeping Piece* (1961–62). She became a member of Fluxus in the early '60s, exhibiting at Maciunas's AG Gallery in New York, and organizing performances (1960–61) in her New York loft. Her pieces involved her audiences and bridged the world of performance and objects, such as *Painting Made to Be Stepped On* (1961), and *Cut Piece* (1961) in which viewers were invited to cut off her clothing. Her films and performances explored her fascination with looking, revealing, and being looked at, as in *Bottoms* (1966) and *Rape* (1969).

LUIGI ONTANI

Born 1943 Italy. His early art experimentation included drawing, painting, and "pleonastic objects"—pieces made from everyday found-objects or cheap material. After several exhibitions and the publication of his poetry, Ontani performed his first *Tableau vivant* in which he impersonated Tarzan during the exhibition "Contemporanea" (Rome, 1974). In 1976 he journeyed to Columbus Circle in New York, dressed as the explorer and holding a copy of Columbus's logbook, and posed for photographs. He has also appeared as Rugantino (the stock comic character of Rome), as Dracula, and as characters from paintings throughout art history.

DENNIS OPPENHEIM

Born 1938 Mason City, Washington. BFA at Sch. of Arts and Crafts, MFA at Stanford U (1965). He created installations, land-art, videos, and performances. In 1966 he moved to New York, where he met Robert Smithon and other artists working on the "dematerialization" of art, creating land-art and conceptual art. His works and exhibitions include *Annual Rings* (1968), *Branded Mountain* (1969), *Gallery transplant* (1969), *Parallel Stress* (1970), *Rocked Circle—Fear* (1971), *Wishing Well* (1973), *Attempt to Raise Hell* (1974), *In Recall* (1974), *Retrospective* (Musée d'Art Contemporain, Montreal, 1978).

ORLAN

Born 1947 Saint-Etienne, France. A multi-media performance artist who has, for over twenty-five years, worked on the relationship between her own image and that of Baroque religious iconography, even resorting to plastic surgery to connect the two. Performances include *Le Baiser de l'Artiste* (1977), *The Reincarnation of Saint Orlan* (Newcastle, 1990), *This is my body…this is my software* (New York, 1993).

JILL ORR

Born 1952 Melbourne. Creates feminist multi-media performances, using her body, art history, painting, installation, and video art. One of her earliest performances was *Bleeding Trees* (Sydney Biennale, 1979). Other performances include *The Meeting ot the Opposites* (London, 1982) and *Marriage of the Bride to Art* (National Gallery of Victoria, 1994), where she explored the social, historical, and cultural contexts of her role as a female artist.

LUCY ORTA

Born 1966 Birmingham, UK. Since 1991, lives and works in Paris. Her performances and clothing are collaborative works which she sees as critiques of the inadequacies of social policies and urban life. *Refuge Wear* (1992) consists of multi-functional clothes that can be transformed into housing apparatus (sleeping-bags, tents). *Collective Wear* (1993) can house up to 16 people; and *Modular Architecture* (1996) allows several people to be linked together and move as a unit.

TONY OURSLER

Born 1957 New York. Studied with John Baldessari and Jonathon Borofsky at Cal Arts, Valencia, and lives and works in New York. His recent video-sculptures—abject freaky talking-heads—are eerily funny mini-dramas starring our alienated, media-infected selves. His exhibitions include "Catholic, performance" in collaboration with Mike Kelley (Los Angeles, 1983), *Spheres of Influence* (Paris, 1986), *White Trash and Phobic* (Geneva and Berlin, 1993), *Fantastic Prayers*, a website and CD ROM in collaboration with Stephen Vitiello and Constance DeJong, (Dia Center for the Arts, New York, 1995), *Anatomy of Space—Time*, group show (Kobe Fashion Museum, 1997), documenta X (Kassel, 1997)

NAM JUNE PAIK

Born 1932 Seoul, Korea. Degree in Aesthetics at U of Tokyo (1956). He met and worked with John Cage and Stockhausen at the avant-garde Studio for Experimental Music, Cologne. Among his earliest works was *Hommage à John Cage* (1959), in which he tipped over a piano on stage. Moving to New York in 1964, he became involved with Fluxus, and collaborated with Charlotte Moorman in such key pieces as *TV Bra for Living Sculpture* (1969) and *Opéra Sextronique* (1966). He began to create video art in 1963, fusing performance, chance, and audio-visual pastiche in works such as *Participation TV* (1963–71), in which images on a TV monitor altered in response to ambient sound. He is often cited as the father of video as an art form.

GINA PANE

Born 1939 Biarritz. Moved to Paris 1960. Studied polychrome sculpture in a minimalistic style at L'Ecole Nationale des Beaux Arts (to 1968). She determined that "nature" would be her material and the social and political reality her context Her first performance was *Modification constant du sol* (1969). and her ecological-sociological-political concerns culminated in *Riz* (1971) referring to the Vietnam War. Her public actions in the '70s explored personal psychological and psychoanalytical obsessions, and involved mutilation, endurance, and suffering. Works include *L'Escalade* (1971), *à Psyché/essay* (1974), symbols of the body mutilated by culture, history, and art. Masochistic and highly controversial, Pane's performances were deeply disturbing. Died 1990.

STEPHEN PETRONIO

Born 1956 Newark, NJ. BA at Hampshire College. The first male dancer in the Trisha Brown Company (1979–86), he founded his own company in 1984, and since then has been exploring a unique movement vocabulary, striving to develop a style that resonates in its cultural moment. His works with the company have included #3 (1986), The King is Dead with sets by Cindy Sherman (1993), #4 with music by Diamanda Galás (1996), Drawn That Way (1996), and ReBourne (1997).

ADRIAN PIPER

Born 1948 New York. BA at CCNY (1974), PhD in philosophy at Harvard U (1981). Performances include Catalysis Series (1970), Some Reflective Surfaces (1975), Funk Lesson (1983–85), and Out of the Corner (1990). Her work deals with issues of racism, gender, and class exploitation, and often exposes the rifts that exist between people. Piper works in numerous media, including performance, drawing, text, video, and installation.

ALAIN PLATEL/ARNE SIERENS

Alain Platel born 1956, Arne Sierens born 1959, Belgium. Platel studied orthopaedics and became fascinated by the motor functions of the human body. Training with Barbara Pearce, who works with non-professional dancers, convinced Platel to establish his own company Les Ballets Contemporaines de la Belgique. The group consists of several very different and versatile dancers and artists who often lack dance techniques. Besides theater and dance pieces, Platel has also collaborated on several projects for TV and a video. Sierens is a writer and director with whom Platel has worked on several plays, operas, translations, and scenographies. They have developed highly visual theater works with children that examine the confrontation between different generations. Performances include Mother and Child (1996), Bernadetje (1996).

SALLY POTTER

Born 1949 London. Trained as a dancer and choreographer. Spent a year at St. Martin's. Joined London Filmmakers' Co-op (1968), making 8mm films. She formed Ltd Dance Company with Jackie Lansley (1974), and toured UK and USA. She became a member of Feminist Improvisation Group (FIG), and collaborated with Rose English on the performance Berlin (London, 1976). She has had solo and collaborative shows in London at the ICA and Hayward Gallery, and in Oxford at MOMA. Her first feature-length film The Gold Diggers was followed by Orlando (1992) and The Tango Lesson (1997) both of which involved changing identities through transformations of the body.

STEFAN PUCHER

Born 1965 Giessen, Germany. Studied theatre history and American language and literature J.W. Goethe U, Frankfurt (1988–94). He directed his first performance in 1988 What you see is what you get, followed by Das kalt Herz—Eine Technomärchen nach Wilhelm Hauff. Zombie (1995) was followed by Zombie II (1996), and Ganz Nah Dran (1996). Dream City (1997) was a collaboration with Berit Stumpf under the name "Copy Club." For documenta X (Kassel, 1997), Stefan Pucher collaborated with the German-British performance group Gob Squad on 15 minutes to comply. Pucher lives in Berlin.

TAMAR RABAN

Born 1955 Israel. Graduated in Art Studies at Haifa U. The bomb shelter that had been her studio became a venue for performances and video shows, and in 1988, with Dan Zakhem and other performance artists, Raban founded Shelter 209, a non-profit organization for the promotion of multi-disciplinary art in Israel. Her key performances include Mirror, Mirror (1982), Opening for Sensitive Areas in Metal (1985), A Cow Eating Without a Knife (1986), Self-Portrait: Autoanatomy and Projected Autobiography of an Israeli Performance Artist (1990), Self Offering (1991), and Live Life (1993).

ARNULF RAINER

Born 1929 Vienna. Studied at Academy of Visual Arts, Vienna, for three days. His first exhibition of abstract paintings took place in 1950. He began body-painting at the opening of the Pinotarium exhibition in Munich (1967), and painted his face black for another exhibition (1968). He studied the body-language of mentally ill people, and used his face and body as material for his work, mimicking expressions of excitement, anger, infantilism, and depression.

YVONNE RAINER

Born 1934 San Francisco. Studied dance with Martha Graham, at the Merce Cunningham Studio, and at a summer workshop with Ann Halprin. One of the founders of the Judson Dance Theater (1962), Rainer investigated ordinary movement in dance works that used both trained and untrained dancers. She was instrumental in gathering together Judson Dance Theater choreographers to form Grand Union (1972), which pushed notions of democratic dance, ordinary task-oriented movement, and improvisation even further. Early works include Three Satie Spoons (1961–62) Terrain (1963), Parts of Some Sextets (1965), The Mind is a Muscle (1966) and WAR, (1970). Lives of Performers (1972) was her first film, followed by This is the story of a woman who…(1973) a dance event that included projections and film, and was later made into a film. Since Kristina Talking Picture (1975), Rainer has worked exclusively in film.

ROBERT RAUSCHENBERG

Born 1925, Port Arthur, Texas. Briefly attended U of Texas to study pharmacology, served in the US Navy during World War II. Then studied at Kansas City Art Institute (1947–48), at the Académie Julian, Paris (1947) and with Joseph Albers at the Black Mountain College in N. Carolina (1947–49), where he met Cunningham, Cage, and David Tudor. Together they created the Untitled Event, which acquired mythical status in the emerging "action" and Happening scene in late '50s New York. Rauschenberg became involved with the Judson Dance Theater in New York in the early '60s, and created many important happenings including Pelican (1963) Elgin Tie (1964), Spring Training (1965), Map Room 1 and 11 (1965), Linoleum (1966), Open Score (1966), Urban Round (1967). He continued his involvement with dance, creating sets and costumes for Cunningham's works, such as Nocturnes 1956, Antic Meet (1958), and Field Dances (1963), and for Trisha Brown pieces, such as Set and Reset (1983) and Astral Convertible (1989).

CARLYLE REEDY

Carlyle Reedy began Monkey Theater in 1972 as part of Monkey Enterprises. One of a handful of women performance artists in Britain at that time, Reedy was involved in a movement that

addressed issues of the body, the subconscious, and the social, and blended body art, visual art, music, and Buddhist-inspired meditation. Reedy performed at the Royal Court Festival (London, 1972) and participated in a 10-day presentation of women's art About Time (ICA, 1980). Other performances include The Boatman, Musicians of Silence and Sound, and Helping Hand, a tribute to Dadaist Emmy Hennings.

STEVE REICH

Born 1936 New York. Studied at Juilliard School, New York, and a graduate of Mills College (1963). Originally a percussionist, Reich had a passion for Bach, Stravinsky, jazz, and African music, and later studied drumming in Ghana (1970). While still at Mills, he experimented with electronic music, making tape loops from short spoken pre-recorded phrases. Working with the two loops simultaneously, and allowing them to go out of sync, he developed a "phase-shifting process" out of which evolved his most significant early work it's gonna rain (1965). Reich returned to New York 1965, transferring his "phase-shifting" ideas to live performers. Key works include Drumming (1971), and Music for Eighteen Instruments (1976). In the early '80s, he wrote pieces for other groups, incuding Telihim (1982) for four sopranos and orchestra, Desert Music (1984), and Different Trains, (1988) recorded by the Kronos Quartet. Reich collaborated with Beryl Korot on The Cave, a multi-screen theatrical event (1993).

TERRY RILEY

Born 1935 California. Studied music at Berkeley where he met La Monte Young, to be a major influence. He played piano and saxophone in clubs in Paris (1962-63) and worked in the studios of French radio. In C, written in San Francisco in 1964, is said to have given voice to the minimalist movement in American music. It consisted of "fifty-three short motifs, constantly repeated, over a fast pulse played high in the piano. Live performances sometimes went on all night.

KLAUS RINKE

Born 1939 Wattenscheid. Apprenticed as a decorator and a poster-painter. Studied at the Folkwangschule, Essen (1957–60), then spent four years in Paris and Rheims. In 1966, living in Düsseldorf, he gave up painting and started to create installations and to perform. Professor since 1974 at the Academy of Art in Düsseldorf, where his students work on conceptual, space-, history-, and situation-related works of art, using film, video, painting, and other media.

ROCK STEADY CREW

Founded by Jo-Jo in the early '70s in the South Bronx, New York. This "break crew" has at different times included Crazy Legs, Prince Ken Swift (both still with the group), Baby Love, Doze and the late Buck 4 and Kuriaki. Rock Steady Crew has many chapters across the USA, in the UK, Japan, and Italy. Crazy Legs has been featured in films such as Flashdance, Beat Street, Wild Style, and Style Wars, and also in the award-winning documentary Dance in America: Everybody Dance Now.

NIGEL ROLFE

Born 1950 UK. Farnham Sch. of Art (1969–71), Bath Acad. of Art (1971–74). Using performance, film, video, photographs, and

sound, Rolfe has been one of Ireland's pre-eminent performance artists since moving there in 1974. From his earliest performance pieces such as *Bird, Dog Tree* (1974), *Mound Man* (1976), *Red Wedge* (1978), and *The Rope that Binds Us* (1986), he used the body and physical endurance to explore metaphors of freedom, labor, industry, and ritual. He has described his work as "man meets the material." His recent works include *Resonator* (1992), an image-based installation with five vast photographic blow-ups of hands holding workaday objects; *Everyday Objects* (1993); and *Per for Mer* (1994).

ULRIKE ROSENBACH

Born 1949 Germany. Student of Joseph Beuys at Academy of Art in Düsseldorf. She began working with video in 1971, and soon was making video/live performances dealing mainly with feminist subjects. Performances and videos include *Don't Believe I am an Amazon* (1975), *Female Energy Change* (1976), *Reflections on the Birth of Venus* (1976), *Zehntausend Jahre habe ich geschlafen* (1976), *Frauenkultur—Kontaktversuch* (1977), *Sabbat-Performance* (1977).

RACHEL ROSENTHAL

Born 1926 Paris. New School for Social Research, New York, and Sorbonne, Paris. Studied acting at Jean-Louis Barrault School of Theatre, and apprenticed with director Erwin Piscator, studied dance with Merce Cunningham's company, and directed several off-Broadway productions of her own. Rosenthal also studied Asian martial arts and was deeply influenced by Zen Buddhism. Her performances include *Replays* (1975), *Arousing, The (Shock, Thunder): A Hexagram in Five Parts* (1979), *Traps* (1982), *Rachel's Brain* (1987), and *Pangaean Dreams* (1991). With her husband she founded Instant Theater (1956), an improvisational performance group influenced by the aesthetics of Antonin Artaud and John Cage. Her art centers on themes that deal with the ecology and animal rights in addition to women's concerns.

DAVID ROUSSEVE

Born 1959 Houston, Texas. BA at Princeton U (1981). Choreographer, writer, director, dancer, and actor, he danced in the companies of Jean Erdman, Senta Driver, Stephanie Skura, Yoshika Chuma, and the Toronto Dance Theater, before establishing his own company REALITY (1988). His *Pull Your Head to the Moon* (1988–92) was a series of 8 dance/theater works which juxtaposed stories from the the life of an elderly Creole woman with those of modern Americans. It mixed text, a gospel choir, MTV, European Expressionism and African-American pop music, and attacked prejudice. A film adaptation of *Pull Your Head* was made for Alive TV called *Whispers of Angels* (1995) depicting the reminiscences, hopes, and fears of a young African-American gay man who is dying of AIDS, the "whispering voices" of his ancestors guiding him.

TOMAS RULLER

Born 1957 Brno, the former Czechoslovakia. MFA in Sculpture at Academy of Fine Arts, Prague (1982). His earliest solo performances were *By the Way* (1974) and *Meditations* (1977). His actions, performances, installations, and multimedia works have included *Celebration of Flying Water Birds* (1981), *Dusting at the End of the Corridor* (1983–84), *The Glass* (1988), *New Ad-Dress* (1990), *Black Market* (1990), and *Waiting Traveller* (1997). He was co-founder of

European international performance movements such as School of Attention—East-West Study Project (1983–86). Head of the Video-Multimedia-Performance department of the Faculty of Fine Arts, U in Brno since 1992.

NIKI DE SAINT PHALLE

Born 1930 Neuilly-sur-Seine. Family moved to New York when she was 3. At 18 she eloped to Boston, and began painting, untutored. In 1952, with husband and baby daughter, she moved to Paris, where she continued painting. She discovered the work of American artists, Johns, de Kooning, Pollock and Rauschenberg, and in 1960 exhibited assemblages in plaster and "target" pictures in Stockholm. In Feb. 1961 she organized the first of more than 12 "shootings" (1961–62), taking shots at sculptures and assemblages and splattering the paint concealed beneath the plaster. In 1961 she was invited to join the Nouveaux Réalistes. With Matial Rayasse and Jean Tinguely, she designed scenery and costumes for Roland Petit's ballet, *Eloge de la folie* (1966), and that same year a monumental reclining female figure for the Moderna Museet, Stockholm. She continued to produce painting, objects, and multi-colored park sculpture. Died 2002.

RICHARD SCHECHNER

Born 1934 Newark, NJ. BA at Cornell U (1956), MA at U of Iowa (1958), PhD at Tulane U (1962). In 1967, Schechner founded the Performance Group (later to include Elizabeth LeCompte and Spalding Gray), and with them performed *Dionysus 1969*, *Mother Courage and Her Children*, *Oedipus*, *The Tooth of Crime*, and *The Balcony*. After leaving the group in 1980, Schechner staged works throughout the USA, Europe, Asia, and S. Africa. In 1991, he founded East Coast Artists, and with them directed *Faust Gastronome* (1991) and Chekhov's *Three Sisters* (1997). He has written many books on theater and performance, among them *Environmental Theater* and *The Future of Ritual*. Professor of Performance Studies at NYU since 1967.

CAROLEE SCHNEEMANN

Born 1939 Fox Chase. Graduate of Bard College. A well-known painter and filmmaker, based in New York, her performances include *Eye Body* (1963), *Meat Joy* (1964), *Up to and Including Her Limits* (1973–76), *Interior Scroll* (1975), *Homerunmuse* (1976), and *Infinity Kisses* (1981–87). Schneemann's own body is always central to her performances, which often center around ritual and the "Great Goddess." She has published several books, including *More Than Meat Joy* (1979), a catalogue of her work.

CINDY SHERMAN

Born 1954 Glen Ridge, NJ. Studied painting and photography at State U College, Buffalo, NY (1976). Moved to New York 1977. Her early *Untitled Film Stills* (1977–80) originated in her practice of appearing as different personalities, dictated by the clothes she wore that day. She photographed herself in settings that provided further narrative clues to that person, like stills from '60s French films and American B-movies. This series was first exhibited at The Kitchen (1978) and at Metro Pictures (1979). Since then, Sherman has developed a formidable œuvre; two decades worth of *Untitled* photographs, produced annually as a series, usually around unstated themes. In the early '80s the high-fashion clothes (Issay Miyake, Comme des Garçons) parodied New York society's

obsession with fashion, while the mid-'80s table settings covered with vomit, decomposing food, and worms, ridiculed the greed of the Yuppie decade and the booming art market. Her feature-length film *Office Killer* (1997) was fashioned after the B-movies that she loves, and reflected her fascination with artificial body parts as a dramatic tool.

ROMAN SIGNER

Born 1938 Appensell, Switzerland. Studied as an architectural draftsman, but switched to art at academies in Zurich, Lucerne, and Warsaw. An "explosion artist," he creates action sculpture and installations in which everyday objects are transformed through movement: a balloon is destroyed by a shooting rocket in *Balloon with Rocket* (1981), rubber boots eject streams of water propelled by explosive charges in *Water Boots* (1994). He documents his work in video and photographs, and his actions are ephemeral events, comments on the classical concept of sculpture as static and everlasting. His first solo exhibition was *Objekte-Konstruktionen* (St. Gallen, 1973). Following his first performance in 1980, key performance works include *Action with a Fuse* (1989) and *I Was Here* (1997).

JACK SMITH

Born 1932 Columbus, Ohio. Moved to Chicago and then to Los Angeles, where he studied with the dancer Ruth St. Denis (1952). Began a 16mm color film, *Harem*, later titled *Buzzards over Baghdad* (1952). Moved to New York 1953, attending film classes at CCNY where he met Ken Jacobs and Bob Fleischner. Made several films, including *Flaming Creatures* (1962), shot on the roof of the Windsor Theater, which was declared obscene in 1964 by the New York Criminal Court. *Rehearsal for the Destruction of Atlantis* (1965) was presented as part of the Expanded Cinema Festival organized by Jonas Mekas. *Secret of Rented Island* (1976–77), an adaption of Ibsen's *Ghosts*, was performed at the Collation Center in New York. Died 1989 from AIDS.

ANNIE SPRINKLE

After working in the porn industry for 16 years, Sprinkle was "discovered," and moved into performance as a cast member of *Deep Inside Porn Stars* (Franklin Furnace, 1985). She wrote a series of plays, which she also performed, called *Annie Sprinkle—Post Porn Modernist* (1991) which then toured N. America and Europe. It traces her journey from shy young girl into porn-star/prostitute/sex-educator. Known also for her *Public Cervix Announcement*, in which she sought to demystify the female body by inviting an audience to inspect her cervix, she is believed by some to have reclaimed a sex-positive feminism. She has prospered as a performer, photographer, writer, and producer of erotic art.

STATION HOUSE OPERA

Founded 1980 in London by artists working in performance. Through the years Julian Maynard Smith became the key figure and is the only original member still involved. Among their performances are *Natural Disasters* (1980) and *Sex and Death* (1981). In 1985 Station House Opera staged *A Split Second of Paradise*, a first performance in a series of architecturally related works, followed by *Piranesi in New York* (1988), and *The Bastille Dances* (1989), one of their most ambitious works. In 1993 the group developed *Limelight*,

followed by another architectural project *Dedesnn-nn-rrrrr* (1996) for the Festival Theater der Welt in Dresden.

STELARC

Born 1946 Limassol, Cyprus. Lives and works in Melbourne, Australia. Stelarc uses cutting-edge technology to explore the reconfiguration of the human body in various states of "realities" (the physical, the psycho-cyber, the virtual). His performances include *Amplified Body Events* (1970–74), *Body Suspensions with insertions into the skin* (1976–88), and *Stomach Sculpture* (1992–94).

GARY STEVENS

Born 1953 London. Studied Fine Art at Goldsmiths' (1953–76) and the Slade (1981–83). Began working in performance in 1984. Works include *Invisible Work* (1984–6), *If the Cap Fits* (1985–88), *Different Ghosts* (1987–88), *Animal* (1989–90), *Name* (1991–93), *Sampler* (1995). *And* (1997) was an installation involving 10 performance artists. He lives and works in London.

ANDRE STITT

Born 1958 Belfast. Foundation Studies in Art at Ulster Polytechnic (1976–77). Met Alastair MacLennan 1977, and studied with him; moved to London 1980. Stitt creates "akshuns" on themes such as oppression, freedom, subversion, alienation, and appropriation of cultures, embracing the madness of society as a means of coming to grips with it. His work is visceral, violent, and cathartic, often involves consumption of products, and uses objects ranging from dildos to buckets of detergent. In 1979 he entitled his performance works *Akshun Man Trixter Cycle*, and his key pieces are *Love Crimes* (1984), *Covert Actitivities* (1988–89), *Romper Room* (1991), and *Geek Shop* (1993).

ELIZABETH STREB

Born 1950. Studied modern dance at SUNY, Brockport. Has been presenting Action work in New York since 1979 and formed the dance company Streb-Ringside in 1985. Her choreography pushes out the boundaries of dance, and combines her interest in sport and gymnastics with her fascination with movement. Faculty member Harvard Summer Dance Center.

MEG STUART

Born 1965 New Orleans. BFA in Dance at NYU. Then trained in release technique and contact improvisation; workshops with Mark Morris, Karole Armitage, and Beth Soll; assistant to Randy Warshaw (1986–91). She formed her own company Damaged Goods (1994), and developed a highly energized dance style that deals with the deconstruction of perspective and physicality, sometimes with visual artists, such as Via Lewandowsky and Gary Hill. The dialogue between artists is a key to her work—its fragility, and fragmentation. Important works include *Disfigure Study* (1991), *No longer Readymade* (1993), *No one is Watching* (1995), *Splayed Mind Out* (1997) in collaboration with Gary Hill for documenta X, Kassel. Lives and works in Brussels.

MIN TANAKA

Born 1945 Japan. Studied and performed modern dance and ballet with other choreographers (1966–73). Then he began to create his own Butoh works, exploring the meaning of the body and dance,

based on improvisation. He frequently danced nude in both urban and country landscapes in an attempt to free the body from conventional aesthetics. In 1981 he founded his international, collaborative dance company. He was a founding member of Plan B (1982), a collaborative performing space in Tokyo. He has collaborated with artists Karel Appel and Richard Serra, musicians Minrou Nogucji and Cecil Taylor, the writer Susan Sontag, and psychiatrist Guattari. With a group of Norwegian dancers (1993–94) he created *Dance of Life*, inspired by Edvard Munch. In 1998 he made a long-term commitment with P.S.122 and P.S.1 in New York and ARCHA Theater in Prague to perform annually in those spaces.

SAM TAYLOR-WOOD

Born 1967 London. Graduate of Goldsmiths' (1990). Her work consists of photographs, video-installations, and films. In the tradition of Warhol's minimalist performance-based aesthetic and of films by Cassavetes, Ferrara, and Coppola, she creates scenes like film-stills, exploring the ambiguities of acting and authenticity. She created a famous photographic series from these non-narrative situations, *Five Revolutionary Seconds* (1995), using a 5-second 360° pan to photograph peopled interiors, so that a square room is flattened into an impossibly elongated space. Her works include *Killing Time*, video-installation (1994), *Method in Madness*, short film (1994), *Travesty of Mockery*, video-installation (1995), *Knackered* (1996), *Misfit*, short film (1996), *Wrecked*, photography (1996).

SABURO TESHIGAWARA

Born 1953 Tokyo. Studied plastic arts and classical ballet in Tokyo. In 1985 he formed his company KARAS (Raven), for which he developed minimalistic choreographies to show the dancing human being in space and time, and also continued to perform solo. In 1991 he curated art exhibitions, and in 1993 he produced his first film. Performances include *Ishi-no Hana* (1986), *Karada-no-Yume* (1989), *Bones in Pages*, solo-performance (1991), *Dah-Dah-Sko-Dah* (1991), *Noiject* (1992), *Here to Here* (1995), *I Was Real—Documents* (1996).

RIRKRIT TIRAVINIJA

Born 1961 Buenos Aires. Went to school in Bangkok, studied at Ontario Coll. of Art in Toronto, Banff Center Sch. of Fine Arts, Sch. of the Art Institute of Chicago, Whitney Independent Studies Program in New York. Since 1989 he has created major installations and events that often involve the audience directly by serving them food or drinks. Exhibitions include *Untitled (Free)* (303 Gallery, New York, 1992), *Migrateurs* (Musée d'Art Moderne, Paris, 1993), *Lost Paradise* (Kunstraum, Vienna, 1994), *Biennale d'Art Contemporain* (Lyons, 1995), *Shift* (De Appel, Amsterdam, 1995), *The Whitney Biennale* (New York, 1995), *Africus* (Johannesburg Biennale, and Kunsthalle, Basle, 1995), *Tomorrow's Another Day* (Kunstverein, Cologne, 1996), *MOMA Project 58* (1997), *Skulptur. Projekte* (Münster, 1997).

TING THEATRE OF MISTAKES

Founded 1975 by Anthony Howell, Fiona Templeton, and Julian Maynard Smith. It originally produced conceptually-based, large-scale performances, such as *Preparations for Displacement* and *The Street* (both London, 1975). By 1976, the group decided to focus on smaller, tighter performances, and changed their name

to Ting Theatre of Mistakes. The company gained international attention after presenting *Going* at the 1977 Paris Biennale and at The Theater for the New City (New York, 1978). The group disbanded in 1981.

CARMELITA TROPICANA (ALINA TROYANA)

Carmelita Tropicana is the alter-ego of Alina Troyana, born 1960, whose comic performances as "Miss Loisaida" (as in Lower East Side) parody the experiences of Cuban-Americans and how they cope with racism and "multicultural" political correctness. Tropicana was active in the New York club scene of the early '80s. Her performances include *Milk of Amnesia* (1985) and *Memories of the Revolution* (1987).

ULAY (UWE LAYSIEPEN)

Born 1943 Solingen, Germany. Studied mechanical engineering and worked in photography. Moved to Amsterdam (1968). He collaborated on a book of polaroid photographs with Jürgen Klauke "Ich & Ich" (1971), exploring androgyny. Ulay and Marina Abramović met in Amsterdam (1975), and their first collaboration *Relation in Space* (1976) was the start of a 12-year relationship that included "permanent movement"—they lived in a truck for a year (1976), traveled through the Central Australian Desert (1980–81), and visited China three times (1985, '86 and '87) before *The Lovers: Walk on the Great Wall* there April–June 1988 which marked the end of their relationship.

URBAN BUSHWOMEN

Founded 1984 by Jawole Willa Jo Zollar, born 1953 Kansas City. Zollar took dance classes with Joseph Stevenson and Trisha Brown, and studied Graham technique. Her research explored the connections between African-American culture and those of other members of the African diaspora in the Caribbean, Mexico, S. America, and Africa. Urban Bushwomen are sophisticated post-feminist African-American women, who are dancers, singers, writers, poets, actors, and musicians. Looking for "a modern outlet for the folklore and religious traditions passed down by African-Americans from generation to generation," the group incorporates contemporary African-American movement traditions such as "the shout dance," or street-dancing. Performances include *Heat* (1988), *Song of Lawino* (1988), and *Praise House* (1990) which was presented at the Next Wave Festival, New York, in 1991.

BEN VAUTIER

Born 1935 Naples. Founder of Total Art, and active in the early '60s with the Nouveaux Réalistes in Nice. He exhibited *40 drawings of a banana* (1957), *Stains* (1958), and *Chance Objects* (1958–62). He met Maciunas and other Fluxus artists at the Misfits Fair (London, 1962), and became one of the artists most closely associated with the group. He declared that "everything is art," and his actions and performances frequently centered on daily routines. In 1962, he performed *Living Sculpture*, exhibiting himself on the "stage of life" for a week in the window of Gallery One. Other important pieces include *Mystery Food* (1963) and *Regardez-Moi Cela Suffit* (1962).

THE VELVET UNDERGROUND

Formed 1965 New York, when Lou Reed, John Cale, Sterling Morrison, and Maureen Tucker were all in their early twenties. They

gained public attention through their collaboration with Warhol in *The Exploding Plastic Inevitable* (1966–67), a touring rock 'n' roll and multimedia show. On Warhol's suggestion, they worked with Nico, and for a short period she sang songs written by Lou Reed. Reed's rock 'n' roll-style and poetic lyrics, combined with Cale's classical training and experimental sensibility created a dynamic exploration of music and performance. Cale left the band in 1968, and Reed in 1970.

WOLF VOSTELL
Born 1932 Leverkusen. Apprenticeship in photo-lithography. Studied painting and experimental typography at Werkkunstschule, Wuppertal (1954). Ecole des Beaux Arts, Paris, and Academy in Düsseldorf, (1955–56). Vostell created some of the earliest happenings in Europe in 1961, using public events to discuss and confront the Nazi atrocities. Co-founder of Fluxus with George Maciunas, Nam June Paik, and Jean-Pierre Wilhelm, he helped organize the first Fluxus Festival in Wiesbaden. Key works include *Das Theater ist auf der Strasse (The Theater is on the Street)* 1958, *dé-collage solo* (Cologne,1961), *PC Petite Ceinture*, bus-happening (Paris, 1962), *Kleenes 1* (Fluxus Festival, Wiesbaden, 1964) and *TV-décollage*, (Tokyo, 1966). *In Ulm...*, (1964) was his most complex happening; 6 hours long and taking place in 24 different locations in the city of Ulm. In 1974 he bought land in Spain, where he built his Museum für den Kunstbegriff in der 2. Hälfte des 20. Jahrhunderts (Museum for the Conception of Art in the Second Half of the 20th Century). Died 1998.

CLAUDE WAMPLER
Born 1966 Pottstown, Pennsylvania. Studied opera at Carnegie Mellon, then acting and dance at SUNY Purchase. Worked with Doug Elkins Dance Co. She lived in Japan (1991–93), studying Butoh with Hakutobo, and danced with his company for two years. "The way in which they work is what kept me there, especially the way in which they allow themselves to be influenced by art," she has said. "They treat the body more like clay, like an object." She has also performed with Richard Foreman, an important influence. Key works are *She is High? True or False*, (1995) a 12-minute work at P.S.122, and *Knit Tease*, (1996) a 5-hour piece in which she unravelled the knitted dress she was wearing, reknitted it, and put it on again. *Blanket, the Surface of Her* (1997), was an 80-minute work in which Wampler invited 8 artists, including Foreman, Paul McCarthy, and Julia Sher, to tell her what to do for 8 minutes each. The result was a highly charged work that captured the mood of contemporary artists in the late '90s.

ANDY WARHOL
Born 1928 Pittsburgh. Studied graphic design at Carnegie Inst. of Design, Pittsburgh. Moved to New York 1949, and worked as a commercial artist (1949–60). In the early '60s he was a leading exponent of Pop Art with his paintings and prints of Campbell's soup cans and Coca Cola bottles, portraits of idolized stars, car crashes, and electric chairs. In 1963 he established the Factory, a large studio on Manhattan's East Side, frequented by young photographers, painters, aspiring actors, and writers. Assistants helped him produce his artwork and make movies such as *Sleep* (1963) and *Empire* (1964). In 1965 he began to manage the rock group, Velvet Underground, with whom he and other Factory

regulars formed the *Exploding Plastic Inevitable*, a touring multi-media and rock 'n' roll show. He is one of the most influential artists of the second half of the century, and his ability to move easily between "high art" and popular culture, between fine arts and commercial art, as well as his passion for "downtown" (Max's Kansas City) and "uptown" (Studio 54), was an inspiration for media-generation artists of the '80s. Died 1987.

ROBERT WHITMAN
Born 1935 New York. His first theatrical work was *American Moon* (New York, 1960). Other key works include *Water* (Los Angeles, 1963), *Light Touch* (first performance, New York, 1966), *Raincover* (first performance, New York, 1982) and *Black Dirt* (several US performances, 1990).

FAITH WILDING
Born 1943. Perhaps best known for *Waiting*, performed at Womanhouse, Los Angeles (1971), in which she slowly recounted what she had waited for throughout her life as a woman. In *Imago Femina* (1982), she examined the cyclical and spiritual qualities of female existence.

HANNAH WILKE
Born 1940 New York. BFA and BS at Temple U, Philadelphia (1961). One of her earliest performances was *Super-T-Artist* (1974). Other performances include *S.O.S.—Starification Object Series* (1976), and *So Help Me Hannah* (1978). She also worked in sculpture, drawing, watercolor, photography, and mixed media. In her performances she used her own body as living sculpture as well as a backdrop for her feminist concerns. Throughout her career she explored female pleasure and scrutinized Western standards of beauty. She died of cancer in 1993.

MARTHA WILSON
Born 1947 Philadelphia. MA at Dalhousie U, Halifax, Nova Scotia (1971). Performances include *Claudia* (1973) in collaboration with Jacki Apple, and *Storylines* (1977). Founder and director of the Franklin Furnace Archive, New York (1976), and later a member of Disband, formed in 1978, Wilson's latest venture takes Franklin Furnace on to the Web.

ROBERT WILSON
Born 1941 Waco, Texas. Attended U of Texas. BFA in Architecture at Pratt Institute, New York (1965). His earliest work developed in the experimental and collaborative mood of late '60s downtown New York. His studio, the Byrd Hoffman School (named after the Waco ballet teacher with whom he had studied body-awareness techniques), ran workshops that attracted fellow artists, including Meredith Monk, Lucinda Childs, and Spalding Gray, who joined him in exercises that explored very slow movement. He integrated a wide range of media, including dance, painting, lighting, furniture design, sculpture, music, and text, in large-scale works. *The King of Spain* (1969), *The Life and Times of Sigmund Freud* (1969), and *Deafman Glance* (1971), were visionary and mesmerizing productions with unforgettable images – slowly changing architectural vistas, and imperceptible human movements. *The Life and Times of Joseph Stalin* (1973) was a 12-hour spectacle, while *KA MOUNTAIN AND GUARDenia TERRACE* (1972) was an

outdoor work that lasted several days. *Einstein on the Beach* (1976), a collaboration with Philip Glass, was a 5-hour opera that would fire a generation of artists and musicians. Other productions include *I Was Sitting On My Patio This Guy Appeared I Thought I Was Hallucinating* with Lucinda Childs (1977), *the CIVIL warS* (1983), *The Forest* (1988), *Black Rider* with Tom Waits and William Burroughs (1990), *Alice* with Tom Waits and Peter Schmidt (1992), and *Time Rocker* with Lou Reed and Darryl Pinckney (1997).

DAVID WOJNAROWICZ
Born 1954 New Jersey. High School of Music and Art until 16. He drifted around New York until his first show at the Civilian Warfare Gallery. Already a writer, musician, and guerrilla artist by 1980, he became known for his montages and found-object paintings depicting sex, violence, and war. Hailed as a star of the East Village Art Scene, he appeared at the 1985 Whitney Biennale. Works include *Wind (for Peter Hujar)*, (1986), *Newspaper as National Voodoo* (1986), and *Fear of Evolution* (1988–89). Diagnosed HIV+, he wrote an essay for a show on AIDS at Artists Space, and found himself the center of an NEA controversy. Died 1992.

THE WOOSTER GROUP
Founded 1977 New York by Elizabeth LeCompte and Spalding Gray (formerly of the Performance Group), it is an ensemble of artists who collaborate on the development and production of theater and media pieces. Its technically sophisticated and evocative use of sound, film, and video has deeply influenced contemporary theater. Productions include their first piece *Three Places in Rhode Island* (1975–79), *Route 1 & 9* (1981), and *The Hairy Ape* (1995). The group's members are Jim Clayburgh, Willem Dafoe, LeCompte, Gray, Peyton Smith, and Kate Valk. Member Ron Vawter died 1994.

LA MONTE YOUNG
Born 1935 in Bern, Idaho. Studied first with Leonard Stein and then with Stockhausen at Darmstadt Summer School (1959) where he was exposed to the ideas of John Cage. This led to his Fluxus performances in Yoko Ono's New York loft (1961–62). He is also a devotee of the Indian master Pandut Pran Nath, whom he met in 1967. Compositions include *for brass* (1957), *for guitar* (1957), *Trio for Strings* (1958), *Vision* (1959), *Poem for Chairs, Tables, and Benches* (1960), *Compositions 1969 No. 1–15* (1960), *The Well-Tuned Piano* (1964). His microtonal blues can take hours to go from one chord to the next. He played for 6 hours 24 minutes at the "La Monte Young 30-year Retrospective" (Mela Foundation, 1987). *Dream House* is a permanent installation of "eternal music" by La Monte Young and Marian Zazeela (Dia Center for the Arts, New York, 1979). In 1990 Young formed the Forever Blues Band.

MARIAN ZAZEELA
Born 1940 New York. A visual artist, married to La Monte Young since 1962, she has been a long-time collaborator in his large-scale performance environments. She creates light shows that match his music—they appear not to move, but they are never the same.

With thanks to Bettina Funcke, Jens Hoffmann, Debra Wacks, and Anne Wehr for all their assistance with the material in the reference section

bibliography

select bibliography and sources

Abramović Marina, *Relation Work and Detour*, Amsterdam, 1980

—, *Nightsea Crossing*, Amsterdam, 1983

—, *Modus Vivendi*, Eindhoven, 1986

—, and Ulay, *The Lovers: The Great Wall Walk*, Amsterdam, 1989

Acconci, Vito, *Vito Acconci*, Lucerne, 1978

—, *Vito Acconci Talks to Louwrien Wijers*, Velp, 1979

Action/Performance and the Photograph (exh. cat.), Los Angeles, 1993

Adorno, T.W. "Culture Industry Reconsidered," *New German Critique*, no. 6, Fall, 1976

Adrian, G., and W. Konnertz, K. Thomas, *Joseph Beuys*, Cologne, 1973

Ana Mendieta, (exh. cat.), Santiago de Compostela, 1996

Anderson, Laurie, *Empty Places: A Performance*, New York, 1991

— *Stories from the Nerve Bible*, New York, 1993

Antin, Eleanor, *Being Antinova*, Los Angeles, 1983

Archer, Michael, *Art Since 1960*, London, 1997

—, Guy Brett, and Catherine Zegher, *Mona Hatoum*, London, 1997

Archive Nigel Rolfe (exh. cat.), Dublin, 1994

L'Art au corps: le corps exposé de Man Ray à nos jours (exh. cat.), Marseilles, 1996

The Art of Performance, (Palazzo Grassi exh. cat.), Venice, 1979

Ascherson, Neal, *Shocks to the System (Social and Political Issues in Recent British Art from the Arts Council Collection)*, London, 1991

Auslander, Philip, *From Acting to Performance: Essays in Modernism and Postmodernism*, London and New York, 1997

Avalanche, nos. 1–6, 1972–74

Ayres, Robert and David Butler, eds., *Live Art*, Sunderland, 1991

Banes, Sally, *Terpsichore in Sneakers: Post-Modern Dance*, Boston, 1980

—, *Democracy's Body: Judson Dance Theater, 1962–1964*, Michigan, 1980

—, *Greenwich Village 1963: Avant-Garde Performance and the Effervescent Body*, Durham and London, 1993

Barney, Matthew, *Drawing Restraint, 7*, Ostfildern, 1995

Barthes, Roland, *The Pleasure of the Text*, Paris, 1973; New York, 1975

—, *Empire of Signs*, Geneva, 1970: New York, 1982

Battcock, Gregory, *The New Art*, New York, 1973

—, and Robert Nickas, eds, *The Art of Performance: A Critical Anthology*, New York, 1984

Baudrillard, Jean, *America*, London and New York, 1988

Beck, Julian, *The Life of the Theatre: The Relation of the Artist to the Struggle of the People*, San Francisco, 1972

Benamou, Michael, and Charles Carammello, eds, *Performance in Post Modern Culture*, Madison, Wisc., 1977

Berg, Eddie, *Video Positive 95*, Liverpool, 1995

Berger, Maurice, *LABYRINTHS: Robert Morris, Minimalism, and the 1960s*, New York, 1989

Bethanien, K., ed., *Performance: Another Dimension*, Berlin, 1983

Birringer, Johannes H., *Theater, Theory and Postmodernism*, Bloomington, Ind., 1991

Blau, Herbert, *To All Appearances: Ideology and Performance*, New York, 1992

Blessing, Jennifer, *Rrose is a Rrose is a Rrose: Gender Performance in Photography*, New York, 1997

Block, Rene, ed., *Soho—Downtown Manhattan: Theater, Musik, Performance, Video, Film*, (Akademie der Kunste and Berliner Festwochen exh. cat.) Berlin, 1976

Bockris, Victor, and Gerard Malanga, *Uptight: The Story of the Velvet Underground*, New York, 1983

The Body and the Object: Ann Hamilton, 1984–1996 (exh. cat.), Columbus, Ohio, 1996

Bogosian, Eric, *Sex, Drugs, Rock & Roll*, New York, 1990

—, *The Essential Bogosian, Talk Radio, Drinking in America, Funhouse & Men Inside*, New York, 1994

Brecht, George, and Robert Filliou, *Games at the Cedilla, or the Cedilla Takes Off*, New York, 1967

Brecht, Stephan, *The Original Theatre of the City of New York. From the mid-60s to the mid-70s, Book 1: The Theater of Visions: Robert Wilson*, Frankfurt, 1978; *Book 2: Queer Theatre*, Frankfurt, 1978

Brett, Guy, *Exploding Galaxies—The Art of David Medalla*, Kala Press and INIVA Publications, 1995

Brisley, Stuart, "Conversations," *Audio Arts Magazine*, Vol. 4 , No. 4, 1981

—, and Michael Archer, *Georgiana Collection*, Derry and Glasgow, 1986

Bronson, A.A., and Peggy Gale, eds, *Performance by Artists*, Toronto, 1979

Broude, Norma, and Mary D. Garrard, eds, *The Power of Feminist Art*, New York, 1994

Cage, John, *A Year from Monday*, Middletown, Conn., 1967

—, *Silence: Lectures and Writings*, London, 1968

—, and A. Knowles, *Notations*, New York, 1969

Cai Guo Qiang, *From the Pan Pacific* (exh. cat.) Iwaki, Japan, 1994

Cameron, Shirley, and Evelyn Silver, *10 Years of Performance Art 1981–1991*, Sheffield, 1991

Cardew, Cornelius, *Scratch Music*, Cambridge, Mass., 1974

Carlson, Marvin, *Performance: A Critical Introduction*, London and New York, 1996

Carolee Schneemann, *I. Early Work 1960/1970* (exh. cat.), New York, 1982

Carr, Cynthia, *On Edge: Performance at the End of the 20th Century*, Hanover, 1993

Catling, Brian, *The Blindings*, London, 1995

Celant, Germano, *Ars Povera*, Tubingen 1969

—, I. Sischy, and P. Tabatabai Ashbaghi, eds, *Art/Fashion*, (exh. cat.)

Biennale de Firenze, Florence, and Guggenheim Museum, New York, 1997

Champagne, Leonora, *Out From Under: Texts By Women Performance Artists*, New York, 1990

Cheek, Chris, series ed., *Language aLive* (writing for live action or developed through live action or directly related to live action), Lowestoft, Suffolk, 1995

Childs, Nicky, and Jeni Walwin, eds, *A Split Second of Paradise: Live Art Installation and Performance*, London and New York, 1998

Chong, Ping, *Nuit Blanche: A Select View of Earthlings in Between Worlds: Contemporary Asian-American Plays*, Imperial Beach, Calif., 1986

Chris Burden: "un livre de survie," Paris, 1995

Confessions of the Guerilla Girls, New York, 1995

Corner, Philip, *The Identical Lunch*, Barton, Vt., 1973

Crimp, Douglas, ed., *Joan Jonas: Scripts and Descriptions*, Berkeley, Calif., and Eindhoven, 1983

Crow, Thomas, *The Rise of the Sixties: American and European Art in the Era of Dissent*, New York, 1996

Cunningham, Merce, *Changes: Notes on Choreography*, New York, 1968

Davy, K., ed., *Richard Foreman: Plays and Manifestos*, New York, 1976

The Decade Show: Frameworks of Identity in the 1980s (exh. cat.), New York, 1990

Diamond, Elin, ed., *Performance and Cultural Politics*, London and New York, 1996

Debord, Guy, *Society of the Spectacle*, Detroit, 1970

The Drama Review, ed., Richard Schechner, Special issue on Reza Abdoh, Vol. 39 No. 4 (148), Fall, 1995

Duberman, Martin, *Black Mountain: An Exploration in Community*, New York, 1972

Duckworth, William, *Talking Music, conversations with John Cage, Philip Glass, Laurie Anderson, and Five Generations of American Experimental Composers*, New York, 1995

Dupuy, J., *Collective Consciousness: Art Performances in the Seventies*, New York, 1980

Elwes, Catherine, Rose Garrard, and Sandy Nairne, eds, *About time: Video, Performance and Installation by 21 Women Artists* (ICA exh. cat.), London, 1980

Fairbrother, Trevor, *Robert Wilson's Vision*, New York, 1991

Felshin, Nina, ed., *But Is It Art? The Spirit Of Art As Activism*, Seattle, 1995

Finley, Karen, *Shock Treatment*, San Francisco, 1990

FLUXUS, Etc. (exh. cat.), Bloomfield Hills, Mich., 1981

Foreman, Richard, *Reverberation Machines: The Later Plays and Essays*, New York, 1985

—, *Love and Science: Selected Music-Theater Texts*, 1991, New York, 1991

—, *Unbalancing Acts: Foundations for a Theatre*, New York, 1992

—, *My Head was a Sledgehammer*, Six Plays, New York, 1995

Forti, Simone, *Handbook in Motion*, Halifax, Nova Scotia, 1975

Fuchs, Elinor, *The Death of Character: Perspectives on Theater after Modernism*, Bloomington and Indianapolis, 1996

Fusco, Coco, *English is Broken Here: Notes on Cultural Fusion in the Americas*, New York, 1995

GAAG: Guerrilla Art Action Group, 1969–1976, A Selection, New York, 1978

Gale, Peggy, *Video by Artists*, Toronto, 1976

Garrard, Rose, *Archiving My Own History: Documentation of Works, 1969–1994*, London and Manchester, 1994

Gitlin, Todd, *The Whole World is Watching, mass media in the making and unmaking of the new left*, California 1980

—, *The Sixties; Years of Hope, Days of Rage*, New York,1987; 1993

Goldberg, RoseLee, "Space as Praxis," *Studio International*, Sept–Oct 1975, pp. 130–5

—, *Performance Art: From Futurism to the Present*, London and New York, 1979; rev. edn. 1988; 2001

—, *Six Evenings of Performance: High and Low; Modern Art and Popular Culture* (Museum of Modern Art performance cat.), New York, 1990

Golden, Thelma, *Black Male; Representations of Masculinity in Contemporary American Art*, (Whitney Museum of American Art exh. cat.) New York, 1994

Gomez-Peña, Guillermo, *Warrior for Gringostroika*, Saint Paul, MN, 1993

Graham, Dan, *Rock My Religion; writing and art projects 1965–1990*, ed. Brian Wallis, Boston, Mass., 1993

Gray, Spalding, and Elizabeth LeCompte, "Play: Rumstick Road," *Performing Arts Journal*, vol. 3, no. 2, 1978

—, "The Making of a Trilogy," *Performing Arts Journal*, vol. 3, no. 2, 1978

Gray, Spalding, *Sex and Death to the Age 14*, New York, 1986

—, *Monster in a Box*, New York, 1991

—, *Impossible Vacation*, New York 1992

Hall, Doug, and Fifer, Sally Jo, eds, *Illuminating Video; An Essential Guide to Video Art*, 1990

Hanhardt, John G., *Nam June Paik*, London and New York, 1982

—, ed., *Video Culture; A Critical Investigation*, 1986

Hannah Wilke: A Retrospective (exh. cat.), Columbia, Miss., 1989

Hansen, Al, *A Primer of Happenings & Time-Space Art*, New York, 1965

Haskell, Barbara, *Blam! The Explosion of Pop, Minimalism and Performance 1958–1964*, (Whitney Museum of American Art exh. cat.), New York, 1984

Heiss, Alanna, *Dennis Oppenheim: Selected Works 1967–90: "And the mind grew fingers,"* New York, 1991

Hendricks, Jon, *Fluxus etc./Addenda I: The Gilbert and Lila Silverman Collection*, New York, 1983

—, *Fluxus etc./Addenda II: The Gilbert and Lila Silverman Collection*, Pasadena, Calif., 1983

Henri, Adrian, *Environments and Happenings*, London, 1974

High Performance, Los Angeles, 1979–

Hodge, Nicola, ed., *Performance Art: Into the 90s*, Art and Design No. 38, London, 1994

Howell, Anthony, and Fiona Templeton, *Elements of Performance Art*, London, 1976

Howell, Anthony, *In the Company of Others*, London, 1986

Hulten, Pontus, *Niki de Saint Phalle*, (exh. cat.) Stuttgart, 1992

Humus: Fifteen Years of the Kaaitheater (exh. cat.), Bruges, 1993

Huxley, Michael, and Noel Witts, eds, *The Twentieth-Century Performance Reader*, London and New York, 1996

Hybrid Magazine, London, Feb.–March 1993

Iles, Chrissie, "Catharsis, Violence and the Alienated Self; Performance Art in Britain 1962–1988," in *L'Art au corps*, 1996 (see above)

—, ed., *Marina Abramovic: objects, performance, video, sound*, (exh. cat.), essays by RoseLee Goldberg, Chrissie Iles and David Elliot, Oxford, 1995

In the Spirit of Fluxus (exh. cat.), Minneapolis, 1993

Johnson, Ellen H., *Claes Oldenburg*, Harmondsworth and Baltimore,1971

—, *Works 1968–1994*, (exh. cat.), Amsterdam, 1994

Jones, Amelia, *Body art/performing the subject*, London and Minneapolis , 1998

Joseph Beuys, (Guggenheim Museum exh. cat.), London and New York, 1979

Deborah Jowitt, ed., *Meredith Monk*, New York, 1997

Kaprow, Allan, *Assemblage, Environments & Happenings*, New York, 1966

Kaye, Nick, *Art into Theatre: Performance Interviews and Documents*, London, 1996

—, *Postmodernism and Performance*, New York, 1996

Kelly, Mary, *Imaging Desire*, Cambridge, 1996

Kershaw, Baz, *The Politics Of Performance: Radical Theater as Cultural Intervention*, London and New York, 1996

Kirby, E.T., *Total Theatre*, New York, 1969

Kirby, Michael, *Happenings: An Illustrated History*, New York, 1965

—, and Richard Schechner, "An Interview with John Cage," *The Drama Review*, New Orleans, vol. 10, no. 2, Winter 1965, pp. 50-72

— *The Art of Time: Essays on the Avant-Garde*, New York, 1969

Kirshner, J.R.,*Vito Acconci: A Retrospective 1969 to 1980*, Chicago, 1980

Kostalanetz, Richard, *John Cage: An Anthology*, New York, 1991

—, ed., *The Theatre of Mixed Means: An Introduction to Happenings, Kinetic Environments and Other Mixed-Means Performances*, New York, 1968

Kultermann, Udo, *Art—Events and Happenings*, London, 1971

Kuspit, Donald, "Dan Graham: Prometheus Mediabound," *Artforum*, New York, Feb. 1984

Lacy, Suzanne, ed., *Mapping the Terrain: New Genre Public Art*, Seattle, 1995

Laurie Anderson: Works from 1969 to 1983, (exh. cat.), Philadelphia, 1983

LeCompte, Elizabeth, "The Wooster Group Dances," *The Drama Review*, vol. 29, no. 2, 1985

Leffinghwell, Edward, ed., *Jack Smith: Flaming Creature: His Amazing Life and Times* (exh. cat.), Long Island City and London, 1997

Life/Live: La scène artistique au Royaume-Uni en 1996 de nouvelles aventures (exh. cat.), Paris, 1997

Lippard, Lucy, *Six Years: The Dematerialization of the Art Object from 1966 to 1972*, New York, 1973

—, *Mixed Blessings: New Art in a Multicultural America*, New York, 1990

Live Art Magazine, Greenwich, UK, May 1994–

Livet, Anne, ed., *Contemporary Dance; an anthology of lectures, interviews, and essays*, New York, 1978

Loeffler, Carl E., and Darlene Tong, eds, *Performance Anthology: Source Book for a Decade of CalifornianPerformance Art*, San Francisco, 1980

Lovejoy, Margot, *Postmodern Currents: Art and Artists in the Age of Electronic Media*, Upper Saddle River, NJ, 1997

Love Forever: Yayoi Kusama, 1958–1968, (exh. cat.), Los Angeles and New York, 1998

Lucy Orta: Refuge Wear (exh. cat.), Paris, 1996

McAdams, Dona Ann, *Caught In The Act: A Look At Contemporary Multimedia Performance*, New York, 1996

McEvilley, Tom, "Art in the Dark," *Artforum*, New York, June 1983, pp. 62–71

MacLennan, Alastair, *Is No: 1975–1988*, (exh. cat.), Bristol, 1988

McNamara, Brooks, and Jill Dolan, eds, *The Drama Review: Thirty Years of Commentary on the Avant-Garde*, Ann Arbor, 1986

Marranca, Bonnie, ed., *The Theatre of Images*, New York, 1977

Martin, Carol, ed., *A Sourcebook of Feminist Theater and Performance on and Beyond the Stage*, London and New York, 1996

Mayor, David, ed., *Fluxshoe* (exh. cat.), Cullompton, Devon, 1972

Mellor, David Alan, and Laurent Gervereau, eds, *The Sixties*, London, 1997

Meltzer, Annabelle, *Dada and Surrealist Performance*, Baltimore and London, 1994

Meyer, Ursula, "How to Explain Pictures to a Dead Hare," *Art News*, Jan. 1970

—, *Conceptual Art*, New York, 1972

Mike Kelley: Catholic Tastes (exh. cat.), New York, 1993

Monroe, Alexandra, *Japanese Art after 1945; Scream Against the Sky*, (Yokohama Museum and Guggenheim Museum exh. cat.), New York ,1994

Montano, Linda, *Art in Everyday Life*, Los Angeles, 1981

Mueller, Roswitha, *Valie Export*, Bloomington and Indianapolis, 1994

Negroponte, Nicholas, *Being Digital*, New York, 1995

Nitsch, Hermann, *Orgien, Mysterien, Theater/Orgies, Mysteries, Theatre* (German and English), Darmstadt, 1969

Nomad, 1986–1993 (exh. cat.), Nuremberg, 1993

Nouvelles de Dance, Brussels, March 1993–

Nuttall, Jeff, *Performance Art Memoirs*, Vols 1 & 2, London, 1979

O'Dell, Kathy, *Contract with the Skin: Masochism, Performance Art and the 1970s*, London and Minneapolis, 1998

Oldenburg, Claes, *Store Days*, New York, 1967

—, *Raw Notes*, Nova Scotia, 1973

Onorato, Ronald, *Vito Acconci: Domestic Trappings* (exh. cat.), La Jolla, 1987

Owens, Craig, *Beyond Recognition, Representation, Power, and Culture*, Berkeley Calif. 1992

Parker, Andrew, and Eve Kosofsky Sedgwick, eds, *Performativity and Performance*, London and New York, 1995

Pearson, Mike, "Theatre/Archaeology," *The Drama Review*, vol. 38, no. 4, 1994

Peine, Otto, and Heinz Mack, *Zero*, Cambridge, Mass., 1973

Performance, New York, 1973–

Performance, special issue, *Studio International*, Vol. 192, Number 982, London, July–August 1976

Performance Anxiety (exh. cat.), Chicago, 1997

Performance Art and Video Installation (exh. cat.), London, 1985

Performance Magazine, London, June 1979–

Performance Research Journal, vol. 1, London, 1995–

Performing Arts Journal, New York, Spring 1976–

Phelan, Peggy, Unmarked: The Politics of Performance, London and
New York, 1993

—, and Lydia Hart, Acting Out: Feminist Performances, Ann Arbor,
1993

Plant, Sadie, The Most Radical Gesture: The Situationist International
in a Postmodern Age, London and New York, 1992

Poggioli, Renato, Theory of the Avant-Garde, Cambridge, 1968

Pontbraid, C., Performance: Text(e)s and Documents, Montreal,
1980

P-Orridge, Genesis, and Colin Naylor, eds., Contemporary Artists,
London and New York, 1977

Postman, Neil, Amusing Ourselves to Death, Public Discourse in the
Age of Show Business, New York, 1985

Rapid Eye, Brighton, 1989–

Ratcliff, Carter, Gilbert & George: The Complete Pictures 1971–1985,
London and New York, 1986

—, and Robert Rosenblum, Gilbert & George: The Singing Sculpture,
New York, 1993

Read, Alan, Theatre & Everyday Life: An Ethics of Performance,
London and New York, 1993

Rebecca Horn, (Guggenheim Museum exh. cat.), New York, 1993

Richter, Hans, Dada: Art and Anti-Art, London, 1965

Robert Rauschenberg, A Retrospective, (Guggenheim Museum exh.
cat.), New York, 1998

Robert Wilson: The Theater of Images, New York, 1984

Rogers, Steve, "Showing the Wires: An Interview with Julian
Maynard Smith," Performance, 1988, nos. 56–57

Rose Finn-Kelcey (exh. cat.), London, 1992

Roth, Maura, ed., The Amazing Decade: Women and Performance
Art in America, 1970–1980, Los Angeles, 1983

—, ed., Rachel Rosenthal, New York, 1997

Rugoff, Ralph, Kristine Stiles ,and Giacinto De Pietrantonio,
Paul McCarthy, London, 1996

Russell, Mark, ed., Out of Character: Rants, Raves, and Monologues
from Today's Top Performance Artists, New York, 1996

Russolo, Luigi, The Art of Noise, New York, 1967

Sam Taylor-Wood, (Chisenhale Gallery exh. cat.), 1996

Sandford, Mariellen R., ed., Happenings and Other Acts, London
and New York, 1995

Savitt, Mark, "Hannah Wilke: The Pleasure Principle," Arts
Magazine , vol. 50, No. 1, New York, Sept. 1975, pp. 56–7

Savran, D., Breaking the Rules: The Wooster Group,
New York, 1986

Sayre, Henry M., The Object of Performance: The American Avant-
Garde since 1970, Chicago, 1989

Schechner, Richard, ed., The Performance Group: Dionysus in 69,
New York, 1970

—, Environmental Theatre, New York, 1973

—, The Future of Ritual, New York, 1993

Schilling, Jürgen, Aktionskunst: Identität von Kunst und Leben?,
Frankfurt and Lucerne, 1978

Schimmel, Paul, Chris Burden: A Twenty-Year Survey (exh. cat.),
Newport Beach, Calif, 1988

Schimmel, Paul, et al, Out of Actions; between performance and the
object 1949–1979 (Museum of Comtemporary Art, Los Angleles,
exh.cat.), London and New York, 1998

Schmidt, P., "The Sounds of Brace Up! Translating the Music of
Chekov," The Drama Review, vol. 36, no. 4, 1992

Schneemann, Carolee, More Than Meat Joy: Performance Works
and Selected Writings, New York, 1979: 1997

Schneider, Rebecca, The Explicit Body in Performance, London and
New York, 1997

Shank, Theodore, American Alternative Theater, New York, 1982

—, ed., Contemporary British Theatre, London, 1994

Shore, Stephen, and Lynne Tillman, The Velvet Years, Warhol's
Factory 1965–1967, London and New York, 1995

Shyer, Laurence, Robert Wilson And His Collaborators, New York,
1989

Sign of the Times: A Decade of Time-Based Work in Britain
1980–1990, (Museum of Modern Art exh. cat.), Oxford, 1990

Sims, Lowery, "Body Politics: Hannah Wilke and Kaylynn Sullivan,"
Art & Ideology, (exh. cat.), New York, 1984

Sohm, H., Happening & Fluxus, Cologne, 1970

Sorgeloos, Herman, Rosas Album, Amsterdam, 1993

Spoerri, D., An Anecdoted Topography of Chance, New York, 1966

Stephen Cripps: A Monograph, London, 1992

Stewart, Nick, Neither Time Nor Material, Dublin, 1995

Stuart Brisley, (exh. cat.), London, 1981

Sundell, Nina, Rauschenberg/Performance 1954–1984, Cleveland,
Ohio, 1983

Tamm, Eric, Brian Eno: His Music and the Vertical Color of Sound,
Boston and London, 1989

Taylor, Diana, and Juan Villegas, eds, Negotiating Performance:
Gender, Sexuality, & Theatricality in Latin/o America, Durham
and London, 1994

Templeton, Fiona, You—The City, New York, 1990

Teshigawara, Saburo, Blue Meteorite, Tokyo, 1989

Theaterschrift, Hebbel-Theater, Berlin; Felix Meritis Foundation,
Amsterdam; Wiener Festwochen, Vienna; Kaaitheater Brussels,
1990–

Tisdall, Caroline, Joseph Beuys, London, 1988

Tony Oursler; Dummies, Clouds, Organs, Flowers, Watercolors…
(Portikus exh. cat.), Frankfurt, 1995

Total Theatre: the magazine for mime, physical & visual theatre,
Kendal, Cumbria, Spring 1989–

Tucker, Marcia, Choices: Making an Art of Everyday Life (exh. cat.),
New York, 1986

Tufnell, Miranda, and Chris Crickmay, eds, Body Space Image:
Notes Towards Improvisation and Performance, London, 1990

Ugwu, Catherine, ed., Lets Get It On—The Politics of Black
Performance, London and Seattle, 1995

Vaughan, David, Merce Cunningham: Fifty Years, New York,
1997

Vergine, Lea, Il Corpo Come Linguaggio (La "Body-art" e storie
simili), Milan, 1974

Viennese Aktionism 1960–1971 (exh. cat.), Vols 1 & 2, Klagenfurt,
1989

Walker, John A., John Latham: The Incidental Person: His Art and
Ideas, London, 1995

Wallace, Michele, and Gina Dent, eds, Black Popular Culture,
Seattle, 1992

Wallis, Brian, Art After Modernism; Rethinking Representation,
New York, 1984

Walther, Franz Erhard, Arbeiten 1969–1976 (exh. cat.), São Paulo,
1977

Waterlow, Nick, ed., 25 Years of Performance Art in Australia:
Performance Art, Performance and Events, Paddington,
New South Wales, 1994

Wilkinson, Samantha, ed., Locus+ 1993–1996, Newcastle, 1996

Wilson, Martha, ed., Art Journal, Special Edition: Performance Art,
vol. 56, no. 4, New York, Winter 1997

Wilson, Robert, A Letter for Queen Victoria: An Opera in Four Acts,
Paris, 1974

Wolf Vostell, 1958–1974 (exh. cat.), Berlin, 1975

Yoko Ono: Have You Seen the Horizon Lately? (MOMA Oxford,
exh. cat.), Oxford, 1998

Yvonne Rainer: Work 1961–1973, Novia Scotia, 1974

list of illustrations

numerals indicate pages on which pictures appear, and a (above), b (below), c (center), r (right), l (left), and t (top) indicate position on the page

index

page references to illustrations are in italic